Buddhism
Art and Faith

Edited by W. Zwalf

Published by British Museum Publications Limited
for the Trustees of the British Museum
and the British Library Board

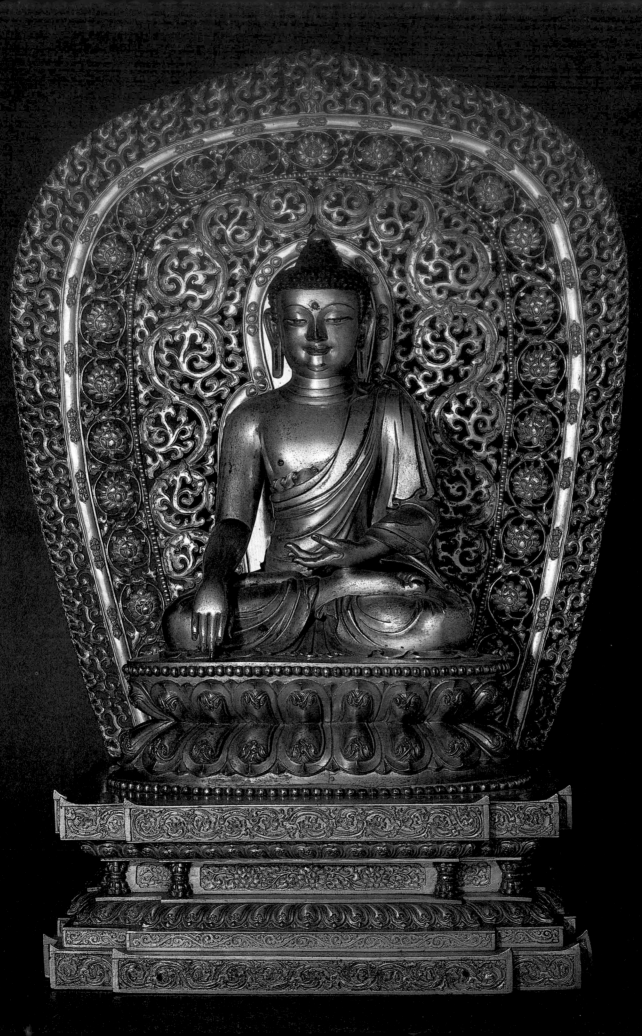

© 1985, The Trustees of the British Museum
and the British Library Board

Published by British Museum Publications Ltd
46 Bloomsbury Street, London WC1B 3QQ

British Library Cataloguing in Publication Data
Buddhism: art and faith.
 1. Art, Buddhist—History
 I. Zwalf, W. II. British Museum, *Trustees*
 III. British Library, *Board*
 704.9′48943′09 N8193

 ISBN 0-7141-1432-4

Designed by James Shurmer

Set in Monophoto Apollo
and printed in Great Britain by
Jolly & Barber Ltd, Rugby, Warwickshire

**The Trustees of the British Museum and the
British Library Board acknowledge with
gratitude the support of Eskenazi Ltd in the
publication of this book.**

Cover Life of the Buddha (no. 237).

Page 1 Śākyamuni (no. 305).

Page 6 Vaiśravaṇa (no. 319).

Contents

Preface *page 7*

Introduction *9*

1 Early cult monuments *26*

2 The Buddha legend *32*

3 The scriptures and their transmission *40*

4 The Buddha image *91*

5 Afghanistan, Pakistan and Kashmir *100*

6 Eastern India *104*

7 Nepal and Tibet *118*

8 The Deccan and south India *145*

9 Sri Lanka *148*

10 Burma *157*

11 Thailand and Cambodia *175*

12 Indonesia *186*

13 Central Asia *191*

14 China *197*

15 Korea *235*

16 Japan *243*

Maps *291*

Bibliography *294*

Index *297*

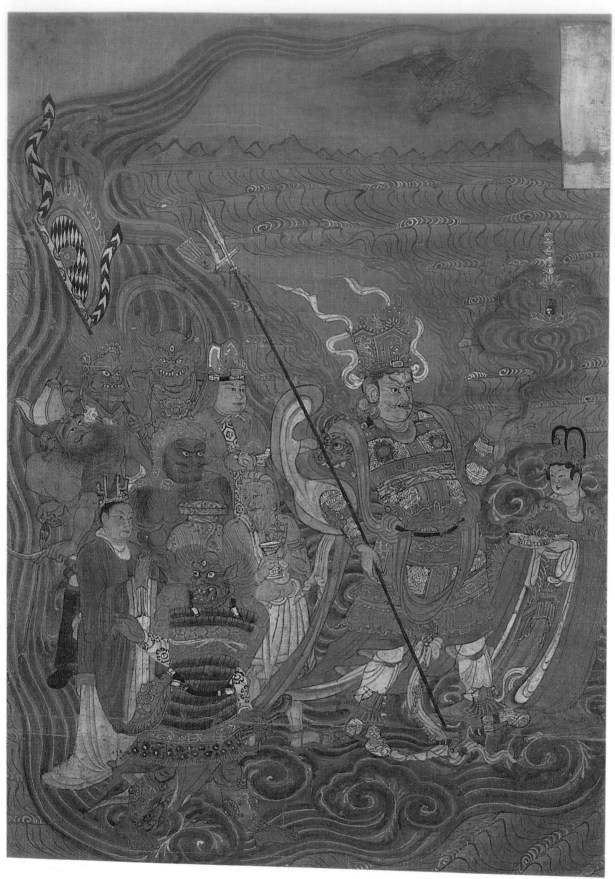

Preface

Despite the great number of books on Buddhism, a catalogue and visual record of an exhibition drawn mainly from the resources of the British Museum and British Library may claim a place. It attempts, without deliberate specialist appeal, to follow the course of Buddhist art and doctrine as they appear from the Indian beginnings of patronage and use of durable materials, some centuries after the Buddha, to recent times. As a collaborative undertaking it avoids a too rigorous editorial consistency, but Sanskrit has been generally used as the international language of Buddhism. To make consultation of the catalogue easier the Index is partly a glossary; the Bibliography contains mainly general works with good bibliographies, but to obviate footnotes a few references have been added to it with the catalogue number of the object to which they particularly apply.

Certain terms are used for simplicity: thus Tibet indicates both the Autonomous Region of the People's Republic of China and areas of Tibetan culture outside it, and Cambodia has been preferred to the less familiar Kampuchea. The source of exhibits is distinguished by prefixing OA (Department of Oriental Antiquities, British Museum) and OMPB and IOLR (Department of Oriental Manuscripts and Printed Books and India Office Library and Records, British Library) to appropriate accession numbers, while lenders have been named in full. Authors' initials are expanded overleaf.

It is pleasant to thank lending institutions and their staffs: the Ashmolean Museum, Oxford, and Dr J. H. Harle; the Bodleian Library, Oxford, and A. Roberts; the Syndics of Cambridge University Library and Dr F. W. Ratcliffe, A. Dalby and D. J. Hall; the Royal Scottish Museum, Edinburgh, and Jennifer Scarce and Jane Wilkinson; the Trustees of the Victoria and Albert Museum and J. V. Earle, Robert Skelton, Dr Deborah Swallow and John Clarke. All illustrations of material lent are copyright and reproduced by courtesy of the lending institutions. Generous support for additional colour illustrations in this catalogue was provided by Eskenazi Ltd.

Scholarly assistance is gratefully acknowledged from Dr S. Bandaranayake, Elizabeth Errington, Dr Youngsook Pak, H. E. Richardson, CIE, OBE, and Dr N. Seeley. Both Derek Gillman, Keeper of the Sainsbury Centre for Visual Arts, University of East Anglia, and Professor Roderick Whitfield, University of London, continued their collaboration after leaving the British Museum.

Warm thanks are due to academic staff at the British Museum and British Library, especially Dr Frances Wood, who have helped beyond the strict limits of their responsibilities. The photographers at the British Museum, Paul Gardner, Jane Beamish and Peter Stringer, and at the British Library, Christopher McGlashon and Andrew Ogilivie, bore patiently with a taxing assignment, and this catalogue owes much to Deborah Wakeling of British Museum Publications.

For the realisation of the exhibition itself grateful thanks must go to the British Museum's Design Office, in particular to the unsparing efforts of Robert Baxter, Gillian Hughes, Simon Muirhead and Julia Walton, as well as to the always dependable Conservators and Museum Assistants. Financial help was generously provided by HTS Managements Holdings Ltd and, towards the provision of Graham Harrison's photographs, by Japan Airlines Ltd.

W. Zwalf, May 1985

Abbreviations used for contributors
to the catalogue

British Museum

JC	Joe Cribb
VH	Victor Harris
MEAMcC	M. E. A. McCord
LRHS	Lawrence Smith
WZ	W. Zwalf

British Library

YYB	Yu-ying Brown
LC	Lama Chime
KBG	Kenneth B. Gardner
HG	Henry Ginsburg
PMH	Patricia M. Herbert
JPL	J. P. Losty
EMcK	Elizabeth McKillop
FW	Frances Wood

DG	Derek Gillman, Sainsbury Centre for Visual Arts, University of East Anglia
RW	Roderick Whitfield, University of London

Introduction

Early doctrine

Buddhism is a world religion with a historical founder who by becoming enlightened (*buddha* in ancient Indian languages) discovered and taught a way to salvation. Called Siddhārtha Gautama, of the Śākya tribe in the Nepalese Terai, he probably lived between 563 and 483 BC. Accurate information on his life is, however, buried in legend, and his own teachings cannot be dependably recovered from a huge body of scriptures which, though attributed to him, was clearly composed over many centuries. He is usually known by titles. The common Śākyamuni (Sage of the Śākyas) derives from his tribal name; that of Buddha may have been generic for tradition recognised predecessors and a successor, Maitreya, still to come. Tathāgata ('thus come' or 'thus gone') may have referred to the idea of succession as well as spiritual attainment, and the title Jina means conqueror. The historical Buddha must at once have been venerated, if not worshipped, for Enlightenment was considered a supernatural condition and a heroic achievement. In time forms of Buddhism acknowledged not one but many transcendental Buddhas to whom these titles were applied. Nevertheless, alongside such complexities the tradition survived of a being beyond mere humanity who was also born, reached Enlightenment under a sacred tree at Bodh Gayā, preached a First Sermon at Sārnāth, and died at Kuśinagara in north Bihar.

Buddhism began as one of many early Indian religious movements, most of them less documented than itself and the older Hinduism preserved in the literature of its hereditary priesthood, the Brahmins. The differences between them, Buddhism's disregard for caste in respect of conversion and ordination, its denial of the efficacy for salvation of faith in gods and ritual, and the refusal to recognise an individual soul or supreme essence make it appear 'protestant'; if Buddhism owed something to its founder's provincial origins, it also had many agreements with other Indian religious developments in its beginnings and at later stages of its history. From the start it accepted rebirth or transmigration, the common Indian belief that an individual life was one of a series in which each life was conditioned by the moral value of deeds performed in a previous existence. Often called *karma* ('act' or 'deed'), it was seen as making life a fundamentally painful process – the first of the Buddha's Four Truths. Everything is suffering: birth, old age, sickness and death; contact with what one dislikes, separation from what one desires, not obtaining what one wishes. The second Truth defines the causes of suffering: desire for what is void of reality, for pleasure, for existence, all leading from one life to another. The third Truth is the suppression of desire and the end of suffering, and the fourth is the means by which that is achieved. Basic to the Truths is that the individual is only a combination of five components or Aggregates (*skandha*). The first, form, accounts for the physical elements of existence: earth, water, fire, wind, the organs of sense (eye, ear, etc.) and their objects (sight, sound, etc.); the other four are feeling or sensation, perception, impulse (or emotion and volition) and consciousness. No one of these Aggregates is a soul or permanent self, nor do they constitute together a real abiding personality or self. Throughout their coexistence as a physical and psychological entity, that is as a life, the Aggregates are subject to constant change, and after death differently conditioned

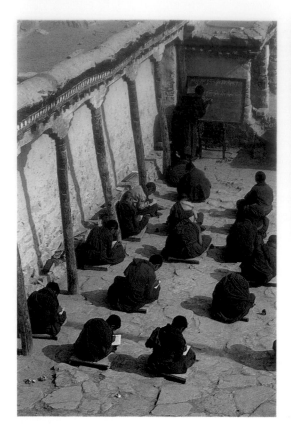

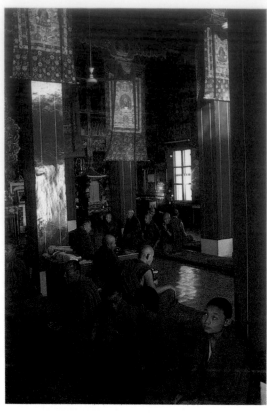

Left A class of novices at a Tibetan monastery in Ladakh, Kashmir. (Photo Graham Harrison)

Right Tibetan monks assembling for scripture reading in the monastery hall at Bodh Gayā, Bihar, India. (Photo Graham Harrison)

Aggregates, reassembled by the force of *karma* into a new life or 'stream' (*saṃtāna*), are again ever changing, devoid of any soul and, by definition, liable to suffering.

This eternal process is anything but arbitrary since Buddhism believed very precisely in cause and effect: as a man sows so he will reap in the six worlds of rebirth (*gati*), be it in hell, as an animal, a ghost, a human, a titan or a god. Classes of action earn appropriate retribution in the current life, immediately after death, in the next birth or later still, and as the effect of an act or acts wears off, consequences of other acts take its place. Intention is decisive since a retributed act must be voluntarily and consciously performed.

A detailed causal statement called Dependent Origination (*pratītyasamutpāda*) can be summarised 'when this exists, that exists' or negatively 'when this does not exist, that does not exist' because Buddhism sought not only the cause of suffering but also its suppression. The sequence has been much discussed and interpreted, and even the Buddha is said to have admitted its difficulty. The first term is moral and intellectual ignorance, especially of the Buddhist Truths and believing there to be a personality or essential self. Ignorance produces forces or dispositions leading to rebirth; the resultant consciousness is the main precondition of mind and body, the sense organs of mind and body produce contact, from contact comes sensation, from sensation desire, from desire grasping after pleasure, false views and mistaken religious practices; grasping produces coming into existence, resulting in birth and old age and death. Birth and old age and death may be interpreted as a life vitiated by the preceding stages causing rebirth, and the whole has from early times been thought of as a twelvefold sequence or wheel.

When the Buddha became enlightened, he achieved *nirvāṇa*. He had eliminated the causes of rebirth but even in him retribution, though much diminished, had still to work

itself out. The technical term for such a person is *arhat*. When he dies the forces reassembling the Aggregates have, in his case, been annihilated. *Nirvāṇa* is salvation and the *arhat* is not reborn. The Buddha had nothing to say of the *arhat*'s condition after death. It sufficed that the goal had been attained.

The fourth Truth, the Noble Eightfold Path to the destruction of suffering, consists of right speech, right livelihood, right action, right effort, right mindfulness, right concentration, right opinion and right intention. It involves a great apparatus of spiritual exercises, in practice largely in the context of monasticism. *Nirvāṇa*, while not unknown or impossible for the layman, was evidently thought not feasible outside a retired way of life. The layman normally gave food and clothing to the monks, made endowments to the Order and sought instruction in Doctrine. Such conduct, called the path to the heavens, brought merit and better rebirths.

The Eightfold Path falls into three divisions of morality, concentration and wisdom. The layman shared certain vows of morality and discipline with the monk, but the latter was obliged to perform them all. Morality consisted of the abandonment of killing, theft, unchastity, untruth and other faults of speech, but the layman could temporarily also adopt restrictions from the monk's discipline, described below, in matters of food, drink, dress and entertainment. Both monk and layman were required to observe careful guard upon their senses and to concentrate on their actions with proper mindfulness.

Concentration was begun by ridding the mind of the Five Hindrances, longing for the world, malice, sloth and torpor, distraction and agitation, and doubt. There are then four

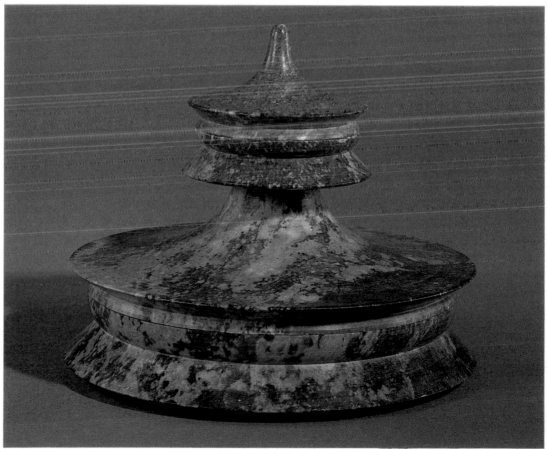

stages of trance, a state of joyful reasoning and investigation, a state of joy beyond them, a state of pleasurable equanimity and a state beyond pleasure and pain of pure mindfulness and equanimity. Subsequent stages, called attainments, bring awareness of the infinity of space and consciousness, of the sphere of nothingness, then of that beyond both consciousness and non-consciousness, and finally there is cessation of perception and feeling.

This sequence is far from exhausting the spiritual exercises which include the cultivation of desirable mental attitudes, meditation on the loathsomeness of the body, fixing the mind on certain objects and colours, contemplating the Buddha and breath-control. The aim is always to achieve wisdom or full intuitive knowledge beyond mere faith and instruction; the knowledge must be a direct and personal achievement and comprise the fullest realisation of the Truths. According to degree of progress there are four stages to *nirvāṇa*: that of the convert, who will not be reborn in hell, as an animal or a ghost, that which results in one more human birth in which *nirvāṇa* will be reached, and that when rebirth takes place in a higher world and *nirvāṇa* is attained there. These first three stages are open to the layman. Finally there is the achievement of *nirvāṇa* as a result of the complete elimination of passions, hatred and error in a last life. Even from this the layman is theoretically not excluded.

Monasticism

Monks or religious wanderers, supported by pious alms-giving, were not new when the Buddha established his own Order (Saṃgha), and a body of common usages already existed. When he had proclaimed his Doctrine, the Buddha began to ordain converts who wished to be monks. The texts describe him as giving rulings on appropriate occasions to his following, and so their code of discipline began to be formed. It must have continued to grow after his death and disagreements took place. Nevertheless, basic texts of discipline of different sects agree to a great extent; the monastic way was worked out at an early stage.

A novice, who might not be admitted before the age of eight, recited a simple formula of faith in the Buddha, his Doctrine and the Order (the Three Jewels) and the Ten Abstentions (from murder, theft, unchastity, untruth, fermented drink, eating after noon, entertainments, ornament, luxurious beds and gold and silver). His head was shaved and he adopted monk's clothing; teachers were provided for study and to sponsor his ordination (*upasampadā*), which could not take place before the age of twenty. It required a quorum of ten monks who were asked to approve his admission by their silence after he had satisfied a questioner that he was of age, male, not a criminal, free from physical deformity and illness, not a soldier, a slave or acting without parental consent. He was then recommended to content himself with eating only food that had been begged, wearing rags gathered from dust heaps, living under a tree and taking only cow's urine as medicine, and warned against unchastity, murder, theft and improperly claiming supernatural powers.

A monk's duties were his spiritual exercises and the instruction of novices and layfolk. He was permitted to own eight articles, his bowl, three pieces of clothing (an upper and lower garment and a cloak, coloured red or yellow), a belt, a razor, a needle and a water filter; to these were added later a garment against the rain, a fan, wooden toothpicks, sandals, a staff and a rosary. Settled community life was originally confined to retreats of three or four months in the rainy season (the Buddhist Lent), when wandering became difficult, in the early monasteries built on land given by pious layfolk. At first haphazard collections of huts, the monasteries eventually consisted of buildings arranged on a standard plan and often

well-endowed, so that the daily begging round ceased to be necessary. Large complexes also served as educational establishments. Various administrative officers were provided for, but traditionally the abbot was the eldest in point of ordination. Rules for nuns were substantially the same as for monks but more severe.

Festivals and special gatherings were celebrated at the beginning and end of the rainy season and to commemorate events from the Buddha's life. The chief monastic gathering, which united a community as a 'parish', was the *uposadha*, days of fasting and specially rigorous observance, in which layfolk also engaged, held on the eighth and fourteenth or fifteenth days of the lunar fortnight, depending on its length. At the full and new moon a monastic code (*Prātimokṣa*, of between 227 and 263 rules for monks and more for nuns) was recited, and breaches were confessed which ranged from those requiring permanent or temporary expulsion to acts of penitence only.

Councils and early sects

After the Buddha's death the task of maintaining the Doctrine fell upon the monastic Order; lacking a central authority, however, Buddhist church history is confused for sources disagree. A Council was held at Rājagṛha (Rājgīr) at which, in some traditions, the scriptures in their threefold division were constituted from the memory of disciples, the books of Discipline (*Vinaya*), Discourses of the Buddha (*Sūtra*) and systematisations of Doctrine (*Abhidharma*). Nothing so complete as any later canon existed then, and transmission must have long remained oral.

The Second Council a century later at Vaiśālī condemned the monks of Vaiśālī for ten objectionable practices, and they appear to have formed a separate community. Another tradition concerns a monk called Mahādeva and his five propositions which reduced the spiritual achievement of the *arhat*, perhaps in response to lay resentment at the claims made for him. The conflicts may have been the beginning of the Mahāsāṃghika sect.

The Third Council at Patna, c.250 BC, is not mentioned outside Buddhist chronicles from Sri Lanka which claim that it sent missions throughout historic India and beyond. By the time of the Fourth Council (said to have been held in Kashmir, c.AD 100) Buddhism had spread to Afghanistan and Sri Lanka if not farther, and this expansion must have furthered the division into sects, traditionally numbered at eighteen.

Our knowledge of the sects is uneven. Among the Mahāsāṃghikas belief in the supernatural character of a Buddha and Bodhisattvas was especially developed, anticipating the Mahāyāna movement; the Dharmaguptakas in this connection are interesting as stressing the greater merit of making gifts to the Buddha than to his Order. The Sautrāntikas and Sarvāstivādins, also of early origin, developed philosophy and scholasticism, for instance in dealing with the problem of what is reborn if the existence of a soul or self is denied and the Agreggates, still seen as real but in constant flux and causally conditioned, were subdivided into elements or phenomena (*dharmas*). There were other schools, but only the Sthaviras or Theravāda (Doctrine of the Elders), popularly known as Pali or southern Buddhism from its canonical language and present distribution in Sri Lanka and South-east Asia, which still sees salvation as becoming an *arhat*, has survived from the Hīnayāna (Little Vehicle) tradition to hold the field with descendants of the Mahāyāna or northern Buddhism and their different goals.

WZ

The Mahāyāna

Probably in the first century AD or earlier a school of Buddhism arose in Southern India so different that it seemed a new movement. It called itself the Great Vehicle (Mahāyāna) transporting all beings to *nirvāṇa*, and applied the disparaging term Hīnayāna (Little Vehicle) to its opponents. *Nirvāṇa* for oneself in the fastest possible time, the aim of the earlier tradition, was now considered selfish. The aim instead was to become a Buddha, first gradually becoming a Bodhisattva, who by indefinitely postponing his own *nirvāṇa* helped others on the way. A Bodhisattva (one whose essence is Enlightenment) is one who has conceived *bodhicitta* (Thought of Enlightenment), the first step on the road to Bodhisattvahood. The historical Buddha was, of course, a Bodhisattva in his previous lives, and the *jātaka* stories of the Hīnayāna Canon show the virtues practised over his various lives culminating in eventual Buddhahood. The immense expansion of this idea and its application to anyone, monk or layman, differentiates the Mahāyāna from what had gone before.

The earliest Mahāyāna texts, the Perfection of Wisdom and the Gem-heap *sūtras*, prescribe the path of the Bodhisattva, the six (later ten) Perfections to be acquired over countless lives and its ten stages. The six Perfections are generosity, virtue, toleration, energy, meditation and understanding. All are shown by the Bodhisattva of the *jātakas*; now, however, the aspiring Bodhisattva must acquire them to progress through the ten stages (*bhūmi*). On these stages the most important advances are the last four: the non-perception of objects; the certainty that phenomena have no beginning; the ability to teach in the guise of his hearers; and omniscience and all-seeing compassion.

The Mahāyāna seems to have adopted certain ideas found in some of the southern Mahāsāṃghika schools, particularly on the transcendence of the Buddha, and on his always having been in control of his own destiny and hence not subject to the laws of *karma*. The original Mahāsāṃghikas had sharply differentiated the *arhat*, the merely liberated, from the fully enlightened and extremely rare Buddha. The Lokottaravādins (the other-worlders)

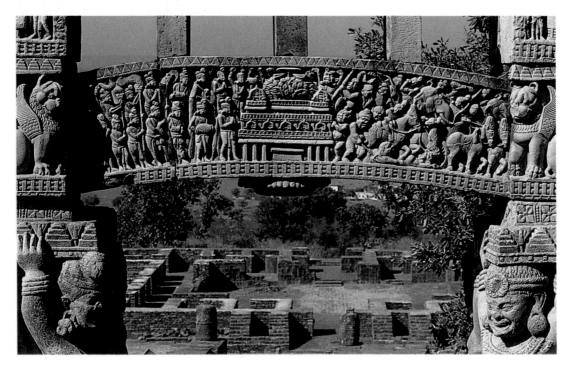

View through the carved lintels of the west gateway of the processional path round stūpa 1 at Sāñcī with monastery ruins below. (Photo Graham Harrison)

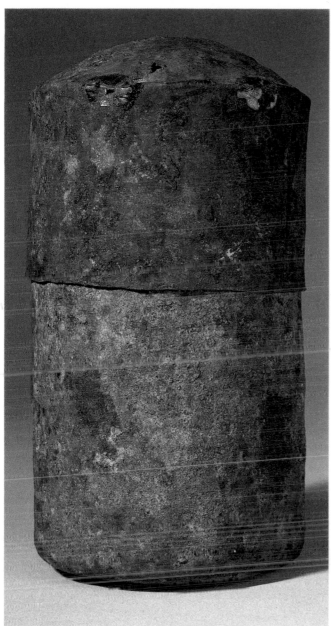

10

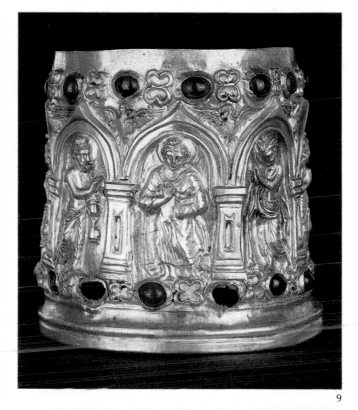

9

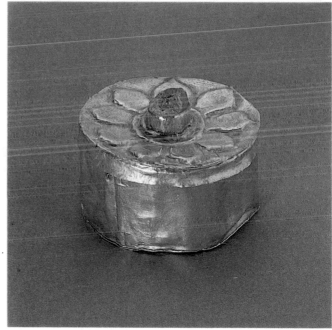

11

expanded this view to make the historical Buddha transcendent. The Mahāyāna expanded these ideas again – the number of worlds was infinite, both in space and time, all required Buddhas and Bodhisattvas to teach the way. Here, then, was hope that all would one day reach these exalted heights. In the meantime, the worship of those Buddhas and Bodhisattvas known to them could only help them, such as the Buddhas Amitābha and Vairocana and their emanations, the Bodhisattvas Avalokiteśvara, Vajrapāṇi and Mañjuśrī.

The Buddha's original doctrine was hard to follow: it involved withdrawing from the world as a monk and concentrating exclusively on *nirvāṇa* to escape from the chain of rebirth. It was to satisfy the desire of the masses to worship transcendent beings, and through worship to increase one's merit and to advance a little towards one's own Bodhisattvahood, that these developments took place. Although it is difficult to see exactly how the Buddha's original path was transformed, as most of the intervening texts have been lost, it is not unique to Buddhism for an original austerity to be compromised by the need for mass appeal. Buddhism cannot be considered in isolation from other religious developments in India, for at this time the Hindu gods Viṣṇu and Śiva were being transformed into Supreme Beings out of local mythologies and pantheistic speculations. Buddhism too needed its lay followers in order to survive; without the laity, there was no food for the monks.

Buddhist doctrine had been slowly developing since the Buddha's *nirvāṇa*, but though all the schools freely interpreted the Doctrine in the systematisations called the *Abhidharma*, they yet hesitated to tamper with the canonical *sūtras*. The monks of the Mahāyāna, however, had no such scruples, and the next five centuries witnessed an immense outpouring of the Indian genius for religious and philosophical speculation, one doctrine rapidly succeeding another, and all of them quickly transmitted throughout the Buddhist world. Freed from the human Buddha and the actual words of his last life, the authors of these *sūtras* rapidly developed both the Doctrine and its philosophical foundations. The way of the Bodhisattva and the transcendent Buddha were followed by the numberless Buddhas of an infinite cosmos.

The early Buddhist schools denied the reality of the self but allowed elements or phenomena (*dharma*) to have an existence; in the new doctrine called Emptiness (*śūnyatā*) no opinion could be logically entertained about the existence or non-existence of anything (though here the Buddha's actual words were claimed as authority). At the same time Buddhas and Bodhisattvas intervened actively to help mankind to Buddhahood, and millions prayed to be reborn in the hedonist paradise of the Buddha Amitābha. The Buddha Śākyamuni became an eternal, omniscient Supreme Being. In an intellectual revolt against Emptiness another group of *sūtras* predicated Consciousness (*Vijñāna*) alone as reality. Other *sūtras* concentrated on the Bodhisattvas, some making Avalokiteśvara the equal of the Buddha. Yet others extolled the virtues of living as a layman and thereby achieving Enlightenment. All these *sūtras* were propounded in an immense cosmic spectacle, the Buddha in conversation with the great Bodhisattvas, before a vast congregation of all the varieties of conscious life. Here the Buddhas are represented in their Enjoyment-bodies (*saṃbhogakāya*), bejewelled and enthroned. They also have false bodies (*nirmāṇakāya*), which they send into the world to preach the Doctrine. At the same time all the Buddhas are identical in being the embodiment of the Doctrine (*Dharmakāya*).

As the doctrines revealed in the *sūtras* progressed, their philosophical underpinnings were in need of systematisation and analysis, and this work progressed in parallel. The Emptiness doctrine of the early Perfection of Wisdom texts was systematised by Nāgārjuna in the second century AD in his *Mūlamadhyamakakārikās*, the fundamental principles of the

Middle Way (*Madhyamaka*). The emotive force of the Buddha's Middle Way, between the extremes of asceticism and hedonism, was still a powerful symbol, and Nāgārjuna's Middle Way was apparently an attempt, ultimately unsuccessful, to reconcile the early schools with the views of the Perfection of Wisdom, by appealing not to the Hīnayāna *Abhidharma* commentators but directly to the words of the Buddha himself. He had refused to speculate on the nature of anything, and constructed no philosophical absolutes. Nāgārjuna followed him, advancing no position himself, but deducing from the positions attributed to his opponents that they were in fact untenable, that no element or phenomenon (*dharma*) had an inherent own-nature, that it was in fact 'empty' of own-nature. His 'emptiness' was not a metaphysical construct, as it later became, but a description. He disallowed the opposite argument, that because nothing exists the universe is non-existent: he denied the existence of non-existence as emphatically as that of existence. It follows that if nothing can be said to exist, nothing can give rise to it, nor can anything be produced from it. Things cannot arise and cannot perish, and are already in *nirvāṇa*, in a state of absolute calm.

Nāgārjuna distinguished between absolute and conventional truth, and his followers who linked the *Madhyamaka* with the Mahāyāna *sūtras* used this distinction to explain why the Buddhas and Bodhisattvas, themselves non-existent, intervened to help others to *nirvāṇa* when in fact they were already there. The Bodhisattva must start at the mundane level, practising the six Perfections until he is advanced enough to perceive ultimate reality, and eventually at the highest level to cease all activity. By this time the break with the old schools was complete. The Middle Way was interpreted as neither affirming nor denying the existence or non-existence of anything.

Such conceptions underlie most Mahāyāna *sūtras*, but there is a group of idealist *sūtras* whose system (the *Vijñānavāda* or Consciousness-school) was formulated by Asaṅga in the fourth century. He criticised the *Madhyamaka* for not taking a middle view at all, but for being at one extreme, the early schools, he claimed, being at the other. The imaginer of the non-existent exists, and is Consciousness (*Vijñāna*) existing in Emptiness – this Asaṅga states is the Middle Way. The two principal schools of Buddhist philosophy debated vigorously with one another, with the proponents of the Hīnayāna *Abhidharmas* and with various Hindu schools.

The Vajrayāna

The development of Sanskrit as a literary language for poetry in the early first millennium AD allowed large numbers of devotional hymns to be addressed to the Buddha. A slightly later development was the production of *dhāraṇīs* (literally concentration), incantations which achieve particular objects, linked to *mantra*, concatenations of words, often meaningless in themselves, which were again recited for particular ends. Passages where the Buddha or a Bodhisattva impart *dhāraṇīs* or *mantras* which encapsulate the entire doctrine occur in some of the Mahāyāna *sūtras* from about the fourth century.

At first perhaps no more than magic spells, these incantations were later linked with ritual and meditational techniques in a series of works called *tantras*. Their ontology is basically *Madhyamaka*, but they differ in their methods of achieving *nirvāṇa*. By using *dhāraṇīs*, *maṇḍalas* (diagrams for the disposition of deities) and *mudrās* (ritual gestures), the initiate meditates on one or other aspect of the Buddha to achieve union with him. In this system the essence of the Mahāyāna, the way of the Bodhisattva, has been completely bypassed. For the

adept to achieve the spiritual powers needed for such a union the complete co-operation of a *guru*, a teacher already possessing such powers, was necessary.

This system of esoteric Buddhism is the Vajrayāna, the Thunderbolt-Vehicle (the *vajra* representing unbreakable reality, the symbol of the Supreme (Ādi) Buddha Vajrasattva or Vajradhara, the Being or Holder of the Thunderbolt). From the Ādi Buddha's meditations emerged the five Jinas (Conqueror Buddhas): Vairocana, Amoghasiddhi, Ratnasambhava, Akṣobhya and Amitābha, the first usually central, the others already long associated with the four directions, usually north, south, east and west respectively. From these five emanated in turn entire families of divinities, many of them terrifying. These served as personified symbols of one or other aspects of the Buddha and the Doctrine. The adept conceptualises them, literally enclosing them within their *maṇḍalas*, cosmic and magic diagrams from which they cannot escape, rendering the malevolent ones harmless, and identifies himself with them in his meditation techniques. Many are thought of, and represented, as embracing their *prajñā*, or insight, envisaged as a feminine divinity. The embrace (Sanskrit *yuganaddha*, Tibetan *yab-yum*) symbolises the union of male compassion with feminine insight, the essence of the Bodhisattva ideal.

Just as the Mahāyāna system made the attainment of Buddhahood possible to anyone, and in many respects easier than in the conservative schools such as the Theravāda, so the Vajrayāna shortens the process again, the long, hard progress in spiritual self-awareness over countless lives being reduced to more 'instant enlightenment', over sixteen lives in one text, and for an adept of the Higher Tantra in the course of one life.　　　　　JPL

China

The earliest reliable textual and archaeological evidence places the introduction of Buddhism into China in the Later Han dynasty (AD 25–220). The first translators and missionaries were virtually all Central Asians, and the importance of Central Asia and China's north-western frontiers and trade routes is crucial. Although China traditionally looked inwards, from the former Han (206 BC–AD 23) to the Tang (618–907) China's relations with the outside world, along Central Asian routes, were of considerable economic importance. With the advent of Buddhist missionaries, they became routes also for Indian and Graeco-Roman art forms into China as well as for Buddhist travellers in search of Indian scriptures.

The gradual entry of Buddhism into China can be explained in historical terms. The Han dynasty which finally collapsed in AD 220 had established the Confucian ideal as the basis for government, and the fall of the Han, implying a heavenly loss of confidence, resulted in political division and also left a spiritual vacuum, filled, to some extent, by Buddhism. With Confucian values in abeyance in the period of disunion (third and fourth centuries AD), the metaphysical order of Buddhism, directly opposed to the worldly, socio-political Confucian ethic, offered a view which accorded with the troubled times. It seems likely that religious Taoism (a native Chinese system of practices designed to achieve immortality and entry into paradise), itself a response to the uncertainties of contemporary life, gave an opening for Buddhism in China. Buddhism's insistence on transience and on mental discipline as the only escape from the vanities of human existence and suffering, and, increasingly, the protective aspect of the Bodhisattvas, all offered a disciplined escape.

In the early period connection with India was close and all the major schools were introduced into China as their texts were translated; Prajñāpāramitā in the second century, Madhyamaka

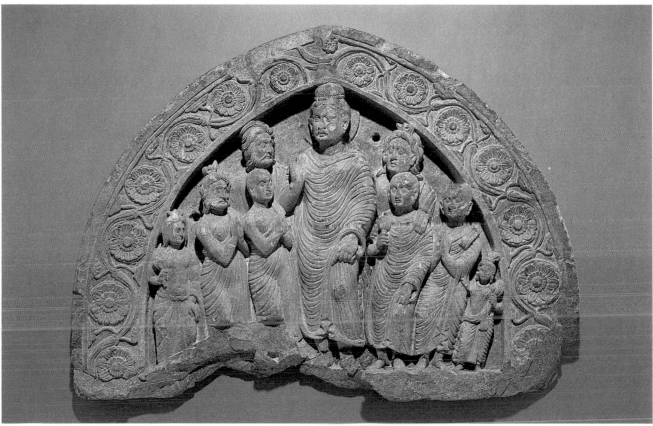

15

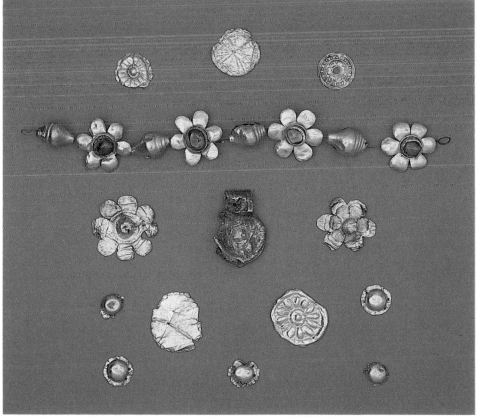

14

in the late third century, Yogācāra around 600 and, later, Tantrism (which flourished briefly in the ninth century). Adherents of these different texts seem to have co-existed, often within the same temple, for the schools of Chinese Buddhism did not emerge fully until the Tang (618–907). Up to the late Tang Buddhism flourished with imperial patronage, vast numbers of translators and commentators and a growing Order. It was not, however, unchanged in the process. Buddhist ideas ran against Confucian polity, and the nature of the opposition which was based on moral, utilitarian, political and economic arguments provided much of the impetus towards transformation. The strongest argument was moral. The monastic system violated the traditional Confucian view that family duties, including service to dead ancestors, were fundamental. Further, it was seen as non-utilitarian for its members did not work; it presented a potential threat, as fiscal privileges made it rich and monasteries were seen as a refuge for rebels (and, indeed, throughout China's later history, many popular uprisings were partly inspired by Buddhist messianism).

A significant aspect of Chinese Buddhism's response to criticism was a stress on lay practice. One of the most original schools, the Chan (Japanese Zen), argued that Buddha-nature is immanent in all and can be achieved without recourse to endless study. Though the term 'sudden enlightenment' is misleading, for the Chan school stressed long practice and self-cultivation, in theory a lay person could achieve Buddhahood without retreat and could thus maintain his family obligations. The great popularity of the *Vimalakīrtinirdeśasūtra* in China, where the central lay believer defeats armies of Bodhisattvas in rational argument, also suggests the same sort of alternative.

The other major Chinese schools were Tian tai, Hua yan and Pure Land. Tian tai (founded by Zhi Yi, 538–97) set out to systematise the vast number of confusingly different *sūtras* by ascribing different doctrines to different periods in the Buddha's life, culminating in the perfection of the *Lotus Sūtra*. Hua yan (Avataṃsaka or One-Vehicle Buddhism) took the Tian tai classification scheme further, adding the recently developed Chan school. As well as ordering the *sūtras*, it viewed the universe as ordered, the world of principle and phenomena being fused, everything leading to the centre, the Buddha.

The school that flourished longest to survive most obviously in later popular Buddhism was Pure Land which stressed meritorious deeds and devotion to Amitābha who presides over the Pure Land (Sukhāvatī). This emphasis on 'heaven' (Amitābha's Western Paradise where he receives the souls of the meritorious) implies a concept of hell, also revealed strongly in Pure Land painting.

Late traditional popular Buddhism in China full of ceremony, hells and paradises was very different from that of the period of translation and intellectual debate which barely survived the late ninth-century imperial persecutions. Separate schools and sects began to merge to form the body of popular belief in China; they often survived more strongly as separate entities in Japan. FW

Korea

Buddhism spread gradually through Korea from the fourth century, until with the unification of the country in AD 668 it had been adopted as the state religion and exploited as a supernatural protective force against invaders. The Silla (AD 668–935) emphasised the role of the Buddha as divine defender, and built temples in and around Kyŏngju to ward off the Chinese armies which threatened to occupy the country. The underlying belief was that Buddhist

divinities, placated by the erection of monuments and temples, would guarantee the well-being of the country.

Of the many schools which entered Korea from China during this period (and the overwhelming influence of Chinese practice in every aspect of Buddhist life in Korea can hardly be overstated), the most important was the syncretist Hwaŏm (Avataṃsaka; Chinese Hua yan) which reached Korea in 670 when the Monk Ŭisang (625–702) returned from studies in China. Sŏn (Chinese Chan, Japanese Zen), with its emphasis on meditation rather than scholasticism, is usually held to have entered Korea in the seventh century. For a time there were acrimonious debates between adherents of Sŏn and scholastic schools, with partisans of each side proclaiming the superiority of its approach. Only with the establishment of the Ch'ŏnt'ae (Chinese Tian tai) school by Ŭich'ŏn (1055–1101) in the Koryŏ dynasty were the foundations laid for the true reconciliation of Sŏn and scholastic Buddhism. This came about through the teachings of Chinul (1158–1210) who from beginnings as a Sŏn monk came to preach a peculiarly Korean form of meditation, known as Chogye-jong, which embraces and stresses both meditation and scriptural study, and which continues to dominate Buddhist practice in Korea to this day.
<div align="right">EMCK</div>

Japan

Buddhism reached Japan late. The main sects, mostly Mahāyāna, in their Chinese or Korean developments, were introduced from the sixth to the ninth centuries, and in most cases revived in the twelfth and thirteenth. The latter period saw nationalist developments which had some doctrinal implications, but these were little more than adjustments of Buddhism to national temperament, circumstances or policy such as had been made since its earliest introduction. Since the late nineteenth century a number of new Buddhist-based sects have arisen, such as the Reiyūkai, which have again followed the same pattern. At no time has there been a doctrinal innovation not related to the practicalities of Japanese society and personality. That Japan is now numerically the most important Buddhist country must in the main be attributed to the exceptionally practical integration of the faith into its everyday life.

The Japanese have never been philosophically speculative or innovative. Their contribution to Buddhism has belonged to the emotional, intuitive, poetic and artistic areas of life, the aesthetic development of Zen, Buddhist literature, particularly the powerful expression of transience in that literature and, most of all, the great body of temples and the Buddhist art they contain. Concepts of reason and logic have not motivated thinkers to produce grand synthetic explanations of existence. The Japanese have less ambitiously taken what *is* as the basis for a more concrete exploration.

Our limited knowledge of the introduction of Buddhism into Japan in the mid-sixth century seems to support this pattern. The great continental religion was rightly seen as bringing the higher civilisation of East Asia, in particular writing and literature, music, a superior architecture, the arts of painting and sculpture, metalwork, lacquer and refined textiles. Its associations were aesthetic from the start. On the other hand the introduction of Buddhism produced immediate violent conflict between those ruling families who saw it as a necessary step towards joining the higher civilisation of Asia, and those who felt it threatened the native Shintō religion and the semi-divine prestige of the Emperor.

These problems were solved, following the military victory of the Buddhist party, in nationally characteristic ways. Buddhism was adopted by the Imperial family, notably by the

great patron Prince Shōtoku (574–622), and made one of the state faiths. In the eighth century the unifying nature of Buddhism was emphasised by the founding of state temples (*kokubunji*) in the provinces, under the leadership of the Tōdaiji temple in Nara, which was under Imperial control. The principal image of the Tōdaiji, the great bronze Buddha Vairocana, was associated with the sun, thus with the sun divinities who were the mythical founders of Japan. Henceforward the state rarely let slip its control. Twice it acted decisively to regain it – once by moving the capital from a threatened theocracy in Nara to the new centre of Kyoto (AD 794), and once when Oda Nobunaga destroyed the Enryakuji complex of temples and its warrior-monks in the mid-sixteenth century. State dominance ensured that the different sects rarely fell into turbulent conflict, for all felt more or less established. This in turn inhibited speculation and imaginative extensions of doctrine. No sect might challenge the precepts of the Japanese state – obedience, duty, order – and this too acted as a dampener. Christianity, with its alternative loyalties, could not consequently be tolerated when it began to grow strong in the late sixteenth century.

The initial difficulty of reconciling Buddhism with Shintō was solved by Imperial patronage and the decision to allow Shintō shrines to be 'protected' and even absorbed by large Buddhist temples such as the Tōdaiji. Very soon (tenth century) the *suijaku* doctrine was developed, explaining that the Shintō deities (*kami*) were forms of Buddhist divinities. This syncretistic argument was scarcely necessary for most Japanese who at no time have found it difficult to believe in both, representing as they do different planes of existence. An integration of the faith into the fabric of Japan itself can also be seen in the *raigō* doctrine of Pure Land Buddhism, especially popular from the eleventh to the thirteenth centuries, where the merciful Buddha Amitābha (Japanese Amida) is imagined descending to specific Japanese places to receive the dying faithful. A whole class of art grew up from this idea.

The tendency towards nationalism was most striking in the Nichiren sect founded by a

378

monk who formed his name from combining the characters *nichi* ('sun' – also part of the name for Japan) and *ren* ('lotus' – part of the title of the *Lotus Sūtra*). He saw devotion to the *Lotus Sūtra* (Sanskrit *Saddharmapuṇḍarīkasūtra*) and the Buddha Śākyamuni as the solution to the national wars, famines and miseries of the troubled thirteenth century, and untypically attacked other sects. His followers, usually from the peasant classes, showed an evangelical zeal which has persisted in Nichiren and its modern descendants, notably those which have arisen since the Pacific War, and has even begun to reverse the traditionally inward-looking tendencies of Japanese Buddhist thought.

The Japanese version of Zen has ultimately had the greatest impact on the non-Buddhist world, principally through its aesthetic activities. By its characteristic transmutation of religious philosophy into concretely understandable and comfortable activities such as calligraphy, pottery, ink painting, flower arrangement, the Tea Ceremony and garden design Japanese Zen has begun to appeal to intellectuals and aesthetes throughout the world, and now rivals Tibetan Tantrism in its influence outside Asia. LRHS

Buddhism today

The fortunes of Buddhism have varied, and its disappearance before the coming of a new Buddha is part of the tradition. In much of Asia where it was once dominant it has left only archaeological traces. In India itself its long decline was hastened by the Muslim destruction of its intellectual centres around 1200, but the reasons for its disappearance are complex and have not been fully resolved. Elsewhere other reasons have operated, and allusions to them will be found in the following pages. In Japan, Korea, Thailand, Burma and Sri Lanka Buddhism survives vigorously, and in India and the West Buddhist groups and societies have made some impact. This revival has been recently described by Bechert (Bechert and Gombrich, 1984). The following account describes the present state of an unbroken tradition that seems in no danger from the secularisation affecting religion in so many parts of the world WZ

Burma

The long dominance of Theravāda Buddhism over Burmese society and culture has never diminished. Buddhism is more pervasive in Burma than any other country, with gleaming whitewashed or gilded temples everywhere. Almost every village supports a monastery (*kyaùng*), and early every morning saffron-robed monks make their rounds to receive food from the people. The highest buildings in town and city are Buddhist temples: the most famous is Rangoon's Shwe Dagon whose shimmering golden dome 110 m high dominates the city and is a focus of pilgrimage and worship. To most Burmese national identity is inseparable from their faith, and during British rule Buddhism became a great nationalist rallying point. It permeates the whole society, governs people's lives, and is an unending subject of discussion; government and politicians are often judged by incidents and characters from scripture.

The most important ceremony is the initiation (*shin-pyú*) held for every young Buddhist male. It is the great merit-making duty of every family to send their son to a monastery as a *sāmaṇera*, or novice (Burmese *ko-yin*), usually at about eleven, but the boy may be younger – if he can repeat Pali phrases clearly – or older, especially if a poor family has had to save for the ceremony. A man is not considered fully Buddhist without undergoing the *shin-pyú*, and parents promoting it perform the noblest kind of giving (*dāna*) and acquire the greatest merit

(*kú-tho*). Rich families increase merit by also sponsoring poor boys, and parents without a son may help sponsor the initiation of a relative. The usual time for the *shin-pyú* is just before the Buddhist Lent, soon after harvest time, when village families have the most money to spend. *Shin-pyú* ceremonies can be very expensive because they confer social prestige as well as merit, and the family feeds as many monks, makes as many donations and invites as many friends as possible.

In Burma this temporary ordination is often celebrated with great pomp. The boy, dressed as a prince, will ride or be carried in procession to the monastery. This symbolises Prince Siddhattha's Great Renunciation. Head and eyebrows are shaved, secular clothes exchanged for those of a novice, and the Ten Precepts and Buddhist Confession of Faith are recited. When the boy has been admitted to the monastery, he will receive further instruction. His parents kneel and pay him reverence, as to any monk. To coincide with the *shin-pyú* parents often hold an ear-boring ceremony for their daughter. This ceremony has no Buddhist elements, however, nor do such other life-cycle events as a child's name-giving ceremony or a marriage – although just before these a special feast may be offered to invited monks who are asked to recite protective texts (*paritta*).

Ideally novices stay in the monastery for at least the three months of the Buddhist Lent, but stays of a few nights are common, especially in towns. The novitiate is not higher ordination (*upasampadā*) which cannot be performed before the age of twenty. Every Burmese Buddhist male will spend one or more periods as a monk. There is no obligation to remain one for life, though monks of long standing are especially revered, and no dishonour is attached to leaving the monkhood. Although there are Buddhist nuns (Burmese *thi-lá-shin* or *me-thi-lá*) who shave their heads and wear pale orange-pink robes, they are less respected than monks.

The Burmese Order numbers approximately 123,000 monks and is regulated by the ancient complex set of 227 rules (*Pāṭimokkha*). The Burmese monk (*hpòn-gyi* meaning 'great glory') symbolises renunciation and is revered above all others in Burmese society. Laity use honorific vocabulary when addressing or talking about monks. They acquire merit by giving monks food on their morning round or on special occasions, by supporting a monastery as a whole, and by hearing monks preach. Merit also comes through reverence of the Buddha, temple offerings and meditation.

Every lay Buddhist follows the first five of the Ten Abstentions (see p. 12). The very pious will observe additional precepts on 'sabbath' days (Pali *uposatha*; Burmese *ú-bok-neî*). The Burmese year is full of Buddhist festivals, occasions for great joy, community activity and merit-making. The full moon day of the month of *Kason* commemorates four events that occurred on this day – the prediction of a future Buddha, the Bodhisattva's birth, his Enlightenment and the Buddha's death – and is observed by watering the Bodhi trees planted in temple precincts. The end of the Buddhist Lent – a solemn period when monks do not travel, marriages are not performed and public entertainments are discountenanced – is the full moon day of October (*Thadìn-gyut*) when a three-day festival of lights commemorates the Buddha's descent to earth after preaching in the heaven of the Thirty-three Gods. Buildings are decorated with lights, special offerings are made to the monks, and street festivals held. The whole following month is celebrated by offering monks their robes (Pali *kaṭhina*; Burmese *kahtein*), and other needs (umbrellas, medicine, soap, blankets, etc.), and the offerings are hung on beautifully decorated offering trees (Pali *padesā*; Burmese *padei-tha-bin*). Huge collective offering ceremonies are performed by groups like government

departments, factories and market traders; the offerings are publicly paraded before being presented to the monastery. The end of the month, the full moon day of *Tazaung-mòn*, is marked by a special ceremony when a robe has to be woven in one night. Throughout Burma weaving teams compete to finish in the fastest time.

Pagoda festivals last several days and are really fairs with souvenir shops, food stalls, fortune tellers, tattooers and all-night dramatic performances. *Nat* or spirit festivals are also held. Belief in the thirty-seven *nats* of Burma coexists very comfortably with Buddhism but is rarely confused with it. Many households have an image of the household *nat*, *Maha giri min*, and many large old trees are believed to house a *nat* to whom offerings are made at a small shrine beneath it; but the elaborate spirit shrines seen in front of many Thai premises are unknown in Burma. Although some Burmese use amulets and other charms, a Burmese Buddhist does not wear round his neck a 'protective' image of the Buddha as often seen in Thailand; it is considered very disrespectful to hold one's head higher than a Buddha, or a monk.

A recent innovation was the convening in May 1980 of a General Saṃgha Conference of All Orders which assembled for the first time representatives of all the different Burmese monastic groups. Over 1,000 monks met at the Great Cave of the Kaba-Aye Pagoda (site of the Sixth Buddhist Council in 1954) to purify the Saṃgha, settle disputes, and promote Buddhism. A central Committee of thirty-three monks was henceforth to administer the Saṃgha whose membership was to be registered. This reform movement and the government proclamation of a general amnesty to coincide with the Conference appeared welcome to monks and laity. The government's initiative in convening the Conference was in keeping with tradition, for the Burmese Saṃgha has undergone many vicissitudes and divided into different branches, disagreeing not on Buddhist precepts but on interpretation and practice. At such times Burmese kings, as chief patrons and defenders of Buddhism, intervened to purify the Saṃgha. The present government has also sponsored, for the first time, the building of a new pagoda, near the Shwe Dagon, the Maha-wí-zayá-zei-di, for which a grand foundation stone ceremony was held, complete with a pageant of a royal court and guardian deities and *nats*. This project has attracted great public financial support and the temple is due for completion in 1985 when the umbrella (*hti*) finial will be ceremoniously erected. Burma's Department of Religious Affairs plays an important role in sponsoring and organising the conferral of titles, awards and certificates on monks and nuns successful in the annual examinations of the *Tipiṭaka* and its exposition. One important outcome of the 1980 General Saṃgha Conference has been the sending of eminent monks and lay helpers abroad to teach Buddhism and Burmese meditation. There are now several thriving Burmese temples, monasteries and meditation centres in North America, Britain, Europe and Australasia. Burmese Buddhists take great pride in this, feeling that their religion and meditation techniques have much to offer a troubled world. PMH

1 Early cult monuments

Although Buddhism began in the sixth century BC, its oldest surviving remains and manuscripts are much more recent. The first independent evidence for Buddhism is in the reign of the Maurya Emperor Aśoka (273–232 BC) whose stone inscriptions are the earliest Indian historical records. They mainly explain a benevolent creed which he called *dhamma* (*dharma*), a word also used for Buddhism. *Dharma* was a system of duties and values, as was Buddhism, but Aśoka's, however ethical, was clearly political.

If the *dharma* of Aśoka as Emperor was not Buddhism, several inscriptions prove that he was a Buddhist. He commends certain texts, the Buddha's teaching in general and condemns schism. One inscription records his visit to the Buddha's birthplace, and another his restoration of the nearby *stūpa*, or memorial mound of a former Buddha. A reference elsewhere may be interpreted as a visit to the Tree of Enlightenment. Buddhist tradition, however, is our only source for his summoning a council at Patna, and of his miraculous construction of 84,000 *stūpas* for the Buddha's remains. Aśoka's building activity obviously grew in Buddhist tradition, but there seems little doubt that his reign promoted Buddhism and the construction and reconstruction of monuments. Nothing in the Buddhist archaeological record can be securely dated before the third century BC.

The chief monument, the *stūpa*, was a round solid and domed brick or stone-built structure, originally a tumulus, that became the hallmark of Buddhism and a potent symbol. As a tomb of the departed teacher, holding his relics, it was venerated, but it could stand for much more. The Buddha's death could be seen as warrant for the Doctrine, and as marking the final dispersal of the aggregated elements of personality the *stūpa* represented the goal, the Doctrine and the Buddha himself in *nirvāṇa*. Image worship came later. No Aśokan *stūpas* survive unchanged, but one of the best early examples, much restored at Sāñcī, in central India, has an original core of bricks in mud and mortar with a presumed diameter of 18m which may be of Aśoka's time.

The great *stūpas* of the last centuries BC and first centuries AD, evidently built with generous patronage, were either enlargements or fresh foundations expressing the expansion of Buddhism and the need to provide focal points for the cult. *Stūpas* were enlarged in accordance with a consistent practice of repairing or encasing them in a larger structure, providing merit for donors, builders and worshippers who walked round them clockwise. The main *stūpa* at Sāñcī was enlarged in the second century BC by a casing of hammer-dressed stones surmounted by a shaft with three parasols rising out of a flattened top and fenced by a square railing. At the base of the *stūpa* was a drum approached by stairs and fenced by a railing, creating an upper processional path. The ground-level path was enclosed by a high railing pierced by gateways at the cardinal points. These railings, based on wooden prototypes, consisted of uprights, crossbars and a coping, and surround many *stūpas*. Some were elaborately carved.

The ground-plan of *stūpas* did not remain circular. Projections at the cardinal points became distinctive in the south where they bore pillars; the *stūpa* also stood on a rectangular plinth. They became high cylinders with reduced domes and arcading and niches for later image worship, and the crowning parasols evolved into a tapering spire. A famous *stūpa* at Peshawar, Pakistan, was reputedly built by King Kaniṣka (*c.* AD 100) of the Kuṣāṇa empire (first to third centuries AD), spanning Afghanistan, Pakistan and northern India, whom Buddhist tradition considers a great patron. Smaller votive *stūpas* surrounded a principal foundation, and sites in Gandhara (Pakistan), and eastern India have great clusters; in Gandhara they accommodated narrative panels. Monasteries were never far away.

Stūpas also contained relics of saints and objects used by the Buddha or commemorated biographical events. The position of relic chambers varied; there might be none and deposits differed greatly. Bone fragments in a gold box frequently nested in a silver box contained in a stone box; crystal, base metal and earthenware reliquaries were common. Human relics are not always found; a *stūpa* might contain beads, crystal, pearls, emeralds or other precious and semi-precious stones, gold wire, rings, gold leaves or discs, stamped with flower patterns, coins, manuscripts, metal plates or strips with punched or incised dedications, cowries and images. The sacred and precious often seem haphazardly mixed and where offerings are modest, intention must have justified the deposit.

Shrines enclosing *stūpas* were also an early development. Free-standing rectangular, circular and apsidal structures hardly survive, but rock-cut examples in the Deccan can be well preserved with figural and other carving. Long pillared

naves ended in an apse with a *stūpa*. Lighting came from doors surmounted by the horseshoe arch, derived from the wooden architecture underlying these shrines; monk's cells occur beside them.

For a type of shrine which may have begun in the context of tree-worship evidence is confined to relief carvings. The Tree of Enlightenment at Bodh Gayā may have been surrounded, in the second century BC, by a pillared pavilion with access to the Tree and the Buddha's Seat of Enlightenment through a hall. Above was a storey of roofed galleries connected through horseshoe arches with a veranda fenced by the usual railing. Early railing pillars from ground level survive. Other Buddhist symbols may have been enshrined but the evidence is scanty. WZ

1. Inscribed pillar fragment

Formerly at Meerut. Mid-3rd century BC
Sandstone. Length 32 cm. OA 1880–21

This curved fragment with the polish typical of Maurya-dynasty stonework is incised with the standard lettering of the imperial edicts. It probably belongs to a damaged pillar later moved, according to a Muslim historian, from Meerut to the Ridge at Delhi. The text, part of the Buddhist Emperor Aśoka's sixth Pillar Edict, is not specifically Buddhist but refers to the Emperor's personal and benevolent policy towards all sects and classes which he calls *dhamma*, a word also used by Buddhists for their religion. WZ

1

2

2. Inscribed slab

From *stūpa* 2 at Sāñcī. 2nd century BC
Sandstone. 13 × 28 cm. Given by Sir Alexander Cunningham.
OA 1887.7–17.1

This slab was one of six separate pieces making up a rectangular box which contained four caskets, three now in the British Museum and one in the Victoria and Albert Museum, all inscribed with the names of saints, some also known in Buddhist literature and probably previously deposited elsewhere. The inscription says that the box contained relics 'of all the teachers, including Kasapagota [Kāśyapagotra] and Vāchi [Vātsi] Suvijayata', both mentioned again on separate caskets inside. WZ

3. Reliquary

From *stūpa* 9 at Bhojpur, near Sāñcī. 2nd century BC
Steatite. Height 14 cm. Given by Sir Alexander Cunningham.
OA 1887.7–17.15

South-east of Sāñcī, in an area rich in *stūpa* clusters, there were once thirty *stūpas* at Bhojpur village alone. In a surviving *stūpa* the relic chamber contained a red earthenware box and inside it this most graceful reliquary. Like others it has more than one compartment, a larger at the bottom and another, much smaller, above. Both contain fragments of human bone and teeth. WZ

Illustrated on page 11

4. Railing pillar

Eastern India, from Bodh Gayā. 1st century BC or AD
Sandstone. Height 1.14 m. Given by Surgeon-Major F.A. Turton.
Victoria and Albert Museum (IS 1065–1883)

This broken upright is from the earliest surviving railing at Bodh Gayā surrounding the early Tree shrine. It shows on both faces two roundels, the upper pair plain-bordered and narrative, the lower framed by open lotuses enclosing a male bust on one face and on the other a winged elephant. Each face is bevelled and the sides have mortices to hold cross-bars. One narrative roundel shows three figures worshipping the Tree of Enlightenment beside the Buddha's throne (*vajrāsana*), the other a princely person, under a parasol, apparently receiving a bird on the end of a pole, perhaps a scene from a *jātaka* telling how the Buddha in a previous existence as a bird had offered his life to save another. On one pillar face is the name of Lady Kurangī, donor of several early pillars at Bodh Gayā; on the opposite face is the name of an unknown person (Vallabha) in characters of the 6th–7th centuries AD. WZ

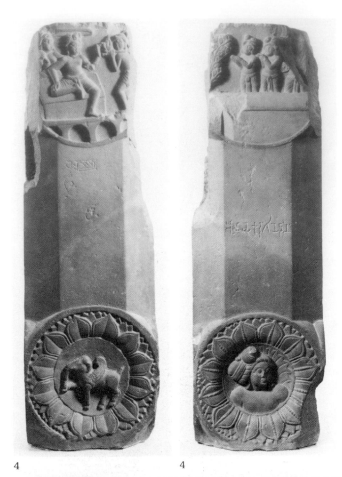

4

4

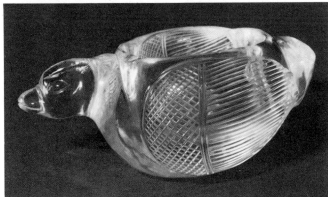

5

5. Reliquary in the form of a goose

Gandhara, from Taxila. 1st century AD(?)

Crystal. Height 3.2 cm; length (max.) 10 cm. OA 1867.4–27.2

This hollowed goose has a circular body with projections forming the head, neck, wings and tail. The wings and tail have incised lines and cross-hatching; the bottom of the body is pierced with two pairs of small holes. When found the goose contained an inscribed gold plate, now lost, which has been translated as meaning that a relic of the Buddha was placed in the goose by one Sirā for her parents' benefit in a future existence. WZ

6. Model stūpa as reliquary

Gandhara, from Mānikyāla. 1st century AD(?)

Steatite. Height 21.5 cm. Given by Sir Alexander Cunningham.
OA 1887.7–17.34

The model is in three separate parts – the drum, the hollow domed cylinder and the moulded base, with shaft and parasols, which slots into the top. It was found in the relic chamber at the base of a *stūpa* and contained the crystal reliquary (no. 7). In the same relic chamber was a coin of the Kuṣāṇa Kujūla Kadphises (early 1st century AD); other coins found farther off are of the same period. WZ

7. Reliquary

Gandhara, from Mānikyāla. 1st century AD(?)

Crystal. Height 5 cm. Given by Sir Alexander Cunningham.
OA 1887.7–17.35

This pear-shaped box with a flat bottom is cylindrically hollowed out to a depth of 2.5 cm and diameter of 6 mm. The pointed stopper has a shaft 6 mm long. It was found inside no. 6 and despite the small space left for a deposit is said by Cunningham to have contained 'a very small piece of bone wrapped in gold leaf along with a small silver coin, a copper ring and four small beads of pearl, turquoise, garnet and quartz'. WZ

8. Replica of the Kaniṣka reliquary

Gandhara. Original (c. AD 100) from the site at Shāh-jī-kī Ḍherī, Peshawar and now in Peshawar Museum

Electrotype. Height 18 cm. OA 1880–270

This reliquary, excavated from the presumed site of the famous *stūpa* of Kaniṣka I, is generally supposed, also on the basis of the incomplete inscription, to be a deposit by that king, but the inscription, a dedication to the Sarvāstivādin sect, contains no date in Kaniṣka's era, as was once thought. The lid has haloed figures of the Buddha, Brahmā (right) and Indra (left); on the box are a standing personage in Kuṣāṇa dress, who has been taken for a beardless Kaniṣka, flanked by the personified sun and moon, and meditating Buddhas worshipped by haloed figures, perhaps Brahmā and Indra. Although the Buddha image appears of an early type and the

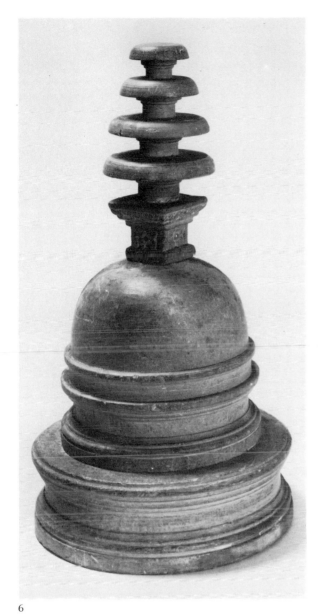

6

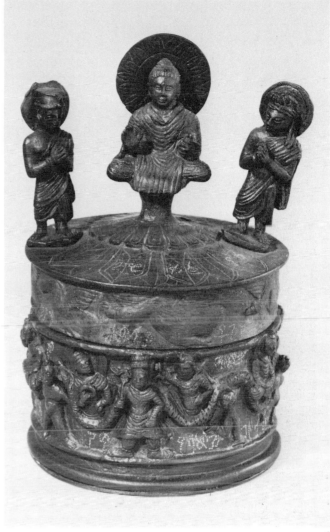

8

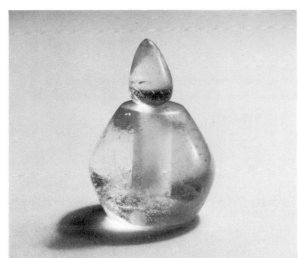

7

style of the casket has been much discussed, its manufacture in Gandhara seems certain. WZ

9. Reliquary

Gandhara, from Bīmarān, Afghanistan. 1st–2nd century AD
Gold set with garnets. Height 6.5 cm. OA 1900.2–9.1

This famous object was found in a *stūpa* inside an inscribed stone box, now also in the British Museum. Framed by arcades formed with the Indian pointed arch are the Buddha and the gods Indra and Brahmā shown twice and separated by a worshipper whose head-dress, earrings and armlets suggest a Bodhisattva. Between the arches are eagles and, above and below, garnets. The inscription refers to relics of the Buddha dedicated by one Śivarakṣita; if the coins found near by were contemporary, the reliquary would be of the 1st century AD and its Buddha image perhaps earlier than Kaniṣka I's reign. The resemblance of the Buddhas on this casket and Kaniṣka I's gold coin (no. 121) appears close. WZ

Illustrated on page 15

10. Cylindrical reliquary

Gandhara, from Mānikyāla. 2nd century AD(?)
Copper alloy. Height 23 cm. OA 1848.6–2.1

Found at the bottom of a *stūpa* excavated in 1830, this box contained no bodily relics but smaller base metal and gold boxes together with coins of Kaniṣka I and Huviṣka (1st–2nd centuries AD). Subsequent investigation at the British Museum of textile traces noticed then has shown that the box was once wrapped in a silk cloth or bag, stretched taut across its base, gathered close at the sides of the lid and sealed to it at several points around the upper edge with wax. This practice seems not to have been isolated. WZ, MEAMCC

Illustrated on page 15

11. Reliquary

Gandhara, from Mānikyāla. 2nd century AD or later
Gold. Height 3.2 cm. OA 1848.6–2.5

This gold box and lid with a decayed amber knob and nine radiating lotus petals formed part of the first deposit found in 1830 in *stūpa* 1 at Mānikyāla. An iron box broken by a pick-axe revealed this reliquary and in it a gold ring, a fragment of ruby and coins ranging from Huviṣka (2nd century AD) to Yaśovarman of Kanauj (*c*. AD 720). Other finds lower in the *stūpa* included Sasanian coins (AD 591–628) and still lower reliquary no. 10 with 1st-2nd-century coins and inscribed objects of comparable date. The deposition of this box presumably in the 8th century may not have been its first, for the petalled design goes back to early Gandhara. WZ

Illustrated on page 15

12. Model stūpa

Gandhara, from Jauliān (?), Taxila. 2nd–3rd century AD
Bronze. Height 10.5 cm. Given by Sir Alexander Cunningham.
OA 1887.7–17.23

This model of a characteristic Gandharan *stūpa* lacks stairs leading to the processional platform. The latticed railing commonly enclosed central Indian *stūpas* but is almost never reported from Gandhara. On one side of the railing is an image of a meditating Buddha. WZ

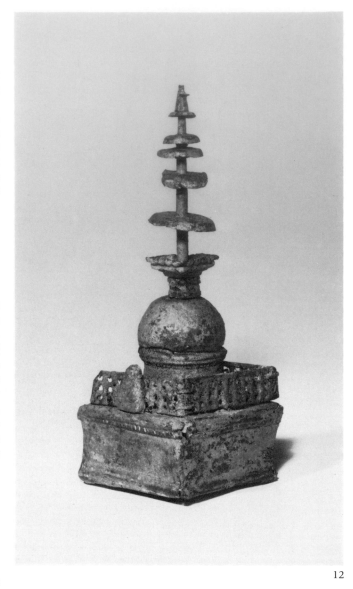

12

13. Drum slab

Deccan, from Amarāvatī. 3rd century AD
Limestone. Height 1.38 m. OA 1880.7–9.72 (Barrett 100)

At Amarāvatī carved slabs covered the *stūpa* drum along the processional path where worshippers could see events from the Buddha's life and representations of the *stūpa* itself. This drum slab shows the *stūpa* in an elaborate form. The railing pierced by an entrance surmounted by lions obscures all but the tops of the drum slabs. The first visible register represents the drum coping; a rectangular projection with pillars occurs at the cardinal points. Two are visible at the sides with lions on the corresponding gateways. Above the drum coping are huge dome panels with crowded scenes. In fact, the drum platform projected 3.7 m around the dome; no stairway is depicted and none was revealed in the excavations. Above the dome panels are registers with running animals, pots of plenty and undulating garlands which mark the beginning of the curvature; above are narrative roundels set in elaborate

swags. Crowning the monument, a rectangular railing encloses a pillar and parasols. All the space beside it is filled by a dense composition of jubilant deities, one of whom is playing the flute. The scene visible in the gateway represents the Buddha, after the Enlightenment, sheltered from a storm by the serpent-spirit Mucalinda. Before him are worshippers; others flanking the gate include standing, sitting and dwarfish figures carrying offerings. The sheltering of the Buddha by Mucalinda was a little-used motif in India but became popular in South-east Asia. There is no evidence, however, for images or panels of this apparent size below the pillared platforms, whose function is obscure. The railing of the processional path consists of uprights, a coping and crossbars with prominent lotus roundels, and projecting on both sides of the gateway are the tops of pillars standing in the processional path.

However inaccurate it may be in minor or even major features, this slab shows the splendour of an eastern Deccani *stūpa* at its most ornate.　　　　　　　　　　　　　WZ

14. Sacred deposits

Eastern India, from Bodh Gayā. Early centuries AD(?)
Gold and sapphire. Length of strung flowers and conches 13.5 cm.
Given by Sir Alexander Cunningham. OA 1892.11–3.13–20; 22; 24

During the restoration of the Mahābodhi temple in 1880–81 a ball of clay was found below the Enlightenment Throne inside the temple. It contained coins, gold, silver, precious and semi-precious stones. This selection consists of coin impressions made into a pendant, gold flowers, some with a central sapphire, imitation conches, and patterned discs and buttons. The coin impressions are taken from an issue of Huviṣka (2nd century AD), and the silver punch-marked coins also found are older but could still have been current in Kuṣāṇa times. A stratification is reported, but the level at which the deposit lay cannot be dated since a redeposition during one of many rebuildings and restorations in antiquity is possible.　　WZ

Illustrated on page 19

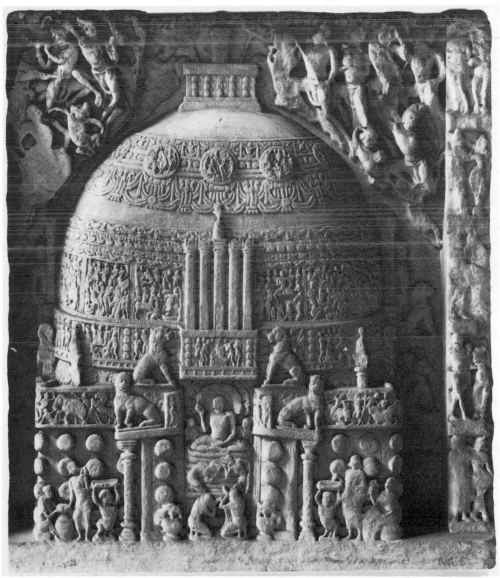

2 The Buddha legend

As Buddhist devotion developed, the superhuman nature accorded to the teacher who lived and preached in eastern India during the late sixth and early fifth centuries BC generated a great body of legend and miracle, and a historical life of the Buddha is beyond recovery. Later chronicles of the uncertain records of north Indian history and Greek evidence following Alexander the Great's invasion (327–325 BC) suggest dates of 563–483 BC (or 566–486 BC) for his life. Certain traditions are clearly old and probable, but any historical facts are so mixed with legend and miracle that the following can be only an uncritical sketch of some of the traditions.

The Buddha legend begins not with his last historical life but, in keeping with the belief in rebirth, when long before he took the vow to achieve Buddhahood. He then became a Bodhisattva, in whom the intention of Enlightenment would progress until he reached *nirvāṇa*. He passed from life to life, performing in each virtuous deeds or Perfections. Stories of these preparatory lives (*jātakas*) were popular from the beginnings of Buddhist sculpture and were illustrated in relief at the early *stūpas* of India and Gandhara in Pakistan. Rich in themes from folklore, they show the Bodhisattva as every kind of being, human and animal.

When the time came for his last birth, the Bodhisattva chose the virtuous Śuddhodana and his queen Māyā of the historically obscure Śākyas of Kapilavastu in the Nepalese Terai beyond the greater states of the time. Although the Buddha's mother was not a virgin, his conception was immaculate. In a dream she saw an elephant enter her right side. Sixty-four Brahmins reassured the royal couple that a boy had been conceived who would become either a Universal Monarch or a Buddha. The miraculous pregnancy lasted ten months. Then the queen entered the Lumbinī garden where, as she stood grasping the branch of a tree that bent down towards her, the child emerged painlessly from her right side. He was received by gods, bathed and then, taking seven steps to the north, announced that this was his last birth.

The child was taken back to Kapilavastu, and his mother died seven days after the birth. His family's protector deity saluted him; another account makes all the gods fall at his feet. The thirty-two major and eighty minor signs of the supernatural being were found on his body and an ascetic predicted his future as Buddha. The boy was called Siddhārtha (or Sarvārthasiddha), 'he whose purpose is accomplished',

and mastered all the martial and intellectual arts. His father, anxious to keep him in the world, had palaces built and called upon his fellow tribesmen to send their daughters for him to choose a wife.

His father's precautions could not prevent the four encounters. The gods contrived to show the prince an old man, a sick man, a corpse and a religious wanderer, and he resolved to renounce the world. The birth of a son was only another bond to be broken. Repelled by the sight of his sleeping attendants, he restrained himself from taking his son in his arms, and left the sleeping city. After putting sufficient distance between the city and himself, he cut off his hair, beard and turban with his sword, exchanged his clothes with those of a huntsman, and sent back the groom while his horse died of grief. Another tradition makes him receive then all the requisites of a monk. What was left of his long hair is said to have turned in curls to the right and to have remained so, like his beard, all his life.

Religious teachers failed to satisfy him; then with five ascetics he engaged in severe fasts. Enlightenment did not come, and he resolved to seek it by less extreme means. He took food, whereupon his five companions, disappointed, left. Seated below a tree, he vowed not to move until he had obtained full Enlightenment.

The god of death, Māra, tried to thwart him for, if the prince found salvation, Māra's kingdom of deaths and rebirths would be in peril. He vainly sought to dislodge the Bodhisattva by physical assault, temptation by his daughters and by challenging his claim to Enlightenment. The Bodhisattva called the earth to witness that throughout all his lives since the vow of Buddhahood he had acted to deserve it; the earth shook in assent and Māra fled.

Enlightenment made the Bodhisattva a Buddha. During the next seven weeks he was sheltered from a storm by the serpent-spirit Mucalinda, walked up and down along a path still marked beside the commemorative Mahābodhi temple, and accepted a myrobalan from the god Indra. Two merchants offered food, and the gods of the four quarters brought bowls which miraculously became one; the god Brahmā urged him to preach the Doctrine, difficult though it might be to understand. Then the Buddha remembered the five ascetics, went to Sārnāth, near Benares, and preached his First Sermon, or 'set in motion the Wheel of the Doctrine'. The ascetics, at first

reluctant even to receive him respectfully, became his first monks. He converted other ascetics with many miracles, while his chief disciples, Śāriputra and Maudgalyāyana, were converted merely by hearing the Buddhist creed: 'whatever proceeds from causes, their causes have been stated, as also (the means of) their cessation'.

At Kapilavastu the Buddha performed more miracles, scandalised his family by begging like any common monk, but converted them. To his son, sent to claim his inheritance, he offered his spiritual insights and ordination. A wealthy merchant, Anāthapindada at Śrāvastī, bought him a retreat by covering its ground with gold. At Kapilavastu again he completed his father's conversion on his deathbed, whereupon his widow, the Buddha's stepmother, asked to become a nun, her request was only reluctantly granted later. Miracles took place at Śrāvastī and Sāmkāśya. At Śrāvastī, competing with six rival teachers, the Buddha emitted fire and water from his body and, on a large lotus, multiplied appearances of himself. Then in the heaven of the Thirty-three Gods he taught his mother and returned to Sāmkāśya with the gods Indra and Brahmā.

Tradition is full of subsequent wanderings and miracles. Devadatta, the Buddha's cousin and rival from their early years, attempted to become head of the Order. He hired assassins who tried to crush the Buddha under a rock and set a wild elephant at him. The Buddha's taming of the elephant appears in later sculpture and painting. Finally Devadatta provoked schism. His secession was soon healed, but Devadatta himself sank into hell.

The death of the Buddha followed a meal at a smith's house where he ate either pork or a delicacy for pigs, perhaps truffles but the oldest commentators say pork. He stoically walked to Kuśinagara (modern Kasia) where he lay down between two trees outside the town. Its inhabitants, the Mallas, were sent for, and the Buddha made a last convert. Then he asked if anyone still had questions; when there were none, the Buddha passed through trance and died. The earth shook and the Mallas grieved; the funeral pyre would not burn until one of the Buddha's great disciples arrived, then it caught fire of its own accord.

The Buddha had ordained that a *stūpa* should contain his remains which the Mallas wished to keep, but other claimants appeared and a quarrel threatened. A division was made into eight parts by a Brahmin called Drona who kept the wooden measuring-vessel used and built a *stūpa* over it. That the word *drona*, the Brahmin's own name, should mean 'wooden measuring-vessel' is an interesting comment on the Buddha legends. The richest early representation of a legendary life-cycle is found in Gandhara, and the following illustrations are from that area. WZ

15. The meeting with Dīpamkara

Gandhara, perhaps from Swat. *c.* 2nd century AD
Schist. Height 49 cm. OA 1980.2–25.1

By tradition the future Gautama Buddha, as a young Brahmin in a previous birth, took his Bodhisattva vow to become a Buddha before an earlier Buddha called Dīpamkara. Having begged flowers from a young woman (far right), he threw them in homage at Dīpamkara and, prostrating himself, spread his long hair for Dīpamkara to walk upon. Dīpamkara promised fulfilment of the vow and the Bodhisattva (seen prostrate on the damaged bottom of the panel) rose into the air. This ending is not shown; on the far left, balancing the young woman, stands the future Bodhisattva holding a flower. WZ

Illustrated on page 19

16. The story of Viśvantara

Gandhara. 3rd–4th century AD
Schist. Height 24 cm. Given by Lt.-Col. G.A. Dale. OA 1913.11–8.21

In his last existence before being born as Siddhārtha Gautama, the Bodhisattva, as the supremely charitable Prince Viśvantara, was expelled from his kingdom for giving away its wonder-working white elephant; before leaving he distributed great quantities of alms and, on his way into exile, gave away his horses, chariot, two children and wife. The story ends happily in the reunion of the family without any loss of merit gained by such sacrifices.

This damaged slab shows the haloed prince riding with his wife and children and bending down to give something to an aged Brahmin whose disciple, with a waterpot, raises his right hand in astonishment. WZ

17. The dream of Māyā

Gandhara, from Takht-i-Bāhi. 2nd–3rd century AD
Schist. Height 20.5 cm. OA 1932.7–9.1

The conception of the historical Buddha took place when his mother, Māyā, consort of the Śākya chief Śuddhodana, saw in a dream a white elephant enter her right side. The Bodhisattva as the elephant is here suitably haloed; a female guard watches over the sleeping queen. This theme is one of the oldest in Buddhist narrative sculpture. WZ

18. The birth and return of the infant

Gandhara, said to be from Buner. 2nd–3rd century AD
Schist. Height 9 cm. Given by Capt. B.C. Waterfield. OA 1902.10–2.38

Two separated scenes show the Bodhisattva's birth and return home. The slightly curved shape of the fragment shows that it comes from a small *stūpa*; the scenes must be read from right to left, following the direction in which the worshipper walked round it.

On her way to her parents at the close of her pregnancy the queen entered the Lumbinī garden where, as she grasped the

16

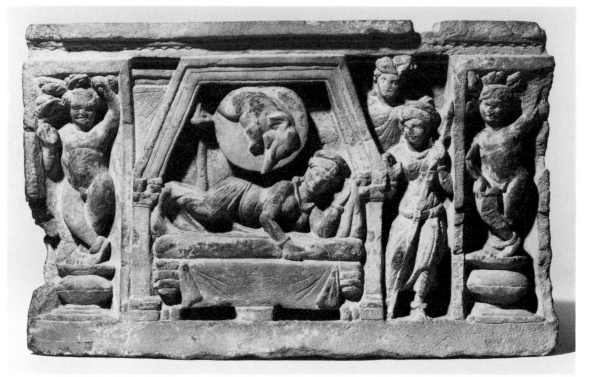

17

18

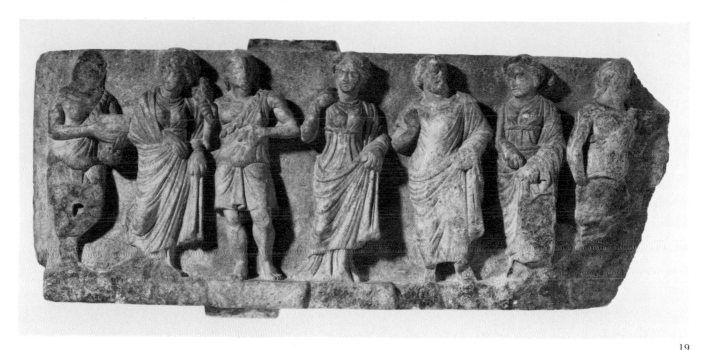

19

branch of a tree, the child emerged painlessly from her right side and was received by the gods Indra and Brahmā. He stepped to the ground, announcing that he was the foremost in the world and that this was his last birth. The queen was supported by her sister. The return home is on a carriage drawn by lions; other panels show litters or carriages drawn by horses or oxen. WZ

19. The presentation of the bride

Gandhara, from Takht-i-Bāhī. 2nd– 3rd century AD
Schist. Height 14.5 cm. OA 1900.4– 14.13

By tradition the Bodhisattva married and this relief, with a woman standing in the centre, is interpreted as the presentation of the bride; on her left may be the family priest or her father. The model was perhaps a secular drinking scene. The figures at both ends of this relief seem to hold bowls, and one on the bride's right may have a bunch of lotuses. WZ

20. The Great Renunciation

Gandhara, from Takht-i-Bāhī. 2nd– 3rd century AD
Schist. Height 18 cm. OA 1900.4– 14.12

The married prince led a life of ease encouraged by his father to keep him from the religious life. When the gods made him see an old and a sick man, a corpse and a religious wanderer, he understood how transient life was and that something better was possible. Repelled one night by his attendants' ungainly attitudes of sleep, he resolved to abandon the world.

The prince is seated beside his sleeping wife; an attendant rests her head on a drum. To the right is a female guard and oil-lamps burn on slender pillars. One of the two abraded figures on the left may be the groom bringing the prince's turban. WZ

21. Emaciated Bodhisattva

Gandhara. 2nd– 3rd century AD
Schist. Height 18 cm. OA 1880– 67

Disappointed by spiritual masters, the Bodhisattva took to severe fasting and was even reported dead. When fasts failed to reveal the truth, he turned to the middle way between worldliness and mortification, one definition of the Buddhist path to salvation. He accepted a rice-brew from a village headman's daughter, who had come to offer it to a nature spirit in thanksgiving for the birth of a son. She stands beside the emaciated Bodhisattva with his frequent companions, the gods Indra and Brahmā, and his protector Vajrapāṇi. WZ

22. The First Sermon

Gandhara. 2nd– 3rd century AD
Schist. Height 26.5 cm. Brooke Sewell Fund. OA 1979.1– 30.1

After the Enlightenment at Bodh Gayā, Gautama, now a Buddha, went to the Deer Garden at Sārnāth, near Benares, and preached his First Sermon, expressed as 'setting in motion the Wheel of the Doctrine', to the five ascetics who had shared his quest and privations. Before his seat is a symbolic wheel flanked by deer; around him sit the ascetics as monks, one making a gesture of benediction or acceptance, and gods beside a tree rejoice. WZ

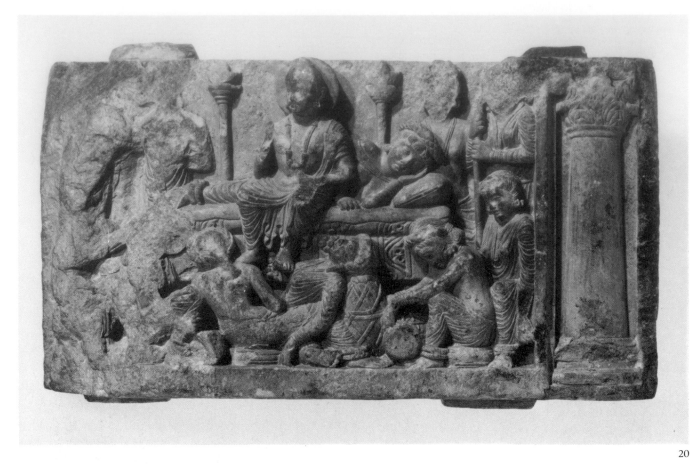

20

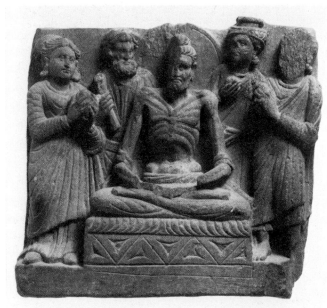

21

23. Buddha preaching

Gandhara. 2nd–3rd century AD

Schist. Height 21 cm. Given by William Crewdson, Esq.
OA 1917.5–1.2

Seated on a hill, the Buddha may be preaching to some of his first converts, the Kāśyapa hermits, still shown long-haired. In the Pali tradition the Buddha is said to have addressed them, after they had become monks, on Mount Gayā (Gayāśīrṣa). 'Everything is burning . . . with the fire of lust . . . of anger . . . of ignorance. . . . Considering this . . . becoming weary of all that [the disciple] divests himself of passion . . . is made free. . . . He becomes aware that he is free . . . and that there is no further return to this world.' WZ

24. Descent at Sāmkāśya

Gandhara. 2nd–3rd century AD

Schist. Height 49.5 cm. Victoria and Albert Museum (IS 11–1947)

The Buddha once went to the heaven of the Thirty-three Gods to teach his doctrine to them and his mother reborn there, and returned by a triple stair: his was of jewels, while the gods Indra (right) and Brahmā (left) accompanied him on stairs of gold and silver respectively. This crowded composition has rows of worshippers in the heavens, while on earth lay notables, a king included, await him. The place of his descent, Sāmkāśya (Sankisa), was for this reason one of the eight traditional Buddhist sites of pilgrimage. WZ

36

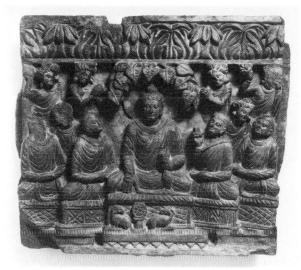

22

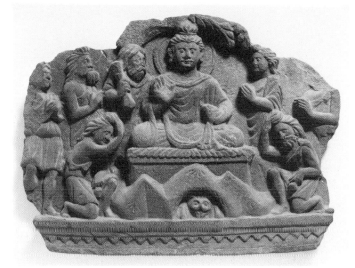

23

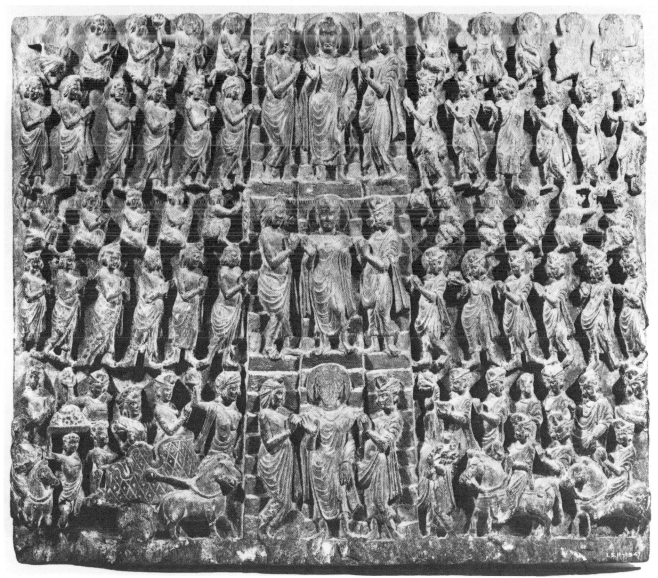

24

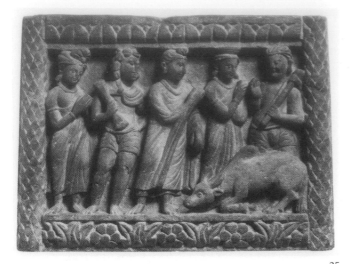

25

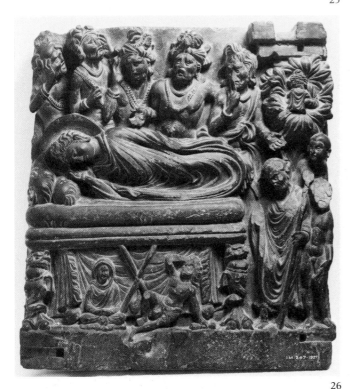

26

by calling them buffaloes, was reborn a buffalo with an ungovernable temper. On seeing the Buddha, however, he fell at his feet and licked them, so gaining a happier lot in his next existence. WZ

26. Death of the Buddha

Gandhara. 2nd–3rd century AD

Schist. Height 53.5 cm. Victoria and Albert Museum (IM 247–1927)

This panel, with its clear signs of attachment to the structure it belonged to, shows the Buddha on a couch with pillows and legs showing lion motifs. Around him monks and lay persons grieve, while Vajrapāṇi, as often in these scenes, lies on the ground; one figure, perhaps Subhadra, the Buddha's last convert, sits serenely beside a water bag hung from crossed sticks. Two monks, one with a staff, stand beside the couch, while behind it Mallas adopt a variety of postures emphasising their emotion. A curious weeping figure in a leafy surround in the top right-hand corner may be the deity or spirit of the grove. WZ

27. Death of the Buddha

Gandhara. 2nd–3rd century AD

Schist. Length 1.22 m; height 41.4 cm. Victoria and Albert Museum (IS 7–1948)

Part of a large composition showing the Buddha's death. Three figures in front of the drapery hanging from his couch appear in expressive postures of grief, one of them supported as he falls back on to the ground. Only one meditating monk appears unmoved, possibly Subhadra, the last convert. Beside him a water bag hangs from a tripod of sticks, an obvious accessory by the bedside of a dying man. The Buddha asked three times for water on his last journey when suffering from the effects of the unwholesome meal at a smith's house. WZ

28. Distribution of the relics

Gandhara, perhaps from Swat. 1st–2nd century AD

Schist. Height 23 cm. Brooke Sewell Fund. OA 1966.10–17.1

After the Buddha's cremation a dispute arose over the division of his remains, and hostilities were prevented by the Brahmin Droṇa who distributed the relics. Droṇa stands behind a table and eight globular and lidded reliquary caskets with one figure left from what may have been a row of claimants. The table, covered with an elaborate textile, is flanked by armed guards. WZ

25. Buddha and a humped bull

Gandhara. 2nd–3rd century AD

Schist. Height 19 cm. OA 1912.12–21.2

This panel shows a humped bull licking the Buddha's feet, the Buddha's guardian spirit Vajrapāṇi, with thunderbolt, and a turbaned worshipper; a figure crowned like the god Indra offers a bag, perhaps ransom for the bull, to a man with an implement who may be its owner or a herdsman. A panel in Peshawar Museum also shows a humped bull licking the Buddha's feet and attendant figures but no transaction as suggested above. These scenes may be versions of an episode found in a text which makes a characteristic Buddhist point. A monk, who had once abused his hearers for their stupidity

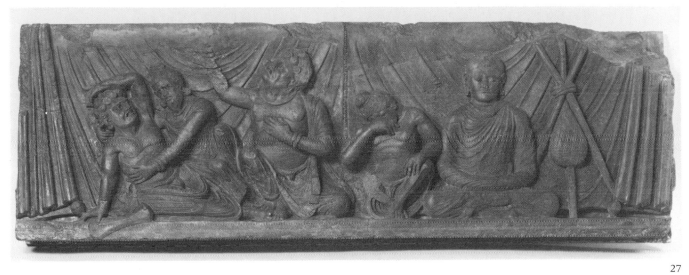

27

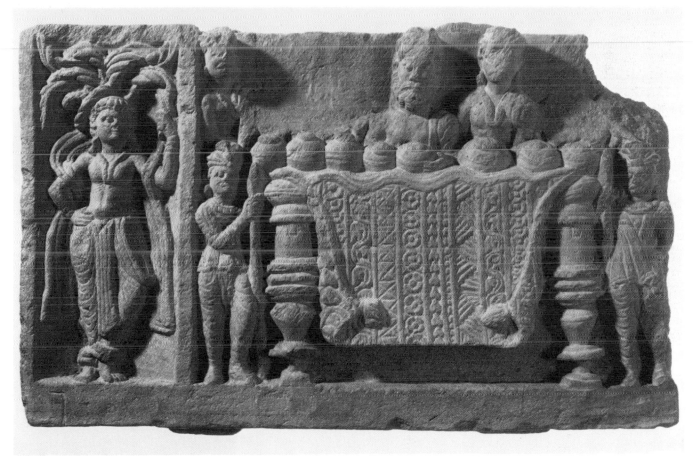

28

3 The scriptures and their transmission

The earliest texts agree that on the Buddha's death 500 monks assembled at Rājgīr to fix the Doctrine and the monastic rules. Those present when the Buddha spoke remembered what he had said; the others approved it as authentic. The Doctrine was preserved in the collection (*piṭaka*) of the Buddha's sermons (*sūtras*) called the *Sūtrapiṭaka* and the monastic rules (*Vinaya*) in the *Vinayapiṭaka*. The *Sūtrapiṭaka* consists of five books (*āgama* or *nikāya*) – the first four, of the Buddha's own discourses roughly in descending order of length, the fifth, of mostly verse works, not spoken by the Buddha but added later. The two major books of the *Vinaya-piṭaka* are the *Sūtravibhaṅga*, based on the *Prātimokṣa*, or 227 basic rules of discipline, with narrative and commentary, and the *Skandhaka*, dealing with the rules in the context of the Buddha's life. References to the Second Council at Vaiśālī, 100 years after his death, prove that some sections must be later, as is the third book, the *Parivāra*, or appendix, summarising the first two. The original Canon must have been in Māgadhī, the language of eastern India where the Buddha lived, but monks from elsewhere would have translated it into their own language.

The texts remained unwritten for several centuries, partly because India preferred oral to written transmission and partly because suitable writing material for so voluminous a literature was lacking until the Maurya expansion southwards (fourth to third centuries BC). The leaf of the southern talipot palm (*Corypha umbraculifera*) was eminently suitable for writing and became the normal material in India until paper was introduced. The sacred texts were meanwhile entrusted in parts to groups of monks to be memorised. Theravāda tradition records that the scriptures were first written down in Sri Lanka in the last century BC.

As Buddhism spread outwards from north-eastern India, it proved impossible in a non-hierarchical church to control the Doctrine. The first schism occurred *c.* 375 BC over the nature of an *arhat*, a perfected being such as the Buddha. The resultant two communities, the Mahāsaṃgha and the Sthaviravāda, split repeatedly until by *c.* 50 BC there were eighteen schools. All had more or less corresponding versions of the *Sūtra* and the *Vinaya*, but they differed among themselves as to the *Abhidharma* (the Higher Doctrine or philosophical rationalisation of the *Sūtra* which forms the third of the three *Piṭakas* of the early Canon). The *Abhidharma* of the Sthaviravāda, the only one still complete in an Indian language, examines in seven books with exhaustive rigour all the topics capable of philosophical analysis in the *Sūtrapiṭaka*. Differences in the *Abhidharma* of the various schools indicate that the need for such formalised philosophical positions arose with the schisms, resulting in each school possessing its own threefold Canon (*Tripiṭaka*) in one or other north Indian language. The fullest extant is in Pali, a language traditionally associated with western India, and belongs to the still flourishing Sthaviravāda (Theravāda) of Sri Lanka and South-east Asia. Pali was first used for commentaries and manuals on this Canon and then increasingly Sinhalese, Burmese and the other vernaculars.

With the spread of Buddhism came the popular cult of the Buddha as a semi-divine and then divine figure, easing the conversion of the less sophisticated. Those sections of the *Vinaya* containing the Buddha's biography were expanded by many schools to include marvels and miracles; his former lives as a Bodhisattva were worked up in the long series of *jātakas* (birth stories); new lives were written in the metres of classical poetry; and the *stūpa*-cult was intensified in order to convert the masses who lacked any relish for Buddhism's philosophical or moral subtleties.

With the development of the Mahāyāna new scriptures were composed in Sanskrit and became canonical since they were claimed as the Buddha's words. Polemical works, establishing the philosophical positions of the various schools, by human authors, though often attributed to 'Bodhisattvas', were considered the Mahāyāna *Abhidharma*. For their *Vinaya* the Mahāyānists used that of one or other Hīnayāna school.

As Buddhism expanded into Central Asia, some of this authoritative material was translated into such languages as Khotanese, Tocharian, Uyghur and Soghdian. Buddhism was formally introduced into China in the Later Han (AD 25–220), and over the next millennium a vast number of Hīnayāna and Mahāyāna texts were translated, often more than once. The Chinese Canon compiled and published under the Ming (1368–1644) contains 1,662 separate works, many of them compilations, and retains the traditional tripartite division. From China Buddhism was introduced into Korea (fourth century) and thence into Japan (AD 552); both regarded Chinese texts as canonical, reserving their own language for further developments.

In India the Mahāyāna was followed by the Vajrayāna which stressed incantations, mystical meditations and ritual in works called *tantras*; it was adopted in Tibet where Buddhism had been introduced in the seventh century. The Tibetan Canon was in two parts, the *bKa'-'gyur*, corresponding to *Vinaya*, *Sūtra* and *Tantra*, and the *bsTan-'gyur*, containing philosophical, commentatorial and polemical texts. This vast collection of more than 4,500 works was translated into Mongolian by 1749.

Although still intellectually developing in the later first millennium AD, Buddhism had declined in popularity; the Muslim Turkish invasion (late twelfth century) destroyed its monasteries and as a result the religion. With the libraries, most Buddhist Sanskrit literature perished except for manuscripts taken to Nepal and Tibet. Tibetan and Chinese translations partly filled the gap; Tibetan translations are exceptionally faithful. However, excavations in Central Asia in the two decades before 1914 uncovered vast quantities of manuscripts in Sanskrit, Central Asian languages and Chinese, which immeasurably enrich our understanding of Buddhism.

JPL

Transmission and independent developments

Sri Lanka and South-east Asia (nos 89–94)

The Sthaviravāda (Theravāda) school of the Hīnayāna, faithful to its original conception of the Buddha and to its Canon, was slowly driven from northern India southwards. Its original Canon in Māgadhī, the Buddha's language, was soon replaced by one in Pali, a word originally used in the commentaries for the canonical text. The school added to its *Abhidharma* various books which seem contemporary with the scholastic disputes of the early Mahāyāna period. The only Hīnayāna *Abhidharma* system completely surviving, it is a *tour de force* in its philosophical restatements of the Buddha's doctrines.

The school took firm root in Sri Lanka where Buddhism had been introduced in the third century BC by Mahinda, son of Aśoka. There a set of ancient commentaries was apparently written in Old Sinhalese on the Canon, but they have not survived. They were used, however, by the Indian Buddhaghosa in the fifth century for his own commentaries in Pali, which have survived complete, along with another set of sub-commentaries from about the tenth century.

Buddhism had been introduced to South-east Asia very early. Contacts were initially more with India than with Sri Lanka, and among the region's religious remains can be found both Mahāyāna and Hīnayāna Buddhist forms as well as

Hindu. However, from the thirteenth century onwards Theravāda Buddhism predominated, establishing itself both at court and among the people in Burma, Thailand, Laos and Cambodia. In island South-east Asia, though, Buddhism was displaced by the rapid spread of Islam. After Buddhism had all but vanished in its homeland, Burma and Sri Lanka were able to re-establish each other's spiritual succession, as when King Dhammaceti of Pegu (1472–92) sent a mission to Sri Lanka to renew the valid ordination line of the Saṃgha. JPL, PMH

Central Asia, China, Korea and Japan (nos 95–111)

Although Buddhism made considerable conversions on its own merits, it was its adoption as a political tool of unification under Aśoka (c. 273–232 BC) and the Kuṣāṇas (first and second centuries AD) which first ensured its widespread dissemination. The Kuṣāṇa empire united the Indian heartlands with Central Asia, and Buddhism was transmitted along the routes that linked India with the main trans-Asian route between China and the Mediterranean. Buddhist manuscripts were thus brought into Central Asia and translated into local languages and, above all, Chinese. Monks from India, Central Asia and China laboured to translate Buddhist scriptures into Chinese. We know the names, works and dates of 173 of them, some such as Dharmarakṣa, Kumārajīva, Xuan Zang and Amoghavajra each responsible for many of the 1,662 works of the Chinese Canon. Many worked in obscurity; others such as Xuan Zang (AD 602–64) and Yixing (AD 634–713) made well-documented and spectacularly successful journeys to India to bring back manuscripts. The Chinese *Tripiṭaka* was compiled over several centuries as the *sūtras* arrived, some being translated more than once. All the different translations are included in the *Tripiṭaka*, first printed in the tenth century.

Buddhism was introduced into Japan from Korea, traditionally in either AD 538 or 552. Korea, under heavy Chinese influence from the first century BC, was far ahead of Japan in its knowledge of Chinese civilisation and Buddhism. As the early Yamato state had frequent contact with China from the third century, the Japanese began learning Chinese under Korean and then Chinese masters. The decision to adopt the Chinese script was momentous. The Japanese, without an indigenous writing system, would otherwise have had no means of assimilating Chinese culture and Buddhism. Nevertheless, few texts were translated into Japanese. Most have continued to be laboriously studied in their Chinese form, and the Buddhist *Tripiṭaka* was not translated into Japanese until the beginning of this century. JPL, FW, YYB

41

Tibet, Mongolia and China (nos 112–18)

Buddhism was introduced into Tibet by King Srong-brtsan sgam-po (c. AD 609–40) but, despite the efforts of Indians like Śāntarakṣita and Padmasambhava in the eighth century, encountered hostility from entrenched nobles and Bon-adherents, until the eleventh century and the regeneration of Tibetan Buddhism by Atiśa and his disciples. Atiśa followed the Vajrayāna, and this form of Buddhism became dominant in Tibet. Tibetan Buddhism was particularly influential in the Xi Xia kingdom in north-western China, and, after its fall to the Mongols in 1227, on the latter. With the establishment of the Mongol Yuan dynasty in China in 1279, a close relationship developed between the predominant Lama in Tibet (at first the head of the Sa-skya-pa school) and the Chinese emperor, the one acting as spiritual adviser, the other as temporal protector, a relationship still in force (with a shifting balance of power) under the Ming and the Qing, though by this time the Grand Lama was the head of the dGe-lugs-pa school, the Dalai Lama.

The work of translating into Tibetan the Indian Buddhist scriptures came to an end in the fourteenth century, and the whole vast collection was arranged by Bu-ston (1290–1364). The *Vinaya*, *Sūtra* and *Tantra* were arranged in 108 volumes, the *bKa'-'gyur*, the philosophical works and commentaries in 225 volumes, the *bsTan-'gyur*. By 1749 both had been translated into Mongolian, the Mongols having been converted to Tibetan Buddhism in the sixteenth century.

Under the Qing emperors parts were translated into Manchu, the native language of the ruling élite. Manchu Buddhist works were frequently printed in multi-lingual editions (Manchu, Mongolian, Chinese, Tibetan) emphasising the close relationship between Lamaist Buddhism and Qing temporal power.

JPL, FW

29. The First Sermon

Burma. 18th–early 19th century

Manuscript of *Dhammacakkappavattanasutta* in Pali. Black Burmese script. Palm leaf, silvered with black lacquered decorated margins. 6 folios. 8 × 52 cm. OMPB Or. 12010/J

The *Dhammacakkappavattanasutta*, or 'turning of the Wheel of the Doctrine', is the Buddha's First Sermon after his Enlightenment and contains the fundamental principles of his teaching, expressed succinctly in the Four Noble Truths (see Introduction). The marginal and outer cover decorations on the manuscript show the earliest iconographic representations of the First Sermon, the Wheel of the Doctrine (*dhammacakka*).

PMH

30. Sūtra of the Net of Brahmā

Sri Lanka. 19th century

Pothī manuscript of *Brahmajālasutta* in Pali. Sinhalese script. Bronze plates with text incised, wooden covers encased in silver with filigree decoration and cotton binding cord. 76 plates. 6 × 39 cm. OMPB Or. 6600 (152)

The *Brahmajālasutta* is the opening *sutta* of the *Dīghanikāya*, the Book of Long Sayings, which contains the Buddha's thirty-four longest discourses. It discusses the sixty-two wrong speculations concerning the world and the self taught by his contemporaries. The manuscript, although metal, keeps the palm-leaf shape traditional in Indian Asia. Such books are known as *pothī* in India (from Sanskrit *pustaka*) or *pot* in Sri Lanka. The leaves are kept between boards and threaded on a string.

JPI

30

31

29

32

31. The Book of Middle-Length Sayings

China, from Dunhuang, Gansu province. AD 602

Scroll of *Zhong a han jing* (*Madhyamāgamasūtra*) in Chinese. Ink on paper. 26 cm × 5 m. OMPB Or. 8210/S. 3548

This title corresponds to the Pali *Majjhimanikāya*, or collection of middle-length *sūtras,* and treats of the Buddha's early life and the Four Noble Truths. It was translated by a monk from Kashmir, Saṃghadeva, in the late 4th century.

Paper, invented in China, was in common use by the 5th century AD. The paper scroll follows an earlier form of document where inscribed bamboo slips were tied together and rolled up for storage. Sheets of paper were pasted together and backed to form a scroll. FW

32. The Book of Middle-Length Sayings

Burma. 19th century

Manuscript of *Uparipaññāsa* of *Majjhimanikāya* in Pali. Burmese script. Palm leaf, inscribed in black ink, between wooden binding boards decorated in gilt and red with title. 373 folios. 5.5 × 52.5 cm. OMPB Or. 6705

This manuscript, a royal presentation copy, is appropriately fine. The margins of the opening and closing leaves record this benefaction of King Mindon, founder of Mandalay, city of gems, and patron of Mahalokamarazein pagoda, establishing the date for the copying and donation between 1864, when King Mindon dedicated the pagoda, and his death in 1878. The text comprises *suttas* 101–52 of the *Majjhimanikāya* of the *Suttapiṭaka.* Unlike most Burmese palm-leaf manuscripts, it has not been incised with a stylus but elegantly written in a slightly squared version of the Burmese script. PMH

43

<div align="right">33</div>

<div align="right">35</div>

<div align="right">34</div>

33. The Book of Kindred Sayings

From a *stūpa* at Khadalik, Xinjiang province, China.
4th–5th century AD

Pothī manuscript of *Saṃyuktāgama* in Sanskrit. Fragments of 15 folios. Gupta script. Ink on birch bark. Originally 7 × 39 cm approx. OMPB Or. 8212/103 (Kha. ii, 1, 3, 6–12, viii, 11)

The *Saṃyuktāgama* is the Sanskrit version of the *Saṃyutta-nikāya*, the third of the four Pali books of the Buddha's sermons. It owes its name to the grouping of its *sūtras*. The Pali version which, unlike the Sanskrit, is complete, comprises 2,889 *sūtras*. This Sarvāstivāda version was known only in Chinese and Tibetan until parts were discovered in Central Asia. This now fragmentary manuscript was written in the Himalayan regions on birch bark, the usual writing material for that area, before being taken to Central Asia. JPL

34. Sūtra on Dependent Origination

India, from Gopalpur, Gorakhpur, Uttar Pradesh. *c.* AD 500

Pratītyasamutpādasūtra in Sanskrit. Gupta script. Incised on baked clay. 12 × 28.5 cm. Ashmolean Museum, Oxford (X. 404)

Buddhist doctrine is concerned with suffering and the means of release from it. Suffering is based on certain causes: if the causes are removed, suffering also will disappear. The Buddha expanded the second of the Four Noble Truths in a sequence recorded at the beginning of Book 2 of the *Saṃyuttanikāya*. The whole chain was later called 'Dependent Origination' (see Introduction). The Sanskrit version along with other bricks embedding the sequence in a narrative were found in 1896 in a subterranean brick chamber in a group of ruins at Gopalpur. They seem to have been votive offerings, and could not have been uncommon. Similar bricks have been found at Nālandā and the same text on different materials as votive offerings elsewhere. JPL

35. The Book of Exalted Utterances

From Dunhuang, Gansu province, China. 5th–6th century AD

Pothī manuscript of *Udānavarga* in Sanskrit. Slanting Gupta script. Ink on paper. 12 folios. 9 × 37.5 cm. IOLR Ch. vii. 001A

The *Udānavarga* is a Sarvāstivādin compilation, attributed to Dharmatrāta (1st century AD?), of popular ethical verse maxims. It significantly overlaps with an old north-west Indian (Gāndhārī) *Dharmapada* and the Pali canonical *Dhammapada* which belongs to the *Khuddakanikāya* or Minor Tradition, the collection of mainly verse texts not considered as spoken by the Buddha but sufficiently ancient to have entered the Canon before the first schisms. The script suggests a scribe from Kucha. JPL

36

37

36. Rules for monks

From Kucha, Xinjiang province, China. 5th or 6th century AD
3 folios from *pothī* manuscripts of *Vinayapiṭaka* in Tocharian. Slanting
Gupta script. Ink on paper. 5 × 29.5 cm and 7.5 × 35 cm.
IOLR Hoernle Ms. 149 $\frac{x}{3}, \frac{x}{3}, \frac{x}{4}$

The three folios are from two different manuscripts, two con-
secutive folios (108, 109) being from the second manuscript.
They comprise Tocharian versions of the *Vinayapiṭaka* of
the Sarvāstivādins, the first leaf being from the *Prātimokṣa*,
the consecutively arranged rules of conduct for monks (rules
71 85), while the other two leaves provide a text similar to
the *Suttavibhaṅga* of the Pali Canon, a rule embedded in the
narrative which gave rise to it and a commentary following it.
The rules covered by these two folios comprise the end of the
section on Expiation and the beginning of that on Confession.

Tocharian, or Kuchean, the language of northern Xinjiang
around Kucha, formed an entirely independent branch of the
Indo–European language family, lost for 1,000 years until the
manuscript discoveries in the 1890s. JPL

37. Rules for monks

Burma. 18th–early 19th century
Incomplete manuscript of *Bhikkhupāṭimokkha* in Pali. Burmese
square script. Palm leaf, black lacquered text, silvered with gilded
and red lacquered marginal decorations. 8 folios. 8 × 53 cm.
OMPB Or. 12010/G

The *Bhikkhupāṭimokkha*, one of the oldest Buddhist texts,
must pre-date the Canon. It contains 227 rules of the order of
confession used by monks at their fortnightly assembly. The
Bhikkhupāṭimokkha and *Kammavācā* are sometimes called
ritual texts. Both represent a continuity of ceremonies from the
earliest times and are read aloud at monastic assemblies (see
Introduction). Burmese manuscripts of these texts are usually
especially ornate with the text written in large lacquered
Burmese square script on gilded or silvered and lacquered
sheets. Silvering is mostly found in Lower Burma. PMH

38. Rules for monks

China, from Dunhuang, Gansu province. AD 406
Scroll of *Prātimokṣasūtra* in Chinese. Ink on paper. 27 cm × 7 m
approx. OMPB Or. 8210/S. 797

This scroll, the earliest dated manuscript found at Dunhuang,
was written only fifty years after the first cave temple was
excavated, and the copier, a monk, apologises for his hand-

39

38

41

writing hoping that no one will laugh at it. The text sets out the *Prātimokṣa* of the Sarvāstivādin school which flourished in Gandhara and north-west India. Kashmiri monks, including Puṇyatrāta who translated this particular work, translated Sarvāstivāda literature into Chinese in the late 4th century.

FW

39. Code of monastic discipline

Tibet. 17th–18th century

Illuminated title-page from a manuscript of *Vinayavibhaṅga* ('*Dul-ba rnam-par 'byed-pa*) in Tibetan. Gold ink on black paper. 22 × 66 cm. OMPB Or. 6724, vol. 1

Protected by multi-coloured silk covers, this title-page consists of text flanked by miniatures of teachers seated cross-legged on lotus thrones and surrounded by a fire nimbus set with jewels. On the left the Buddha's disciple Kāśyapa makes the

40

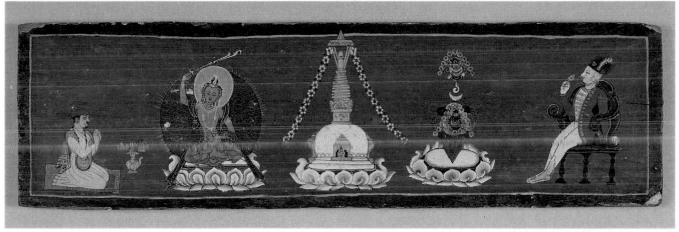

45

46

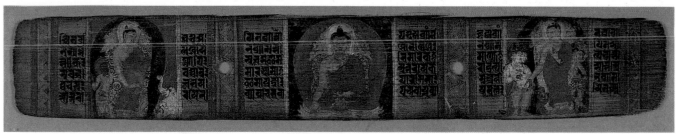

48

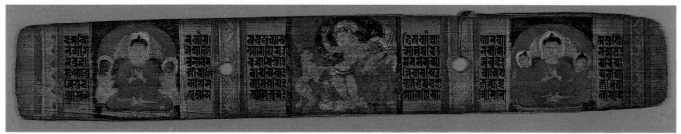

48

42

其心愛樂歡喜踊躍光遍不能目睹誠勸諸
天使行此法教令歡離一切有為生老病死
求無上法是時諸明菩薩大士觀彼諸天眾如
師子王欲下生時其心安隱不懼不怖不畏
下亂復更重告諸天眾言沙等諸天一切當
如此我覺率正念後受後遊身是時正念一心
從魁率下如餘諸菩薩下時則不如是菩
薩下時具足一切不可思議希有之法諸明菩
薩從天下時諸天憶菩薩故時號哭
嗚呼苦哉嗚呼苦哉我等既失諸明菩薩我
從今去永更不復得聞正法減損我等功德
之利生死根本今益增長時淨居天告彼一
切諸大眾言沙等今見諸明菩薩欲下生時
莫生憂惱何以故彼下生時必之當得成阿
耨多羅三藐三菩提成已還來至此天宮為
汝說法猶住首毗婆尸佛尸棄佛毗舍
淨佛迦羅迦孫馱佛迦那牟尼佛迦葉如
來被等諸佛皆後此去憐愍沙等志各還來
到此天宮為沙說法攝受沙等今此諸明菩
薩大士還如是來攝化於汝如前不異
今時諸明菩薩大士於衣下生當欲降神入
於摩耶夫人胎時時彼摩耶當其夜自淨飯

44

48

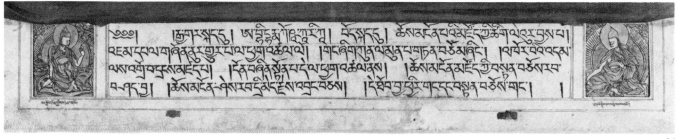

43

teaching gesture; on the right is Tsong-kha-pa (1357–1419), founder of the dGe-lugs-pa (Yellow Hat) school. He holds the sword of discriminative wisdom, which cuts through delusion, and a sacred text.

Tibetan monastic discipline is based on the translated Sanskrit *Vinaya* of the Mūlasarvāstivādins and belongs to the first division of the Canon (*bKa'-'gyur*). LC

40. Rules for bathing

From a house at Niya, Xinjiang province, China, and 3rd century AD
Wooden board, perhaps part of a wooden *pothī* manuscript, with inked inscription of *Vinaya* texts in Prakrit. *Kharoṣṭhī* script. 15 × 89 cm. OMPB Or. 8211/1682 (N. xxiv. vi. I)

Most of the numerous wooden documents found at Niya in *kharoṣṭhī* characters (a north-west Indian script derived from Aramaic and found mostly in Gandhara and the Panjab) are official missives in Prakrit. This board, however, contains a *Vinaya* text. It extols the performance of a certain bathing ritual, and the blessing conferred thereby even on the bath attendants. Its purpose is not clear, nor the reason for its being in an archive of official documents in the local magistrate's house. JPL

41. Commentary on the Abhidhammapiṭaka

Burma. 1790–1
Manuscript of *Ṭīkāpaṭṭhāna* in Pali with a Burmese *nissaya* (word for word translation). Burmese script. Palm-leaf, gilded and red lacquered at edges, between decorated binding boards. 498 folios. 5.5 × 51.5 cm. OMPB Or. 5699

The *Ṭīkāpaṭṭhāna* is a commentary upon the last and most important treatise of the Theravāda *Abhidhammapiṭaka*, the *Paṭṭhāna*, which deals with the twenty-four *paccaya*, or causes, and their origins and relationships. Burmese Buddhist scholars have long excelled in studies of the *Abhidhamma*. According to the colophon, this *nissaya* was compiled and written 'holding the stylus with my own hand' by the monk Nandamedha of Bodhi Kyaung (monastery), Tantabin, in the Burmese year 1121 (1759) 'so that the Buddha's religion may last for many years' and that 'students should study and learn this *Paṭṭhāna nissaya* with love and with a pure heart'. PMH

Illustrated on page 46

42. The Treasury of the Higher Doctrine

From Dunhuang, Gansu province, China. 13th–14th century
Bound volume containing a Uyghur commentary, with some Chinese, on Sthiramati's commentary on Vasubandhu's *Abhidharmakośa*. Ink on paper. 164 folios (each folio double). 17 × 13 cm. OMPB Or. 8212/75 (Ch. xix. 001)

Vasubandhu, who lived probably in the 5th century AD, belonged to the Sautrāntika school whose doctrines were based solely on the *sūtras*, rejecting the interpretation in the Sarvāstivāda *Abhidharma*. Even the Sautrāntikas, however, needed answers to the basic questions posed in the *Abhidharma* controversies, and Vasubandhu wrote this extremely influential work on the basis of the Hīnayāna *Sūtrapiṭaka*.

The Uyghurs, Turks from the north of the Tianshan, built an empire in western China in the late 1st millennium AD, including Dunhuang. Although found in the walled-up library, this and other late volumes were added by the priest-in-charge between the discovery in 1900 and Stein's visit in 1907. JPL

43. Commentary on the Treasury of the Higher Doctrine

Tibet. 18th century
Commentary on *Abhidharmakośakārikā* in Tibetan. Block-print on paper. 281 folios. 13.5 × 62 cm. OMPB 14310 a, vol. 63

As a commentary this text belongs to the Tibetan *bsTan-'gyur*. The text exhibited is flanked with miniatures showing (left) Vasubandhu, the 5th-century Indian Sautrāntika scholar who wrote the original work, and (right) dPal-brtsegs, one of the famous *lo-tsā-ba* or Tibetan translators of the scriptures. LC

44. Sūtra of the Great Departure

China, from Dunhuang, Gansu province. 7th–8th century AD
Scroll manuscript of *Abhiniṣkramaṇasūtra* in Chinese. Ink on paper. 27 cm × 6 m. OMPB Or. 8210/S. 293

This *sūtra*, translated by Jñānagupta of the Sui dynasty (c. 589–618), is a biography of the Buddha associated with the Dharmagupta school which was most active in promoting Buddhism in Central Asia and China. Its tradition lived on in the rules of discipline for religious communities after the introduction of the Mahāyāna.

The *stūpa* cult was also introduced by the Dharmagupta school with which this *sūtra* is associated, and Emperor Wen of the Sui dynasty put up 111 *stūpas* between 601 and 604 to house relics, in deliberate imitation of Aśoka. FW

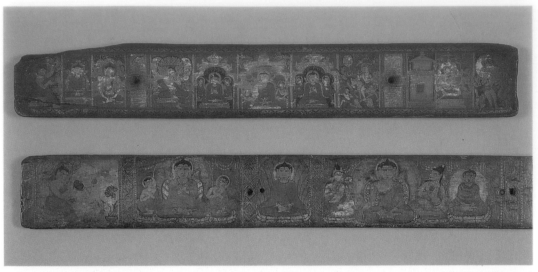

50 (top), 49 (bottom)

52

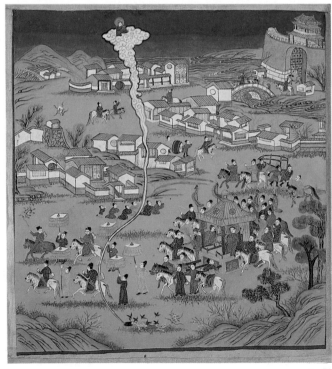

51

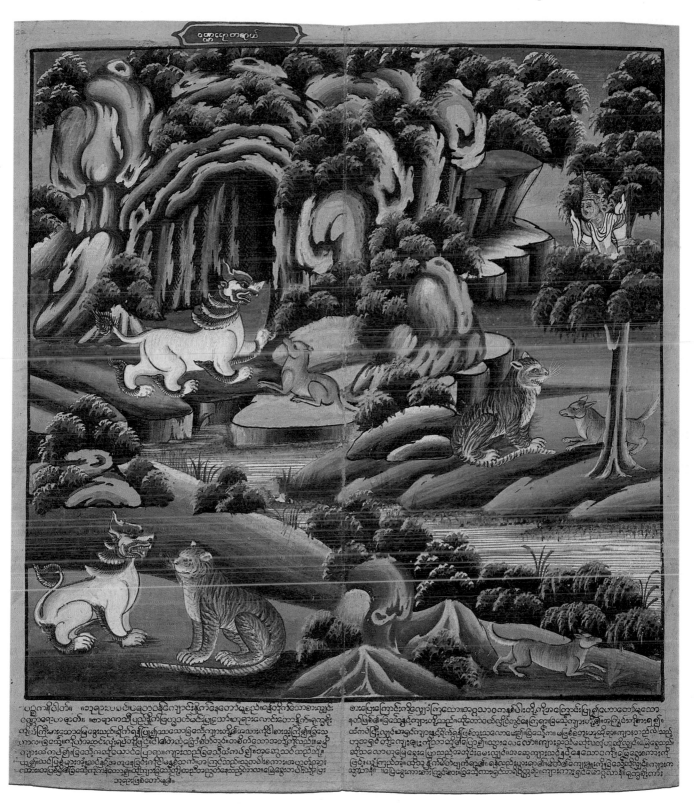

45. Sūtra of Great Magnificence

Patan, Nepal. 1803

Pothī manuscript of *Lalitavistara* in Sanskrit. Commissioned by Captain W.D. Knox. *Nāgarī* script. Ink and gouache on paper; gouache on wood. 254 folios. 12.5 × 40 cm. IOLR Ms. 688

The *Lalitavistara* is perhaps the most popular Sanskrit biography of the Buddha. It probably began as a Hīnayāna (Sarvāstivāda?) expansion of the *Vinaya* but was turned by the Mahāyānists into a regular *sūtra*. Its twenty-seven chapters include all the miracles up to the First Sermon. Captain Knox, an officer of the East India Company's army, resident in Nepal in 1803–4, is depicted receiving the volume from the scribe Amṛtānanda in the last miniature and on the inside back cover. These portraits are in the standard Rānā style of Nepal, but the elaborately drawn and gilded miniatures of the text proper show influence from the Tibetan monastery of Tashilhunpo. JPL

Illustrated on page 47

46. Rules for monks

From a *stūpa* at Gilgit, Pakistan. 7th century AD

Pothī manuscript of *Vinayavastu* of the Mūlasarvāstivādins in Sanskrit, originally of 423 folios approx. North-western Gupta script, with *cakras* (wheels) marking chapter ends. Ink on birch bark. 12 × 66 cm. OMPB Or. 11878 A

The Mūlasarvāstivādins were a late (4th-century AD) offshoot of the Sarvāstivādins, concerned to return to an orthodoxy (*mūla*) from which, in their opinion, the latter had strayed. They flourished in Kashmir and Gandhara. Their *Vinaya* included a particularly large number of illustrative stories, including many expanding the life of the Buddha, thus providing a rich source of early Buddhist history as well as of ancient Indian narrative literature. This and other manuscripts were found in a collapsed *stūpa* in Gilgit in 1931, presumably the personal library of the monk whose relics were enshrined there. Four of the manuscripts had been commissioned by members of the dynasty of the Patōla Śāhīs, Iranian rulers of the Chitral-Gilgit area in the 6th and 7th centuries (see also no. 70). JPL

Illustrated on page 47

47

47. Sūtra of the Practice of the True Law

China, from Dunhuang, Gansu province. 10th century (?)

Manuscript of *Saddharmasmṛtyupasthānasūtra* in Chinese. Ink on paper, folding book format. 27.5 × 7 cm. OMPB 8210/S. 5662

This Mūlasarvāstivāda *sūtra* provides exercises for monks. It covers much basic doctrine emphasising 'self-possession' achieved by observing the body, sensations, thought and phenomena to eliminate desire and cultivate aversion from the world. It was translated by Prajñāruci in AD 539. The folding-book format illustrates the first development beyond the paper scroll, towards the traditional printed book with its folded leaves. FW

48. The Eight Great Events

Eastern India. *c*. 1125–50

Pothī manuscript of *Aṣṭasāhasrikā Prajñāpāramitā*. *Siddhamātṛkā* script. Ink and gouache on palm leaves. 6 × 39 cm. OMPB Or. 12461 ff. 148b, 149a, 254b, 255a

The four most important incidents in the earliest Buddha lives were his birth, his Enlightenment and Temptation, his First Sermon, and his death; another four of lesser importance were his descent from heaven, his multiplication of himself, his taming of the elephant, and being offered a bowl of honey by monkeys. Towards the end of the first millennium these eight incidents were often depicted together round the back plate

of a Buddha image (no. 148) or on the covers of a manuscript (see following) or as here as part of a series of miniatures. By the Pāla era the depiction of these events had transcended narrative illustration and served, as did other miniatures, as icons to protect the manuscript and increase the spiritual welfare of the donor. The compositions differ only in detail, indicating faithfulness to a tradition whose beginning is still unknown. In sculpted Pāla versions the Buddha is always represented frontally, whereas in the painted versions of the elephant, monkey and descent scenes he is normally in three-quarter profile. JPL

Illustrated on page 47

49. Events from the Buddha's life

Eastern India. Late 12th century

Manuscript cover. Gouache on wood. 5.5 × 56 cm. OMPB Or. 14133

Six scenes from the Buddha's life, five of them from the Eight Great Events, but one unusual in this period in Pāla book illustration, namely the snake-king Mucalinda protecting the meditating Buddha with his hoods. JPL

Illustrated on page 50

50. Events from the Buddha's life

Eastern India. 12th century

Manuscript cover. Gouache on wood. 5.5 × 39 cm. OMPB Or. 14142

On this quite small cover are crowded ten events from the Buddha's life: five of the Eight Great Events, with in addition the snake-king Mucalinda protecting the Buddha; the fasting Buddha being attacked by two cowherds who drive pegs into his ears (because he did not look after their cows), cutting off his hair on becoming an ascetic; as a young prince riding from the palace, probably to the park where he discovers misery; and his encounter with a beggar. The style of the miniatures links this cover with the *Kāraṇḍavyūha* manuscript, and hence to eastern India outside the Pāla dominions. JPL

Illustrated on page 50

51. Life of the Buddha

China. 1818

Shi jia ru lai ying hua shi ji, hand-coloured woodblock print. 4 folios. 32 × 29 cm. OMPB Or. 13217

The life of the Buddha, as recorded in the *Tripiṭaka*, became a popular subject for illustration in China. The story tells how the young prince Siddhārtha encounters an old man, a sick man and a corpse outside the palace walls. Other illustrations depict stories appealing to the Chinese such as the young Bodhisattva at school. In a traditional academy, with Chinese threadbound books on shelves, his halo sets him apart from the other pupils. FW

Illustrated on page 50

52. The story of Vessantara

Thailand. Early 19th century

Manuscript of *Vessantarajātaka* in Pali. Cambodian script. 28 palm leaves with 8 pairs of miniatures. 5 × 44 cm. OMPB Or. 1245A

An elegantly produced text of two sections of the last of the 547 *jātakas* in the Pali canon. As the Great Jātaka, it is the most revered in Thailand. It epitomises the merit of giving, for the Buddha-to-be gives away his property and loses his position. Wandering in the forest with his family, he even gives away his wife and children but they are later reunited. The illustrations of these sections show various forest animals in natural settings on gold, or black, backgrounds. They do not specifically illustrate the story. HG

Illustrated on page 50

53. The previous lives of the Buddha

Burma. Mid-19th century

Illustrated paper book in 137 folds of the *Jātaka* in Burmese. 41 × 18 cm. OMPB Or. 13538

The *Jātaka* was among the first Buddhist texts in Burma; on the great temples of Pagan, Burma's capital from the 11th to the 13th centuries, *jātakas* abound on terracotta plaques and in wall-paintings, captioned in Pali, sometimes with Mon and Burmese glosses. Although many Burmese *nissayas* of the Pali *Jātaka* commentary of Buddhaghosa were compiled over the years, popular Burmese prose translations were made only in the late 18th and early 19th centuries. Illustrated *Jātaka* manuscripts in Burmese date from this time and no doubt helped teach the Buddhist precepts as the earlier temple illustrations had done.

The opening displayed is of the *Vaṇṇāroha jātaka* (number 361) which tells of the Buddha's previous birth as a tree spirit (the gilded figure depicted top right). A lion and a tiger (left foreground) lived as good friends in a mountain cave in the forest. A greedy jackal tried to make them quarrel by telling them separately that each maligned the other. The jackal hoped to make them kill each other so that he could eat them, but they wisely refused to believe gossip. PMII

Illustrated on page 51

54

The Mahāyāna

54. Hymn in 150 verses

From Dunhuang, Gansu province, China. 5th–6th century AD
Incomplete *pothī* manuscript of *Śatapañcāśatikāstotra* of Mātṛceta in Sanskrit. Slanting Gupta script. Ink on paper. 3 folios. 8.5 × 36.5 cm. IOLR Ch. vii. 001B, 1–3

Hymns in praise (*stotra*) of the divine characterise both Hinduism and Buddhism from about the 1st century AD. Even in the Hīnayāna the Buddha's development of a superhuman, transcendent personality made such hymns possible. The most famous Buddhist hymn-writer was Mātṛceta (2nd century AD) who seems to have worshipped Śiva before becoming a Buddhist. He is supposed to have been converted by Āryadeva, disciple of Nāgārjuna.

The simple beauty of these Sanskrit hymns appealed to Hīnayānists and Mahāyānists alike, as for example: 'Revilers have you overcome by mildness, the malicious by making them secure, liars by the truth and the malevolent by your friendship' (v.122). Such non-sectarian sentiments were ideally suited to communal chanting in monasteries where monks of both persuasions dwelt together. JPL

55. The Gem-heap Sūtras

China, from Dunhuang, Gansu province. 8th century AD
Scroll of *Ratnakūṭaparipṛcchāsūtra* in Chinese. Ink on paper. 27 cm × 11.5 m approx. OMPB Or. 8210/S. 351

The earliest Mahāyāna *sūtras* appear to be those collected in the *Ratnakūṭa*, or 'Gem heap', a collection of forty-nine separate works from different periods made before the 2nd century AD. Some had previously been translated separately into Chinese, but the collection as a whole represents the earliest Mahāyāna group. This scroll contains the forty-seventh work in the collection, the *Ratnakūṭaparipṛcchā*, the Bodhisattva Ratnakūṭa's Assembly, translated by Fa Hu of the Western Jin dynasty (AD 265–316). The paper scroll is attached to its original wooden roller and the silk tie, showing the complete form of the early 'book' in China. Various *sūtras* in this collection attempt the first systematic statement of the way of the Bodhisattva. FW

56. Sūtra of Eternal Life

China, from Dunhuang, Gansu province. 6th century AD
Scroll of *Sukhāvatīvyūha* in Chinese. Ink on paper. 27 cm × 6.5 m. OMPB Or. 8210/S. 2117

The principal *sūtra* of the Pure Land school (which began in China in the early 5th century and was later exported to Japan) is the *Sukhāvatīvyūha* which exists in a long and a short version. There are several translations of both; this is an example of the shorter version, the *Amitāyuḥsūtra*, translated by a Soghdian, Kang Senhui (or Saṃghavarman), in AD 252. Both versions contain detailed descriptions of the Pure Land, or Paradise of Amitābha (in the east in Sanskrit and Khotanese, in the west in Chinese). Rebirth in the Pure Land results from meritorious deeds combined with faith and devotion to Amitābha in the longer version, faith and prayer alone in the shorter version. FW

57. Incantation of the Sūtra of Eternal Life

From Dunhuang, Gansu province, China. 9th–10th century AD
Pothī manuscript of *Aparimitāyuḥsūtradhāraṇī* in Khotanese. Upright Gupta script. Ink on paper, with 1 miniature in gouache. 20 folios. 6.5 × 35 cm. IOLR Ch. xlvi. 0015

This brief text is a *dhāraṇī*, or incantation (see Vajrayāna section), explaining the rewards gained by reciting the *sūtra* of its title. Like all such works it repeats endlessly the same basic formulae, varying only the numbers of persons, times or years involved. Whoever recites this *sūtra* in praise of Aparimitāyuḥ, or has it written, will repeatedly have his life extended by 100 years, until when he finally dies he will obtain rebirth in the paradise (*buddhakṣetra*) of Aparimitāyuḥ. Although the basic texts of the Pure Land school are Indian in origin, its ideas attracted little interest in India itself, no doubt because of the discrepancies between its sensual paradise and the orthodox Middle Way.

At the beginning of this manuscript is a small roundel of two concentric circles with a coloured seated Buddha (apparently Amitābha) superimposed against the inner circle. Amitāyuḥ and Aparimitāyuḥ mean the same thing – Endless Life – and are alternative names of the Buddha Amitābha (Endless Radiance). Khotanese was the ancient language of western Xinjiang and has now been identified as one of the Śaka or Scythian languages of the Iranian group. JPL

55

56

58

58. The Doctrine of the Middle Way

China, from Dunhuang, Gansu province. 5th century AD
Scroll manuscript of *Madhyamakaśāstra* in Chinese. Ink on paper.
27 × 91 cm. OMPB Or. 8210/S. 3286

The Middle Way, rejecting doctrinal extremes, is associated
with Nāgārjuna (2nd century AD). It was introduced into
China through Kumārajīva's translations and Seng Zhao's
interpretations. Seng Zhao continued Nāgārjuna's arguments
on Emptiness and the unreality of all forms of existence. In his
essay 'Prajñā is not knowledge' he expresses ideas approach-
ing Chinese Taoist philosophy which also stresses the Middle
Way, and closeness to Taoism is sometimes cited as one of the
reasons for the success of the *Madhyamaka* doctrines in 4th-
and 5th–century China. FW

57

59. Eulogy on the Middle Way

Japan, Daianji Temple, Nara. 1294
Block-printed Japanese edition of Nāgārjuna's *Madhyamakakārikā*
(*Chūron geju*). 1 folding vol. Ink on a mixture of *gampi* and mulberry
paper. 25.3 × 8 cm. OMPB Or. 81. c. 4

The text is one of the three fundamental doctrines of the
Sanron (Three Treatises) school which stressed the Middle
Way. The first real school to reach Japan from China in the
7th century, it was to flourish in the Kamakura period at the
Tōdaiji, the main monastery in Nara. This is one of the three
Buddhist texts printed, between 1292 and 1295, under the
patronage and supervision of the monk Sokei of the Daianji
temple. The present copy came from the Tōdaiji Shinzen'in
collection, as the large black seal of ownership testifies. YYB

59

60

60. The Perfection of Wisdom in 8,000 Sections

From a *stūpa* at Khadalik, Xinjiang province, China.
7th–8th century AD

4 folios from a *pothī* manuscript of *Aṣṭasāhasrikā Prajñāpāramitā-sūtra* in Sanskrit. Upright Gupta script. Ink on paper. 11.5 × 40cm.
OMPB Or. 8212/56 (Kha. i. 5)

The title 'Perfection of Wisdom' embraces numerous scriptures written on the twin themes of the way of the Bodhisattva (the Six Perfections) and the doctrine of Emptiness. Some of these texts are as long as 100,000 *ślokas* (a unit of thirty-two syllables); others as short as a few hundred (nos 64–9). The earliest of these, and perhaps the earliest of all Mahāyāna *sūtras*, is this version in 8,000 *ślokas* produced probably in Āndhra in southern India in the 1st century AD. Its philosophy may be succinctly stated thus: 'The nature of all phenomena (*dharmas*) is non-nature and their non-nature is their nature. Their one characteristic is having a non-characteristic.' Even emptiness is not a characteristic; entities are empty because they do not exist. The non-perception of these non-entities is called the Perfection of Wisdom. The *Prajñāpāramitā* was one of the earliest texts translated into Chinese, and many manuscripts were produced in Central Asia. JPL

61. The Perfection of Wisdom

From a *stūpa* at Khadalik, Xinjiang province, China. 8th century AD
2 fragments of a *pothī* manuscript of *Prajñāpāramitā* in Sanskrit. Upright Gupta script. Ink and gouache on paper. 10 × 12.5 and 13.5cm. Roundel originally 5.5cm diameter. OMPB Or. 8212/174 (Kha. i. 220)

The seated Buddha is a larger version of that in the *Aparimitāyuḥsūtra* (no.57) but corresponding to that in the *Vajracchedikā* (no.66) in position.

The Indian-script manuscripts with miniatures or illuminations found in Central Asia are all either in the Iranian language Khotanese or found in the Iranianised districts of south-western Xinjiang near Khotan itself. The ancient Iranians loved richly illuminated manuscripts, and explored the decorative possibilities of the large roundels found in such Indian manuscripts as no. 46. There the roundels serve as chapter markers, which in some of the pages in New Delhi are

61

elaborately drawn *dharmacakras*. Among the Central Asian manuscripts the *dharmacakras* in no. 76 have been coloured. No. 66 has line drawings of the Buddha against a *dharmacakra*, while in this and in no. 57 the background has been simplified and the main figure coloured. As so few surviving Central Asian manuscripts have decorations of this sort, it would seem that illumination was rarely attempted. The reason lies perhaps in a respect for the calligraphic austerity of the original Indian models. This is the only extant illustrated manuscript from the Khotan area, all the others being from Dunhuang. JPL

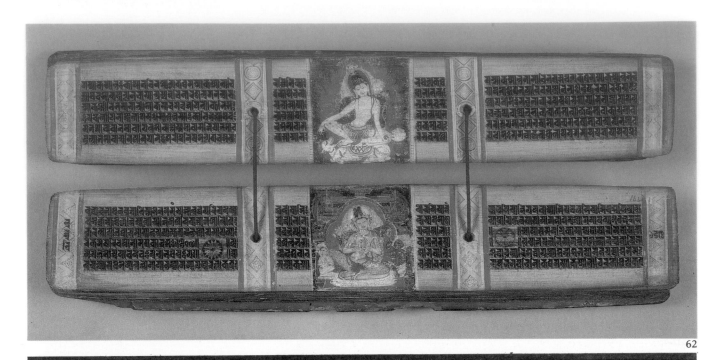

62

菩別復次菩薩得如是大智心然不高心相
常清淨故如虛空相常清淨烟雲塵霧假來
故覆薩不淨心然如是常自清淨无明等諸
煩惱客來覆薩故以為不淨除去煩惱如本
清淨行者功夫微薄此清淨非汝所作不應
自高不應念何以故畢竟空故日舍利弗
知心相常清淨何以故問荅日菩薩發阿㝹多
羅三藐三菩提心漸入深著故難問心畢竟
空常清淨猶憶想分別耶是无心相以是故
問是无心相為有為无若有无著阿㝹多羅
三藐三菩提相若无何以讚嘆當成佛道答
日是无心相中畢竟清淨有无不可得不應
難舍利弗復問何等是无心相荅日畢竟空
一切諸法无分別是名无心相舍利弗復問
但心相不壞不分別餘法无然如是須菩提
處誑以不貢實故菩薩滿未盡故凡夫法可言
多羅三藐三菩提作是念諸阿㝹多羅三藐
提然如虛空无壞无分別諸菩薩深著阿㝹
言諸法无如是若今者阿㝹多羅三藐三菩
清淨玄何阿㝹多羅三藐三菩提雖是第
是時心驚不悅須菩提知其心已思惟籌量
我今應為說實相法不思惟已自念今在佛
前當以實相荅若我有失佛自當說重思惟
相行不應作者當隨阿㝹多羅三藐三菩提
相以是故行者有人言嗟羅門從
竟次是故說阿㝹多羅三藐三菩提雖是第
一点德處誑法過生故然是空不壞不分別
言善武善武佛時有時舍利弗讚須菩提
梵天王口過生故共四色眾生中第一以是
舍利弗所嘆延佛口生所以者何見
言善武善武佛言嗟然聽須菩提
故合利弗讚言汝真延佛故得供養晨名
法知法故有未得道者依佛故得供養晨名

63

64

58

65

62. The Perfection of Wisdom in 8,000 Sections

India, Vikramaśila monastery, Bihar. c.1145

Pothī manuscript of *Aṣṭasāhasrikā Prajñāpāramitāsūtra* in Sanskrit, copied in the 15th year of Gopāla. *Siddhamātṛkā* script. Ink and gouache on palm leaves, with plain wooden covers. 337 folios. 7 × 41 cm. OMPB Or. 6902

Most surviving illuminated Indian Buddhist manuscripts of the 11th and 12th centuries are of this text, by that time long accepted as the final scriptural statement of the Mahāyāna philosophy. As such, it had a mystical significance for the lay community who commissioned illuminated manuscripts of it, even though the subjects of the miniatures had no particular reference to the text. Here the divinities represented are Avalokiteśvara as Siṃhanāda (the Lion's Roar) seated on the back of a lion, and Maitreya in the teaching gesture between Sudhanakumāra and Yamāri.
JPL

63. The Exposition of the Perfection of Wisdom

China, from Dunhuang, Gansu province. AD 593

Scroll manuscript of *Mahāprajñāpāramitāśāstra* in Chinese. Ink on paper. 27 cm × 9.4m. OMPB Or. 8210/S 227

This work is a commentary by Nāgārjuna II on the Perfection of Wisdom in 25,000 *ślokas*, translated by Kumārajīva (AD 384–417). Nāgārjuna I, his teacher, founded the *Madhyamaka*, or 'Intermediate' school, which stressed a middle path between the extremes of believing in existence and non-existence. Nāgārjuna II linked his master's philosophy directly with the Perfection of Wisdom texts. Through his translations Kumārajīva established the school in China where it was called the 'School of the Three Treatises'. Kumārajīva was not Chinese but half Brahmin, half Kuchean and studied Buddhism in Kashmir and Kashgar. He set up a translation bureau of 1,000 monks in the Chinese capital, which translated Sanskrit works, many of them now known only in Chinese.
FW

64. The Perfection of Wisdom in 100,000 Sections

Northern India, from Dunhuang, Gansu province, China. 8th century AD

Incomplete *pothī* manuscript of *Śatasāhasrikā Prajñāpāramitāsūtra* in Sanskrit. Late Gupta script. Ink on palm leaves. 69 folios. 4.5 × 50.5 cm. IOLR Ch. 0079a

Among the most precious relics found at Dunhuang was a large palm-leaf manuscript of the longest recension of the *Prajñāpāramitā*, which must have originally been written in northern India before undertaking its perilous journey to Dunhuang, perhaps through Tibet, as this is the period of the Tibetan occupation of Dunhuang. The manuscript must originally have contained some 1,000 folios.
JPL

65. The Perfection of Wisdom in 100,000 Sections

Central Tibet. 17th century

Illuminated title-page from a manuscript of *Śatasāhasrikā Prajñāpāramitāsūtra* in Tibetan. Gold lettering on black paper. 322 folios. 25 × 66 cm. OMPB Or. 6724, vol.14

The lettering of the title-page is in relief and gilded. The text is contained between two miniature portraits of female deities: Prajñāpāramitā, Mother of all the Buddhas (left), holding a rosary, a *vajra*, a text of the Perfection of Wisdom, and a vase; Sarasvatī (right), consort of Mañjuśrī, Bodhisattva of Wisdom, who is playing a lute. Within the text are two gold lotuses, each containing a single turquoise, the three turquoises (upper left) symbolising the Three Jewels, the Buddha, the Dharma and the Saṃgha.
LC

66

66. The Diamond-Cutter Perfection of Wisdom

From Dunhuang, Gansu province, China. 9th–10th century AD
Pothī manuscript of *Vajracchedikā Prajñāpāramitāsūtra* in Khotanese.
Upright Gupta script. Ink on paper. 44 folios. 7 × 25.5cm. 2 roundels
6cm diameter approx. IOLR Ch. 00275 and x1vi. 0012a

The *Vajracchedikā* is a summary in 300 sections of the
Prajñāpāramitā, it and the *Heart Sūtra* being the most fre-
quently found of these summaries. There are versions extant
in Sanskrit, Khotanese, Soghdian, Tibetan and Chinese (four
times translated between AD 400 and 800). This Khotanese
manuscript, with the *Aparimitāyuḥsūtra* (no.57), proved
the keys to one of the two 'unknown languages' of Xinjiang
(Khotanese), since both texts are fairly literal translations
from known Sanskrit originals. The *Vajracchedikā* is illustrated
with two line drawings of the Buddha meditating, in roundels,
at the beginning and end of the text, while on another folio
the roundel is drawn without the Buddha. On the final folio
the roundel against which the Buddha is drawn is a *dharma-
cakra*. In addition there is a small coloured *dharmacakra* on
the opening folio in the corner and on the closing folio the
same with the Buddha depicted against it. These tiny circles
echo that of no.57. On the recto of the first folio is a date
equivalent to AD 941. JPL

67. The Diamond-Cutter Perfection of Wisdom

China, from Dunhuang, Gansu province. 10th century
Manuscript in booklet form of *Vajracchedikā Prajñāpārimitāsūtra* in
Chinese. 4 pages of drawings. 14 × 11cm. OMPB Or. 8210/S. 5646

The *Vajracchedikā* in Kumārajīva's translation was one of the
most popular texts in 7th-century Dunhuang judging from
the number Stein collected there; it comes second only to the
Lotus Sūtra. In it Śākyamuni Buddha instructs his disciple
Subhūti in the Perfection of Wisdom. This booklet with its
rather crude drawings of Bodhisattvas and Lokapālas (World-
protectors) represents a stage in the development of the
Chinese book, beyond the scroll form. The later traditional
book in China consisted of thin leaves folded at the outer
margin, but the booklets from Dunhuang are generally written
on very thick paper sewn at the inner margin. FW

68. The Heart of the Perfection of Wisdom

China, from Dunhuang, Gansu province. 9th century AD
Scroll of *Prajñāpāramitāhṛdayasūtra* in Chinese. Ink on paper.
42 × 22cm. Or. 8210/S. 4289

The brief *Heart Sūtra* can be written on a single sheet of
paper, here in the diagrammatic form of a *stūpa* or pagoda.
This presentation recalls the *stūpa*-building activities of the
Emperor Wen (601–4) in emulation of Aśoka. The translation
is by Xuan Zang (*c*.602–664), one of the best-known translators
of Buddhist works into Chinese, also famous for his epic
journey to India to bring back scriptures. His travels lasted
sixteen years, and he returned to China with 657 titles packed
in 520 cases. His translations are smooth and fluent, revealing
his mastery of both Sanskrit and Chinese, and they are more
detailed than many others. FW

68

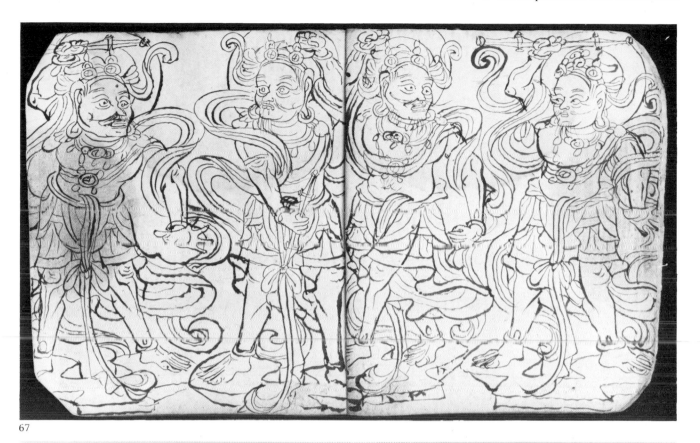

67

69

70

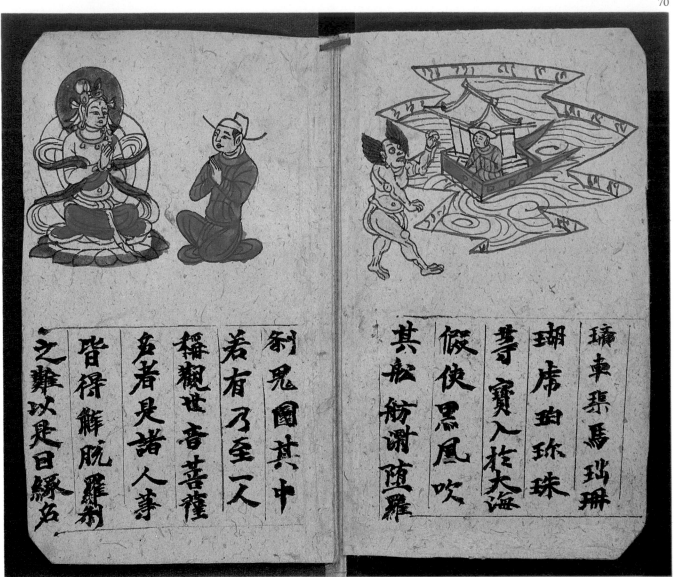

72

71

73

69. The Heart of the Perfection of Wisdom

From Dunhuang, Gansu province, China. 9th century AD
Single sheet with text of *Prajñāpāramitāhṛdayasūtra* in Tibetan.
Ink on paper. 23.5 × 38 cm. OMPB Or. 8212/77 (Ch. 00183)

The *Heart Sūtra* is a succinct summary of the *Prajñāpāramitā*.
This beautifully written Tibetan translation is on the back of
a draft letter in Old Turkish by a military official, which is
datable to the 9th century. The Tibetans occupied Dunhuang
for about 100 years from AD 766. JPL

Illustrated on page 61

70. The Lotus of the Good Law

From a *stūpa* at Gilgit, Pakistan. 6th–7th century AD
Pothī manuscript of *Saddharmapuṇḍarīkasūtra*. Cursive Gupta
script. Ink on paper. 7 folios. 7.5 × 27 cm. OMPB Or. 11878 B

The *Lotus Sūtra* is a restatement of the way of the Bodhisattva.
It pays particular attention to Avalokiteśvara, merely to think
of whom saves from peril, but also includes fresh doctrinal
matter in chapter 15 concerning the Buddha, now regarded as
omnipotent and eternal. Perhaps this shows a concession to
the masses' craving for a divinity to worship, and not surpris-
ingly this is the most popular scripture in Far Eastern Budd-
hism. The passage can, however, be interpreted in the light of
the Emptiness doctrine as meaning that there is no distinction
between transmigration and *nirvāṇa*, and neither in fact
exists: the Buddha is therefore eternal.

The Gilgit *stūpa* excavated in 1931 contained three frag-
mentary paper manuscripts of the *Lotus Sūtra*. These are the
earliest specimens of paper from South Asia proper, probably
of local manufacture. The list of the forty-two donors of this
manuscript on the colophon page, a happy survival, indicates
a mixture of Indian and Iranian names, some of the latter
being Khotanese. JPL

Illustrated on page 62

71. The Lotus of the Good Law

From a *stūpa* at Khadalik(?), Xinjiang province, China. 7th century AD
Pothī manuscript of *Saddharmapuṇḍarīkasūtra* in Sanskrit. Up-
right Gupta script. Ink on paper. 500 folios approx. 18 × 56.5 cm.
OMPB Or. 9613

This magnificent manuscript of the *Lotus Sūtra* is now split up
among various institutions, the major part in Leningrad. Its
find-spot is unknown, but was probably a *stūpa* in the
neighbourhood of Khotan such as Khadalik, which had excep-
tionally rich manuscript deposits. Its native finders sold most
of it to the Russian consul in Kashgar, but other folios were
also taken to British and German consular officials. The calli-
graphy is extremely fine, the severity of the manuscript being
relieved only by large circles at chapter endings sometimes
the full height of the text. On the incomplete colophon page
the circle becomes a *dharmacakra*. The details of the colophon
indicate that the commissioner (whose name is lost) and her
family were of Indian origin but used the local language
Khotanese. Towards the end of the manuscript considerable
fire damage is apparent.

The text of the Central Asian manuscripts of the *Lotus Sūtra*
apparently represents an earlier state of the text than that of
the Nepalese and Gilgit manuscripts. It was the version trans-
lated into Chinese by Dharmarakṣa in AD 286. Meanwhile in
India the text seems to have been re-edited, some of the
peculiarly Buddhist Sanskrit 'improved' to bring it into har-
mony with classical Sanskrit. This is the version known from
the Nepalese and Gilgit manuscripts, and was used by
Kumārajīva for his classic Chinese translation completed in
AD 406. JPL

72. The Lotus of the Good Law

China, from Dunhuang, Gansu province. 9th–10th century
Manuscript in booklet form of *Saddharmapuṇḍarīkasūtra* in
Chinese. 25th section. Ink on paper, with coloured illustrations.
18 × 10 cm. OMPB Or. 8210/S. 6983

The *Lotus Sūtra* outnumbers all others brought back from
Dunhuang by Stein. The most popular section was the twenty-
fifth which describes how a person in distress, threatened by
fire, thieves or drowning, can be saved by calling upon the
Bodhisattva Avalokiteśvara, whose name is translated into
Chinese as 'The one who hears the cries of the world'. This
booklet illustrates the earliest stage of what was to become an
immensely popular form of book production, particularly
with the enormous development of printing in the early Ming
(1368–1644), where each page contains both text and illus-
tration. FW

Illustrated on page 62

73. The Lotus of the Good Law

Western Japan. *c.*1240–80
Block-printed paper roll of *Saddharmapuṇḍarīkasūtra* in Chinese.
Vol. 7 (sections 20–4). 27.5 cm × 9.9 m. OMPB Or. 64. b. 35

From its introduction, probably in the 6th century, the *Lotus
Sūtra* in Chinese became as popular in Japan as in China. The
earliest Japanese manuscript extant is a copy of a Chinese
commentary on the *Lotus Sūtra* of 614–15 by Prince Shōtoku
Taishi. The first printed edition of known date was issued in
1225. This handsome copy of the seventh roll, block-printed
in jet-black ink, was formerly in the Jissōji temple in Ueno
province to which, according to a handwritten colophon, it
was presented by the monk Shinshū in the early 16th century.
It is printed in a bold regular style of script characteristic of
the mid-Kamakura period (1185–1333) and is ornamented
throughout, on the borders with random gold and silver foil,
and sprinkled with gold dust. KBG

74

74. The Teaching of Vimalakīrti

From Dunhuang, Gansu province, China. 8th–9th century AD (?)
Scroll of part of Vimalakīrtinirdeśasūtra in Soghdian, written on the
reverse of a Chinese *sutra*. Ink on paper. 27 cm × 2.93 m.
OMPB Or. 8212/159 (Ch.00352)

The teaching of Vimalakīrti is another exposition of the
Emptiness doctrine. It takes the form of a conversation be-
tween the layman Vimalakīrti, pretending to be ill, and the
Bodhisattva Mañjuśrī, sent by the Buddha to enquire after his
health. At first the *sutra* is a witty account of earlier conver-
sations between Vimalakīrti and the disciples and Bodhisattvas
attendant on the Buddha, all of whom have been worsted in
earlier discussions through Vimalakīrti's exposition of 'empty'
conversation – nothing can be taken for granted because
nothing is capable of ultimate confirmation – and hence
refuse to go to Vimalakīrti's bedside. After exchanges of this
sort with Mañjuśrī, Vimalakīrti finally explains the way of
the Bodhisattva in terms of the Emptiness doctrine (how the
Bodhisattva lives in the world but apart from it, etc.) JPL

75. Collected commentaries on the Sūtra of Vimalakīrti's Teaching

China, from Dunhuang, Gansu province. AD 674
Scroll of commentaries on *Vimalakīrtinirdeśasūtra* in Chinese. Ink on
paper. 27 cm × 6 m. OMPB Or. 8210/S. 1412

This *sutra* has long been popular in China, the character of
Vimalakīrti explaining its success, for he was a brilliant
conversationalist and lived in comfort though a disciplined
follower of the Buddha. For the Chinese who believed it
essential for family members to look after each other and care
for their ancestral spirits, monasticism was the antithesis of
family life and worship. This *sutra*, with its emphasis on the
layman, suited the Chinese view. The commentaries on the
sutra were written by Kumārajīva and his disciples Seng Zhao
(374–414), who was converted to Buddhism by this *sutra*, and
Dao Sheng (c.360–434), who spent much time on the beautiful
holy mountain of Lu Shan, and Seng Rui. FW

75

65

76

76. Sūtra of Golden Light

Found near Khotan, Xinjiang province, China. 7th–8th century AD
Pothī manuscript of *Suvarṇaprabhāsasūtra* in Khotanese. Upright
Gupta script. 11 folios. 10 × 37.5 cm. OMPB Or. 9609

The *Suvarṇaprabhāsa* continues the ideas on Emptiness of
the *Prajñāpāramitā* and on the eternality of the Buddha from
the *Lotus Sūtra*, but introduces many Hindu gods and god-
desses, all anxious to advance Buddhism. The idea of the
mantra, the charm for warding off evil and magically gaining
one's desires, is advanced, as is material reward for the
promulgation of this particular *sūtra*. Such ideas were to
develop into the Vajrayāna.

 The manuscript contains roundels with coloured and un-
coloured *dharmacakras*, intermediary perhaps between the
uncoloured *dharmacakra* of no. 46 and the roundels enclosing
pictures of the Buddha (nos 57 and 61). JPL

77. Sūtra of Golden Light

China, from Dunhuang, Gansu province. Late 8th century AD
Scroll of *Suvarṇaprabhāsasūtra* in Chinese. Ink on paper.
27 cm × 6 m. OMPB Or. 8210/S. 1963

The protective idea of the *mantra*, advanced in the *sūtra*, is
given further significance in the colophon which reads: 'The
Buddhist disciple Lu, on behalf of her deceased ancestors of
seven previous incarnations and her kinsfolk and because
she herself has fallen into the hands of the foreign barbarians

77

滅有无品不瑣大慧白佛言世尊若一切法
不生者則攝受法不可得一切法不生故著名
字中有法者唯願為說佛告大慧善哉善哉
諦聽諦聽善思念之吾當為汝分別解說
大慧白佛言唯然受敬佛告大慧我說如來
非无性亦非不生不生者一切外道聲聞緣覺七
敌不生不滅亦非无義大慧我說意生法身
如來名彼不生不生者一切外道聲聞緣覺七
大慧辟如因陀羅釋迦不蘭陀羅如是等
諸物一一各有多名亦非多名而有多性亦
非无自性如是大慧我於娑呵世界有
三阿僧祇百千名愚夫悉聞各說我名而
不解我如來異名大慧或有眾生知我如來
者有知一切智者有知佛者有知救世者有
知自覺者有知導師者有知廣導者有
一切尊者有知仙人者有知梵者有知毗
者有知自在者有知勝者有知迦毗羅
有知真實邊者有知月者有知主者
者有知无主者有知无滅者有知空者有知
如如者有知諦者有知實際者有知法性者
有知涅槃者有知常者有知平等者有知
不二者有知无相者有知解脫者有知道者
有知毫主者大慧如是等三阿僧祇百千名
号不增不減此及餘世界皆悉知我隨二邊故
月不出不入彼菩愚夫不能知我墮二邊故
然悉恭敬供養於我而不善解知解句義

79

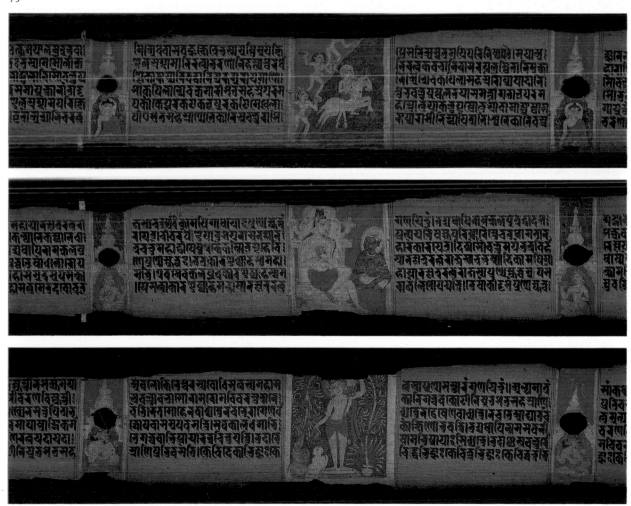

81

或刹光明體　光明輪安住　金色摘擲青　光明雲常照
或刹光無量　一切寶為地　金剛蓮遍覆　離垢淨莊嚴
隨其自業起　眾生界難議　隨種之相已　或受樂受苦
二毛孔中　不思議憶刹　無量形充滿　種之葉而起
彼佛刹土中　唯見人天趣　劫德果成就　常受諸快樂
諸富生趣中　受無量種身　隨宿行業故　初德果成就
閻羅王界中　平正住莊嚴　清淨業力起　微妙善安隱
或有七寶刹　飢渴苦常逼　延上大火山　長受無量苦
或有刹世界　飆湯苦銅國　諸山石穢惡　長受雜光明
或有鐵圍剎　眾生骨苦惱　長真雜光明　一切海能照
或有杰銅國　諸山石穢惡　眾生業出起　長受無量苦
或有刹土刹　煩惱大恐怖　樂少憂當多　薄福之所廬
見無量佛剎　延土不清淨　離明常闇冥　延眾生而住
或有佛刹起　延土不清淨　諸佛而持故　國清淨離垢
於二之念中　火災不可議　京現不清淨　石刹常整固
一切國土中　無量佛剎起　諸佛而持故　國清淨離垢
或依風輪住　或復依水輪　或成或有取　眾生行業故
或叔清淨光　離垢眾寶體　種之妙莊嚴　諸佛令清淨
清淨不清淨　無量諸佛刹　葉海司錄起　菩薩之而化
清淨不清淨　佛剎不思議　眾生怖坐起　菩薩之而持
或有佛刹地　垢穢不平正　眾生煩惱故　起如是佛剎
波蓮花綱中　佛刹網依住　種之妙莊嚴　眾生而依廬
元量真珠號　延覆諸佛剎　色現各不同　離垢莊嚴現

[Tibetans], has reverently caused one roll of the *sutra* to be copied, praying that the two countries [China and Tibet] may live in amity, that hostilities may cease and that all homeless people may speedily reach their native villages.' FW

78. Garland Sūtra

China, from Dunhuang, Gansu province. AD 522

Scroll of *Buddhāvataṃsakasūtra* in Chinese. Ink on paper. 27 cm × 4 m. OMPB Or. 8210/S. 2724

The *Garland Sūtra*, one of the Mahāyāna idealist *sūtras*, appears to have been composed in the 3rd century AD. There are three Chinese translations; this is the first, made by Buddhabhadra in AD 418–20. These *sūtras* are concerned with the Bodhisattva's quest for truth and establishing a view of the world in which all principles are related. A totalistic system is envisaged with everything leading to the centre, the Buddha. The Hua yan, or Garland school, flourished in China from the early 8th to the late 9th centuries and is supposed to have been popular with the ruthless Empress Wu, as it provided a religious sanction for her totalitarian schemes. FW

79. Crossing to the island of Lanka

China, from Dunhuang, Gansu province. *c*.7th century AD

Scroll of *Laṅkāvatārasūtra* in Chinese. Ink on paper. 30 cm × 12.9 m. OMPB Or. 8210/S. 5311

The *sutra* was translated by Guṇabhadra in 443 but is particularly associated in China with one of the later schools, the Chan (Japanese Zen), traditionally founded by Bodhidharma who sat in front of a wall for nine years in the early 6th century. The *Laṅkāvatārasūtra* is named after its setting in Sri Lanka, and its subject is the Doctrine of Inner Enlightenment, accepting Consciousness as the only existent principle. Transcendence of mental discriminations is made possible by the presence in everyone of the embryo of the future Buddha. A Chan, or Zen, aspect is that communication of ideas is not necessarily verbal. FW

80. The Doctrine of stages of the Yogācāra school

Japan, Kōfukuji Temple, Nara. *c*.1213

Block-printed Japanese edition of *Yogācārabhūmiśāstra* (*Yuga shiji ron*) in Chinese. 77th of 100 *maki*. Ink on white mulberry paper. 1 roll. 25.5 cm × 9.7 m. OMPB Or. 64.b.4

The doctrines of the idealist *sūtras* were analysed and systematised by Asaṅga (*c*.AD 290–360), particularly in his *Madhyāntavibhāgaśāstra* (Discrimination between the Middle

80

and the Extremes). He regarded the *Madhyamaka* denial of existence as an extreme rather than a middle position, the latter being one in which existence is credited only to the imaginer of the non-existent, i.e. Consciousness (*Vijñāna*) is the only existent. In his lengthy dissertation *Yogācārabhūmiśāstra* he applies this position to the doctrine of the Ten Stages on the way of the Bodhisattva.

This fundamental work of the Yogācāra school was translated into Chinese by Xuan Zang and became one of the leading scriptures of the Japanese Hossō sect. Though undated, this *maki* belongs on stylistic grounds to the celebrated edition of Kenryaku 3 (1213) by the monk Kōei, a leading figure in Kōfukuji printing. This 100-*maki* edition constitutes the largest printing undertaken in Japan up to that time, apart from the Empress Shōtoku's *dhāraṇī* (no. 391). The printed postface records that donations were received from 'the rich and poor of Nara' to finance the printing, the earliest acknowledged example of a practice that was to become common.

YYB, JPL

81. The Collection of Avalokiteśvara's Qualities

Eastern India. *c.*1100

3 folios from a *pothi* manuscript of *Kāraṇḍavyūhasūtra* in Sanskrit. Transitional *Siddhamātṛkā* script. Ink and gouache on palm leaves. 53 folios, 5 × 35 cm (max.). OMPB Or. 13940, ff. 17a, 21a, 32a

The *Kāraṇḍavyūha* is a comparatively late *sutra* (6th–9th centuries) for the glorification of the Bodhisattva Avalokiteśvara, firstly as succouring all humanity (rescuing beings from hell and other unpleasant situations), but also in its latest passages, as one whose glory exceeds that of the Buddhas: in him is contained the entire universe. This is a phase of the Mahāyāna where the Bodhisattvas are akin to the great gods of Hinduism (Avalokiteśvara has many qualities in common with Śiva), and where the Buddha is overshadowed by the glory of his creations.

This manuscript is unique amongst 11th- and 12th-century Indian Buddhist manuscripts in containing miniatures illustrating the text: Avalokiteśvara as the magic horse Vālāha escaping from the *rākṣasīs* (cannibalistic demonesses) of Sri Lanka with the merchants' sons; or with the Bodhisattva Sarvanivaraṇaviṣkambhin, whose questions form the mainstay of the text; and exuding water from all his pores to relieve those in hell.

JPL

Illustrated on page 67

The Vajrayāna

82. Stamp with text of an incantation

Kashmir. 7th–8th century AD

Steatite rectangular stamp with handle and petal decoration on upper surface. 13 lines of Gupta script in reverse. 4.9 × 6.3 cm. OA 1880–168

Slightly later than the development of the *stotra* in Buddhism came the *dhāraṇī*, a (usually) brief text in *sūtra* form embodying a *mantra*, a charm, of frequently unintelligible syllables whose repetition protects from ill or ensures advantage. This stamp bears a *dhāraṇī* in Sanskrit, engraved in reverse for impressing on clay, couched as a litany to Śākyamuni (the golden-eyed, the perfectly enlightened, the refuge of all the Tathāgatas, etc.). It ends: whoever constructs a *caitya* after having written this *dhāraṇī* and thrown it inside, will gain the merit of having constructed 100,000 *caityas*. JPL

83. Incantations to the Five Great Protectresses

Eastern India. *c*.1057

Pothī manuscript of *Pañcarakṣā* in Sanskrit. Commissioned by Queen Uḍḍākā. *Siddhamātṛkā* script. Ink and gouache on palm leaves. 70 folios. 5 × 56 cm. Cambridge University Library (Add.1688)

The *Pañcarakṣā* is a collection of five *dhāraṇīs* addressed to goddesses for protection against evil spirits (Sāhasrapramardinī), sin and all obstacles (Pratisarā), snakes (Māyūrī), wild animals and insects (Sītavatī), and diseases (Mantrānusāriṇī). When these five hymns became a collection is not certain, but since the Chinese Canon possesses no complete translation, the date may be assumed to be between the 8th and 10th centuries, when the earliest Indian manuscripts are found. At least two are much earlier: the *Mahāmāyūrīdhāraṇī* was translated into Chinese by Kumārajīva *c*.AD 400; and the *Mahāpratisarādhāraṇī* was translated by Amoghavajra *c*.AD 746–71.

This is the earliest illustrated manuscript of the text with a unique series of thirty-six miniatures. Here Māyūrī, the Peacock Goddess who protects against snakes, is accompanied by two Mortal Buddhas, Maitreya, Vajrapāṇi and Tārā. JPL

Illustrated on page 117

84. Incantations and other esoteric sūtras

From Dunhuang, Gansu province, China. AD 943

Scroll of *dhāraṇīs* and *sūtras* in Sanskrit and Khotanese. Upright Gupta script. Ink on paper, headpiece of gouache on cloth. 29 cm × 21.5 m. IOLR Ch. c.001

The six texts in this scroll form a ritual collection of esoteric *sūtras*. At the beginning is a rectangle of cloth painted with two geese standing on lotuses holding stems of lotus buds in their mouths. The effect resembles the later Islamic *'unvān*, or headpiece opening a text, and like the latter doubtless derives from late classical and Byzantine headpieces. There are four colophons, giving a date equivalent to AD 943. JPL

82 (reproduced in reverse)

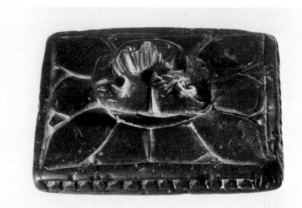

82

84

87

85

85. Incantations

From Dunhuang, Gansu province, China. 9th–10th century AD
Pothi manuscript of *dhāraṇis* in Khotanese. Upright Gupta script.
Ink on paper. 7 folios (3 with drawings in margin recto and verso).
5.5 × 27.5 cm. IOLR Ch. 00276

Here the left margin has been broadened and used for drawings
of the Buddha, two to a side. This arrangement resembles
more the Chinese style of book illustration, separating painting
and text as in no. 72, than other Central Asian illustrated
manuscripts (nos 61, 66), so that it may be considered as
outside the Central Asian tradition of manuscript illumination.

JPL

86. Incantation

From Toyuk, Xinjiang province, China. 10th–11th century AD
Block-printed sheet in 4 sections, each containing an identical Uyghur
dharaṇi with glosses in Sanskrit in Gupta script. Ink on paper. Each
leaf 26 × 11 cm. OMPB Or. 12551A (Toyuk 040)

Block-printing allowed the rapid dissemination of a charm
among an enormous number of people (see no. 391). This
charm in Uyghur contains an interlinear Sanskrit translation,
to be read at 90 degrees to the Uyghur. JPL

87. The Tantra of the Secret Assembly

Tibet. 17th century
Title-page of a manuscript of *Guhyasamājatantra* in Tibetan. Gold
ink on black paper. 407 folios. 25 × 66 cm. OMPB Or. 6724, vol. 67

This text, known as the Secret King of the Tantras, is held to
contain the essence of the esoteric teachings on ultimate
reality or Vajradhara and provides, through the three medi-
tation stages, techniques for utilising evil as well as good to

86

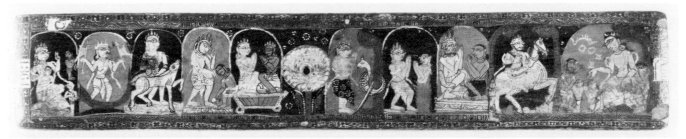

88

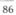

89

90

negate the ego and attain unity with the Buddha; even obstacles thus become a means of progress. The page exhibited has two seals inscribed with stylised Sanskrit characters (*lantsha*): that on the left denotes wisdom, that on the right compassion, the two great complementary virtues of Mahāyāna Buddhism. LC

88. The Tantra of Kālacakra

India, Bihar. 1446

Pothī manuscript of *Kālacakratantra* in Sanskrit. Maithili/Bengali script. Ink on palm leaves, gouache on wooden covers. 128 folios. 6 × 33.5 cm. Cambridge University Library (Add.1364)

The *Kālacakratantra* appears to be the last major *tantra*, probably as late as the 11th century. The meditating adept, who already needs to visualise the whole universe within himself in order to identify with Buddha, now must include Time (*Kāla*) also. The aim is union with Buddha as Kālacakra, the Wheel of Time.

This manuscript was commissioned by the pious Buddhist Śrījñāna Śrīka in Magadha in Saṃvat 1503 (1446) and written by the Kāyastha Śrījayarāmadatta, evidently a Hindu, of Keraki. The outer sides of the covers are illustrated with *jātakas* and the inner with the Eight Great Events and the Seven Mortal Buddhas with three Bodhisattvas. Though descended from Pāla illumination, the style shows the linear treatment and bodily distortions common to all medieval Indian schools. That a Buddhist text was commissioned in India two and a half centuries after the destruction of the monastic libraries shows that the extinction of Buddhism in its homeland after the Turkish conquest was not so rapid as is usually supposed. JPL

89. The Way of Purity

Sri Lanka. Early 19th century

Pothī manuscript of *Visuddhimagga* of Buddhaghosa in Pali. 236 folios. Sinhalese script. Palm leaves, text incised, carved ivory covers. 7 × 54 cm. OMPB Add.11658

In addition to his commentaries (*atthakathā*) on the Pali Canon Buddhaghosa wrote this summation of early Buddhist philosophy and the *Abhidhamma* which became highly popular with the Theravāda. A masterly epitome of the Buddha's doctrine, it is thought to have been a test-piece of Buddhaghosa's knowledge when he arrived at the Mahāvihāra in Anurādhapura asking to be allowed to use the traditional commentaries in Old Sinhalese for his projected commentary on the entire Canon. JPL

90. Light on the True Meaning

Sri Lanka. 14th century

Incomplete *pothī* manuscript of *Saratthadīpanī* of Sāriputta in Pali. Sinhalese script. Palm leaves, incised and inked text, wooden covers painted in gouache. 241 folios. 6 × 60 cm. OMPB Or. 6676

Buddhaghosa's commentary *Samantapāsādikā* on the *Vinayapiṭaka* was commented on by Sāriputta, a monk in the Jetavana *vihāra* in Sri Lanka, in the 12th century. The Theravāda in Sri Lanka had by the 4th century split into three. Its headquarters was the great Mahāvihāra outside the old capital at Anurādhapura, founded by Mahinda, the son of Aśoka, in 256 BC. A split developed in 38 BC, when King Vaṭṭagāmaṇi founded the Abhayagiri *vihāra* which was much more open than the Mahāvihāra to the ideas of the Mahāsaṃgha and other Indian schools. In the 4th century another sect, the Sāgaliyas, was founded at a time when the ideas of the Vaitāliyas, the 'magicians' (i.e. the Mahāyānists or Illusionists) were gaining ground in Sri Lanka.

The three branches of the Theravāda were finally reconciled in the reign of Parākramabāhu I (1153–86), who convoked a

91

92

93

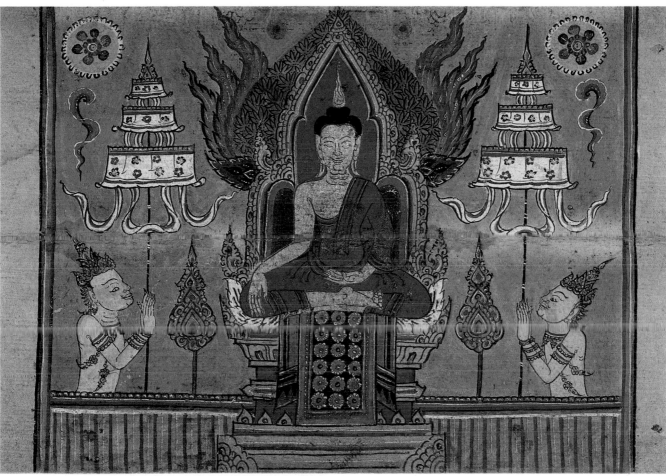

94

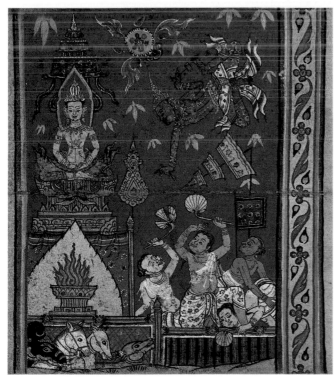

94

great council of reconciliation under Mahākassapa. One outcome was the decision to write a new set of sub commentaries (*ṭīkā*) on the commentaries (*aṭṭhakathā*) of Buddhaghosa, with which all could agree, and Sāriputta, as one of the leading monks of the Jetavana *vihāra*, was given the task of compiling *ṭīkās* on the *Vinaya* and on sections of the *Sutta-piṭaka*.

The covers of this (for Sri Lanka) exceptionally old manuscript are painted with lively scenes of dancers and musicians on the outside (now much faded) and lovely creeper designs on the inside. JPL

91. The Maunggun gold plates

Burma. 5th century AD
2 gold plates, each inscribed on one side only with 3 lines of Pali in early Pyu script. Plate A 3 × 25 cm; plate B 3.5 × 33.5 cm.
OMPB Or. 5340 A & B

These plates are the earliest Buddhist texts discovered in Burma and among the earliest proofs of Buddhism in Burma. They were found sealed in a brick in the field of one Maung Kan (hence Maunggun), near Hmawza in Prome District in 1896. Twenty similar gold plates were excavated near Hmawza in 1926, and fragments of stone inscriptions in Pali were also

discovered. Hmawza was the site of Śrī Kṣetra, one of the capitals of the ancient Pyu kingdom (5th–9th centuries). The script on the gold plates and on the stone inscriptions varies slightly but is closely allied to the 5th-century Kadamba script of south India. Each plate begins with the well-known Pali credal formula *Ye dhammā.* . . . Leaf A continues with nineteen categories from the *Abhidhamma* in numerical order; leaf B continues with the praise of the *Triratna.* PMH

92. Texts for protection from evil

Burma, Arakan. 1748

Pothī manuscript of *Paritta* in Pali and Burmese. Black ink on yellow paper. 47 folios. 10 × 33cm. OMPB Add. 12258/B

The *Paritta*, a collection of texts from the *Suttapiṭaka*, are learnt and recited on special occasions to ward off misfortune, danger or illness in Burma and Sri Lanka. Various recensions exist. In Burma the most common has eleven sections of which the best known is the *Maṅgalasutta*. Monks are frequently called upon to recite the *Paritta*. This practice is ancient – a list of the possible texts occurs in the *Milinda-pañha* (1st century AD?), and the Buddha himself allowed his monks to use the *Khandaparitta* as a protection for the Order.

This manuscript, Indian, not Burmese in format, comes from Arakan, which borders Chittagong (in Bangladesh) and was an independent kingdom until conquered by the Burmese in 1784. The script has certain Arakanese characteristics distinguishing it slightly from ordinary Burmese script and uses different numerals. It is dated Sakkarāj 1110 (1748). Examples of such manuscripts from this period are extremely rare. PMH

Illustrated on page 74

93. Fifty birth tales

Thailand. *c.*1830–50

Manuscript of *Paññāsajātaka* in Pali. Cambodian script. Palm leaf, with inked text, title leaves bearing gilt and lacquer roundels of pavilions and ceremonial parasols, gilt wooden covers with vegetal designs. 256 folios. 6 × 58cm. OMPB Or. 12524

The text comprises fifty *jātakas* additional to the 547 of the Pali Canon, compiled about 500 years ago, probably in northern Thailand, and includes tales from various sources. A characteristic story is the *Sudhanajātaka*, in which Prince Sudhana (the Buddha-to-be) marries the *kinnarī* (bird maiden) Manoharā. When she is forced to flee to her homeland on the slopes of Mount Kailāsa, the prince undertakes the dangerous quest to regain her. It is one of the most widespread tales in Buddhist literature, with versions dating to the early centuries of the Christian era. This copy of the *Paññāsajātaka* is from central Thailand and contains nine sections of the work. HG

Illustrated on page 74

94. Merit of the Great Buddha

Thailand. Late 18th century

Paper manuscript in 53 folds of *Mahābuddhaguṇa* in Pali. Cambodian script with 14 illustrated pages. 9 × 60cm. OMPB Or. 14068

The text is a compilation of brief extracts from the Canon relating to the Buddha's life, but the illustrations are of the last ten *jātakas*, together with forest scenes such as generally accompany Thai manuscripts of the last tale, the *Vessantara-jātaka*. The last illustration is the Buddha seated with attendants. These are painted in the finest Thai style with delicate detail and vivid colours.

One of the pairs of illustrations shows Prince Candakumāra, the Buddha-to-be, whose father has fallen under the influence of an evil Brahmin. The priest orders a human sacrifice, including the noble prince of whom he is jealous (shown seated calmly awaiting his fate above the pyre). But the god Indra suddenly appears, destroying the royal umbrella that sanctified the sacrifice. Another pair of scenes is from the story of Nārada who is the Buddha-to-be. He descends from heaven where he resides as the god Brahmā, to aid princess Rujā (shown within a curtained palace enclosure), in redeeming her heretical father from evil habits. HG

95. Buddhist text on silk

Found at a *stūpa* at Bash-Koyumal, Xinjiang province, China. 6th century AD

Folio from a *pothī* manuscript in Sanskrit. Indian Gupta script. Ink on a chalk ground on silk. 13 × 30.5cm.
OMPB Or. 8212/1594 (B. Koy.i.016–1020)

In Central Asia Indian tradition was adapted to suit new languages and manuscript materials. Paper, used in China since the 1st century AD, was widespread in Central Asia probably by the 3rd century. Silk also was an ancient Chinese writing material. This single folio is the only known example of a Sanskrit silk manuscript cut to *pothī* shape. It was covered with a chalk ground and the script written with a pen. This does not suit the material (which the Chinese wrote on direct with a soft brush) as much of the chalk has lifted off taking the writing with it. The scribe, writing in Indian Gupta script, was perhaps unfamiliar with the usual method. The folio was found below a niche, once apparently containing a statue, surrounding the base of a brick *stūpa* inside the fort at Bash-Koyumal. JPL

95

96. List of sūtras translated into Chinese by AD 254

China, from Dunhuang, Gansu province. 6th century AD
Manuscript in Chinese. Ink on paper. 26 × 50cm.
OMPB Or. 8210/S.2872

Thirty-six works, mostly shorter Mahāyāna texts, were supposed to have been translated by Zhi Qian between AD 220 and 252. These included a version of the *Dharmapada* and one of the *Vimalakīrtinirdeśasūtra*, both of which survive. Though his family had lived in China for some generations, Zhi Qian was of Central Asian origin. He worked closely with an Indian master Vighna, particularly on their new version of the *Dharmapada*, in which the preface, usually attributed to Zhi Qian, raises the question of how Buddhist texts should be translated. The alternatives were faithful, literal and perhaps inelegant, the style advocated by Vighna, or a more polished version attractive to the literate Chinese public, which was Zhi Qian's method and the one favoured in the better-known translations of Xuan Zang. FW

96

97. Eulogy of Fo Tu Deng

China, from Dunhuang, Gansu province. 10th century
Manuscript in Chinese. Ink on paper roll, with part of a calendar on the reverse. 27cm × 1.5m. OMPB Or. 8210/S.276

This fragmentary text, entitled 'In praise of the *lohan* and monk Fo Tu Deng', records episodes in the life of the monk who was, like so many early Buddhist translators and teachers in China, of Central Asian origin. He arrived in north China early in the 4th century to set up a religious centre, but warfare prevented him from doing so. His magical achievements included producing a lotus from a bowl of water and drawing water from dry wells with a toothpick, but more in keeping with the Doctrine he tried to persuade rulers to eschew violence in war and government. His success as a missionary was such than 893 monasteries and temples were said to have been built at his instigation, two entire tribes of 'barbarians' were converted, and 10,000 disciples instructed by him. FW

98. Life of Kumārajīva

China, from Dunhuang, Gansu province. 9th century AD
Scroll in Chinese. Ink on paper. 27cm × 1.37m. OMPB Or. 8210/S. 381

Kumārajīva and Xuan Zang are the most famous early translators and teachers in Chinese Buddhism. Kumārajīva (AD 344–c.413) was born in Kucha of a Brahmin father and a Kuchean princess. His fame was such that rulers in different parts of China competed to possess him at court and he was held a virtual prisoner by a general in Kucha for seventeen years. He was a stylish and innovative translator who tried to produce an elegant version faithful to the text. He believed that no translation could capture the flavour of the original and is supposed to have said that reading *sūtras* in translation was like eating rice that someone else had already chewed.

FW

97

98

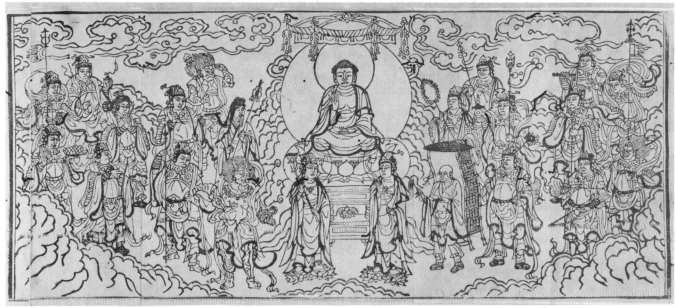

99

100

99. Frontispiece illustration to the Perfection of Wisdom

Japan, Kōfukuji Temple, Nara. 1383 or earlier

Japanese woodblock edition of *Mahāprajñāpāramitāsūtra* (*Dai hannya haramitta-kyō*) in Chinese. 1 folding vol. Ink on a mixture of *gampi* and mulberry paper. 29 × 9.6 cm. OMPB Or. 64.b.16

From the Nara period this huge *sūtra* was thought to possess the power of protecting Japan from natural and human disasters. Copying and, later, printing it were piously encouraged by the state and priesthood. Each *maki* of this edition, bearing a handwritten date of Eitoku 3 (1383), has a large frontispiece depicting Xuan Zang meeting the Buddha to receive the *Tripiṭaka*. Seated on a lotus throne, the Buddha is surrounded by deities whom he commands to protect Xuan Zang on his return from India to China. This illustration was copied from a Song Chinese exemplar, but the silver borders, together with the graceful ornamentation in gold and silver of the wrap-around covers are strikingly Japanese. YYB

100. Syllabary of Khotanese Gupta script

China, from Dunhuang, Gansu province. 8th–10th century

Scroll of alphabet and syllabaries of cursive Gupta on reverse of Chinese scroll. Ink on paper. 26.5 cm × 3.2 m. IOLR Ch. lviii.007

The 'cursive' Gupta of Central Asia was a hand developed in the Khotan region from the upright form for secular use. In the walled-up library at Dunhuang several rolls like this were found with syllabaries of the cursive script. Though far from Khotan, the phonology of the syllabaries indicates that they were written by Khotanese scribes. Such syllabaries are described in Xuan Zang and other sources as *xi tan zhang*, i.e. *siddham* sections. The work begins with the Sanskrit alphabet, and the syllabary proper consists of each consonant in combination with the twelve vowels, followed by a variable number of sections of ligatures (consonant clusters), each

with the twelve vowels. Each section (*zhang*) in this scroll begins with the word *siddham* (perfect, or auspicious) which is the name by which the Indian Gupta script became known in China and Japan.

JPL

101. Incantation to the Blue-throated Avalokiteśvara

From Dunhuang, Gansu province, China. AD 650–750
Scroll of *Nīlakaṇṭhadhāraṇī* in Sanskrit. Alternate lines of late Gupta (*Siddham*) and Soghdian scripts. Ink on paper.
14.5cm × 1.29m. OMPB Or. 8212/175 (Ch. 0029)

A *dhāraṇī* in honour of Avalokiteśvara as *Nīlakaṇṭha*, blue-throated, a sobriquet borrowed from the Hindu god Śiva. The Gupta script has been influenced by later developments (post-Gupta) in India itself; the Soghdian is not a translation but a transliteration of the Sanskrit sounds into the Soghdian alphabet, which is derived from Estrangela Syriac, brought to Central Asia by the Nestorian Christians. Since Soghdian is written in vertical columns, the scribe, who wrote both scripts but allowed his native Soghdian to influence his spelling of Sanskrit, had to turn the scroll through a quarter-circle at the beginning of each Soghdian line.

101

102

105

106

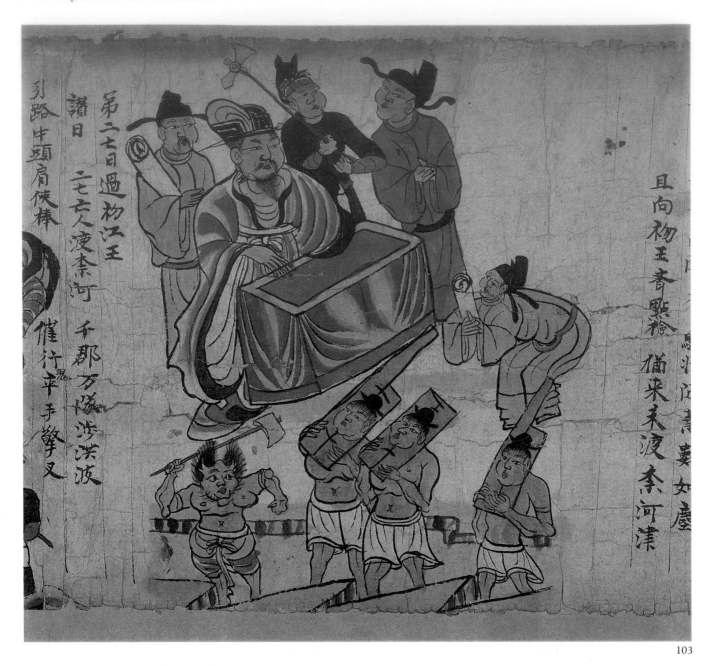

引路牛頭肩俠棒
催行鬼手擎叉

第二七日過初江王
讚曰
二七亡人渡秦河
千郡万隊涉洪波

且向初王香點撿
猶采柔渡秦河漢

103

Soghdian colonies existed in Xinjiang during the Tang dynasty, and the paper used in the Soghdian manuscripts resembles that of the Chinese manuscripts found at Dunhuang of the Tang period. Some Soghdian translations also seem to be taken from the Chinese. The evidence therefore suggests that the Dunhuang Soghdian manuscripts (see also no.74) were local products rather than from far away Soghdiana (western Turkestan between Oxus and Jaxartes). JPL

102. The Heart of the Perfection of Wisdom

China, from Dunhuang, Gansu province. 8th–9th century AD
Folding book containing *Prajñāpāramitāhṛdayasūtra* in Sanskrit. Alternate columns of late Gupta (*Siddham*) and Chinese scripts. Ink on paper. 18 folds, each of 5 columns. 26 × 99cm.
OMPB Or. 8212/195 (Ch.00330)

Unlike the preceding manuscript, where the Soghdian transliteration is forced to accommodate the Sanskrit version, this folding book accommodates both Chinese and Sanskrit scripts perfectly. The *Siddham* script is written in vertical columns with a brush, lending the script some of the idiosyncrasy of Chinese calligraphy, while the Chinese characters representing the Sanskrit sounds occupy the adjacent column. The

script continued to be used in China and Japan for Sanskrit, both in manuscript and block-printed forms. One of its most famous masters was the Japanese monk Jiun Sonja (d. 1803).

JPL

Illustrated on page 80

103. Sūtra of the Ten Kings

China, from Dunhuang, Gansu province. 10th century
Scroll of *Fo shuo shi wang jing* in Chinese with illustrations. Ink and wash on paper. 27 cm × 5.5 m approx. OMPB Or. 8210/S. 3961

The apocryphal *sūtra* of the Ten Kings of Hell appears to have been composed during the 10th century but probably reflects earlier ideas. It describes the ten stages through which the soul must pass after death. Of the Ten Kings who preside over the stages four are Buddhist (including Yama and the Wheel-turner of the Five *Gati*), one is borrowed from traditional Chinese belief, and the rest are unidentifiable. The paintings in the manuscript depict the tortures of sinners. The Kings and attendants are dressed as officials with black ear-flapped hats; the imagery is a mixture of traditional Chinese and Buddhist iconography.

FW

104. Sūtra of filial piety

Korea. 18th century
Taebo pumo ŭnjung-gyŏng in Korean. Woodblock print on brown paper. 29 × 17 cm. OMPB Or. 74.b.3

The earliest known version of this *sūtra* was found at Dunhuang, and the text probably originated in China between the 4th and 6th centuries AD. Though Buddhist, it incorporates the Confucian ethic of repaying one's parents' kindness and devotion through acts of self-abasement. The illustrations are rough and popular; the pages shown describe the pain of childbirth and emphasize the hardships borne by mothers to bring children into the world.

EMCK

105. Invocations

Korea. 1800
Woodblock-printed book of *dhāraṇīs* with manuscript additions. Ink on paper. 36 × 23 cm. OMPB 15313.f.1

Dhāraṇīs in the Far East are Sanskrit sounds used to invoke Buddhas and Bodhisattvas. These magical formulae are here transcribed in Sanskrit, Chinese characters and Korean *han'gŭl*. The pages displayed are explanations, with phonetic gloss, of Sanskrit letters found in the *dhāraṇīs*. At the end of the book is a list of the names of those who contributed towards its publication.

EMCK

Illustrated on page 81

104

106. Commentary on a basic Risshū text

Japan, Saidaiji monastery, near Nara. *c.*1250–60
Commentary on *Bonmōkyō* (*Brahmajālasūtra*) in Chinese. 27 cm × 11 m. OMPB Or. 64.b.5

The *Brahmajālasūtra*, translated into Chinese by Kumārajīva in AD 406, is a basic scripture of the Risshū sect (which maintained the strict discipline of the original *Vinaya* and the importance of ordination). However, the original Hīnayāna text has now been changed to include the way of the Bodhisattva. It was widely studied and many Chinese and Japanese commentaries were compiled. A block-printed edition of the *Bonmōkyō*, produced in 1220, was the earliest work to have been printed at the Hōryūji monastery in Nara.

The commentary exhibited (*Bonmōkyō koshakki*) was written by a Korean monk Tae-hyŏn in the 8th century. It is in roll form, comprising the second of two volumes and, although undated, was probably printed in the mid-13th century. Judging by the script, it may be the oldest surviving Japanese copy of this work, and it bears clear signs of having been printed at the Saidaiji monastery, a stronghold of traditional *Vinaya*.

KBG

Illustrated on page 81

107

107. Essentials for achieving rebirth in Paradise

Japan, probably Kyoto. c.1255 or earlier

Block-printed edition of *Ōjō yōshū* in Chinese. Originally 6 fascicules, rebound in 3 vols. Ink on *hishi* paper. 25 × 25 cm. OMPB Or. 64.b.7

This is one of the major native works of Japanese Jōdo (Pure Land) Buddhism, written by Genshin (942–1017). The Jōdo doctrine was transmitted to Japan in the 7th century, but between the 12th and 13th centuries it split into many schools. Genshin laid the theological foundation for the Japanese Nembutsu sect which advocated salvation through invoking the name of Amitābha. This copy belongs to the rare *Kentōbon* recension, which was intended for dispatch to China for study, so it was more carefully edited than the edition made for circulation in Japan. YYB

108. The Tendai view of the highest Enlightenment

Japan, Mt Hiei, near Kyoto. 1280–2

Block-printed edition of *Mo he zhi guan* (*Maka shikan*) in Chinese. 6 *maki* (of 10) bound in *detchō* style. Ink on paper composed of mixed mulberry and *gampi* fibres. 26 × 15 cm. OMPB Or. 64.b.9

This essential scripture of the Tendai (Chinese Tiantai) sect was expounded by the Chinese founder Zhiyi (531–91) and recorded by his disciple Guanding (561–632). The Tendai sect, based on the *Lotus Sūtra*, teaches that everyone can become a Buddha. The sect was introduced into Japan by Saichō (767–822) who was sent by the Emperor to China in 804, to search for the best form of Buddhism. Eventually, the humble monastery where he had lived in solitude grew into a huge complex of 3,000 temples.

This is a fine and very rare example of an *Eizan-ban* (Hieizan imprint), reproducing faithfully the handwriting of the copyists all of whom were calligraphers of note. YYB

忍不成今措若到妄心空見如橋地海惣集
我身心終不動若空見聞雜措縱一專精念
念泯入又空見搖動不能妄一至誠懺悔息
二攀緣一切種智不用者无明未破措觀空
見法性現前對火進剪不證不休如是對治
助開涅槃淤識位次不盤上地內外風塵不
能破壞順道法愛不生故无頃隨心心寂滅

108

109. Commentary on a 'Consciousness-only' text

Japan, Nara. c.1170–80

Commentary on *Jōyuishiki-ron (Vidyāmātrāsiddhiśāstra)* of Dharma-pāla in Chinese. Vol.3. Block-printed paper roll. 26 cm × 25 m. OMPB Or. 74.cc.15

The 'Consciousness-only' sect of Far Eastern Buddhism (*Fa xiang zong* Chinese, *Hossō-shū* Japanese) is based on the idealist positions of Vasubandhu (brother of, and commentator on Asaṅga) and Dharmapāla, among others. The *Vidyāmātrāsiddhiśāstra*, a basic scripture of this sect, was translated into Chinese by Xuan Zang in the 7th century. It deals with the eight distinct types of consciousness possessed by all sentient beings. These doctrines were transmitted from China to Japan during the 7th and 8th centuries.

A fundamental scripture of the Hossō sect in Japan, the *Jōyuishiki-ron* was first printed at the Kōfukuji monastery of that sect in Nara. The edition printed there in 1088 is the earliest authenticated example of Nara printing. This commentary (*Jōyuishiki-ron jukki*) was written by the Chinese monk Kuiji in the 7th century. The copy on display was printed in Nara, almost certainly at the Kōfukuji, towards the end of the Heian period (794–1185). KBG

110. Sacred spell of the Golden Peacock Goddess

Japan, Tōji temple, Kyoto. 1224

Japanese edition of *Buddhamātṛkā mahāmāyūrī vidyārājñī sūtra (Butsumo dai kujaku myōō-kyō)* in Chinese. 3 block-printed rolls. OMPB Or. 74. cc. 14

This *sūtra*, esteemed by the Shingon (True-word, or Tantric) sect, was translated into Chinese by Amoghavajra (746–74). It advocates chanting the 'golden peacock' *mantra* to ward off

109

110

evil. This edition is the oldest known work printed at Tōji, the temple which was granted to Kūkai by the emperor and which subsequently became the chief seminary of the Shingon sect. This rare copy was previously preserved in the temple. Shown here is the colophon giving the date of printing (1224), the names of the sponsor (*ganshu*), copyist and woodblock-cutter. YYB

111. The vow of the Bodhisattva Jizō (Kṣitigarbha)

Japan, Kōfukuji temple, Nara. 1306

Japanese edition of *Kṣitigarbhapraṇidhāna sūtra (Jizō bosatsu hongankyō)* in Chinese. 3 block-printed folding volumes. Ink on a mixture of *gampi* and mulberry paper. 25.3 × 10 cm. OMPB Or. 64. b. 13

This work, translated by Śikṣānanda (652–710) from Sanskrit into Chinese, concerns the original vow of the Bodhisattva Jizō to act as a saviour of all living beings until the coming of Maitreya. Like Kannon, Jizō is regarded by the Japanese as a Buddhist saviour *par excellence*. He is the guardian saint of children, pregnant women and travellers. A fine example of the *Kasuga-ban* editions printed at the Kōfukuji, this is also one of the very few works of popular Buddhism among them, in which the textual matter is predominantly that of the philosophical Hossō sect. YYB

112. Nirvāṇa of Padmasambhava

Tibet. 19th century

Guru Padma-'byung-gnas-kyi rnam-thar in Tibetan. Block-printed on paper. 396 folios. 9.5 × 52 cm. OMPB 19999. a. 6

The title-page of this life of Padmasambhava is flanked by miniatures surrounded by rainbows and a fire nimbus. On the left is Amitābha, from whom Padmasambhava emanates, holding a begging bowl; on the right Padmasambhava, the Indian Tantric evangelist in Tibet of the 8th century, wearing a hat with the sun and crescent moon motif surmounted by a feather. His right hand holds a *vajra* and his left a skull-cup; his left arm supports a ritual trident (*khaṭvāṅga*). The miniatures on the second page, with a background of snowy mountains, rivers and trees indicating Tibet, show (left) Avalokiteśvara and Ye-shes 'tsho-rgyal (right), Padmasambhava's chief consort holding a ritual knife and vase. LC

112

111

113. Śālistamba's Sūtra

Tibet, from Endere, Xinjiang province, China. Early 8th century AD
Fragments of a *pothī* manuscript of *Śālistambasūtra* in Tibetan. Ink on paper. 6.5 × 46.5 cm. OMPB Or. 8212/168

This *sūtra* is a Mahāyāna restatement of Dependent Origination (*Pratītyasamutpāda*, see Introduction), on the analogy of the rice plant from the seed to the grain. The fragments of fifteen folios of the *Śālistambasūtra* were found before images round the Buddhist temple at Endere, deposited to propitiate the divinities. They must date from the Tibetan occupation of this part of Xinjiang and before the temple was abandoned in the mid-8th century. The manuscript was almost certainly written not in Xinjiang but in Tibet, as it uses daphne fibres. Daphne species grow in the high Himalaya and the Tibetan plateau and were early used by Nepalese and Tibetans for paper manufacture. These and other Tibetan fragments found at Endere represent the earliest known Tibetan manuscripts, scarcely a century after the introduction of the script.　JPL

Illustrated on page 89

114. The Hundred Thousand Precepts

Tibet, 16th–17th century
Ma-ṇi-bka'-'bum in Tibetan. Block-printed on paper. 377 folios. 9 × 53.5 cm. OMPB 19999. d. 93

A text on the six-syllable *mantra, Oṃ maṇi-padme huṃ,* the most important in Tantric Buddhism and used to invoke Avalokiteśvara. Two miniatures show (left) the eleven-headed Avalokiteśvara and (right) King Srong-brtsan sgam-po, holding a jewel. This 7th-century king introduced Buddhism into Tibet. He is regarded as an emanation of Avalokiteśvara, and his two wives, a Chinese and Nepalese princess, as emanations of the White and Green Tārās, feminine personifications of compassion.　LC

Illustrated on page 89

115

116

113

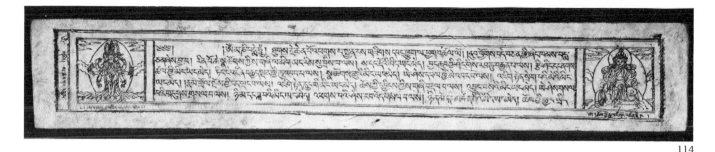

114

115. Collected Works of Five Sa-skya-pa Lamas

Tibet. 18th–19th century

Manuscript of *rJe-btsun Sa-skya-pa sku-phreng gong-ma lnga'i gsung 'bum dkar-chhag* in Tibetan. Red and black ink on paper. 63 folios. 9.5 × 55.5 cm. OMPB Or. 11375

This text contains the history and doctrine of the Sa-skya-pa school of Tibetan Buddhism as set out in the works of five of its hereditary Head Lamas and was produced as a gift for the Mongol emperor, Kublai Khan (1260–94). A Sa-skya-pa Head Lama submitted Tibet in 1244 to Mongol suzerainty and was appointed Regent. This manuscript, notable for its fine calligraphy, is arranged in three scripts: first in *lan-tsha* (decorative Sanskrit characters) in black ink, followed by a phonetic transliteration into Tibetan characters in red, and finally a translation into Tibetan in cursive script in black. At the top of some pages (including that exhibited) the contents are described in cursive Tibetan. LC

116. Essentials of the cultivation of teaching and alms-giving

China, Guangzhou. 1737

Illustrated woodblock edition of *Xiu she yu jie ji yao shi shi tan yi* in Chinese. 28 × 18 cm. OMPB 15101.c.24

In a popular, illustrated work the protective and beneficial effects of certain *dhāraṇīs* are explained and illustrated. They are combined with different *mudrās*, positions of the hands. The combination of magical pictures, mysterious gestures and incomprehensible foreign sounds is characteristic of late popular religion in China, whose ideal was to be 'Confucian in office, Taoist in retirement and Buddhist as death approached', for its rituals and the funerals in particular promised consolation. The endless chanting of the Sanskrit *dhāraṇīs* and the low mumbling tones of the priests gave rise to a Chinese phrase in which purring is described as 'a cat reading the *sūtras*'. FW

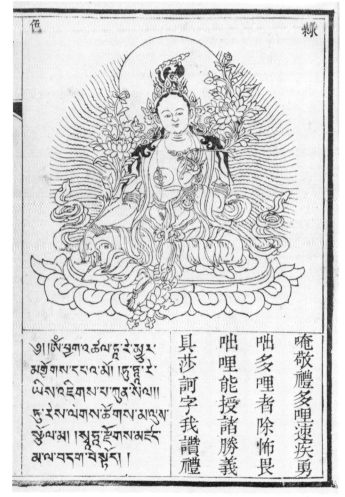

117

89

118

117. Collection of Lamaist texts translated into Chinese

China. 1825

Illustrated woodblock edition of *Yao shi qi fo gong yang yi gui* and other texts. 29 × 15 cm. OMPB 15101.g.8

These Tibetan canonical texts, concerned with medicine and the Buddha of Healing (Bhaiṣajyaguru), were translated and entered the Chinese Canon during the Qing dynasty, when interest in Lamaist Buddhism was strongest. This was particularly so under the Qian Long emperor (r. 1736–96) who built the Lama temple in Beijing, housing hundreds of monks, and constructed mock Potala palaces in his summer retreat. In this late illustrated work Tibetan deities are depicted with prayers in both Tibetan and Chinese. The illustration shows the Green Tārā. FW

118. The Perfection of Wisdom

Tibet, Lhasa(?). 18th century

Manuscript of *Prajñāpāramitāsūtra* in Tibetan. Gold on blue paper with two carved and gilt pinewood covers, title-page in wood with Mongolian inscription and two paintings in Mongolian style. 23 × 64 cm. Victoria and Albert Museum (IM 316–1920)

The 'title-page' exhibited exemplifies the connections between Lamaist Mongolia and Tibet and the trading relations of both with China; while the manuscript is Tibetan, the title-page is Mongolian. The Mongolian inscription states that the text is in Tibetan, translated from the Sanskrit, and the two small paintings of deities are in the Mongolian style. The brocade binding the edges of the block and the yellow silk damask cover are Chinese, linking the two Lamaist extremities of the Qing empire. FW

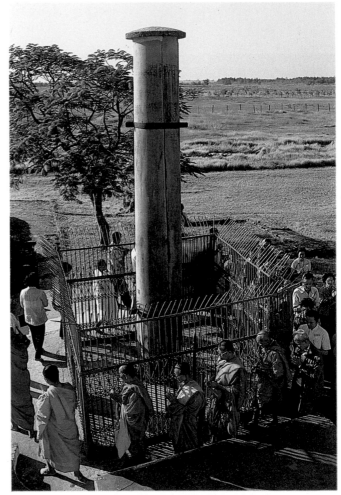

Thai monks visiting the pillar set up by the Buddhist king Aśoka in 248 BC to mark the Buddha's birthplace at Lumbinī (Rummindei), Nepal. (Photo Graham Harrison)

4 The Buddha image

Buddhist images in human form appeared much later than the beginnings of Buddhism and the worship of *stūpas*. When legends of the Buddha's life were illustrated on early *stūpas* and their railings, the Buddha was originally shown only by symbols. His presence was indicated, if at all, by footprints, while a standing woman, his mother, represented his birth, a tree the Enlightenment, a wheel the Doctrine and the First Sermon, and the *stūpa* his death. The lack of human cult images until the last centuries BC was common to the classical Indian religions.

The Buddha image poses problems of date and origin. The earliest images are in the Mathurā tradition of central India and the western influenced Gandharan style of Pakistan and eastern Afghanistan. It was once widely supposed that when Gandhara, the Peshawar Valley, was ruled by Greeks from Alexander the Great's colony in Bactria (northern Afghanistan), Greek influence inspired the Buddhists of Gandhara during the second and first centuries BC to create the first Buddha image, but this proposition was contested and a compromise view is that the Buddha image evolved in both centres independently and more or less simultaneously in response to a growing devotionalism in Indian religion.

The Gandharan images showed the Buddha standing or seated, his robes in the Graeco-Roman tradition of drapery in more or less realistic folds. The hair was usually in wavy lines and the Buddha's cranial bump (*uṣṇīṣa*) a bun. Comparisons were proposed with such Western models as the Graeco-Roman Apollo and the early imperial statue.

The standing Mathurā Buddha copied the thick-set popular nature spirit (*yakṣa*) but wore monastic robes leaving the right shoulder bare. The seated image resembled that of Jain religious teachers (Jinas or Tīrthaṃkaras) and may have been imitated from them. Its posture is that of the seated *yogin* with crossed legs and hands laid in the lap, though sometimes, as more commonly with standing figures, the right hand is raised. The robes worn over the left shoulder and arm cover part of the chest and most of the lower part of the body. On the head a twisted coil of hair or bun corresponds to the later cranial bump.

Recently the discussion of priority was reopened by the examination of Gandharan seated Buddhas which appear early and closely resemble Mathurā Buddhas, particularly those thought the earliest. Since early Mathurā Buddhas have been found in Gandhara while Gandharan influence on Mathurā appears late, it was concluded that the first Buddha images were in the Indian Mathurā style, while the Gandharan Buddha grew out of that prototype by incorporating the local Graeco-Roman stylistic features. This development is dated to the last century BC and the first century AD.

By the time of the Kuṣāṇa ruler Kaniṣka I (*c.* AD 100) a coin of that monarch bearing a standing figure captioned 'Buddha' shows a developed type which looks Gandharan. Standing Buddhas, in stone, at eastern sites, inscribed and dated in regnal years of Kaniṣka, are Mathurā images, or copies, modelled on the nature spirit. A Buddha image in both traditions thus already existed in the time of Kaniṣka, whose date, though given here as AD 100, remains disputed. Earlier images can be assumed, but their chronology is uncertain.

After these beginnings Buddha images converged iconographically while developing regional characteristics. On the Gandharan type a naturalistic hairstyle persisted, whereas Mathurā began to represent the Buddha with curls turning to the right and this manner eventually prevailed. The cranial bump, or *uṣṇīṣa*, became generalised and thought of as a bony protuberance indicating wisdom, though its origins may lie in a bun or hair arrangement suitable for wearing a turban or the ascetic's top-knot. A hairy spiral between the eyebrows (*ūrṇā*) becomes common, usually as a raised circle, palms and soles are marked by wheels, and on the hands the fingers are often joined as though webbed. These are among the thirty-two major and eighty minor marks of a Buddha or Universal Monarch. The earlobes are long as if from the weight of pendants worn by the princely Bodhisattva or Universal Monarch, and the halo makes an early appearance. The robes are usually two garments rather than the prescribed three of the monk: a lower held up by a belt, particularly visible on the early standing images, and an overgarment worn either in what has been called the open mode, leaving the right shoulder bare, or covering both shoulders and reaching almost to the ankles where the lower garment protrudes. Differences of dress depend on whether the image is standing or seated, or have sectarian reasons.

Gestures became stereotyped: the hands in the lap of the seated image indicated meditation; the right hand touching the ground, palm turned inwards, referred to the challenge of Māra, when the Buddha called the earth to witness; a raised

right hand with the palm usually turned outwards was the offer of reassurance to the faithful; while the right hand held down towards the ground, palm turned outwards, indicated generosity or the granting of a boon. When the hands were brought together in front of the chest, the left below the right, the gesture was that of preaching. This basic repertory was later expanded. The left hand, holding an end of the robe to keep it in place, is not symbolic.

The Gandharan style produced between the first and sixth centuries AD a vast number of images and narrative reliefs in stone and later in stucco, using moulds to multiply images in the interests of increasing merit. Changes in belief also led to a great number of princely Bodhisattva images whose identification with specific Mahāyāna Bodhisattvas is not often possible; only the future Buddha Maitreya is always recognisable. Buddhas in a Bodhisattva's head-dress occasionally appear: these become the different 'parent' or Dhyāni Buddhas from whom deities emanate. This sculpture was for *stūpas* and monasteries which abounded in Gandhara, though only ruins remain. The monasteries are of the standard Indian ground-plan: rectangular enclosures with cells along the inner walls, a veranda fronting them and a central quadrangle.

At Mathurā under the Kuṣāṇas the native Indian style produced images of a sturdy outward-looking type. Here too Bodhisattvas were carved. Mathurā under the Gupta dynasty (AD 320–550) produced Buddhas and Bodhisattvas of a classical perfection which still reflected the robust qualities of the Kuṣāṇa period. A related school at Sārnāth, near Benares, created a spiritual introspective Buddha image with a subtly smooth modelling and suppression of garment lines making the robes translucent and clinging. It became one of the most influential models within India and beyond. WZ

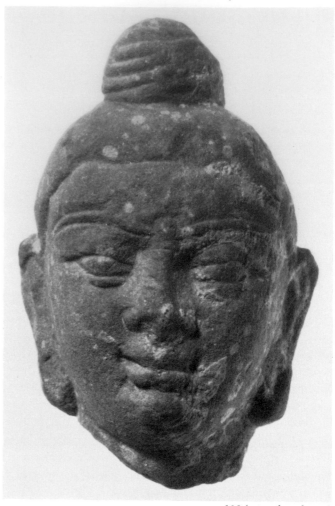

119 (reproduced × 2)

119. Buddha

Mathurā, from Mānikyāla. 1st–2nd century AD
Sandstone. Height 6.5 cm. Given by Sir Alexander Cunningham.
OA 1892. 11–3. 88

This small head is typical of the Mathurā style of central India with its oval shape and hint of a full-fleshed face. The later cranial bump (*uṣṇīṣa*) is here of the *kaparda* (snail-shell) type, a bun or coil of hair peculiar to early Mathurā Buddha images and representing the hair left after the Bodhisattva had cut off his turban and long hair with his sword on becoming an ascetic. Found on the eastern edge of the Gandharan region, this head is another example of the many exported Mathurā Buddhas which were also probably the source of the Gandharan Buddha image. WZ

120. Buddha

Mathurā. 2nd century AD
Sandstone. Height 14 cm. Given by Sir Alexander Cunningham.
OA 1887. 7–17. 54

Seated in meditation, left hand over right in his lap, in a variety of the early Indian gateway (*toraṇa*), the Buddha is entirely wrapped in his robes, their folds indicated by summary incisions. The later cranial bump (*uṣṇīṣa*) is an almost indistinguishable bun under hair also shown incised. This treatment is influenced by Gandhara, but the halo with its scalloped decoration is purely Mathurā. WZ

Illustrated on page 94

121. Coin

Gandhara, from Ahin Posh *stūpa*, Afghanistan. *c*.AD 100
Gold. Diameter 2 cm. C & M India Office Collection no.289

Gold coin of the Kuṣāṇa King Kaniṣka I showing on its reverse an image of the Buddha identified by an inscription in Bactrian reading *Boddo*. The symbol beside the Buddha is Kaniṣka I's personal mark. The Buddha is shown in a

sculptural style, wearing monastic robes and making the gesture of reassurance.

This is the earliest relatively datable image of the Buddha in the Gandharan style. Certain of its features support the attribution of the famous Kaniṣka reliquary (cf.no.8) to the reign of Kaniṣka I; it also places the Buddha images on the Bimarān casket in an early Kuṣāṇa context. When compared with the Mathurā-style Buddhist sculptures from central India, dated to Kaniṣka I's reign, this Gandharan-style image creates a clear picture of the relative development of these two schools.

The use of this coin design by Kaniṣka I testifies to his involvement with Buddhism and supports legends in later Buddhist literature of his erection of monuments and assembling the Third Buddhist Council in Kashmir. JC

Illustrated on page 95

122. Coin

Gandhara. *c.*AD 100

Bronze. Diameter 2.5 cm. Given by Sir Alexander Cunningham. C & M Or 0323

Bronze coin of the Kuṣāṇa King Kaniṣka I showing on the reverse an image of the future Buddha Maitreya, identified by a Bactrian inscription *Mētrago Boudo*. He is shown seated on a low stool, wearing the clothes and jewellery of a prince or nobleman. With one hand he is making the gesture of reassurance, the other holds a water bottle.

This recently discovered coin design shows perhaps the earliest known identifiable image of Maitreya. It gives a fresh insight into the development of Buddhist theology and worship during the early Kuṣāṇa period. Its composition also provides a relatively datable point of comparison for the development of Gandharan images of Maitreya. JC

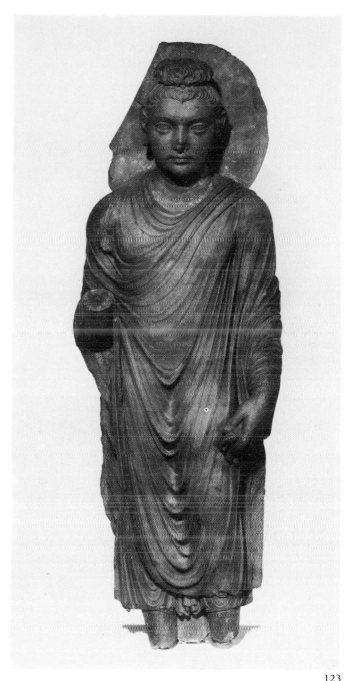

123

123. Buddha

Gandhara, from Takht-i-Bāhī. 2nd century AD

Schist. Height 1.04 m. OA 1899.7–15.1

The angle of the right forearm and rough projection at the armpit where a strut supported the lost hand show that this Buddha was in the gesture of reassurance, offering protection to the worshipper. The left hand holds an end of cloth from the robe, and the lower undergarment can be seen above the lost feet. There is a noticeable moustache on the upper lip, and the broken halo has traces of an ancient repair. In type this Buddha is reminiscent of that on the Kaniṣka coin (no.121). WZ

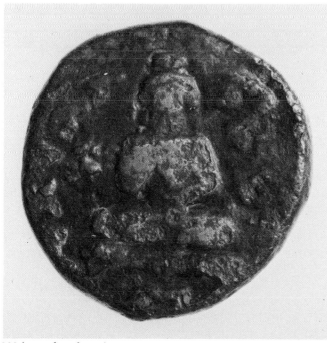

122 (reproduced × 3)

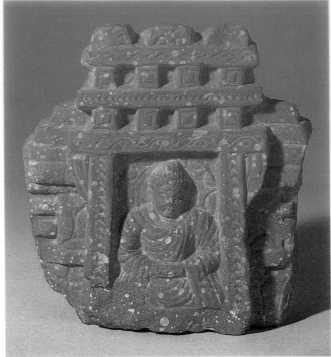

120

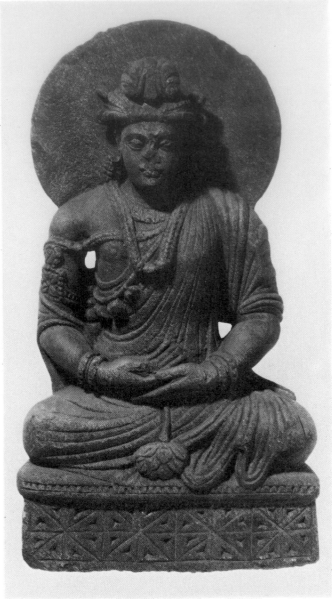

124

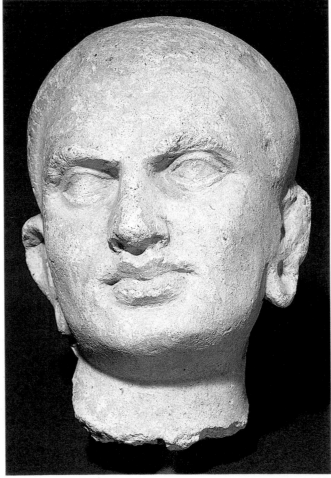

127

124. Padmapāṇi

Gandhara. 2nd–3rd century AD
Schist. Height 32cm. OA 1886. 3–19.1

Haloed and with turban and ornaments, this princely figure has the usual appearance of what are considered the earliest images of Bodhisattvas as saviour deities. Few can be securely identified with named Mahāyāna Bodhisattvas. The lotus hanging from the lap, however, makes it probable that this is Padmapāṇi ('lotus in hand'), who merged with the compassionate Avalokiteśvara. WZ

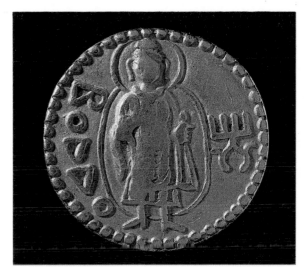

121 (reproduced × 3)

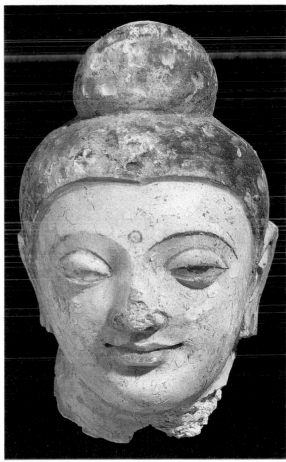

126

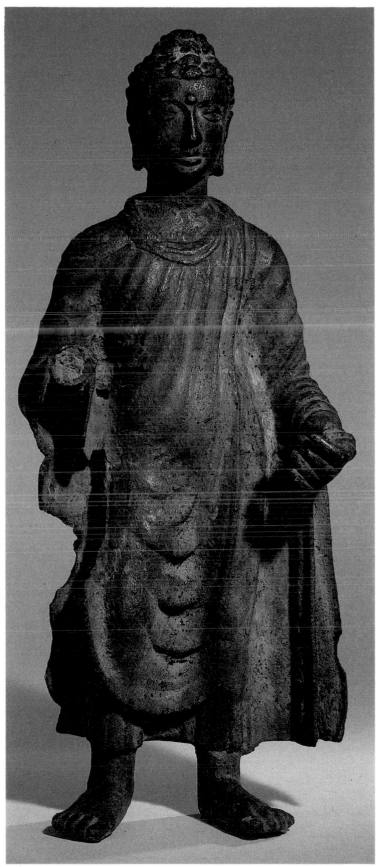

128

95

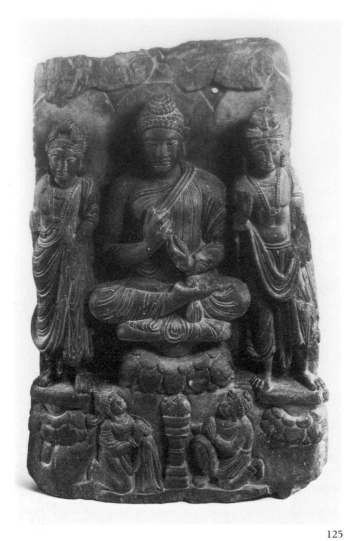

125

125. Buddha and Bodhisattvas

Gandhara, from Jamālgarhī. 4th–5th century AD

Schist. Height 41 cm. Given by Sir Alexander Cunningham
OA 1887.7–17.48

This slab with its worshippers in foreign dress beside a fire altar may be an icon of developing Buddhism. The central Buddha, flanked by Bodhisattvas and preaching, can be seen as expounding fresh doctrine as in many Mahāyāna *sūtras*. The Bodhisattvas are, on the left, Maitreya, since his distinguishing flask is almost preserved and, on the right, perhaps Avalokiteśvara, though he lacks the Buddha figure in the head-dress occasionally seen in Gandharan sculptures also in this context. This is an early example of the triads of Buddhas flanked by Bodhisattvas that became common later. WZ

126. Buddha

Gandhara. 4th–5th century AD

Painted stucco. Height 18 cm. Given by the Trustees of Brigade Surgeon Henry Atkins. OA 1962.4–21.1

Of the vast numbers of surviving Gandharan stucco heads many still show traces of their colouring. On this head the hair, eyebrows and irises are black; a bright orange-red is used on the lips and to outline other features. Fewer bodies survive, since on them the more durable stucco was thinly spread over clay. WZ

Illustrated on page 95

127. Monk

Gandhara, said to be from Haḍḍa, Afghanistan.
4th–5th century AD

Stucco. Height 12.7 cm. Bought from the Brooke Sewell Bequest.
OA 1978. 3–6. 1

This head of a monk, with its expressive, almost individual features, full lips and shaven hair, is astoundingly Roman but no more than many examples from the prolific stucco production of the Kabul valley in Afghanistan in the later Gandharan period. Like many such heads it would have been part of a larger composition, most probably narrative, in which the monk, with other figures, was standing or sitting turned towards the Buddha as he preached or performed some action from his legendary life-cycle. WZ

Illustrated on page 94

128. Buddha

Gandhara. 4th–5th century AD

Bronze. Height 41 cm. Given by P.T. Brooke Sewell, Esq.
OA 1958.7–14.1

Presumably once making the gesture of reassurance, this rare example of a Gandharan bronze has a face of great individuality with its youthful open-eyed expression recalling the vivid later stucco sculptures. The ridged garment continues the Western realism in the Gandharan treatment of drapery but also contributes, with the large feet and hands, to a certain heaviness. If the dimensions were sufficient proof, this bronze might be one found by Cunningham at Mānikyāla. WZ

Illustrated on page 95

129. Buddha

Gandhara, from Sahrī Bahlol. 5th century AD or later
Bronze. Height 31 cm. OA 1981.6–10.1

This very different example from the few surviving Gandharan bronzes belongs to a group from a single findspot and perhaps atelier. The ridged drapery is very conventional, and the face recalls not only the later Gandharan stucco sculpture but, even farther afield, Gupta-period Buddhas from central India such as that from Mankuwar dated to AD 448–9 (or 429). The backplate, common to the whole group, has a radiating ornament which appears early in Gandhara, but its closest resemblance is with painting dated to the 7th century.

WZ

Illustrated on page 99

130. Buddha preaching

From Danesar Khera, Central India. 5th century AD
Bronze. Height 35.5 cm. Bought from the Brooke Sewell Bequest.
OA 1969 7–25 1

The rarity of early Indian metal sculpture makes attributions and dating uncertain. Here, however, there is an inscription: the queen of Harirāja of the Gupta family dedicates the merit gained by commissioning this bronze for the attainment of supreme knowledge (i.e. Buddha rank) by her parents and all living beings. Numismatic evidence for Harirāja, perhaps a member of a cadet branch of provincial governors but otherwise unknown, places him in the 5th century.

Centres of Gupta metal-casting may have existed in eastern India, and the resemblance between this bronze and the Sārnāth-inspired Mon sculpture of Thailand (cf. no. 248) is instructive. The findspot yielded a stylistically mixed group of bronzes, one of which, lithographed in Smith and Hoey (1895), remains untraced.

WZ

Illustrated on page 98

131. Buddha preaching

Eastern India, perhaps Sārnāth. 5th century AD
Sandstone. Height 1.18 m. OA 1880–7

The Buddha sits enthroned, instead of in the more usual cross-legged position, and holds his hands in the preaching gesture, associated with the proclamation of doctrine. He is the teacher whether as a wandering monk, as in the earlier tradition, or as in the later, a divine figure preaching advanced doctrines at celestial gatherings. The half-closed eyes are those of withdrawn meditation, but the hands are active to bring his message to the world. The monastic garments typical of the Sārnāth school cling with simplicity to the body; the decorated throne anticipates the crowned and ornamented image which became increasingly common as a symbol of the transcendent Buddha.

WZ

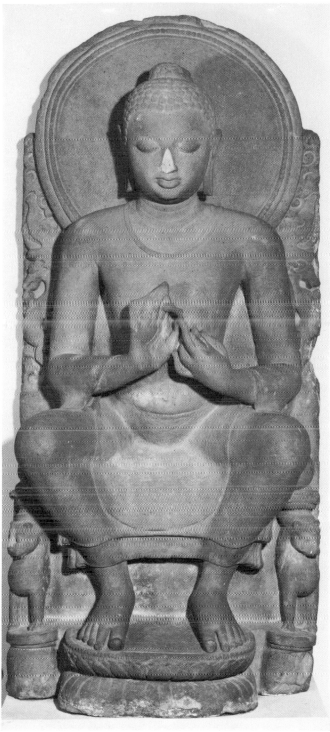

131

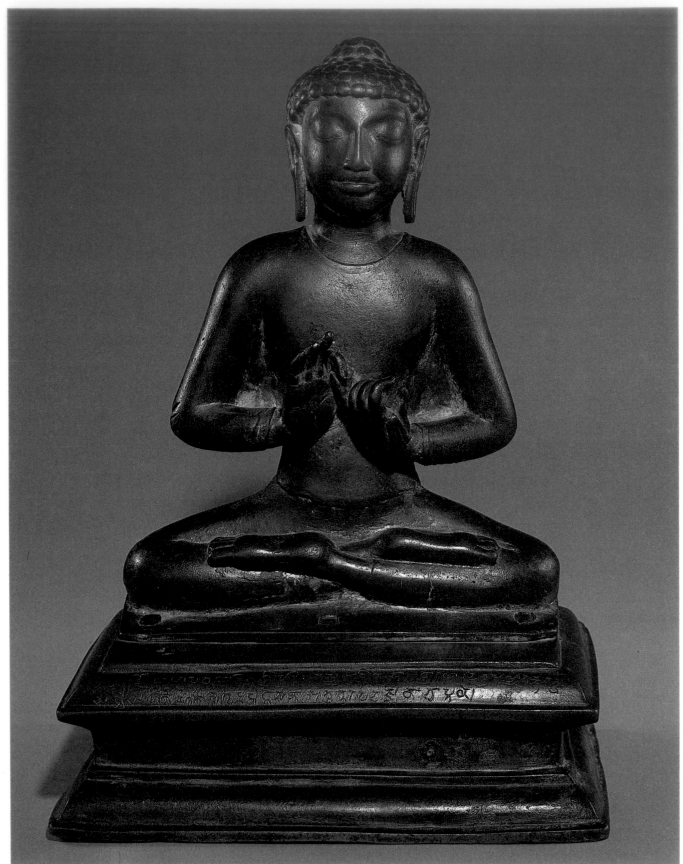

130

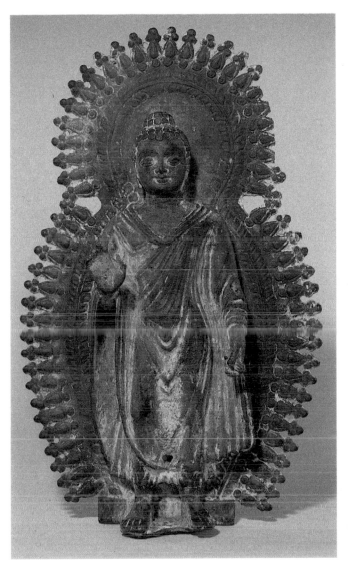

129

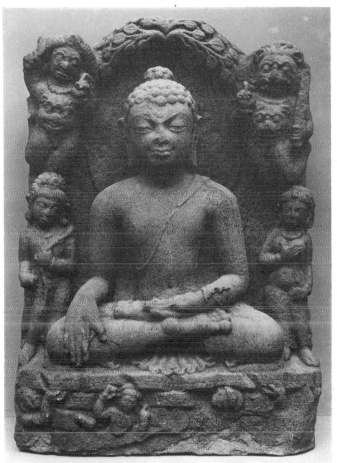

132

132. Assault of Māra

Eastern India, perhaps Sārnāth. 6th–7th century AD
Sandstone. Height 51 cm. OA 1880–11

Unlike the sometimes fantastic Gandharan narrative scenes where the Buddha is assaulted by the rejected Māra's army of monsters, this Sārnāth representation is more an icon with dominant central cult figure. Instead of the heavy-lidded Sārnāth introspection there is here an apt, if serene, awareness of triumph as monsters hover over the Buddha while Māra and a daughter stand beside him. The apparently rocky ground beneath may show not only the discomfited followers of Māra tumbling when the earth shook at the Buddha's summons but also the earth goddess emerging to bear witness. wz

5 Afghanistan, Pakistan and Kashmir

The huge output in the Buddhist Gandharan style (first to sixth centuries AD) is believed to have ended with the devastations by the Central Asian Hephthalites or White Huns in the early sixth century. Three related and influential styles succeeded it in Swat, Kashmir and Afghanistan. Bronze sculpture and rock-carving are associated with the Swat Valley, the ancient Uḍḍiyāna; ruined monasteries, clay and stone sculpture, and particularly bronzes, survive from Kashmir, while in Afghanistan clay replaced stucco and wall-painting is found. Buddhism spread into what is now Soviet Central Asia through Afghanistan following the trade routes and lasted there until the Muslim conquests (seventh to eighth centuries AD); in Chinese Central Asia it had a longer life.

The most abundant Afghan remains are the late Gandharan stucco sculptures of vivid and often extremely Western appearance, but stone sculpture can also be followed up to the Oxus. By the seventh century huge Buddha images express the advanced deification of the Buddha. These Buddhas at Bāmiyān are 53 and 36m high and carved in cliff faces honeycombed with monastic caves. Here and at other Buddhist sites are wall-paintings in Indo-Iranian styles executed between the fifth and seventh centuries. Although Hinduism was now strong, Buddhist art persisted until the eighth or ninth centuries: at Tapa Sardār near Ghazni a huge clay dying Buddha occurs near a Hindu goddess. At Fondukistan between Bāmiyān and Kābul in about the seventh century a graceful mannered and Indian style in sculpture and painting characterised not only Bodhisattvas but also a famous ornamented clay Buddha, indicative of new tendencies witnessed also by impressed clay seals with the Buddhist creed and miniature *stūpas*, as in India. In the ninth century this region passed to the Muslims.

In Pakistan Buddhism persisted in the Swat Valley in post-Gandharan stone and metal sculpture. Some images belong to Vajrayāna Buddhism but they are still too few to confirm that Swat was the Uḍḍiyāna of Tantric tradition, a stronghold of esoterism and magical practice. By the eleventh century it also was ruled by Muslims.

Buddhist tradition makes Kashmir, evangelised as early as Aśoka's time, a major centre of scholarship in the Gandharan period, when the Fourth Council was held under Kaniṣka, and important sectarian developments took place. Buddhist scholarship continued into the fourteenth century.

The Buddhist art of Kashmir from the seventh century is documented especially in bronzes. Terracotta sculpture prolonged stucco conventions; that of Akhnur and Ushkur, though still close to Gandhara, was influenced, like Afghanistan and Soviet Central Asia, by Indian Gupta art. The Kārkoṭa dynasty (AD 622) brought a golden age for both Hindu and Buddhist art, especially under the conqueror Lalitāditya Muktāpīḍa (725–61). His Central Asian minister, Caṅkuṇa, a Buddhist, was also an active patron, and *stūpas*, monasteries and colossal metal images are reported. The style was a distinctive blend of Gandharan and Gupta elements. It influenced Central Asia, to which objects were carried, and was influenced by it.

Patronage and bronze casting in an increasingly linear and dry style continued. The range was very great and included simpler monastic as well as ornamented Buddhas, goddesses and other, more complex and rare Vajrayāna images. They were also influential in Tibet, which was partly evangelised by Kashmir. Two of the most celebrated teachers of the Buddhist revival in Tibet were Rin-chen bzang-po (980–1055), who studied in Kashmir and returned with texts and craftsmen and later Śākyaśrībhadra (1127–1225), a Kashmiri who returned to die in his native land when, according to Tibetan accounts, Buddhism was at a low ebb there. Unlike northern India, Kashmir was protected by its mountains from the direct Muslim conquest that did so much to extirpate Buddhism; Muslim rule began in 1339 with the accession of a Muslim king after a period of anarchy. wz

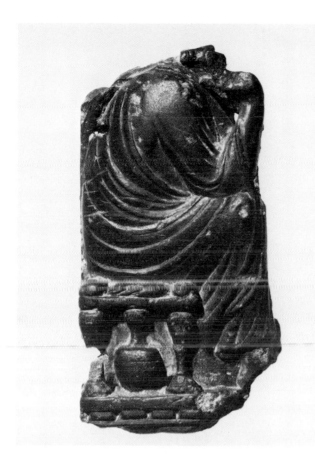

134

134

133. The First Sermon

From Ali Masjid, Pakistan. 7th century AD
Schist. Height 8.5 cm. Given by Sir Alexander Cunningham.
OA 1887.7–17.71

This small openwork panel may have been contained in a
portable shrine and represents the First Sermon in a more
stylised way than the earlier Gandharan manner. Below the
preaching Buddha is the Wheel of the Doctrine on a pedestal
flanked by deer, but the traditional audience of five is reduced
to four. WZ

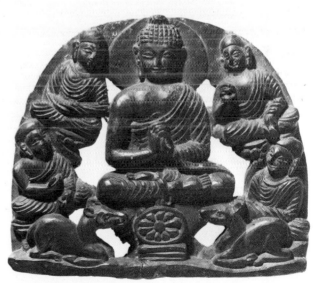

134. Leaf from a diptych

Gandhara or Kashmir, found at Khotan, Xinjiang province, China.
7th century AD
Schist. Height 8.5 cm. OA 1902.12–20.176

Similar leaves of carved stone survive, parts of diptychs,
portable folding objects showing scenes from the Buddha's
life. The headless figure, hand on chin and seated on a stool
above his Brahmin's waterpot, may be the ascetic who pre-
dicted the newborn's Buddha destiny; on the reverse panels
show, above, the assault of Māra and, below, the First Sermon
with the wheel just recognisable below the Buddha. The leaf
was found at Khotan, in Central Asia, and is not the only
example of this kind of object to have been found outside the
Kashmir–Gandhara area of its manufacture. WZ

133

101

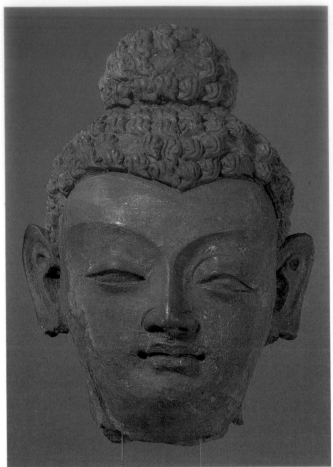

135

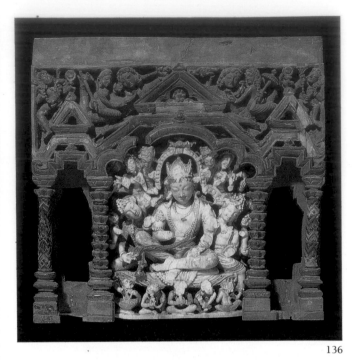

136

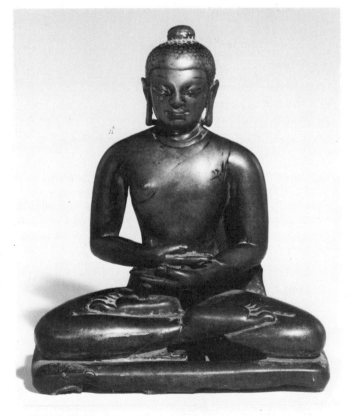

137

135. Buddha

Kashmir (?). 7th–8th century AD
Terracotta. Height 20 cm. OA 1861.7–28.1

This head is still close to the Gandharan stucco tradition dated to the 4th and 5th centuries, but must belong to the later clay production known from sites in Kashmir of the so-called Buddhist Baroque, from Afghanistan and the presumed site of Kaniṣka I's *stūpa* outside Peshawar. The purchase of this head at Peshawar in the last century as part of a larger collection of unknown provenance leaves its attribution open to considerations of style. WZ

136. Bodhisattva

Kashmir. 8th century AD

Ivory and wood, painted. Height 14.5 cm. Brooke Sewell Fund.
OA 1968.5–21.1

This wooden panel, with one surviving seated Bodhisattva,
probably belonged to a shrine imitating a Kashmiri temple
which, even with a proportionately high superstructure, would
have been readily portable. The Bodhisattva's crown, where a
'parent' Buddha might have been, is damaged and there is no
other evidence to identify him. The flanking niches must also
have contained acolytes. This form of Buddhist devotional
object was a characteristic product of the Kashmir region. WZ

137. Buddha

Kashmir. 8th century AD

Inlaid bronze. Height 22.5 cm. OA 1966. 2–16.1

Despite its modest size this bronze has a monumental aspect
with a fullness of face and body due to the influence of Gupta
modelling absorbed by the art of Kashmir. While it resembles
seated Buddhas in central and even eastern India on account
of this common influence, its distinctively regional features
appear in the shape of the head, the hairline and the upward
tilt of the eyes. The copper inlay of the lips and silver in the
eyes, like the flap of the robe hanging from the left shoulder,
are Indian medieval characteristics; inlay became progressively
commoner. The damage on the image may be due to casting
faults. WZ

138. Avalokiteśvara

Kashmir. c.1000

Brass. Height 24 cm. Brooke Sewell Fund. OA 1969.11–3.1

The Bodhisattva sits on a cylindrical stool in a rocky setting,
with goats, perhaps of his mountain home Potalaka. His pre
sumably multicoloured lower garment is shown by alternating
strips of inlaid brass, silver and copper. The texts call this
complex form of Bodhisattva 'Lokeśvara who points out good
births' and his hands, read clockwise, make the gestures of
giving and protection (unusually turned inwards), and hold a
rosary, a triple staff, a waterpot, and the stalk of the silver-
inlaid lotus. His 'parent' Buddha sits prominently on his head-
dress, and an antelope skin is draped over one shoulder. WZ

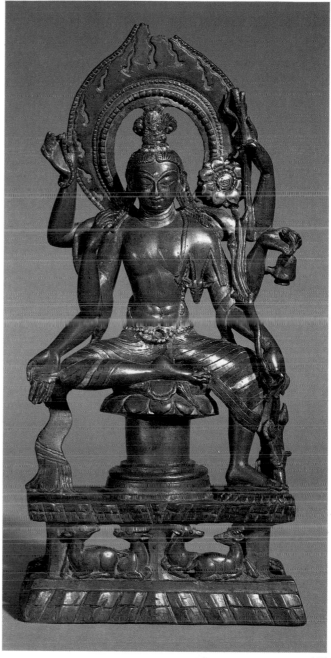

138

6 Eastern India

The Buddhist holy land, where the historical Buddha lived and taught is in and around ancient Magadha or south Bihar. Its holiest site, still a pilgrimage centre, is Bodh Gayā. The tree shrine carved and captioned on a *stūpa* railing of *c*.100 BC as that of the Tree of Enlightenment at Bodh Gayā has been briefly described (p.27). It may be faithful since similar carvings occur. Much of a railing of the last century BC together with some other stonework has survived, but the present restored Mahābodhi temple with a tall central and four smaller spires is hardly earlier than the Gupta period. The old railing appears to have been moved to accommodate it. Xuan Zang's description in the seventh century may refer to a building very similar to that standing today, but the best evidence for its appearance in antiquity are the many little models from around the beginning of the second millennium AD.

The prolific Gupta workshop (fifth century AD) at Sārnāth created an influential stylistic current soon transmitted eastwards; sculpture at the famous monastery at Nālandā, established during the fifth century, shows how well the Sārnāth style had taken root in Bihar during the post-Gupta period (AD 550–750). Another monastery, on the Ganges, is famous for its tall (2.22 m) metal image of the Buddha (now in Birmingham Museum), probably only one of more large Buddhist bronzes, now vanished, made at that period.

The post-Sārnāth style became that called Pāla-Sena after the two chief dynasties of Bihar and Bengal between *c*.AD750 and the Muslim conquests at the end of the twelfth century, a period of rich production in stone and metal sculpture. Much of it served Buddhism which still had a considerable following; the Pāla emperors were Buddhists and their seal bore the wheel and deer emblem associated with the First Sermon at Sārnāth. They founded great monasteries – Vikramaśīla, possibly the recently excavated complex at Antichak, and the similar structure at Somapura (Pāhārpur in Bangladesh).

A monastery at Kurkihār, near Bodh Gayā, together with Nālandā was one of the chief centres of metal casting; others lay in east Bangladesh. Bronze images were also exported to other parts of the Buddhist world. Bronzes of the Pagan period in Burma (eleventh to thirteenth centuries AD) and of the Malay peninsula and Indonesia followed eastern Indian models (indeed, one Nālandā monastery was maintained at the request of a Sumatran ruler); eastern Indian bronzes have been found in Sri Lanka and many were taken to Tibet and preserved in monasteries. Vajrayāna became very marked in art and doctrine.

A related tradition flourished at this time in Orissa which has important Buddhist remains. Vajrayāna was strongly represented in stone and metal sculpture, and since Orissa was spared the destructive Muslim incursions Buddhism survived until at least the sixteenth century.

The best example of an eastern Indian monastery is Nālandā where Buddhist studies continued into the thirteenth century. Its brick buildings were continuously maintained and reconstructed; the excavated remains are a row of rectangular buildings, each with cells along the four inner wall-faces, fronted by a veranda which was formerly pillared and gave on to a central courtyard or quadrangle containing various structures like raised platforms, perhaps for lecturers. There was usually a shrine in the middle of the row of cells opposite the main entrance. These monasteries also had an upper storey. The cells were simple rectangular rooms.

Near the monasteries were large temples with huge stucco images and a shrine expanded over the centuries into a high rectangular structure approached by stairs. This may have been the building compared by Xuan Zang in the seventh century to the Bodh Gayā temple and could therefore have had a central tower above an image chamber presumably containing a Buddha.

Sculpture fell into a number of regional sub-styles in what is now modern West Bengal, Bangladesh and Bihar; Orissa is usually quite distinctive. The bewildering iconography thought typical of Tibetan Buddhism in fact originates in the complex Vajrayāna pantheon that grew up in Bihar, Bengal and Kashmir and was codified into a system of *maṇḍalas* and Buddha families. A new feature, commoner in later Nepalese and Tibetan Buddhist art, is of deities in stylised sexual union. They represent a symbolism of emancipation: the male is compassion or the active means to salvation, while the female is wisdom; together they attain the 'great bliss' of non-duality sought by the Vajrayāna. Fierce folk gods were incorporated as protectors and meditational deities. WZ

Manuscript illumination

The great monasteries of eastern India developed the form of Buddhism called Vajrayāna in which the summoning to mind and then meditating on a divinity or series of divinities according to the prescribed *sādhana* (summoning up of a deity) were one of the means of advancing to Buddhahood. Though intended originally as spiritual exercises, the precise descriptions in the *sādhana* enabled the divinities to be realised also in paint, as frescoes on monastery walls or hanging banners by Vajrayāna monks. None of these paintings has survived, but manuscripts written and illuminated in monasteries such as Nalanda, Vikramasila and Uddandapurī exist from the late tenth century. The text most usually copied is the Perfection of Wisdom, and it is illuminated (normally in a cycle of eighteen miniatures but other patterns also occur) with transcendental Buddhas (the Jinas), Bodhisattvas and other divinities, and the Eight Great Events of the Buddha's life. This abstruse metaphysical text, the most complete scriptural statement of the Mahāyāna philosophy, had by then acquired a mystical, semi-magical significance and probably, as later in Nepal, was more worshipped than read. The miniatures added to it do not illustrate the text (only one manuscript, no. 81, has such miniatures) but perform the same spiritual service to their painters as do larger realisations of the *sādhanas*, as well as bestowing spiritual merit (*puṇya*) on their donor and his family.

Although it is possible that the wooden covers of palm-leaf manuscripts were painted before our earliest dated survivals, it is unlikely that the leaves were. Everything about them proclaims their experimental nature. The art reached a peak of technical perfection under the Pāla monarchs Mahīpāla II and Rāmapāla (c.1075–1120), though elements indicating disintegration of both style and content are strangely present even in the greatest manuscripts. The art was effectively destroyed at the end of the twelfth century, when the monasteries were sacked by the Muslim invaders, but the tradition seems to have lingered: some Indian influence still seems apparent in the thirteenth and fourteenth centuries on Nepalese illumination (nos 159, 176), while even in the fifteenth century examples of Buddhist illumination occur in Bihar (no. 88). JPL

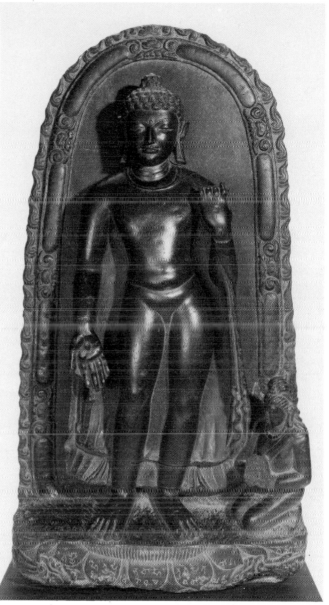

139

139. Buddha

Eastern India, from Sultānganj. 7th-8th century AD
Schist. Height 70 cm. Brooke Sewell Fund. OA 1982.3–31.1

Still showing strong traces of the Gupta idiom of Sārnāth, (cf. no. 132), this image from the Sultānganj monasteries was found in the last century above the largest surviving bronze of Indian antiquity, the celebrated Sultānganj Buddha (2.22 m high), now in Birmingham Museum, which on account of its Sārnāth reminiscences has defied accurate dating. The theme of the Buddha worshipped by his successor, Maitreya, here kneeling on the right, occurred also on a 7th-century stucco panel (now badly damaged) at Nālandā. The inscriptions are a personal dedication and the Buddhist creed (p. 33).
WZ

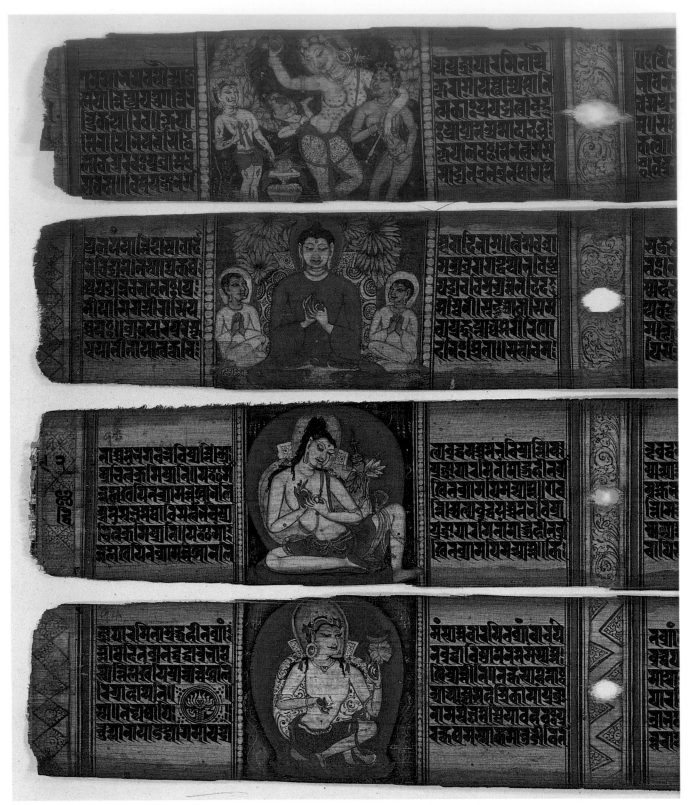

156

140. Buddha

Eastern India. 8th century AD

Bronze. Height 19 cm. Brooke Sewell Fund. OA 1979.1–30.2

The evidence of a datable but now lost Bengal bronze shows that the aureole, or nimbus, supported by struts decorated by flowers, was a feature of smaller metal images by the later 7th century. With its prominent straight nose and soft modelling of the body this figure shows a late stage in the transition from the Gupta style to the great period of eastern Indian metal-casting between the 9th and 12th centuries AD; the way in which the legs seem suspended from the body is a particularly 8th-century feature. WZ

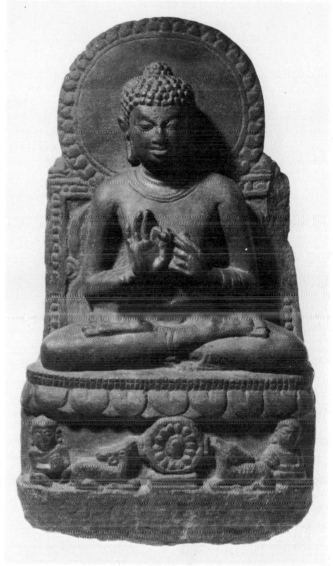

141

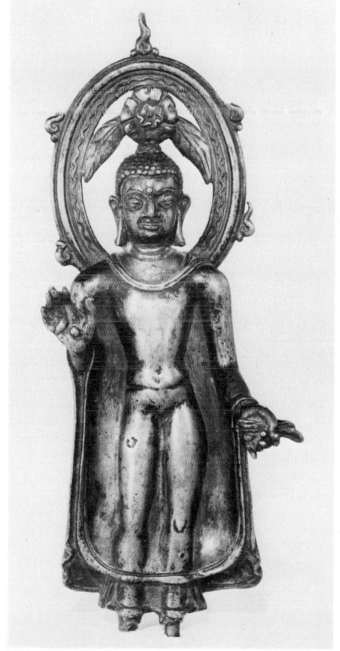

140

141. The First Sermon

Eastern India. 8th century AD

Schist. Height 33 cm. OA 1854.2–14.1

While the Gandharan and early Deccani schools often depicted events from the Buddha's life with a vivid realism, the Sārnāth school represented them more as stylised icons. In this Bihar version of the Sārnāth convention the Buddha sits on a lotus pedestal against a decorated throne-back surmounted by a halo, while the wheel and deer below him are flanked by adoring rather than listening monks, who may be the donors of the image. WZ

142. Descent at Sāmkāśya

Eastern India. 9th century AD
Schist. Height 43 cm. Bridge Collection. OA 1872.7–1.31

In contrast to the crowded and well-ordered narrative scene from Gandhara (cf. no. 24) this slab continues the simplification of life scenes as at Sārnāth. The Buddha's return from the heaven of the Thirty-three Gods is indicated only by the two figures flanking him, Indra and Brahmā. Indra holds a pole of the royal parasol above the Buddha; Brahmā holds a fly-whisk. Around the backplate are a stylised flame motif, a raised band, *stūpas* and the words of the Buddhist creed – a frequent combination on eastern Indian Buddhist sculpture. WZ

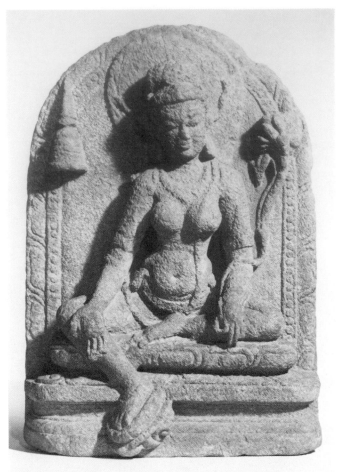

143

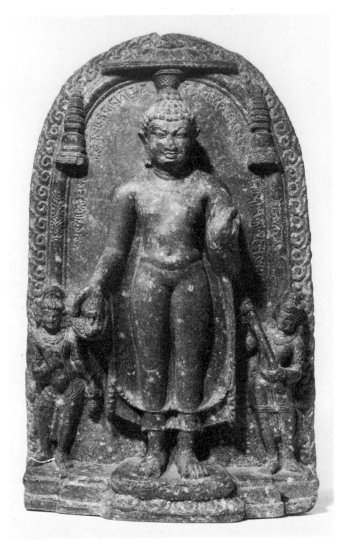

142

143. Tārā

Orissa. 9th century AD
Laterite. Height 32 cm. Brooke Sewell Fund. OA 1964.6–17.2

A widely worshipped goddess in later Buddhism is Tārā whose name can mean 'saviouress'. She is associated especially with Avalokiteśvara. In this carving she appears as the green Tārā, her right hand in the gesture of giving while her left holds the stalk of a closed blue lotus. As in the related art of Bihar and Bengal, her backplate is edged with lotus petals and a pearled border; a large elongated halo reaches the pointed top of the stele. A *stūpa* in relief balances the closed lotus.

WZ

144. Miniature votive stūpas

Eastern India. 8th–9th century AD
Terracotta. Height 7.5 and 6.5 cm. Given by Sir Alexander Cunningham. OA 1887.7–17.90 & 93⁻

Building *stūpas* of every size produced merit: until recently small clay *stūpas* were still impressed from moulds in Tibet, and in 7th-century India they were made from small piles of earth. Great numbers of terracotta *stūpas* have been found in eastern India and, where they are damaged or have been broken open, seen to contain an impression of the Buddhist

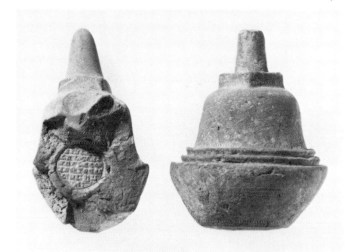

144

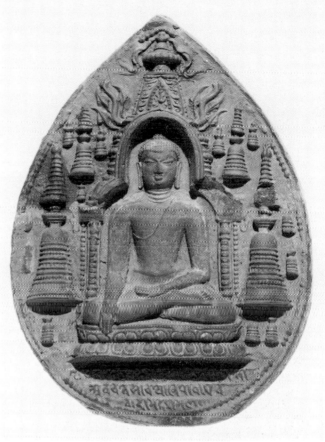

145

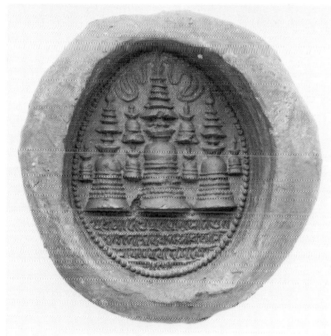

146

creed as a 'relic' or deposit by which these modest objects
were sanctified. Both these examples are from Gayā District,
the complete *stūpa* from the vanished shrine at Dharawat, the
broken *stūpa* from Bodh Gayā. Like plaques they were pre-
sented to the shrine and placed in larger *stūpas*. Their profiles
resemble *stūpas* and *stūpa*-shaped finials of *c.* AD 800 in Java.
WZ

145. Plaque

Eastern India, from Bodh Gayā. *c.*9th century
Terracotta. Height 15 cm. Given by Sir Alexander Cunningham.
OA 1887.7–17.81

One of the commonest Buddhist votive objects was the im-
pressed plaque, such as this example with the Mahābodhi
temple in the form of an arched sanctum surmounted by a
spire and containing the Buddha in the appropriate earth-
touching gesture. As they still do today, numerous small *stūpas*
surround the temple, and behind the spire extend branches of
the Enlightenment Tree which stood on the terrace. A three-line
inscription gives the Buddhist creed (see p. 33). The presentation
and enshrinement of such plaques were meritorious acts. WZ

146

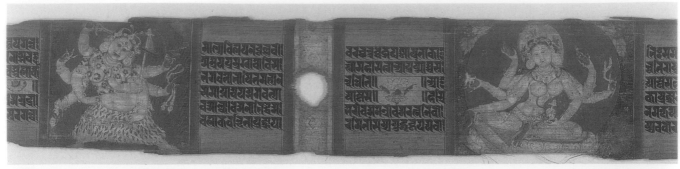

157(6)

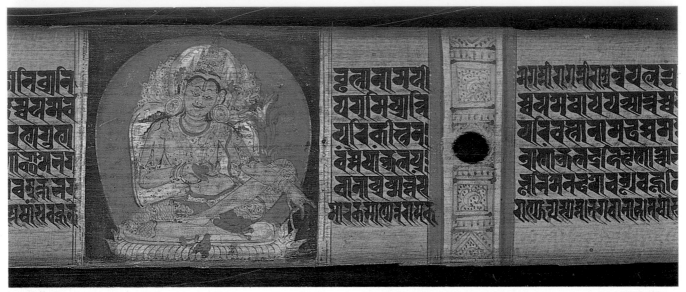

158 (f.136b)

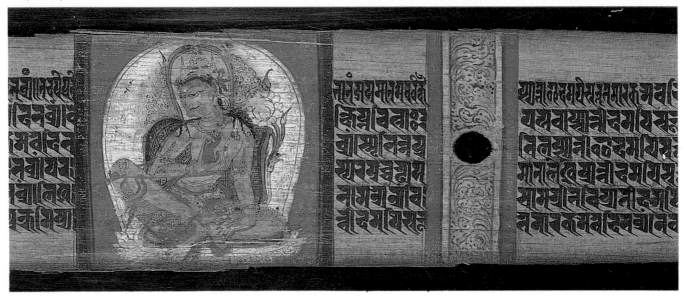

158 (f.137a)

Opposite The Mahābodhi temple commemorating the Buddha's Enlightenment at Bodh Gayā, Bihar, India. (Photo Graham Harrison)

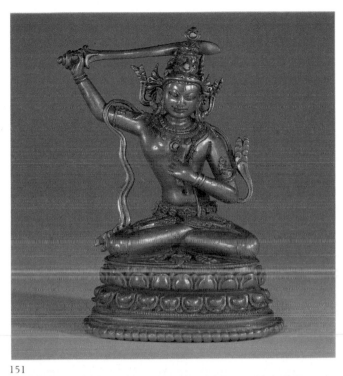

151

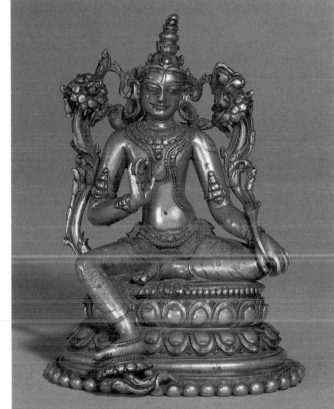

150

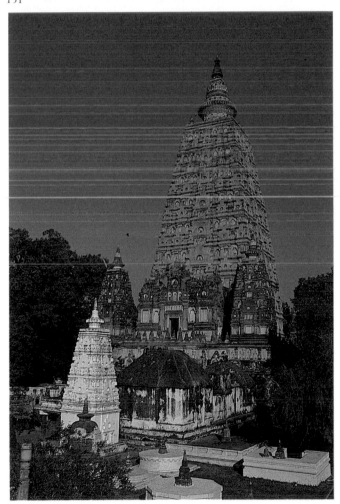

152

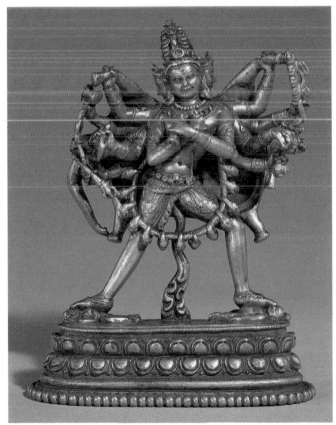

146. Sealings

Eastern India, from Nālandā. 9th-10th century
Terracotta. Diameter 5 and 8 cm. OA 1937.4–14.4 & 14

The smaller sealing shows the wheel flanked by deer which, despite the association with the First Sermon, acquired a more general Buddhist application: it occurs as the device of the Pāla emperors who patronised Buddhism between the 8th and 12th centuries. The legend reads '(seal) of the noble community of monks at the Great Nālandā Monastery'. The other sealing consists of a deep impression of *stūpas* above the Buddhist creed and must have been a symbolic offering of small votive *stūpas* which also abound structurally at Nālandā.　　WZ

Illustrated on page 109

147. Votive stūpa

Eastern India. 11th century
Sandstone. Height 93 cm. OA 1880–4085

Standing on a moulded base showing on one side the seven treasures of the Universal Monarch, this votive *stūpa* is of a

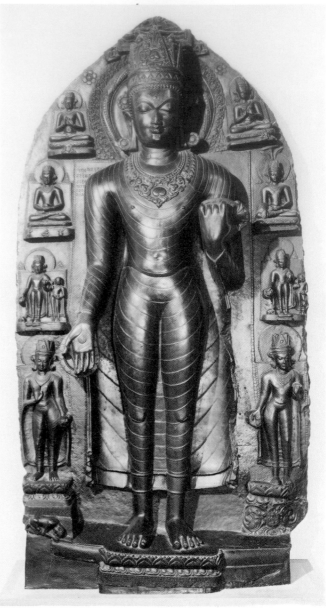

148

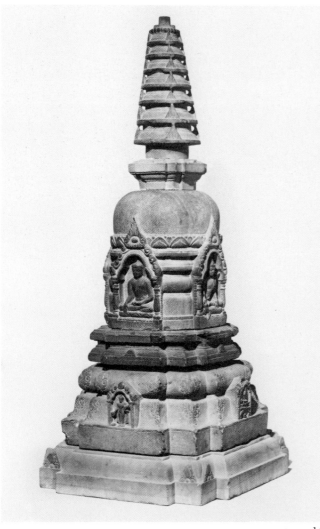

147

type found in great numbers at the principal sites of eastern India. Set into the lower mouldings are four small niches, two containing the scene of the taming of the elephant, one of the Buddha's miraculous birth and, opposite, his death. In the larger arched recesses beneath the dome is a seated Buddha in the earth-touching gesture of the Enlightenment; in the other niches are seated figures of the Bodhisattva Padmapāṇi and the saviouress Tārā.　　WZ

148. Crowned Buddha

Eastern India, from Bodh Gayā. 11th–12th century
Schist. Height 1.95 m. Bridge Collection. OA 1872.7–1.30

The crowned and ornamented Buddha holds his right hand in the gesture of giving, repeated by the smaller crowned figure

on his left, while the one on the right makes the gesture of reassurance. The minor scenes, with the central figure, are eight in number and should represent the Eight Great Events of the Buddha's life. The first, reading clockwise, shows the Buddha taming an elephant, his power represented by the small lion emerging from his outstretched hand. Above, a monkey offers a bowl of honey to the Buddha and on its acceptance throws himself with joy down a well. The First Sermon, death and Śrāvastī miracle, where one confounded heretic represents six beneath the Buddha's left, are followed by the temptation beneath a tree crowned by a parasol. The taming of the elephant is repeated exactly with an acolyte holding monastic staff and bowl, while the usual birth scene is omitted and the descent from the heaven of the Thirty-three Gods is not explicitly represented by the central figure. At the Buddha's right shoulder is the usual Buddhist creed, and on the base a damaged verse naming a donor 'desirous of release from the ocean of existence' who is also shown prostrate on the left. WZ

149. Mahākāla

Eastern India. 12th century

Porphyritic basalt. Height 1.09 m. Victoria and Albert Museum (IM 10–1930)

An excellent example of the Indian source of Nepalese and Tibetan fierce deities is furnished by this image of the powerful protector Mahākāla, an aspect of Śiva absorbed by Buddhism. He stands against a flame-edged background on a defeated long-haired foe, who is also being attacked by a small animal. He carries a chopper and skull-cup; his second pair of hands holds a skull-topped trident formed like the Buddhist *vajra* and a rosary, though the beads are not carved. His hair rises horrifically above a snake, and his armlets, bracelets, anklets and sacred cord are all snakes. His eyes stare fiercely, his mouth is fanged, and a garland of severed heads hangs down to his knees. WZ

150. Avalokiteśvara

Eastern India. 12th century

Bronze with silver and copper inlay. Height 13 cm. Brooke Sewell Fund. OA 1982.12–16.1

This Avalokiteśvara, as Padmapāṇi, the lotus-holder, reflects, without altogether lacking spiritual presence, a late and opulent development in eastern India. The 'parent' Buddha is absent from the head-dress which is itself a late form. The sacred cord from the right shoulder to the left thigh is no doubt jewelled, an elaborate series of necklaces covers the upper torso, the lower garment is patterned, and the lotuses were once inlaid with precious or semi-precious stones. The right hand is raised in an almost languid gesture. WZ

Illustrated on page 111

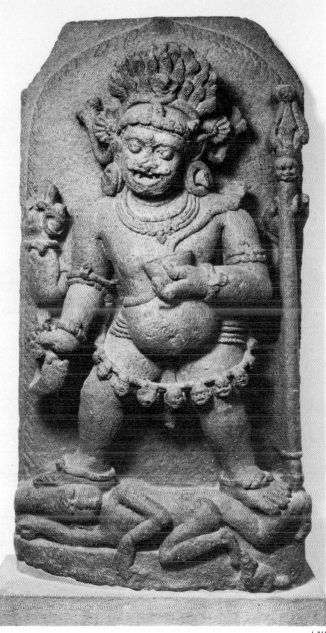

149

151. Mañjuśrī

Eastern India. 12th century

Bronze with silver and copper inlay. Height 11 cm. OA 1973.5–14.2

The Bodhisattva Mañjuśrī became popular in developed Buddhism and his cult spread to China and to Nepal, a country of which he is in a sense patron. Known also as prince or youth, he is the god of wisdom, and his usual attributes are the sword to cleave ignorance, and the oblong object in his left hand, the palm-leaf book equated with the text of the Perfection of Wisdom. The exceptional preservation of this image must be due to its export in antiquity to Tibet. WZ

Illustrated on page 111

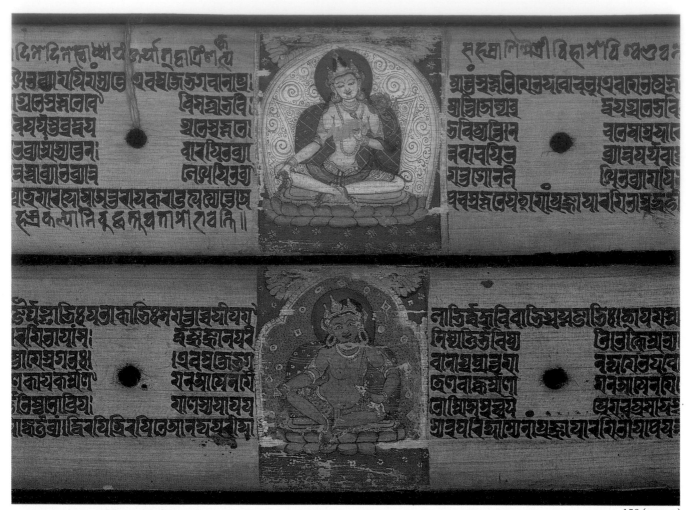

159 (covers)

159

[]

dedication by the Buddhist layman (*upāsaka*) Dantanāga. The figure of Akṣobhya looks Burmese of the Pagan period, but other similar work has lately been found in Bihar. The figures have traces of blue pigment and gilding which suggest that this *maṇḍala* once received Tibetan worship. WZ

154. Model of the Mahābodhi temple

Eastern India (?). 12th century
Mica schist. Height 10.8 cm. OA 1922.12–15.7

The Mahābodhi temple commemorating the Buddha's Enlightenment at Bodh Gayā was copied in buildings and in miniature. Small models survive in several collections, and in 1957 a model Mahābodhi complex was reported as being preserved in Tibet where the present model was found. These models appear to be close imitations of the temple before the restoration of 1880–1 and show the projection at the rear on which the Bodhi tree then stood. Holes at the four corners of the upper terrace secured the corner chapels. Like other examples, it has a Burmese-looking arch at the foot of the spire which may date from a Burmese restoration in the late 11th century. WZ

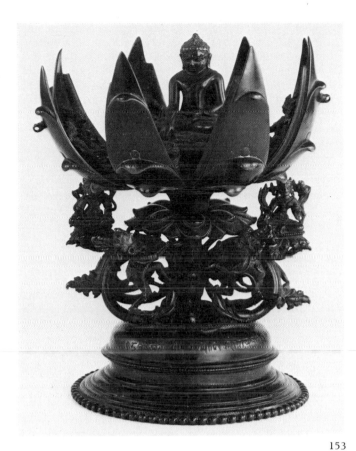

153

152. Samvara

Eastern India. 12th century
Bronze with silver and copper inlay. Height 14.6 cm.
Brooke Sewell Fund. OA 1976.9–27.1

Fierce manifestations of Buddhahood, generally called Heruka, were a feature of Tantric Buddhism and classified according to their corresponding Buddha. Samvara is the Heruka form of Akṣobhya and in his twelve-armed and four-headed form tramples on beings, stretches an elephant skin behind him and, in addition to the *vajra* and *ghaṇṭā* in front, holds a drum, an axe, dagger, trident, severed head, skull-cup, noose and *yogin*'s wand. WZ

Illustrated on page 111

153. Lotus maṇḍala

Eastern India. 12th century
Bronze with silver and copper inlay. Height 14 cm. OA 1982.8–4.1

A few Indian Buddhist lotus shrines survive; others come from Burma, Tibet and China. They are *maṇḍalas*, symbolising the emanation of the phenomenal from the Absolute, a process which, like the opened petals, could be ritually reversed. The presiding deity is Akṣobhya whose symbol, the *vajra*, lies before him; he has an unusual head-dress of inlaid copper and silver, and disposed on the petals around him are eight Bodhisattvas, a standard grouping. The lotus is supported by deities, and the inscription on the base is a

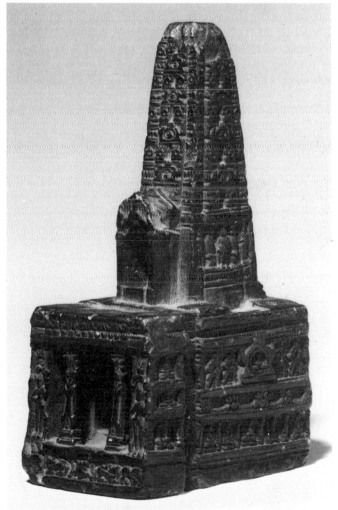

154

115

155. Manuscript of the Perfection of Wisdom

Eastern India. *c.*1000

Pothī manuscript of *Aṣṭasāhasrikā Prajñāpāramitā* in Sanskrit.
Siddhamātṛkā script. Ink and gouache on palm leaves. 227 folios.
5 × 53.5cm. Cambridge University Library (Add. 1464)

This, the earliest known Indian illustrated manuscript, was
commissioned by Lāḍakā, daughter of Bahubhūti, and is
dated in the 5th year of Mahīpāla (*c.*995–1043). Its miniatures
are in a vigorous linear style (note the lively monkeys and the
terrified monks clinging to the Buddha as he tames Nālāgiri),
very near the beginning of the Indian tradition of illuminating
manuscripts. Exhibited are six of the Eight Great Events of
the Buddha's life. JPL

156. Manuscript of the Perfection of Wisdom

Eastern India, Nālandā monastery. *c.*1097

Pothī manuscript of *Aṣṭasāhasrikā Prajñāpāramitā* in Sanskrit.
Siddhamātṛkā script, copied by Ahanakuṇḍa Bhaṭṭāraka. Ink
and gouache on palm leaves. 188 folios. 6 × 55.5cm.
Bodleian Library (MS Sansk. a. 7 (R))

Three illuminated manuscripts are known to have been copied
at the monastery of Nālandā; Rājyapāla, a pious layman, is
named as the patron of this one, dated in the 15th regnal year
of Rāmapāla (*c.*1082–1124). The Eight Great Events occupy
the outer spaces of the first and last pairs of folios. The central
divinities in the first are Prajñāpāramitā, unusually depicted
reclining, and Mañjuśrī Vādirāj, on a lion. The middle pair
show four Bodhisattvas – Maitreya, Vajrapāṇi, Candraprabha
and Jālinīprabha – on either side of the Ādi Buddha Vajrasattva
and the Buddha teaching Indra. The last two folios include
two more Buddhas – teaching, and in relaxed conversation
with two disciples.

 The glory of this manuscript is the exquisite set of Bodhi-
sattvas in the central pair of folios. Their style is unusual for
their provenance, and possibly the artist was Burmese. Early
in his reign Kyanzittha of Pagan (fl.1084–1113) repaired the
Bodh Gayā temple, and his chief queen, Abeyadana, probably
from Bengal, decorated her temple in Pagan in a style sug-
gesting links with the Pāla monasteries. JPL

Illustrated on page 106

157. Divinities from a manuscript of the Perfection of Wisdom

Eastern India. *c.*1118

6 folios from a *pothī* manuscript of *Aṣṭasāhasrikā Prajñāpāramitā*
in Sanskrit. *Siddhamātṛkā* script. Ink and gouache on palm leaves.
6 × 54cm. Victoria and Albert Museum (IS 4–9, 1958)

Famous as the Vredenburg manuscript after a former owner,
this manuscript was commissioned in the 36th year of Rāmapāla
by Udayasiṃha, who describes himself as *Vāsāgārikarāṇaka*
(not *bhāṇaka* as usually read), which may be translated as
'chief of the bed chamber', the title perhaps of a high court
official.

 The figures in this cycle of eighteen illustrations are re-

markable for their graceful elegance, especially of the nine
Bodhisattvas, and for their unity in colour and composition.
Colour is restricted to red, pale yellow, white and slate blue
(the latter instead of the required green). The first and second
pairs of leaves form a *maṇḍala* around Amitābha, com-
prising nine Bodhisattvas, Vajrasattva and Mārīcī (who in one
form is Vajradhātvīśvarī, Vajrasattva's consort). The final
pair of leaves forms another unit of mostly female divinities
based on Vasudhārā.

1. The Bodhisattva Samantabhadra; the Jina Amitābha; Mañ-
juśrī Vādirāj.

2. Maitreya, holding *nāgakeśara* flower with a pot on top; Srī-
Potalaka Avalokiteśvara, the only form of this Bodhisattva in
the teaching *mudrā*; Avalokiteśvara Lokanātha.

3. Vajrapāṇi, with *vajra* on lotus; Vajrasattva holding *vajra*
and bell; the Bodhisattva Akṣayamati, with remains of a
sword on his lotus.

4. A blue Bodhisattva, possibly Ratnapāṇi; the six-armed
Mārīcī within a *caitya* with usual attributes including needle
and thread (to sew up the mouths of the wicked); a yellow
Bodhisattva with white lotus, possibly Amoghadarśin.

5. Mahāśrī Tārā, on a sofa, teaching the goddesses Aśokakāntā
and Āryā-Jāṅgulī; Avalokiteśvara Lokanātha; and Ucchu-
ṣma Jambhala, the terrifying form of the god of wealth.

6. An eight-armed, three-faced (one of a pig) goddess, who
must be Mārīcī, but with unusual attributes (a goad, *vajra*,
arrow, sword, bow, noose, flag and warning gesture); the six-
armed form of Vasudhārā; a six-armed goddess holding mace
(or axe?), arrow, *vajra*, bow, cluster of leaves and warning
gesture, who must be Parṇaśabarī, but with one face in-
stead of three. JPL

Illustrated on page 110

158. Divinities from a manuscript of the Perfection of Wisdom

Eastern India. *c.*1125–50

Pothī manuscript of *Aṣṭasāhasrikā Prajñāpāramitā* in Sanskrit.
Siddhamātṛkā script. Ink and gouache on palm leaves. 325 folios.
6 × 39cm. OMPB Or. 12461

This most heavily illustrated Pāla manuscript originally con-
tained seventy-eight miniatures combining the standard cycle
of eighteen with one commoner to Nepalese manuscripts,
where miniatures mark the beginnings of chapters. The style
foreshadows the linear drawing of medieval India – projecting
further eyes in three-quarter profiles, pointed chinbones
with double chins – while retaining the elegance of surviving
Pāla illustrations. This and the Vredenburg manuscript in
many respects seem linked to the same monastic atelier.

f.136b. The Bodhisattva Samantabhadra holding jewel(?) and
blue lotus.

f.137a. Possibly Avalokiteśvara, pink in colour, showing
abhaya mudrā and white lotus, reflecting in his colour his
spiritual succession from Amitābha.

f.170a. Tārā, showing *varada mudrā* and a blue lotus.

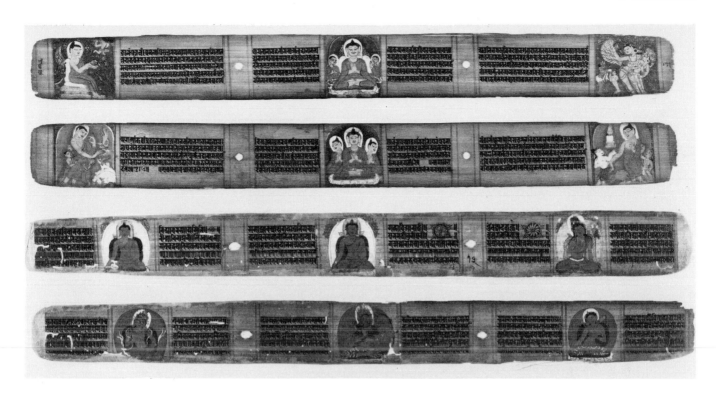

155 folios (top pair), 83 folios (bottom pair)

f.192b. Vajra Tārā, showing the same attributes as f.170a, but white.

f.246b. Avalokiteśvara on the Potalaka mountain.

f.247a. Mañjuśrī, showing the teaching gesture and a manuscript on top of his blue lotus.

f.250b. The Bodhisattva Sarvanivaraṇaviṣkambhin (effacer of all sins), in the gesture of pacification in his right hand and of earth-touching in his left.

f.251a. Vasudhārā, goddess of wealth, showing the *varada mudrā* in her right hand combined with a sheaf of rice, and in her left a red lotus with a pot of jewels. JPL

Illustrated on page 110

159. Manuscript of the Perfection of Wisdom

Eastern India and Nepal. 12th and 13th century?

Pothī manuscript of *Aṣṭasāhasrikā Prajñāpāramitā* in Sanskrit. Proto-Bengali script. Ink and gouache on palm leaves, gouache on wood. 339 folios. 6.25 × 33cm. OMPB Or. 14203

The mixture of Indian and Nepalese elements in this manuscript presents insoluble problems. The script, intermediate between the *siddhamātṛkā* of the Bihar monasteries and the Bengali hand, is either less advanced than the manuscript considered the earliest in a Bengali hand (Cambridge University Library, Add. 1699 of 1198–1200) or else reflects a transitional state in an area where the Bengali hand was spreading, such as Mithilā (north Bihar) or Assam. (The Bengali-Maithili hand was used in Bihar in the 15th century for Buddhist manuscripts, see no.88.) While the six miniatures are in probably 13th-century Nepalese style, the covers are more linked in their angular linearism to late Pāla work. Nevertheless, certain themes, such as the method of delicately decorating in red the white halo of some of the divinities, are taken up in the building in the Nālāgiri scene on the covers, so that the two do seem linked. The covers depict the Eight Great Events – the *parinirvāṇa* scene is unique iconographically, and its emotional impact is extremely fine. The two miniatures exhibited are of Lokanātha and Jambhala, the god of wealth. JPL

Illustrated on page 114

117

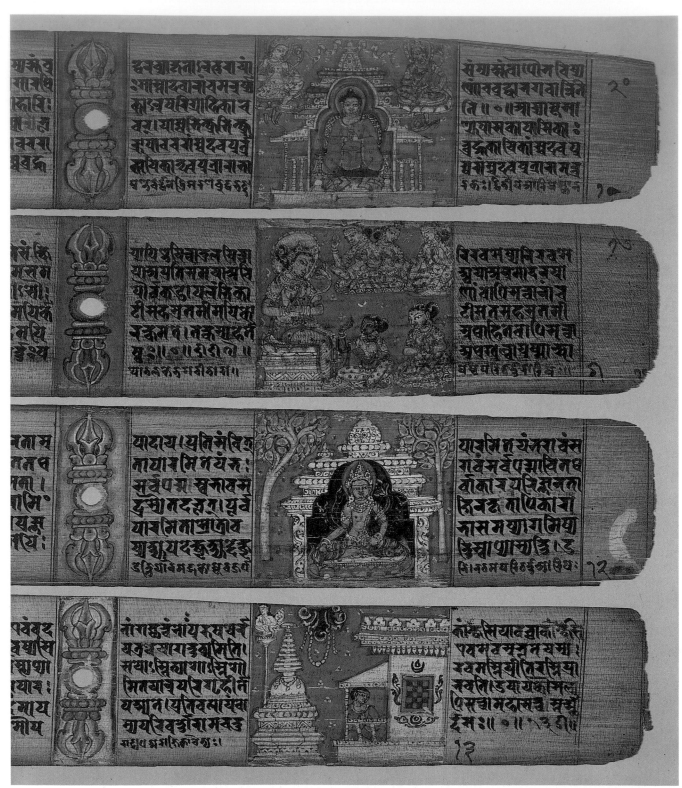

167 (from top to bottom ff. 20b right, 74b right, 89a right, 127a right)

167 covers (top pair), 168 covers (bottom pair)

169 (top), 172 (bottom)

7 Nepal and Tibet

Nepal

The Kathmandu valley, of about 200 square miles, contains the *stūpas*, monasteries and statuary of Nepalese Buddhism, and the historic population, the Newars, have been responsible for its traditions and artistic expression. It is claimed that Aśoka founded *stūpas* in the valley, but the introduction of Buddhism must have accompanied the inflow of Indian civilisation over the centuries when Hinduism was also introduced. A Nepalese ruler was vassal of the Gupta Emperor Samudragupta (*c.* AD 335–76) and by the fifth century there was a recognisable Nepalese sculptural idiom. The oldest Buddhist image datable by inscription, a Padmapāṇi dedicated between *c.*532 and 560, is a substantial work showing clear affinities to Sārnāth but with a robustness probably influenced by Mathurā. A Nepalese style incorporating these elements became well established in the sixth and seventh centuries; the subsequent resemblance to eastern India, though close, may rather be the result of development from a common source, each idiom achieving in stone and metal a more svelte and linear treatment of the body and a greater emphasis on ornament. Nepal was often more conservative. Buddhist influences from eastern India ceased after the Muslim conquest, but the large pantheon of Buddhist deities continued to be represented in all the arts. Indeed, the Newars were so skilled in metal that a Newar master, Aniko, was sent to the Chinese Mongol court of the Buddhist Kublai Khan in the late thirteenth century, and until recently Newars remained in great demand as metalworkers in Tibet. Their craftsmanship is still extremely fine and traditional.

Nepalese Buddhism has gradually merged with Hinduism and survives in a non-monastic form. The monks abandoned celibacy and are now communities with hereditary caste status in the Indian fashion; they live in and around the old monasteries. The Vajrācāryas, the higher priestly caste, still possess some Buddhist learning; the lower, called *bhikṣu*, are usually metalworkers. It is not surprising that iconography and ceremonies can have a hybrid character. There has, however, been a distinct continuity from Buddhist India, not least in painting on cloth and in manuscripts. WZ

Manuscript illumination

As in eastern India, examples of illuminated manuscripts from Nepal have survived from *c.*1000, coming from the same kind of monastic atelier and illuminated for the same reasons (see p. 105). It is not as yet possible to identify their precise provenance, as the sites of monasteries such as Śrī Hlam are still unknown. Again as in India, the art reached its peak in the last quarter of the eleventh century, but whereas in Pāla illumination in the twelfth century there are clear indications that this is the end of a tradition, this is not the case in Nepal, where the exquisite vitality of the art was maintained throughout most of the twelfth century, though with some indications of a more mechanical output from the studios. An attempt has been made in the catalogue entries to arrange much of the material in an acceptable chronological sequence.

For reasons still unclear the standard and numbers of illuminated manuscripts dropped sharply in the thirteenth century, when the arrival of refugees with their manuscripts from the ruined monasteries of Bihar should have given the art renewed inspiration. It would seem, however, that inspiration was henceforth poured into the painted banners, some of the surviving examples of which have been plausibly attributed to about this time, though it is impossible to tell whether this is coincidental with the influx from India or a direct result of it.

For reasons again still unclear the quantity of illuminated manuscripts increased at the beginning of the sixteenth century. The major medium was by this time paper, and typically the very dark-blue paper made in Nepal since at least the twelfth century (see no. 173), with the writing in the archaistic, and increasingly unreadable, *rañjanā* script (known as *lan-tsha* in Tibet) in gold ink. Manuscripts were by now more worshipped as the embodiment of wisdom than read, but their commissioning was still a pious deed bringing merit to all associated with it. Elaborate colophons show the family groupings of the three cities of the valley, with much valuable information about the scribes and their monasteries.

The Nepalese style changed drastically in the middle of the seventeenth century, when two waves of influence arrived more or less simultaneously in Kathmandu. From India came the so-called 'Rajput influence', though Popular Mughal would be a better description, displaying Indian costume, full rather than three-quarter profile, a horizon, and an altogether less

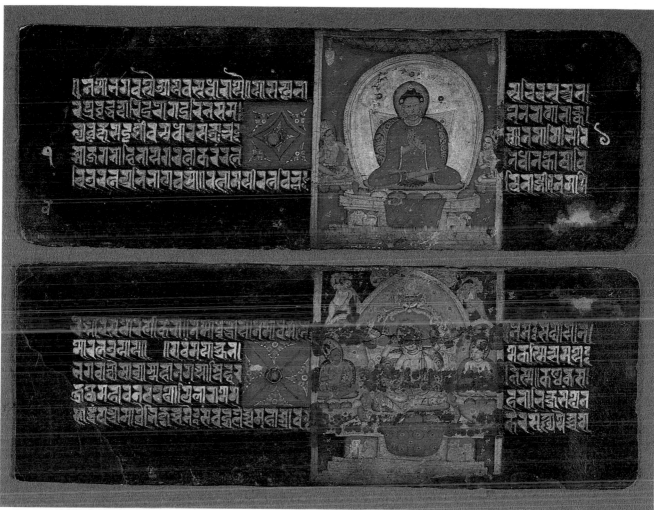

173

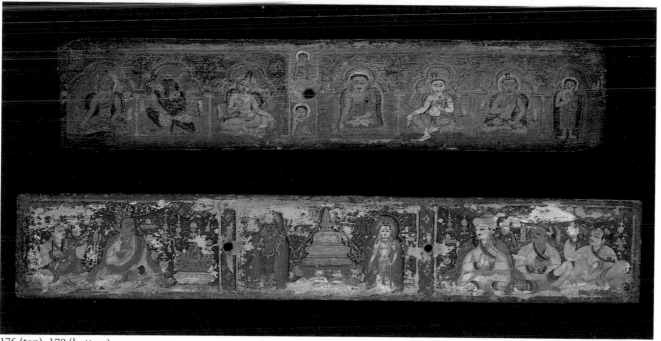

176 (top), 179 (bottom)

cluttered composition. This style was probably brought by the two princesses from Cooch Bihar who were the chief wives of Pratāpamalla of Kathmandu (r. 1641–74). This period also saw the colonising and revitalising of the great *stūpas* of the valley by Tibetan monks, who brought with them their own style which greatly influenced Nepalese landscape painting and then increasingly all Nepalese Buddhist iconography. Contacts from this time on between Newar Buddhist merchants and artists on the one hand and the great Tibetan monasteries such as Tashilhunpo on the other enriched both traditions. JPL

160. Buddha

Nepal. 7th-8th century AD
Schist. Height 62 cm. Brooke Sewell Fund. OA 1966.2–17.2

This, the oldest Nepalese image in the British Museum, is executed in the Gupta tradition that was well represented in the Nepal valley, but the treatment of mass is more summary in ways that recall developments in Bihar during the pre-Pāla period (*c.* AD 650–750). The inscription is also still in a Gupta character which seems a little later than many 7th-century examples. It names several donors who dedicate the merit from commissioning this image to the attainment of supreme knowledge (i.e. Buddhahood) by their teachers, kinsfolk and all sentient beings. The kneeling figure may be an undifferentiated donor carved to a common formula without reference to the specific commissioners of the piece. WZ

Illustrated on page 124

161. Maitreya (?)

Nepal. 10th century
Gilt bronze. Height 28 cm. Brooke Sewell Fund. OA 1967.7–13.1

The early concept of successive ages each ruled by a different Buddha recognised a future Buddha called Maitreya. Originally represented as an ornamented figure with a pot, he can later be indistinguishable from a Buddha making the preaching gesture and seated in the so-called European posture as on a chair. The identification of the seated and preaching Maitreya in Buddha form is clear when he has a *stūpa* in his head-dress or on a flanking lotus. This image shows how the Gupta style persisted in Nepal. WZ

Illustrated on page 124

162. Vajrasattva

Nepal. 15th century
Gilt bronze. Height 44.5 cm. Given by Mrs Griffith. OA 1932.2–11.4

This superbly regal figure with *vajra* and *ghaṇṭā* follows an old Nepalese style of representing Bodhisattvas. The presence of Akṣobhya in the crown can be justified in the case of Vajrasattva as Supreme (Ādi) Buddha, since their connection is established in the texts. There is, however, also a Bodhisattva Vajrasattva, one of sixteen, connected with Akṣobhya. An identification as the Bodhisattva Vajrapāṇi seems textually unjustified, as Vajrapāṇi is not reported in this form, although one late Nepalese image, holding both attributes in a somewhat different way, is claimed by Bhattacharyya as Vajrapāṇi and of Akṣobhya's 'family'. WZ

Illustrated on page 125

163. Samvara

Nepal. 16th century
Copper gilt set with coloured stones. Height 27 cm.
Given by Louis King, Esq. OA 1921.2–19.1

A form of Samvara with one head and two arms is shown here in a vigorous posture, striding to the right and embracing his female partner. Both tread on Hindu gods, Bhairava, a form of

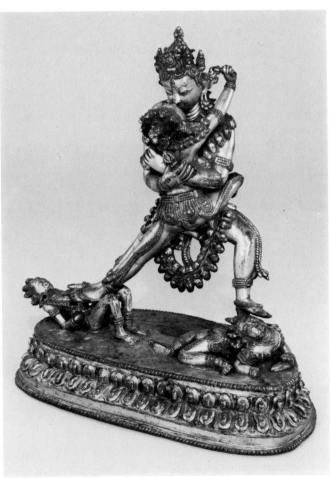

163

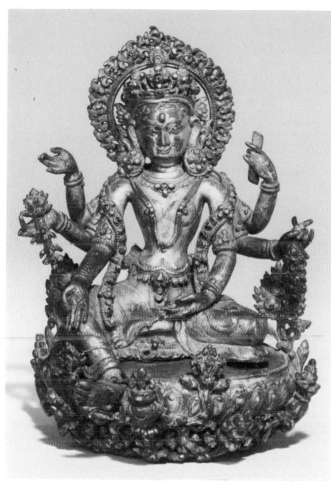

164

165. Maṇḍala

Nepal. Dated 1504 (Nepal era 624)

Painting on cloth. 1.15 m × 86 cm. Given by Sir Herbert Thompson, Bt., and Louis Clark, Esq. OA 1933.7–22.01

A painted *maṇḍala*, a diagram within which a principal deity is enclosed with his or her entourage or emanations, is physically one or more squares representing a sacred building which has gateways at the cardinal points. The centre is occupied by the deity being invoked; the squares are enclosed in a circle demarcating the sacred area. *Maṇḍalas* are used for initiations, meditation and rites of a magical character.

A *maṇḍala* of Vasudhārā is used for a ritual of material advantage. The inner building of this *maṇḍala* consists of three concentric squares with gateways. In the centre the large figure of the six-armed Vasudhārā makes her usual gestures (cf. no. 164): only the empty hand in her lap should hold a pot of plenty. Above is her 'parent' Buddha Ratnasambhava, 'the jewel-born', and below the goddess Ilā, and she is flanked by Bodhisattvas while spirits pour jewels from above. The blue deity at her bottom right is Jambhala, god of riches, and corresponding to him on the left a serpent king. In the second and outer squares are protector spirits. The area immediately outside the circle contains Ratnasambhava, Bodhisattvas and auspicious symbols, and framing the painting almost entirely are rows of scenes. In the top centre are the five Dhyāni Buddhas. Other scenes are devoted to the story of Sucandra and his son who stole bricks from a *stūpa* with unhappy results. The theft is shown in the middle section of the single strip on the bottom left-hand side. The Buddha, propitiated by Sucandra, recommends the worship of Vasudhārā (she is seen emerging from a flower in the strip below the top right-hand corner). Sucandra was restored to his former wealth.

At the bottom of the painting above the dated dedication is the Bodhisattva Mañjuśrī. He is flanked by scenes showing a horse and an elephant, each carrying auspicious symbols, perhaps together representing with the other figures the Universal Monarch and his attributes. Beside them are worshippers. The *homa*, or fire sacrifice, is being performed on the left by a Vajrācārya wearing his helmet and pouring ghee into the fire; male and female worshippers kneel on both sides.

WZ

Śiva, apparently holding a skull-cup, and his consort, Kālarātrī, with ritual knife and skull-cup; her emaciation, as goddess of death, is apparent from her pendulous breasts and angular arms and legs. Samvara holds his *vajra* and *ghaṇṭā* behind his consort's back, while she, one leg thrown over his left thigh above his lower garland of severed heads, holds a skull-cup and a broken ritual knife surmounted with the *vajra* finial.

WZ

164. Vasudhārā

Nepal. 16th century

Gilt bronze inlaid with coloured stones. Height 17 cm. Given by D.R. Hay Neave, Esq. OA 1956.12–10.8

The Indian texts describe Vasudhārā, goddess of abundance and consort of Jambhala, god of riches, as two- or six-armed. In Nepal a six-armed form makes an early appearance and shows few variations. In this example, reading clockwise, one hand makes the gesture of giving, the next holds a jewelled stalk, and the third is raised in salutation; on the right are a book, a stalk of rice and a bowl held in the lap. The right foot rests beside a pot of plenty.

WZ

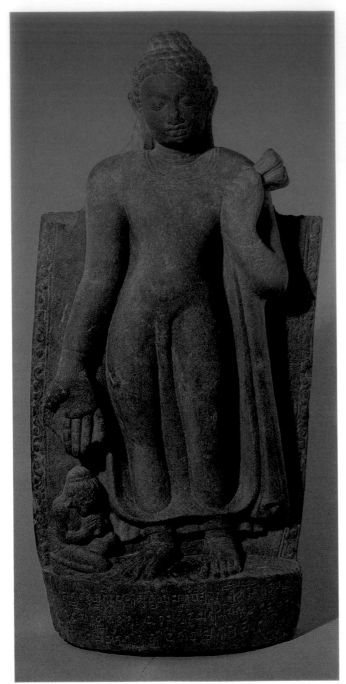

160

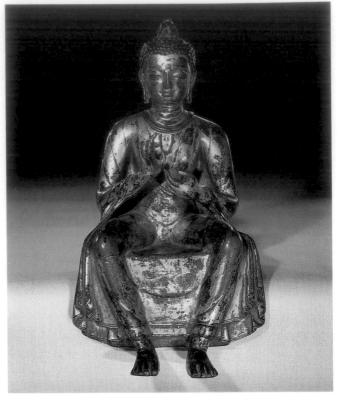

161

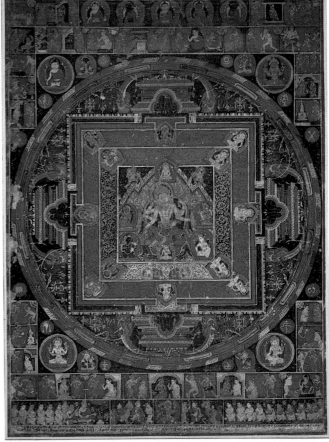

165

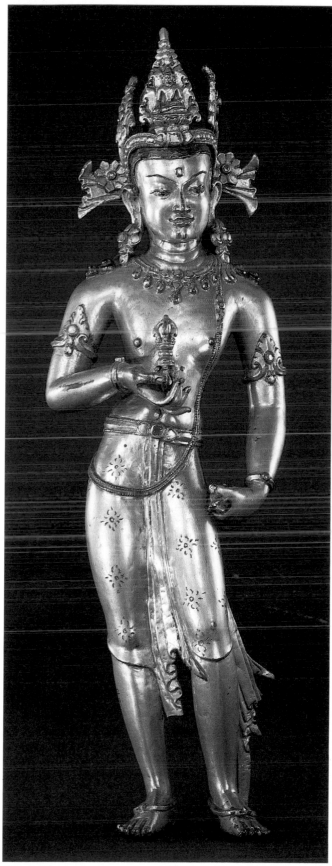

162

174

175

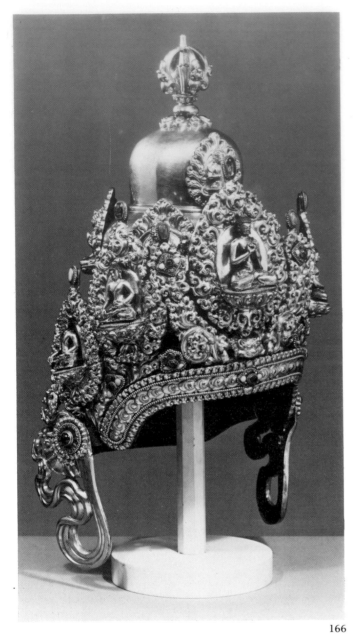

166

167. Manuscript of the Perfection of Wisdom

Nepal, Śrī Hlam monastery. 1015

Pothī manuscript of *Aṣṭasāhasrikā Prajñapāramitā* in Sanskrit. Transitional *Siddhamātṛkā* script, copied by Sujātabhadra. Ink and gouache on palm leaves, gouache on wood. 223 folios. 5.25 × 54cm. Cambridge University Library (Add. 1643)

This is the earliest illuminated manuscript from Nepal, important for its variety of miniatures, each accompanied by a note, with the name of the divinity and its place of worship. Most places are in eastern India and Nepal, but some are in China, Java, Sri Lanka, western and southern India.

f.20b. (Left) the Buddha, Dīpaṅkara, who saves from the monsters of the deep; (right) the Buddha from Puṇḍavarddhana (west-central Bengal).

f.74b. (Left) the Buddha expounding the Doctrine to five Bodhisattvas; (right) Tārā, on the Potalaka mountain.

f.89a. (Left) Lokanātha, on the Kūṭaparvata mountain in Gandhara; (right) Vajrapāṇi, from Uḍḍiyāna (Swat valley).

f.127a. (Left) Samantabhadra, as worshipped in China; (centre) Lokanātha, from Rāḍhya; (right) the Aśokan *stūpa* and pillar at Rāḍhya (north Bihar) and its monastery.

f.147a. (Left) Lokanātha; (right) Avalokiteśvara with 1,000 arms from Śivapura in the Konkan.

f.169a. (Left) a *stūpa* in Oḍradeśa (Orissa), with its parasol staying aloft miraculously; (right) Tārā from Tārāpura in Lāṭadeśa (Gujarat).

f.176b. (Left) the sixteen-armed Cundā from Paṭṭikera(?); (right) the *stūpa* of Mṛgasthāpana in Varendra (north Bengal).

f.200b. (Left) Vasudhārā from Kāñcīpuram (in Tamilnadu); (right) Mārīcī, the dawn goddess, from Uḍḍiyāna.

The covers of this manuscript were added later. A manuscript in the Cleveland Museum dated 1117 has close parallels with the female figures of one cover which shows seven of the Pāramitās. These, extremely beautiful, are iconographically quite distinct from the orthodox representations of the Perfections on, for example, no.171, apart from Prajñāpāramitā. The other cover shows seven Bodhisattvas who may be identified as (left to right): Maitreya, Samantabhadra, Candrapabha, Avalokiteśvara Ṣaḍakṣarī, Jālinīprabha, Gandahasti and Sāgaramati. This cover is smaller and perhaps not the original. JPL

Illustrated on pages 118, 119

168. Manuscript covers of the Buddha and Prajñāpāramitā

Nepal. Late 11th century

Gouache on wood. Each 5.5 × 54cm. Cambridge University Library (Add. 1464)

On both covers a central formal group of three divinities is flanked by informal groups of Bodhisattvas. On one, the Buddha is teaching between Avalokiteśvara and Mañjuśrī, with five Bodhisattvas on each side, including perhaps Sāgaramati (yellow, with shells) and Gandahasti (green, with an

166. Ritual helmet

Nepal. Dated to 1677 (Nepal era 797)

Gilt copper set with coloured stones. Height 76cm.
Victoria and Albert Museum (IS 5–1946)

This type of helmet is still worn by Vajrācāryas at ceremonies. It consists of three domes, like tiered *stūpas*, and, at the back, below an engraved knotted band, is a dated inscription invoking Vajrasattva. Medallions on the domes show Bodhisattvas; the top is surmounted by a five-pronged half-*vajra* rising out of a pot on a lotus. In front a detachable tiara, enhanced with inlaid coloured stones, shows the five Dhyāni Buddhas, their chief, Vairocana, in the centre, and each framed by scrolling. WZ

elephant's trunk). On the other, Prajñāpāramitā with Green Tārā and six-armed Vasudhārā occupy the central panel, Jambhala is on Tārā's right with a *gandharva* (musician) beside him, and on Vasudhārā's left possibly a white Ganda-hasti, Amitaprabha (green, with a jar of nectar), and Kubera (red with a money-bag).

These covers are related to a pair in the Musée Guimet, Paris, and to a vanished cover formerly in the Roerich collection. They must be dated close to the Calcutta *Prajñāpāramitā* manuscript of 1071; their elegant, svelte figures, exquisite modelling and compositional imagination represent the highest point of Nepalese manuscript illustration. JPL

Illustrated on page 119

169. The First Sermon

Nepal. *c*.1100–30

Manuscript cover. Gouache on wood. 5 × 55.5cm. OMPB Or. 14189

The Buddha, enthroned in the gesture of teaching or setting in motion the Wheel of the Doctrine, has intent flanking listeners. Their individually drawn faces, and the grizzled appearance of the one on the Buddha's right, suggest portraits of real monks. JPL

Illustrated on page 119

170. Three protective goddesses

Nepal. *c*.1130–50

3 folios from a *pothī* manuscript of *Pañcarakṣā* in Sanskrit. *Nāgarī* script. Ink and gouache on palm leaves. 5.5 × 29.5cm. OMPB Or. 14000

Four of the five miniatures survive. The miniature of the goddess usually stands at the beginning of her hymn, but here Māyūrī and Sitavatī begin theirs, while Mantrānusāraṇī ends hers, the colophon folio. Pratisarā occupies its obverse, though her hymn ends on the same folio on which Māyūrī's begins.

The Rakṣā goddesses have three or four heads, six to twelve arms, and carry appropriate weapons to repel enemies. They are, however, represented, with the exception of Sāhasrapramardanī, as beautiful young girls. The two best preserved, Māyūrī and Sitavatī, are exquisite creations of 12th-century Nepalese art. Māyūrī's special attributes (jewels poured from a pot, a standard decorated with peacock feathers, and a lotus surmounted by a bowl with a monk on top) and her crown and jewels, and those of Sitavatī are superbly rendered. JPL

Illustrated on page 128

171. Scenes from the life of the Buddha and the Pāramitās

Nepal. Mid–12th century

2 manuscript covers. Gouache on wood. Each 6 × 55.5cm. Bodleian Library (MS Sansk.a.7 (R))

These two covers exemplify the mid 12th-century Nepalese style. The supreme elegance of late 11th-century work was replaced by a more solid treatment of flesh, rounder features, an occasional squatness in seated figures, and even glibness in the attendant figures. The alternation of panels of blue and red ground found from this period tends to inhibit individual creativity. The Neotia covers, which may be assigned to the second quarter of the 12th century, stand at the beginning of all these trends, while the Swali covers come between the former and these Bodleian covers. The *Vessantara Jātaka* cover of the National Museum, New Delhi, may then be dated slightly earlier than the Neotia covers (*c*.1100–20).

The lower cover shows the Eight Great Events centred on the Temptation with, additionally, the heretics sticking spikes into the Buddha's ears. Five lions spring from the Buddha's fingers as he tames the elephant Nālāgiri (fourth from left). The upper cover shows Prajñāpāramitā enthroned, surrounded by the other nine Pāramitās, and with the Green Tārā on the far right. Prajñāpāramitā is represented here as usual. All the other Pāramitās are given their appropriate colour, holding in their right hands a jewel, and in the left their attribute. Their representation accords so precisely with the iconographic pattern laid down in the almost contemporary *Niṣpannayogāvalī* of Abhayākaragupta of Vikramaśila that a direct connection is probable. Such agreement is usually rare. JPL

Illustrated on page 130

172. Scenes from the life of the Buddha

Nepal. *c*.1150–75

Manuscript cover. Gouache on wood. 5.3 × 58cm. OMPB Or. 14034

The inner surface illustrates seven scenes from the Buddha's life, centred on the temptation by Māra. Three of the other six are not among the Eight Great Events, and show the Bodhisattva cutting off his hair, being offered rice-pudding by the housewife Sujātā, here depicted as a beautiful girl, and attacked by two cowherds who stick pegs into his ears for not tending their cattle. JPL

Illustrated on page 119

173. Manuscript of a hymn to Vasudhārā

Nepal. 1184

Pothī manuscript of *Vasudhārādhāraṇī* in Sanskrit. *Siddhamātṛkā* script. Gold and silver ink and gouache on deep blue paper. 21 folios. 9 × 26cm. OMPB Or. 13971A

This manuscript, extolling the goddess of wealth Vasudhārā, was the pious gift of the Buddhist layman Lakṣmaṇacandra. The two miniatures depict the Buddha teaching flanking Bodhisattvas and the six-armed Vasudhārā, both seated on

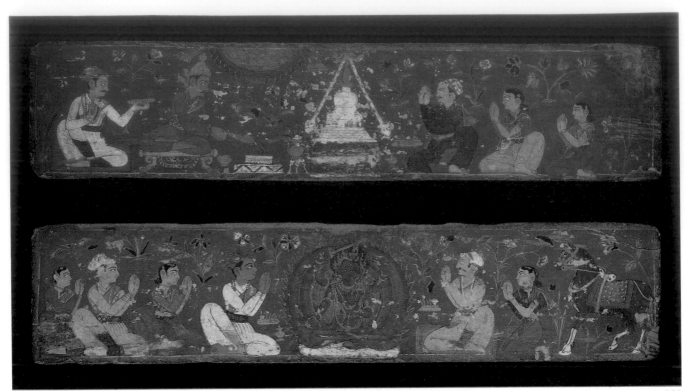

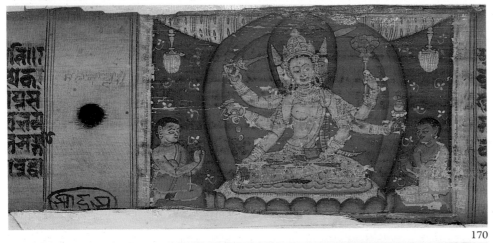

180

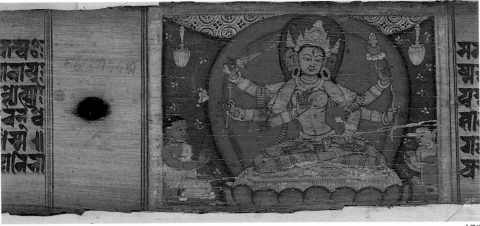

170

170

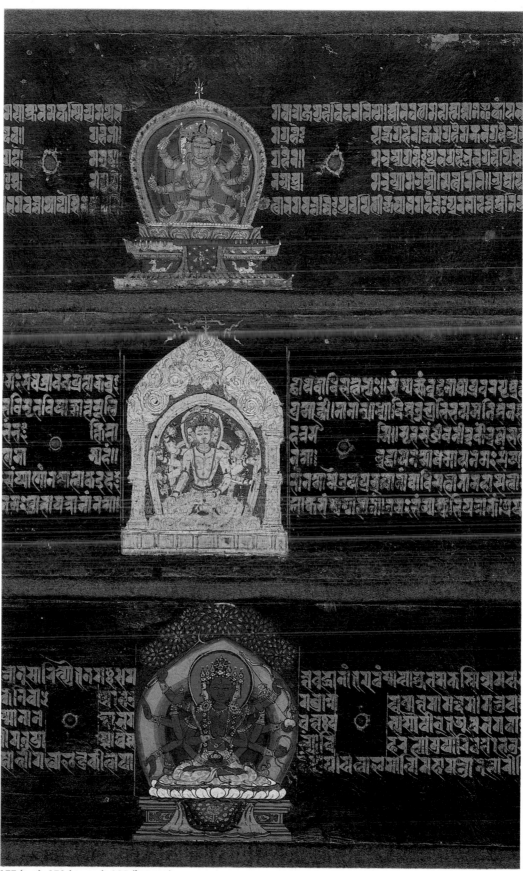

177 (top), 178 (centre), 182 (bottom)

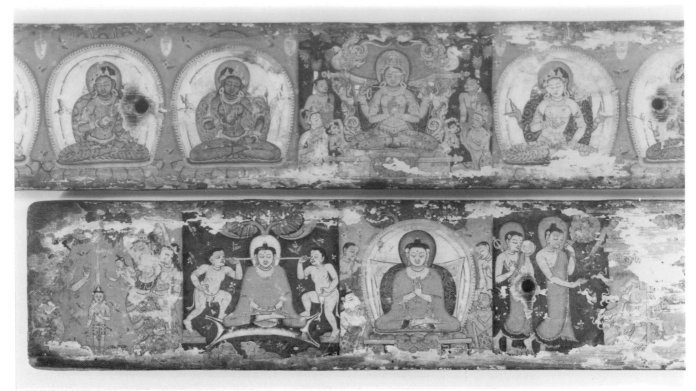

171

lion thrones. The simple composition of the former contrasts with the brilliantly organised bustle of the latter, where Vasudhārā is flanked by Avalokiteśvara and Vajradhara, an elaborate throne-back and *toraṇa* behind, while above, two *yakṣas* pour money from large bags. This Vasudhārā is unique in contemporary manuscript painting. Normally space is lacking for more than the image of the goddess herself (see nos 157,167). Here, however, the composition corresponds to the central image of various later Nepalese *paubhas* of the Vasudhārā *maṇḍala* (see no.165). JPL

Illustrated on page 121

174. Manuscript of a litany of the names of Buddha

Nepal. 1184

Pothī manuscript of *Paramārthanāmasaṃgīti* in Sanskrit. *Siddhamā-tṛkā* script. Gold and silver ink and gouache on deep blue paper. 28 folios. 9 × 26 cm. OMPB Or 13971B

Though undated, this belongs to the same *pothī* as the *Vasudhārādhāraṇī* (no.173), and the same scriptorium. There are four miniatures: the Buddha in teaching mode inside a five-spired shrine; the Jina Vairocana in *bodhyagrī mudrā* (tips of thumbs and forefingers together) against his symbol, the *cakra*, whose spokes are formed here most imaginatively by four crossed *vajras*; the Bodhisattva Nāmasaṃgīti, the personified divinity of the text, with twelve arms; Yamāntaka or Black Yamāri, the conquerer of death (Yama), with six faces, eight arms and six legs standing on the back of a

terrified, crouching buffalo (the vehicle of Yama), crushed under the god's weight. JPL

Illustrated on page 125

175. The Rakṣā goddess Pratisarā

Nepal. *c.*1200

Folio from a manuscript of *Pañcarakṣā* in Sanskrit. *Siddhamātṛkā* script. Silver ink and gouache on deep blue paper. 9 × 35 cm. OMPB Or. 14032

A single folio from a manuscript of a *dhāraṇī* to Pratisarā, the most important of the Rakṣā goddesses, who protects against sin and disease. As it is numbered 2, opposite her on f. 1b would have been her corresponding Jina, or 'parent' Buddha, Vairocana. The whole manuscript would have been very impressive, written in silver ink with comparatively large-scale illustrations. JPL

Illustrated on page 125

176. The Buddha with attendant Bodhisattvas and Acala

Nepal, under Indian influence. c.1400
Manuscript cover. Gouache on wood. 6 × 29cm. OMPB Or. 14134

Two Buddha images are shown here, in the earth-touching gesture, and in the gesture of reassurance. They wear patch-work robes but lack *ūrṇā* and *uṣṇīṣa*. Avalokiteśvara and, possibly, Maitreya are among the attendant Bodhisattvas. The half-kneeling figure is Acala or Caṇḍamahāroṣaṇa. The cover seems Nepalese, but with Indian features. The architectural setting with here the roof outlines filled with floral scrollwork is more typical of Pāla than Nepalese work. The ends of the *dupaṭṭa* or scarf worn by the divinities float outwards in a manner typical of Indian work, both Pāla and later. Possibly the artist had seen recent Indian Buddhist work which was still going on in India as indicated by no.88 of 1446. JPL

Illustrated on page 121

177. Manuscript of the Five Protective Hymns

Nepal, Dharmacandra [=°cakra?] monastery, Kathmandu. 1511
Pothī manuscript of *Pañcarakṣā* in Sanskrit. *Rañjanā* script, copied by Vajrācārya Jayasīharāja. Gold and gouache on deep blue paper. 137 folios. 9.5 × 31.5cm. OMPB Or. 12593

This manuscript was commissioned by Abhayarāja, who lived with his family in the Dharmacakra monastery beside Jamaleśvara (just north of the Rānī Pokharī in Kathmandu), and his two younger brothers and their families, in memory of their parents. Originally it had miniatures of all the Rakṣās and their Jinas, but only Śitavatī (who protects against inauspicious planets, wild animals and unpleasant insects) and her parent Buddha Amoghasiddhi have survived as a pair. JPL

Illustrated on page 129

178. Manuscript of the Five Protective Hymns

Nepal, Maṇisaṅgha monastery, Kathmandu. 1512
Pothī manuscript of *Pañcarakṣā* in Sanskrit. *Rañjanā* script, copied by Vajrācārya Jinacandra. Gold and gouache on deep blue paper. 115 folios. 9.5 × 32cm. OMPB Or. 13651

The manuscript was commissioned in memory of the Śākyabhikṣu (literally, a Buddhist monk, but by this date simply a caste of Buddhists) Lakṣmīrājacandra by his wives Dhanalakṣmī and Kamalalakṣmī, his son Raghurājacandra and his wife and other members of the family, whose home was in the Jamaleśvara monastery in the Kelam Tol in Kathmandu. Another hand adds that in 1777 the manuscript was a pious donation by Vajrācārya Amṛtapati of the Tarumūla monastery (next to the Kumārī house in the Darbar square). The five goddesses are painted almost entirely in gold, with coloured details. Exhibited is Māyūrī, the Peacock Goddess, who wards off snakes. JPL

Illustrated on page 129

179. Manuscript of the Five Protective Hymns

Nepal, Kathmandu. 1532
Pothī manuscript of *Pañcarakṣā* in Sanskrit. *Bhujiṃmolī* script. Ink and gouache on palm leaves, gouache on wood. 132 folios. 5 × 32.5cm. OMPB Or. 2205

A manuscript commissioned by the Śākyabhikṣu Lakṣmaṇasiṃhapāla as a pious offering. The colophon's details are now almost unreadable, but the donor and family are depicted on the lower cover, engaged in a ritual with a crowned Vajrācārya. The miniatures of the goddesses are simpler in style than the cover portrait. Exhibited is Sāhasrapramardanī, the Great Lady who strikes 1,000 times, who alone is depicted as a fearsome divinity. She kneels on two terrified men who are both her vehicle (*vāhana*) and the obstacles she protects against (*vighna*) – she is particularly invoked against evil spirits. JPL

Illustrated on page 121

180. Manuscript of the Five Protective Hymns

Nepal, Tarumūla monastery, Kathmandu. 1659
Pothī manuscript of *Pañcarakṣā* in Sanskrit. Newari script, copied by Kuśaladeva Vajrācārya Mahāpātra. Ink and gouache on yellow paper, gouache on wood. 127 folios. 8 × 36cm. OMPB Or. 13852

Although commissioned by the Śākyabhikṣu Jakerāja and family, who lived in the Paśupati monastery in Bhatgaon, the manuscript was written in the Tarumūla monastery in Kathmandu. Miniatures of the goddesses are accompanied by their respective Jinas or 'parent' Buddhas (here Amoghasiddhi accompanies Sitavatī, both seated on the Garuḍa bird, half-man, half-eagle) and painted in traditional Nepalese style. The manuscript has two covers with portraits of the donor and his family, apparently the earliest dated manuscript paintings in the new Indian influenced style. On one, Jakerāja and his wife Īrmnālakṣmī are shown worshipping a *stūpa* with another couple, doubtless the donor's parents, while a Vajrācārya pours from a ladle into a fire. On the other the donor, his wife, their two sons and their wives pay homage to Mañjuśrī Arapacana. JPL

Illustrated on page 128

181. Manuscript of the Five Protective Hymns

Nepal, Tarumūla monastery, Kathmandu. 1676
Pothī manuscript of *Pañcarakṣā* in Sanskrit. *Rañjanā* script, copied by Ācārya Vidrapatideva and Vajrācārya Vekhāsiṃha. Gold and gouache on deep blue paper, gouache on wood. 155 folios. 11.5 × 39.5cm. OMPB Or. 13946

This decorative manuscript includes miniatures of the five goddesses and their respective 'parent' Buddhas, and a full-page portrait group. The pairs are: Vairocana and Pratisarā, with their lion vehicles, and Hindu gods worshipping the goddess; Akṣobhya and Sāhasrapramardanī, he with his elephant vehicle and she trampling on two terrified males; Ratnasambhava and Māyūrī with their horse vehicles;

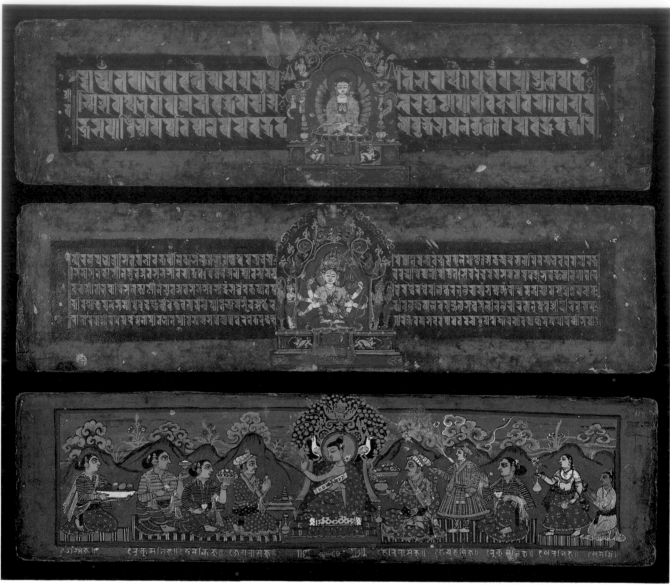

181

Amoghasiddhi and Sītavatī with their Garuḍa vehicles; and Amitābha and Mantrānusāraṇī with their peacock vehicles. The donors, the merchant (*turadhāra*) Jayarāma and his wife Rukmaṇī and their family, who lived in Suvarṇapraṇāli, the northern half of Kathmandu, extend offerings to the Buddha in the full-page donor portrait. Indian influence shows in costume, full profile and uncluttered composition, Tibetan influence in the depiction of landscape with cloud-topped mountains. JPL

182. Manuscript of the Five Protective Hymns

Nepal, Duganabahiṣa monastery, Kathmandu. 1684

Pothī manuscript of *Pañcarakṣā* in Sanskrit. *Rañjanā* script, copied by Viśvācārya Devana. Gold and gouache on deep blue paper. 151 folios. 8.5 × 36 cm. OMPB Or. 11124

The manuscript was commissioned by Munideva Bhāro and his family in memory of his father Jayakuśala, and he describes himself as the first son of Mātālakṣmī Gitā Rāṇī who lived in the Sāracche *tol* in Kathmandu. Munideva claims to have been an architect who built structures at the Tashilhunpo monastery in Tibet. The five miniatures of the goddesses are in Tibetan style, with spindly arms and flat treatment, painted in Kathmandu by a Tibetan artist or a Newar trained at Tashilhunpo. Each has a different tree (the trees of the five last Mortal Buddhas), part of the elaborate symbolism associated with the goddesses but not represented pictorially until the 17th century. Here Mantrānusāraṇī is associated with the *śirīṣa* tree (*Acacia sirissa*). JPL

Illustrated on page 129

Tibet

Buddhism, introduced into Tibet in the seventh century, met resistance until the so-called Second Propagation from the late tenth century, when native elements merging with the forms of eastern Indian and Kashmir Buddhism produced a remarkable culture in which Indian traditions flourished. The greater monasteries became landowners and abbots were chosen by a system of succession by incarnation. From 1642 nobility and monks administered the country under a supreme pontiff, the Dalai Lama. There were over 3,000 monasteries with perhaps a quarter of the population monks or nuns, and the dominant sect in the last centuries was the dGe-lugs-pa (Yellow Hats). Tibet, now secularised, is an Autonomous Region of the People's Republic of China.

In south and central Tibet metal sculpture and painting followed eastern Indian and Nepalese models, and Newar craftsmen were employed. Stone carving, except in low relief, is hardly known, but cloth and wall-painting became highly developed. In the west Kashmir influence was strong, but here too eastern India made itself felt. A Tibetan style was

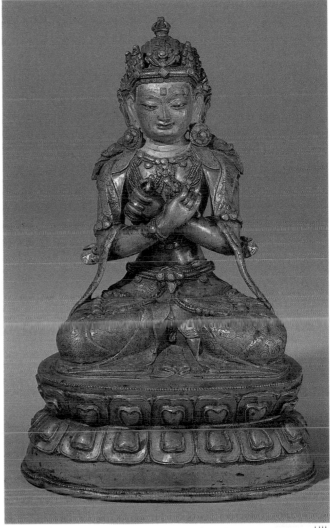

186

born out of a mixture of influences which included the Chinese from an early period.

As in Nepal a great heritage of meditational practice used images and paintings to induce mental states to bring the practitioner into a mystical union with a chosen divinity representing Buddhahood and the Absolute, but rites also aimed at material advantage, or expressed simple devotion. The Indian *maṇḍala* lived on and can be interpreted only through a knowledge of the almost limitless variations of iconography.

Although there were married monks, the tradition of celibacy was maintained and a strict propriety demanded by reformers throughout Tibetan religious history. The sects differed in practice and emphases, but there was no great hostility between them. Scholars of one sect studied the writings, and were initiated into the practices, of other sects, and monasteries were not always exclusive. Most families sent a child

A Tibetan monk with his rosary at the Svayambhūnāth Stūpa, Kathmandu, Nepal. (Photo Graham Harrison)

into the religious life very young. Monks of the smaller monasteries acted as village priests, and those from the larger establishments were in demand as teachers.

Most Tibetan houses or tents contained altars. Money was willingly spent on commissioning books, images, ritual implements and ceremonies to increase one's own or another's stock of merit. The vast production of Tibetan religious art in the last stages of what has been called Lamaism, the religion in which the lama or teacher had enormous power, became increasingly standardised, but its two main influences, Nepalese and Chinese, continued to be identifiable. WZ

183. Akṣobhya

Tibet. 12th-13th century
Bronze with silver and copper inlay with coloured stone.
Height 32 cm. Brooke Sewell Fund. OA 1981.11–9.1

One of the earliest distinctive Tibetan bronzes, this monumental figure represents a development of the eastern Indian tradition. It recalls Kurkihār bronzes and painting from Karakhoto, probably a Tibetan adaptation from the lost eastern Indian tradition of cloth painting. Akṣobhya was a preferred

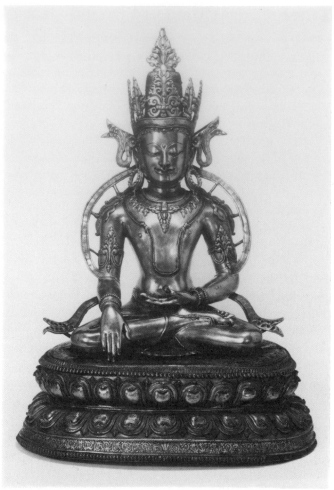

184

principal deity in eastern India during the second evangelisation of Tibet. On the back of the image are the three Tibetan syllables for body, speech and mind, and the Buddhist creed in Sanskrit in a curious form of Indian character. A tenon projects below the shallow double lotus base indicating another plinth. WZ

184. Akṣobhya

Tibet. 14th century AD
Brass. Height 54.5 cm. Brooke Sewell Fund. OA 1984.1–26.1

Seated on a more recent base, this crowned and ornamented figure, like no. 183, derives from eastern Indian traditions but is even more distinctively Tibetan. Many similar bronzes are recorded, with a prominent semicircular scarf sometimes attached by struts, as here, and twisted round the forearms. The scarves have Indian antecedents on Bodhisattvas and other deities and also occur in Central Asia and China. It would seem that the scarves usual on crowned and ornamented Bodhisattvas have been extended to the crowned and ornamented Dhyāni and Ādi Buddhas of Tibet, but on stylistic evidence it is less certain that this feature proves a western Tibetan origin as is often supposed. WZ

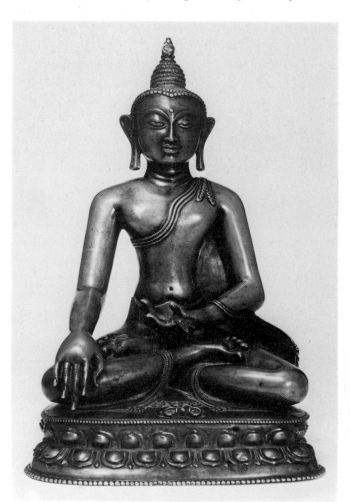

183

185. Teaching figure

Tibet. 15th century or later
Bronze with silver and copper inlay. Height 36 cm. Brooke Sewell
Fund. OA 1979.7–26.1

This imposing portrait figure with unappealing, if memorable,
features is uninscribed but can be plausibly identified. Other,
inscribed, bronzes, including one in the British Museum,
with the same large jaw bear invocations to Phyogs-las rnam-
rgyal of Bodong (1306–86), a celebrated scholar of the Jo-
nang-pa philosophical school, who is credited with a large
literary output and control of various monasteries. This image
may have been produced soon after his death; that it was
highly regarded is clear from its three castings, the original
head and torso and two additions or repairs below. WZ

186. Vajradhara

Tibet. 15th–16th century
Bronze with silver and copper inlay. Height 24 cm. Bought from the
Brooke Sewell Bequest. OA 1979.5–14.1

The Supreme (Ādi) Buddha was represented both as Vajrasattva
and Vajradhara but they are iconographically distinct
(cf. no. 162). Always crowned and ornamented, Vajradhara
holds the *vajra* and *ghaṇṭā* before him, wrists crossed. Here
his crown, necklaces and breast ornaments, armlets and
bracelets all have silver inlay; he wears patterned upper and
lower garments, the latter secured by a silver-inlaid girdle.
Both garments seem to have an inner lining to judge from the
copper inlay where they are folded back. The face, with
silver-inlaid eyes and copper lips, is gilded and the hair
painted blue in the Tibetan tradition. Stylistically there is
some affinity with the Sino-Tibetan bronzes of the 15th
century. WZ

Illustrated on page 133

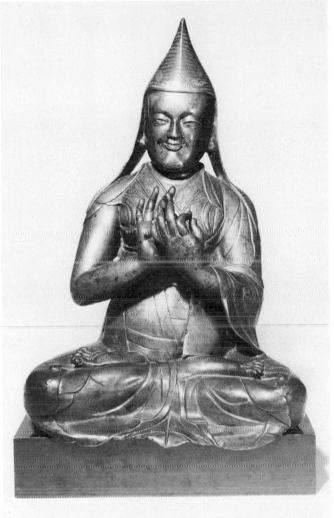

185

187. Tārā

Tibet. 17th–18th century
Brass and silk. Height 15 cm. Bequeathed by Sir Charles Bell.
OA 1946.12–17.3

Tibetan images in worship were commonly clothed, draped
with scarves and painted. This image wears a fringed apron
and a tippet, or cloud collar, each a patchwork of silk brocade
enhanced with gold thread and lined with silk. The Hindu
practice of dressing images must have a common origin. The
face is painted the usual gold with features picked out, and
the head-dress the blue of peaceful deities with ornaments in
gold and red. WZ

188. Padmasambhava

Tibet. 18th century
Gilt copper and brass. Height 38 cm. Given by C.A.W. Oldham, Esq.,
as executor for Lady Holmwood. OA 1942.4–16.1

Padmasambhava is a deified teacher considered a second
Buddha by the rNying-ma-pa sect. Said to have visited Tibet
in the 8th century, he brought Tantric practices when another
Indian master was establishing orthodox monasticism. The
tradition of turning 'tamed' native deities into protectors of
Buddhism is supposed to have started with him. Padmasam-
bhava is popular with the older sects and has numerous
manifestations. This very common form shows him with
vajra and vase of life but lacks the lost *khaṭvāṅga*, or *yogin's*
staff. On his hat is the sun-moon symbol of transcended
duality and a peacock feather. WZ

187

189

188

191

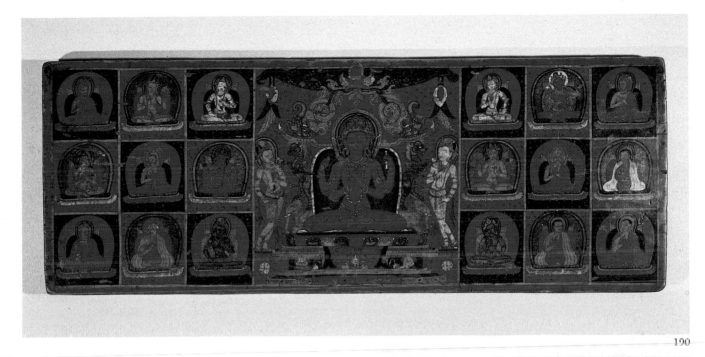

190

189. Rol-pa'i rDo-rje

Tibet or Peking. 18th-19th century

Painted clay. Height 8 cm. OA 1880–161

The impressed plaques of later Buddhist India may have inspired the common and varied stamped talismans (*tsha-tsha*) which Tibetans produced in quantity from metal moulds and enshrined or carried in bags or boxes. The figure shown corresponds to illustrations of Rol-pa'i rDo-rje (1717–86), the Hutuktu, or incarnation in charge of the Lama temple in Peking. An incarnation – more strictly emanation – of Mañjuśrī, he carries Mañjuśri's sword and book on flanking lotuses, while his right hand is raised in reassurance and the other holds the vase of life. WZ

190. Painted bookcover

Tibet. 13th century

Wood. 27 × 71 cm. Brooke Sewell Fund. OA 1973.5–14.1

The wonderfully preserved painted face of this bookcover is its inner side; the outer, slightly convex, is carved with Buddhas. The style of painting derives from Nepal and eastern India, but the cover is Tibetan. The limited size of the oblong Indian and Nepalese palm-leaf pages was increased by the Tibetan use of paper, and wooden covers were correspondingly enlarged. The central deity is Prajñāpāramitā, or the Perfection of Wisdom, representing a central conception of Mahāyāna Buddhism, and the cover may have belonged to a Perfection of Wisdom text. The figures beside the goddess are Bodhisattvas and monks; the latter include what look like portraits of living or recent teachers whom it may be possible to recognise from other sources. WZ

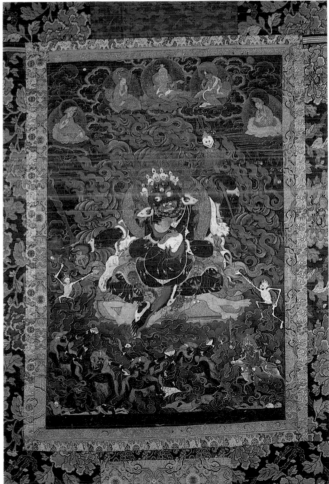

193

191. Kanakavatsa

Tibet, from a ruined monastery at Shigatse. 14th century
Painting on cloth. 57 × 44 cm. OA 1955.4–16.029

An Indian tradition greatly developed in Central Asia, Tibet and the Far East was the conception of a number of *arhats* who remained in the world to defend the Doctrine. Among such *arhats* the sixteen with two attendants were very popular in Tibet. Prayers were said to them and they were credited with many miracles.

Bearded and haloed, Kanakavatsa sits bent slightly forward, his luminous eyes large and prominent. An attendant carries a bag and an Indian adorant offers coral. In the characteristically Chinese background a mountainous mass of green and blue inclines in the opposite direction to the *arhat*'s posture; a waterfall descends beside him, and a large tree fills the space created by the slope of the mountain. Such strongly Chinese forms in a Tibetan painting reflect the intimate relationship created by the conversion of Kublai Khan to Tibetan Buddhism and the political favour extended to the sect he followed.

There are many legends about Kanakavatsa whose attribute, a string of precious stones, grants understanding of the Buddhist doctrine. Born in Bihar, he is considered to live in Kashmir with his retinue of 500 *arhats*. WZ

Illustrated on page 136

192. Samvara

Tibet. 18th century
Painting on cloth with silk border. 1.6 × 1.27 m. OA 1957.4–13.01

The form of Samvara in this painting has a female partner, unlike no. 152. He is blue with yellow, blue, green and red heads and his partner is red. The colours are significant and laid down in the texts. The god carries the same attributes as the bronze, though they are now more Tibetan in form, while his partner has the chopper and presumably the skull-cup. Above are Dīpaṃkara, Śākyamuni and Maitreya in his Buddha form on the right, and, below, the Buddha of Long Life is flanked by the Green and White Tārās. WZ

Illustrated on page 140

193. Mahākāla

Tibet. 19th century
Painting on cloth. 1.55 m × 91.5 cm OA 1949.11–12.01

Mahākāla (cf. no. 149), seated on a naked figure as Protector of Science, holds a blood-filled skull-cup, a fruit instead of the chopper, and the usual sword and wand with a trident above a skull. He is blue with a crown of skulls below erect and billowing hair, and from his waist hangs a garland of severed heads. Skeletons dance, and below are four bird-beaked goddesses with choppers and skull-cups and the protectress Lha-mo (Śrī Devī) on her mule. At the top is the *siddha* Saraha holding the arrow symbolising his swift comprehension; beside him are the Indian scholar Ñāgārjuna and the *siddha* Ña-lto-pa or Lui-pa, flanked in their turn by the

first Panchen Lama and Ngag-dbang Byams-pa, a literary assistant of the Fifth Dalai Lama. WZ

Illustrated on page 137

194. Edict

Tibet, Tashilhunpo. 1775
Illuminated text on yellow silk. 2.18 m × 75 cm. OMPB Or. 14067

Tibetan edict (*bka'-shog*) in scroll form with interlinear Mongolian translation issued by the Third Panchen Lama, Blo-bzang dPal-ldan Ye-shes (1738–80). It constitutes a passport authorising safe travel within and beyond Tibet by the monk for whom it was issued and invites donations on the occasion of a monastic degree-giving ceremony. It was issued at the behest of the Abbot of dGa'-ldan monastery, whose predecessor had been a special teacher of the Seventh Dalai Lama who had taught the Third Panchen Lama. The central figure above represents Tsong-kha-pa with two disciples and beneath (left) the Third Panchen Lama and (right) the Seventh Dalai Lama. The goddess above them is the White Tārā and, from left to right, are the protector deities Vaiśravaṇa, Śrī Devī, Mahākāla, Yamarāja and Beg-tse. LC

Illustrated on page 143

195. Gayadhara

Tibet. 19th century
Painting on cloth with silk border. 1.09 m × 72 cm.
OA 1980.12–20.03

The dominating and haloed Gayadhara was an Indian master who brought the teachings of Buddhism to Tibet in the early 11th century. His Indian origins are clearly indicated by the beard and colour of his skin contrasting with his robe and the skin of the kneeling Tibetan below. He wears a decorated red pointed cap of the old Tibetan monastic type. Gayadhara was the teacher of 'Brog-mi, a founder of the Sa-skya-pa tradition, and is said to have been induced by large monetary rewards to part with his knowledge, represented by the Indian palm-leaf book in front of him. His right hand is in the gesture of exposition, while his left holds a rosary. A holy water vase stands beside the book; below, a goat makes an offering of fungus, symbolic of long life. The landscape is Chinese with an overhanging canopy of rocks and various auspicious plants.

WZ

Illustrated on page 142

196. Bookcover

Tibet, said to be from the Gyantse Jong monastery. 17th century AD
Wood, painted. 27 × 73 cm. OA 1905.5–19.86

An outer face with a flat central compartment bordered by a sloping edge is carved with figures of deities, scrolling, animals and Buddhist symbols. The central figure is the Buddha Vairocana; on the left is Vajrasattva and on the right the saviouress Tārā. The scrolling on the flat panel emerges from two lions' tails; below, it terminates in two confronted lions.

In the upper border the monster head symbolising fertility is connected with the scrolling which contains the eight auspicious Buddhist symbols. WZ

Illustrated on page 142

197. Printing block with impression

Tibet. 19th century (?)
Wood. 58.3 × 20 cm. Bequeathed by H.G. Beasley, Esq.
OA 1948.7–16.19

This printing block is carved on both sides but only one has illustrations. The upper shows the Buddha Vairocana flanked by monks, the lower the goddess of the text flanked by attendants. The text is a *dhāraṇī*, or spell, called after the goddess Aparājitā Sitātapatrā, the Victorious White Parasol over the cranial bump of all the Buddhas. In the illustration she lacks the parasol and carries instead, in her six hands, bow and arrow, goad and noose, and wheel and *vajra*. She is said to preserve from the ill effects of planetary misfortune and belongs to the 'family' of Vairocana. According to the text (translated from the Sanskrit), the spell issued from the Buddha's *ūrṇā*. WZ

197

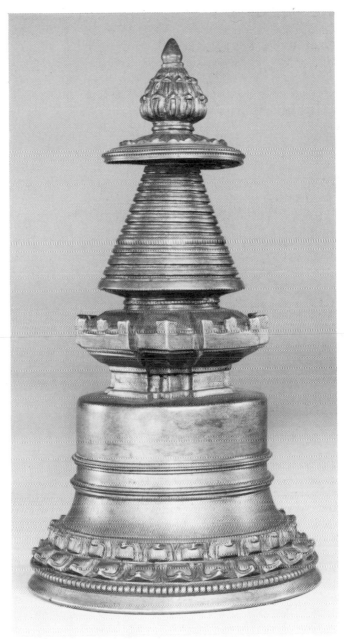

198

198. Stūpa

Tibet. 12th century or later
Brass. Height 21 cm. OA 1893.3–20.149

This model *stūpa*, now empty, is almost identical with a larger one in Newark Museum which was opened by a previous owner who meticulously investigated its contents; they were most varied and included barley grains, dated by radiocarbon to a mean of AD 1230, and drawings compatible with the same period. *Stūpas* of this type, having a double lotus base, a cylinder with two simple string-course mouldings, a splayed superstructure supporting a spire surmounted by a disc and closed lotus, are associated with the bKa'-gdams-pa sect which revived Tibetan Buddhism after the 11th century. WZ

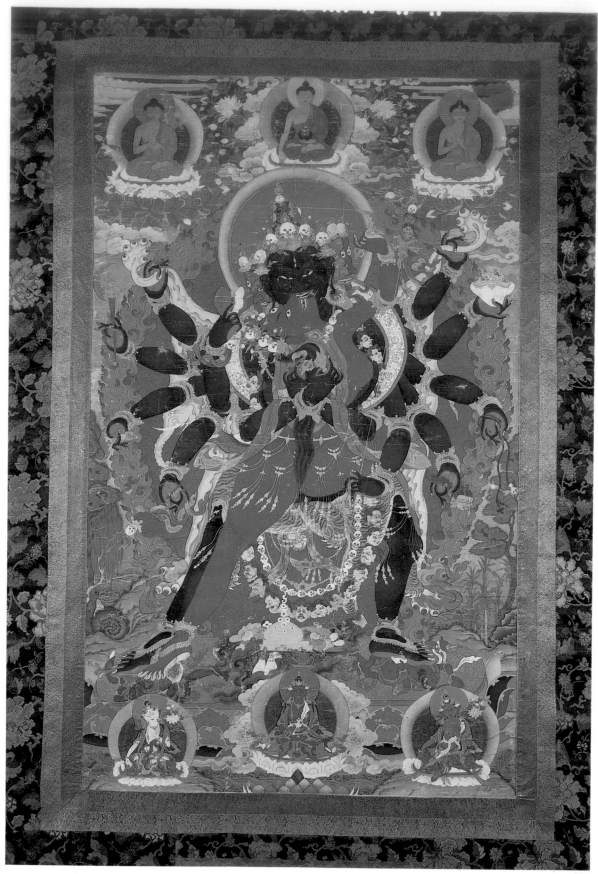

192

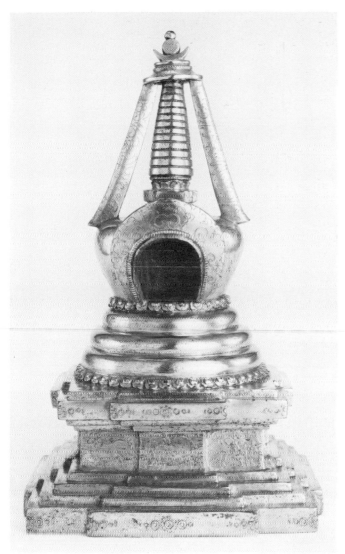

199

201

199. Stūpa

Tibet. 18th-19th century

Gilt bronze. Height 24 cm. Given by Sir A. W. Franks.
OA 1887.5–24.14

Different in many ways from no. 198, this *stūpa*, probably
also used as one of the ritual objects on an altar, incorporates,
above a stepped pedestal and indented rectangular base,
ancient dome and spire elements. Here the dome, in the
common Tibetan architectural form of an inverted pot, has a
niche which once held an image. The spire, with the usual
thirteen sections representing the stages to Buddhahood, is
crowned with the sun-moon and drop symbol of unified
opposites and has pennants at the sides. WZ

200. Shrine

Tibet. 19th century

Wood and clay, painted. Height 43 cm. Given by Mrs H.G. Beasley.
OA 1954.2–22.8

This wooden box has metal loops at the sides for easy transport
and may have belonged to a monk whose servant strapped it
to himself when accompanying his master. The interior holds
gilt clay plaques (*tsha-tsha*) representing the many-armed and
-headed Vajrabhairava, tutelary deity of the Yellow Hat sect,
the Buddha, the saviouress Tārā, and other deities and ec-
clesiastics. The inner faces of the doors are painted with
conventional offerings symbolising wealth. WZ

Illustrated on page 143

196

195

194

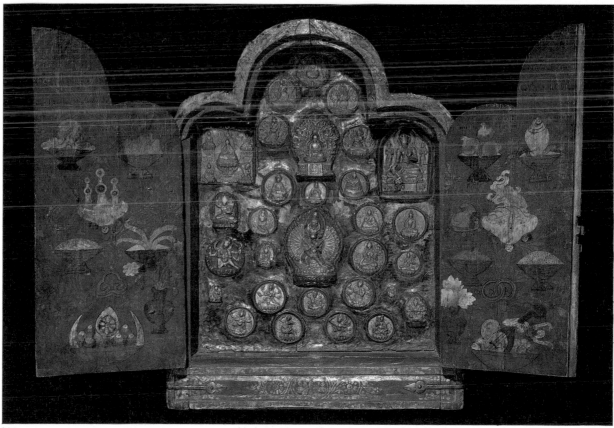

200

201. Wheel of the Doctrine

Tibet. 19th century
Silver, gilt copper and semi-precious stones. Height 37 cm.
Brooke Sewell Fund. OA 1983.4– 22.1

The wheel, an ancient symbol of sovereignty adopted by
Buddhism also to represent the Doctrine, had a long life. It
appears in Tibet, flanked by deer, over the Lhasa Jo-Khang,
or cathedral, and as altar furniture where it can be part of a set
of the Universal Monarch's attributes. This wheel consists of
twelve spokes, inlaid with turquoise and coral, a three-leaved
hub of coral, turquoise and lapis which symbolises constant
change, and a silver surround rising on a gilt foliate stalk from
a lotus pedestal. WZ

Illustrated on page 141

203

202. Vajra and ghaṇṭā

Tibet. 19th century (?)
Brass fire gilt and bell metal. Height 23 and 18 cm. Bequeathed
by H.G. Beasley, Esq. OA 1948.7–16.11

The *vajra* and *ghaṇṭā* were the most important ritual imple-
ments of Vajrayāna Buddhism. The *vajra*, symbolising the
unbreakable Absolute, hardly survives as a ritual object from
Buddhist India but is found in Indonesia, Nepal, Tibet and
Japan. Paired with the bell, it symbolised compassion or the
'male' skill in means for salvation; the bell was the symbol of
supreme knowledge seen as female. Together they constituted
a unity of coefficients for salvation. Held in the right and left
hands respectively to make elaborate ritual movements, they
are also the attributes of many deities. WZ

203. Prayer wheel

Tibet, collected at Darjeeling. 19th century
Silver and wood. Length 24.5 cm. Given by Mrs Margaret Lewin.
OA 1925.3–13.11

The portable prayer wheel contains a tightly rolled scroll
with block-printed invocations. The wheel is usually a metal
cylinder or drum rotated with the help of a metal weight
which sets up a centrifugal motion around a pin projecting
from the handle. The rotation of the wheel is the equivalent of
reading or reciting the invocations inside, and the effective-
ness of the act derives from the late Buddhist belief in the
power of sound and the formulas to which deities were
subject. WZ

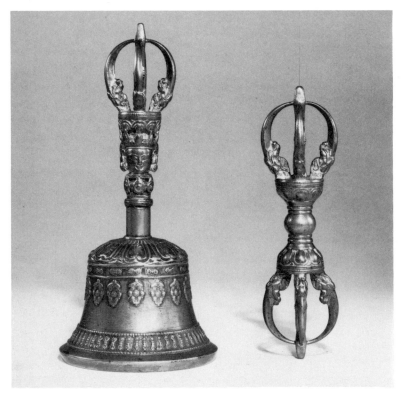

202

8 The Deccan and south India

Peninsular India south of the Vindhya mountains and the Narbada river consists of the Deccan, or the states of Maharashtra, Andhra Pradesh and Karnataka, and the south proper, or the states of Tamil Nadu and Kerala. These two divisions have a long historical and cultural justification. Buddhism is recorded as having been propagated south of the Vindhyas when the Council of Patna sent missions to Maharashtra and Karnataka (c. 250 BC).

The richest Buddhist remains are in the Deccan, chiefly cave temples and monasteries and *stupas* and monasteries in the open. In the west the excavations, in the second and first centuries BC, reproduced in the rock the free-standing wooden architecture now lost, enshrining *stupas*. The oldest surviving Buddhist paintings, on the walls at Ajanta, are of this period. On the east coast were free-standing *stupas*, temples and monasteries. Perhaps the most celebrated is the former *stupa* at Amarāvatī, ancient Dhānyakaṭaka, which stood on a drum 49 m in diameter, entirely covered with sculptured slabs; parts of the dome also had carvings. What survives is for the most part of the second and third centuries AD.

Also in the east is the site of Nāgārjunakoṇḍa (third to fourth centuries), a rich complex of *stupas*, *stupa* halls, image chapels and monasteries. Both sites show the transition from symbol to Buddha image and carry inscribed dedications by members of a variety of sects, most of them either Mahā-sāṃghika or their Āndhra offshoots. The Buddhist art in this region influenced Sri Lanka and South-east Asia.

In the west excavations of the Vākāṭaka period (fifth to sixth centuries) produced cave architecture and sculpture comparable with the high achievements of the Guptas in northern India; and the later paintings at Ajaṇṭā are of a grandeur that their present poor condition cannot disguise. In addition to apsidal shrines the excavations also included monasteries with pillared façades through which light was admitted by doors and windows to a pillared quadrangular hall with a veranda on four sides, while cut into the rock on three sides were cells and, opposite the door, an image chamber. Rock excavations ceased soon after this period, but Buddhist occupation continued; Ajaṇṭā appears to have been visited by Xuan Zang, and at Kanheri structural brick *stupas* contained clay tablets stamped with the Buddhist creed in letters of about the tenth century.

On the east coast at Amarāvatī Xuan Zang noticed function-ing as well as deserted monasteries. In the seventh and following centuries Buddhas, Bodhisattvas and goddesses were carved in a style clearly connected with the South-east Asian art inspired by India, and the Kṛṣṇā delta has also yielded bronzes.

Various traditions of bronze casting are represented in hoards found at Nāgapaṭṭiṇam on the south-east coast and are presumably connected with monasteries founded by a king of the Śailendra dynasty of the Malay peninsula with the agreement of two Indian kings in the eleventh century who granted the revenue of a village for their upkeep. The bronzes have affinities with the style of north-east India and provide examples of several periods in south India. Nāgapaṭṭiṇam is last mentioned as a Buddhist establishment in a Burmese inscription of 1476.

Kāñcī, or Kāñcīpuram (Conjeevaram) was a long-established Buddhist centre and is connected with many Buddhist scholars; tradition makes Bodhidharma, who introduced Dhyāna Buddhism (in Chinese Chan and Japanese Zen) into China in AD 520, a son of a king of Kāñcī. Many eastern Indian bronzes, found at Kurkihār near Bodh Gayā, were dedicated by monks from Kāñcī. Literary references to Buddhism in south India are in fact numerous, but the remains have been insufficiently studied.

Buddhist Kāñcī was still active in the fourteenth century, and the Buddhist survival into the second millennium was perhaps reinforced from Sri Lanka. The *stupa* at Amarāvatī continued in worship as several inscriptions record; the last reference to it is in a rock inscription in Sri Lanka of 1344 describing the restoration of an image house by a Sinhalese. By the end of the eighteenth century the *stupa* was a mound and its purpose forgotten. wz

204. Bodhisattva

Deccan, from the Kṛṣṇā Delta. 6th–7th century AD
Bronze. Height 15.2 cm. Victoria and Albert Museum
(IM 300–1914)

This figure, now generally taken to be Avalokiteśvara, was probably made in the eastern Deccan where many Buddhist bronzes have been found, especially in the Kṛṣṇā Delta, and falls between the traditions of the north-west Deccan and developments in southern India, Sri Lanka and South-east Asia. The treatment of the hair and even the flower ornament

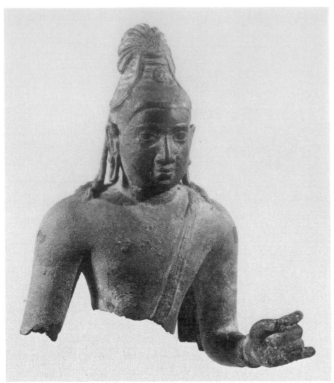

204

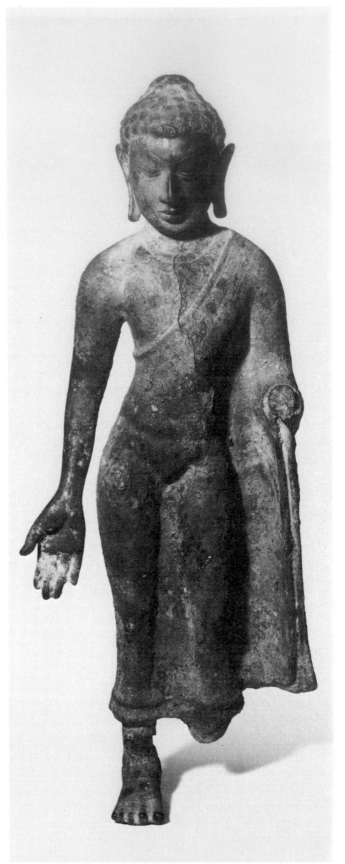

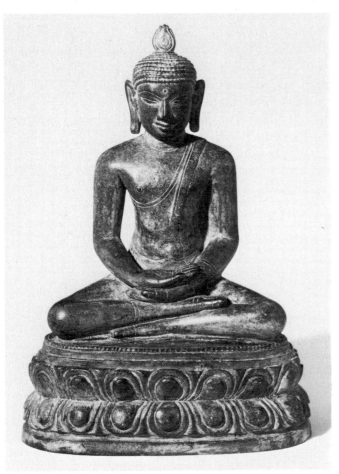

207

205

in the head-dress can be derived from the Western Caves (e.g. Avalokiteśvara at Kanheri, 66), and the gesture of the surviving hand suggests a lotus held by its stalk. Amongst similar South-east Asian figures of direct Indian inspiration perhaps the closest parallel is an Avalokiteśvara with an almost identical hairstyle, but also a 'parent' Buddha, in the National Museum at Lopburi in Thailand, and attributed to the art of Śrīvijaya or the Malay peninsula. WZ

205. Buddha

Deccan, from Buddhapād. 7th–8th century AD

Bronze. Height 38 cm. Given by the Secretary of State for India. OA 1905.12–18.1

The small *uṣṇīṣa* elegantly crowns an oval head with a mannered hairline and curvature of the ears. The smooth robe is worn close to the body with the right shoulder bare and a broad sweep of cloth below the broken left arm: the right hand is expressively large and makes the gesture of giving. Several styles developed under the eastern Cāḷukya dynasty (*c.* AD 630–1078) in Āndhra Pradesh, and this example represents a fusion of northern influences of Gupta origin with traditions of the Deccan. The elongation, softness and delicacy of this bronze mark the beginning of the early medieval period. WZ

206. Buddha

South India, probably from Nāgapaṭṭiṇam. 11th–12th century

Gilt bronze. Height 68.6 cm. Victoria and Albert Museum (IPN 2639)

This imposing figure, one hand in the gesture of reassurance, holds an end of the robe in the other. It follows the northern manner: the robe, worn over both shoulders, falls with concentric lines and has stylised pleats at the bottom. The restrained flame motif of the *uṣṇīṣa* resembles that on a number of eastern Indian bronzes. Its origin is obscure and, though there are northern instances (Swat and Bihar), its full development is seen in the south, Sri Lanka and South east Asia. The heavily moulded lotus base is pierced back and front by four aligned holes, perhaps to secure the image when carried in procession. WZ

207. Buddha

South India, from Nāgapaṭṭiṇam. 13th century AD

Bronze. Height 17 cm. OA 1928.10–16.13

One of the many seated Buddhas from the Nāgapaṭṭiṇam finds, this piece is more south Indian than its standing companion (no. 206) and shows affinities with the Sri Lanka style of seated Buddha which was to have a long life on the island. The treatment of the face is linear and symmetrical, the flame *uṣṇīṣa* is characteristic, if summary, and the *ūrṇā*, nipple and robe edges at wrist and ankle are simply incised. WZ

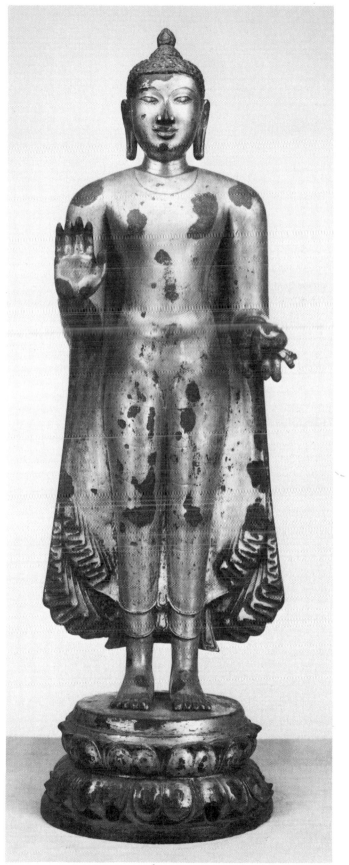

206

9 Sri Lanka

The introduction of Buddhism into Sri Lanka dates from the evangelisation traditionally claimed for Aśoka: the island's Buddhist chronicles tell how Mahinda, son or nephew of Aśoka, together with his sister, both members of the monastic Order, established the religion in the reign of Devānampiya Tissa (247–207 BC) whom they converted. They founded a *stūpa* at Mihintale for a relic of the Buddha and planted a cutting of the Tree of Enlightenment from Bodh Gayā. A tree at Anurādhapura claimed to descend from this cutting is still venerated. Inscriptions in a character similar to Aśoka's on the mainland record the dedication of cave shelters for monks. Kings of Sri Lanka continued to extend patronage; the early intellectual and spiritual centre of Buddhism on the island was the Mahāvihāra monastery, of the dominant Sthaviravāda (Theravāda) sect. The power of the monks has always been very great in Sri Lanka. Pious donations turned the monasteries into landlords, and their wealth and lay patronage were reflected in the splendour of monuments.

The Sthaviravāda was not alone on the island: the Abhayagiri monastery, founded in the first century BC, became associated with other, innovating traditions, including the Mahāyāna which was studied there, according to Xuan Zang, in the seventh century. This was followed by Tantric tendencies evident, for instance, in impressed sealings of northern Indian type. Official religious uniformity was, however, created under the banner of the Sthaviravāda in the twelfth century when King Parākramabāhu I (1153–86) made the Mahavihāra supreme after the destruction of the Abhayagiri monastery in the Tamil invasions in the tenth century from south India, after which time the higher ordination had to be renewed from orthodox sources in Burma.

The art of Sri Lanka, like its history, is conveniently divided into two great periods, named after the capital cities: Anurādhapura (from the third century BC to the Tamil occupation of the tenth century) and Polonnaruva (1070–1236) when Tamil rule had been shaken off. Renewed Tamil invasions led to the abandonment of Polonnaruva for a succession of capitals where the Polonnaruva style was preserved with diminishing inspiration; the last independent kingdom, at Kandy, maintained impoverished but colourful arts and crafts in the uplands, while the coasts were dominated by the Portuguese and Dutch (1505–1815).

The early school of Anurādhapura, closely related to the Āndhra tradition of Amarāvatī, is hard to date. It was only slowly influenced by mainland styles, but sculpture absorbed Gupta elements followed by the import of bronzes from the productive Buddhist centres of north-east India. Many gigantic rock-cut images were carved under Mahāyāna inspiration and bronze casting produced masterpieces. *Stūpas*, often very large, were of characteristic design, with projections at the cardinal points adapted from Āndhra models, and temple forms included distinctive circular buildings with concentric rings of pillars enshrining *stūpas*. Typical monastery plans also evolved.

Buddhist art was not entirely neglected under Tamil rule (993–1070), but with the restoration of independence at Polonnaruva Buddhist constructions increased and the traditions of Anurādhapura were revived. Huge stucco-faced brick temples at Polonnaruva adopted barrel vaulting and housed standing and seated Buddha images. The Gal Vihāra monastery is famous for its huge rock-cut Buddhas, particularly the recumbent figure passing into final *nirvāṇa*. This and other constructions are due to Parākramabāhu I, whose reign marked the apogee of Polonnaruva, and Sri Lanka became the religious centre for the South-east Asian Theravāda lands.

In the ensuing period of shifting capitals patronage reflected the decline of the successor states with their political instability, the destruction of the irrigation system and the onset of colonial rule. The period after 1236 saw the growth of religious syncretism with shrines combining Buddhist worship with that of gods identified with Hindu deities. Mahāyāna survives in the continued worship of the Bodhisattva Avalokiteśvara who has become known as Lokeśvara Nātha, and the shrine of this popular protector deity is still worshipped at Kandy.

In Sri Lanka today Buddhism continues to be the chief religious force except among the substantial Hindu communities of south Indian origin. There are some 20,000 monks divided into three main traditions of ordination, one transmitted from Thailand and two from Burma. Their principal functions are preaching, presiding at funerals, and reciting spells (*pirit*) to drive away misfortune and improve the material and physical well-being of the faithful. Many monks indeed resemble village priests. They are offered gifts and food, which for the layman procure merit and the prospect of better rebirths – the ancient secular alternative to the quest for personal salvation. WZ

Literature

Later Sinhalese chronicles record that the Pali Canon was committed to writing, presumably on the leaves of the talipot palm, in the first century BC when the Saṃgha was in disunion. Tradition also records that at this time commentaries already existed, composed by Mahinda himself, which formed the basis of the huge set in Pali (*atthakathā*) composed by Buddhaghosa in the fifth century. These are the earliest and most important interpretations extant of the Pali Canon. Buddhaghosa appears to have been a north Indian convert to Theravāda Buddhism, driven southwards to study its sacred texts. Other commentators followed Buddhaghosa, especially Dhammapāla, a south Indian from Kāñcīpuram, who composed sub-commentaries (*ṭīkā*) on Buddhaghosa's works as well as *atthakatha* on the poetical books of the Minor *Nikāya*.

Sri Lanka is almost unique in pre-Islamic South Asia in possessing continuous historical chronicles, written in Pali, concerned primarily with the history of the Buddhist church on the island, but also of the greatest value for secular history of Sri Lanka and early Indian history. The original *Mahāvaṃsa* (Great Chronicle) belongs to the fifth century, and was composed in Pali, which had become the natural literary medium of the Sinhalese, as Sanskrit for the Indians. It is used for all kinds of literature, religious and secular, technical and belles-lettres. The great age of Sri Lanka's literature was the twelfth and thirteenth centuries. When Parākramabāhu the Great (1153–86) finally re-united the threefold Saṃgha, new sets of sub-commentaries were written on the *atthakathā* with which all the monks could agree; and the continuation of the *Mahāvaṃsa* from the fifth to the twelfth centuries was completed by a monk named Dhammakitti. JPI

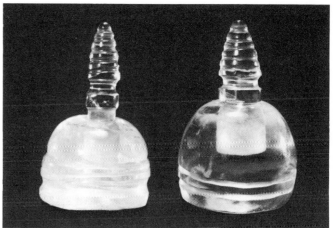

208

208. Reliquaries

Sri Lanka. Early centuries AD
Crystal. Height 6 and 5.5 cm. OA 1898.7–2.8 & 9

Like many *stūpa* deposits these reliquaries (*karaṇḍuvas*) are hard to date. They closely resemble crystal reliquaries of *stūpa* form found at Anurādhapura (Ruvanväli and other *stūpas*) and from the early Yaṭṭāla Dāgäba of the Tissa group where coins and a seal of the early centuries AD were also found. Their type seems distinct from the crystal reliquaries of the Polonnaruva period. They are not entirely identical, but both agree in having the *harmikā* and parasol rings carved on the stoppers and base mouldings indicated. The nature of their contents is not reported. WZ

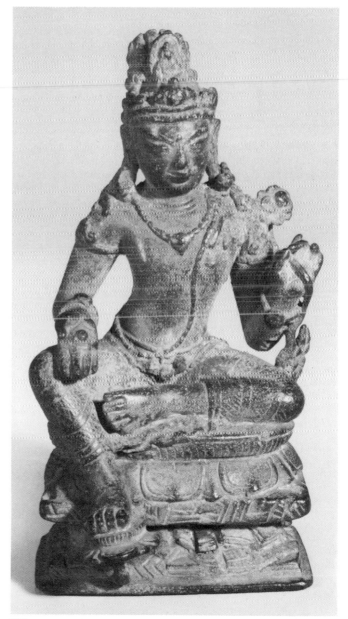

209

209. Avalokiteśvara

Sri Lanka. 9th century
Bronze. Height 15 cm. OA 1898.7–2. 133

Seated with one leg pendent and the body in the so-called triple bend, changing direction at the waist and shoulders, this figure has the usual attributes, but one, of Avalokiteśvara. His posture, the antelope skin over the right shoulder, the lotus held by its stalk in the left hand, the right in the gesture of giving and prominently displaying its auspicious mark are all compatible with Avalokiteśvara. The stylised rocks on the pedestal indicate his mountain home, Potalaka, but the 'parent' Buddha with one hand in the earth-touching gesture is Akṣobhya who is not usual with Avalokiteśvara. The style of this bronze suggests eastern Indian influence, known in Sri Lanka from other examples and imports; a well-known standing stone Bodhisattva from Nālandā, representing what would otherwise be a form of Avalokiteśvara, also has Akṣobhya in his head-dress. WZ

210. Tārā

Sri Lanka, found between Trincomalee and Batticaloa.
9th-10th century
Gilt bronze. Height 1.43 m. Given by Sir Robert Brownrigg.
OA 1830.6–12.4

Almost life-size, this exceptional and individual figure stands with one knee slightly bent forward while her right hip thrusts gracefully towards the outstretched arm, its hand in the gesture of giving. The left hand makes the holding (*kaṭaka*) gesture. The almost perfectly oval head is surmounted by a tall mass of tubular hair, in front of which is a pointed medallion on *makaras*, or mythical aquatic beasts, with raised trunks and gaping jaws containing a small figure. In the medallion a large hole surrounded by smaller holes in the flame border presumably held gemstones unless there was also a central 'parent' Buddha. Similar medallions occur on a number of Anurādhapura-period bronze masterpieces. The goddess is naked to the waist, and her lower garment alternates between a clinging smoothness and well-realised pleats.

The suggestion that images of the local goddess Pattinī, for which this figure was long taken, might be Tārā instead was made by Paranavitana in 1928. While she closely resembles an exquisite small bronze goddess from Kurunägala identified as Tārā, she also recalls the much cruder colossal Tārā flanking an Avalokiteśvara about 12 m high and carved in the rock in high relief at Buduruvagala in Ūva Province. WZ

211. Buddha

Sri Lanka, from Kandy. *c*.14th century
Bronze. Height 49.5 cm. Royal Scottish Museum, Edinburgh (395.9).

Found in 1826 near a ruined temple, this imposing, solid cast Buddha sits on a low double lotus base, the treatment of the robe end over his left shoulder and the lower garment both clearly indicated. The classical right-turning curls are surmounted by an inserted, separately cast lyre-shaped flame-

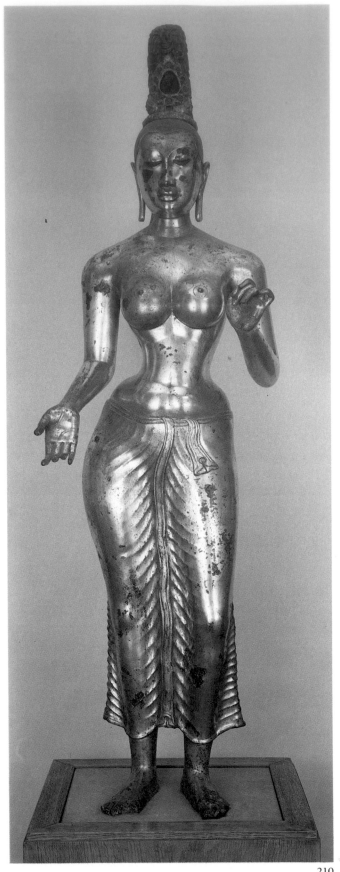

210

uṣṇīṣa. Hands and feet of almost exaggerated length with articulated fingers and toes show auspicious marks which, like the suspended curled *ūrṇā*, occur also on south Indian metal Buddhas from Nāgapaṭṭinam. The broad shoulders and modelled trunk give this figure great individuality; the sweep of the line connecting the eyebrows with the nose and the somewhat oval shape of the head hint at a relationship with Sukhothai (cf. no. 252). Mudiyanse compares this image, with its characteristic flame-*uṣṇīṣa*, to certain bronzes of the Gampola period (1341–1415); his illustrations and some similarity also with Polonnaruva Buddhas make this dating possible. WZ

212. Buddha

Sri Lanka. 18th century
Silver and silver gilt. Height 32 cm. OA 1905.6–16.83 & 89

This type of arched shrine was common to Sri Lanka and south India. The Buddha's right hand with open palm covered in a floral design is raised as if in the gesture of reassurance, but thumb and index finger meet in the argumentation gesture. The densely pleated robe leaves the right shoulder bare, while the left hand holds the robe away from the body. The usual flame-*uṣṇīṣa* rises above the Buddha's pigmented hair. The plinth, jambs and arch are covered in floral decoration with the arch emerging from the jaws of *makaras*, the traditional Indian aquatic monsters used in ornament; in the centre is the *kīrttimukha*, a leonine head spewing out ornament and affording protection and good augury. WZ

213. Buddha

Sri Lanka. 18th century
Ivory. Height 35 cm. Given by the British Museum Society.
OA 1985.1.26.1

The active arts and crafts of Sri Lanka in the last independent highland kingdom of Kandy included the wide use of ivory. Much was of a decorative character, but its high quality reflected the status of the ivory carvers, an artistic élite who also built and painted. Figural carving can hardly have been more successful than in this late Buddha image wearing the characteristic densely pleated robe with the garment end neatly folded and plain over one shoulder. The right hand is raised palm outwards as if in reassurance, but the index and thumb meet in the argumentation gesture. On the palm is an elaborate scheme of auspicious marks; on the other hand, holding the robe away from the body, a flower is partly visible. The projecting robe is supported from the turned and waisted pedestal by a decorative strut. On the pedestal are petals, but the lotus-petal anklets appear quite exceptional; they may represent separate lotus bases or the auspicious marks on the soles of the feet. WZ

Illustrated on page 154

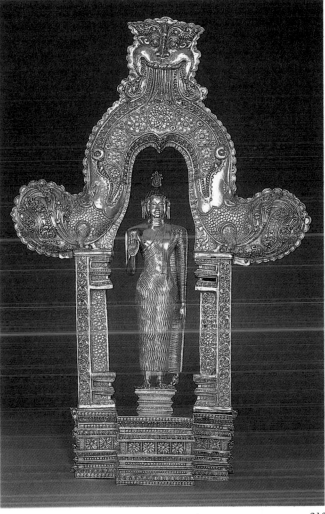

212

214. Stūpa

Sri Lanka. 18th century (?)
Brass. Height 36 cm. OA 1898.7–2.13

This model *stūpa* consists of two separable parts, the dome with finial and the base with its three lotus-petal tiers. Both are hollow, the dome to contain relics or offerings. The plinth (*harmikā*) for the finial is also ornamented with lotus petals incised and in high relief, and some incised decoration also occurs on the dome. In essentials this *stūpa* reproduces the form that developed in the later Anurādhapura period and found complete expression during the Polonnaruva period in such *stūpas* as the Kiri Vehera Dāgāba of the 12th century. WZ

Illustrated on page 153

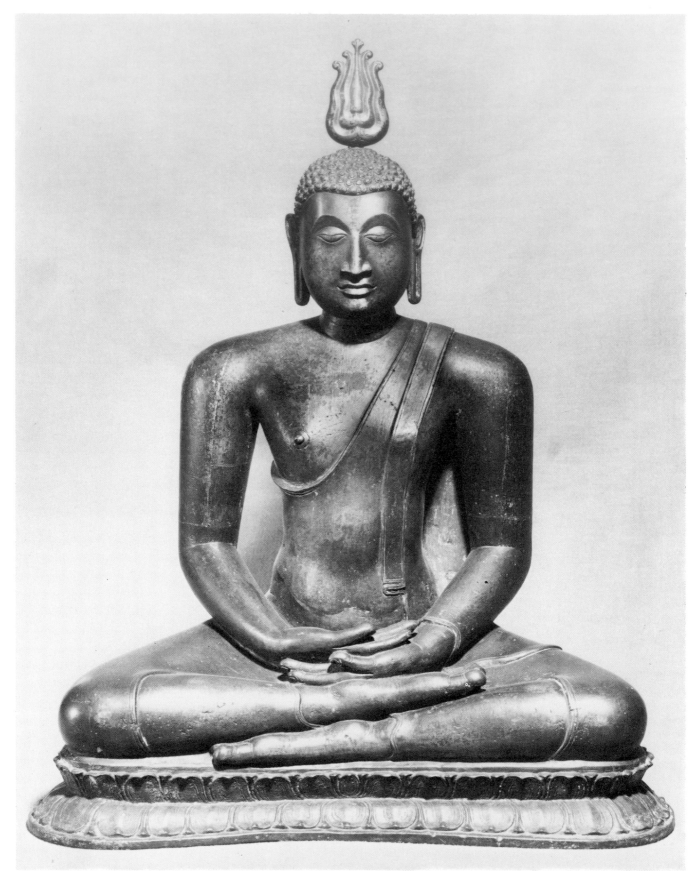

211

215

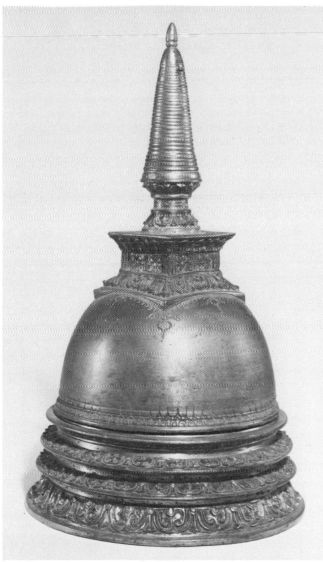

214

215. The Buddha's former birth as Vidhura

Sri Lanka. c.1800

Pothī manuscript of *Vidhurapaṇḍitajātaka* in Sinhalese. Text and illustrations incised on palm leaves and inked. 14 folios. 6 × 44 cm. Given by Mrs F.K. Gane. OMPB Or. 11666

This *jātaka* (number 545) tells of the Buddha's former life as Vidhura, a King's wise minister, who was coveted by Vimalā, the wife of the ocean-god Varuṇa. She arranged for the *yakṣa* Puṇṇaka to try to bring Vidhura to her, which he did by winning him in a game of dice with the King. Eventually Vimalā and Varuṇa were so delighted with Vidhura's wisdom that they allowed him to return to the King. Here Vidhura is welcomed back by the King, while on the final folio monks worship the Buddha.

Except for a few late examples, palm-leaf manuscripts from Sri Lanka were austerely unillustrated apart from their wooden covers. JPL

216. The Buddha's former life as a deer

Sri Lanka. 1862

Pothī manuscript of *Nigrodhamigajātaka* in Sinhalese. Text and illustrations incised on palm leaves and inked. 15 folios. 6 × 47 cm. OMPB Or. 13174

The story is of the Buddha's birth (*jātaka* 12) as a golden king of the deer. The King of Benares, a great meat-eater, kept a deer herd; to spare each other the pain of being hunted, the deer drew lots to be executed. The golden deer, whose life the king had previously guaranteed, took the place of a pregnant doe. Amazed at his determination to die, the king spared him and, after the deer had preached the Doctrine to him, all other animals, birds and fish. Here the butcher informs the King of the golden deer's determination, and the King comes to the execution-block to dissuade him. JPL

Illustrated on page 155

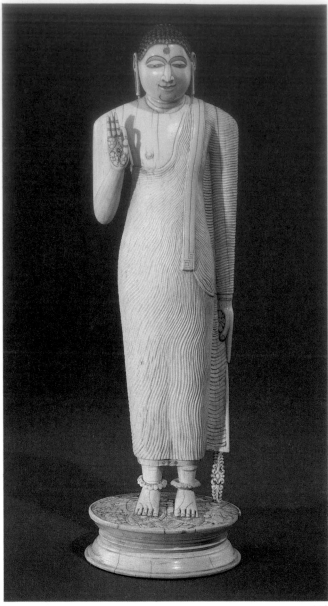

213

2. The *Samuggajātaka* (number 436, the basket *jātaka*) tells a story typical of the misogyny of early Buddhists. A demon carried off a rich and lovely woman, whom, to keep safe and chaste, he put in a basket and swallowed. When he let her out, she enticed a magician into her basket with her; unaware, the demon returned the basket to his belly. The Bodhisattva, at this time an ascetic dwelling near by, told the demon what was going on inside him. He brought up the basket, and the magician escaped. In disgust the demon released the woman.

JPL

218. The Buddha's former life as Dhammasoṇḍa

Sri Lanka. 1870

2 manuscript covers. Gouache on wood. 6 × 45.5 cm.
OMPB Or. 2253

The covers illustrate the story of Dhammasoṇḍa, which, though a *jātaka*, is found first in Sri Lanka in the *Rasavāhinī*, a compilation by the 14th-century monk Vedeha, and also in the *Paññāsajātaka* (see no. 93). The Buddha-to-be was born as Dhammasoṇḍa, King of Benares, and desired to hear the Doctrine. Although he sent sacks of money on the backs of elephants through his kingdom to be given to anyone who could preach the Doctrine, no teacher could be found. In despair he became a forest ascetic; there he met Sakka, the king of the gods, disguised as a goblin, who agreed to preach the Doctrine in return for his flesh. Dhammasoṇḍa climbed a cliff and, as the demon recited the *Dhamma*, jumped into his mouth. Then the demon resumed his true form as Sakka and took him to the world of the gods.

JPL

219. The Procession of the Buddha's Tooth Relic

Sri Lanka. *c.*1796–1815

Scroll. Watercolour on paper. 8 sheets, each 35 × 55 cm approx., mounted together, with descriptions in English and Sinhalese.
OMPB Or. 11901

The style of this annual Procession of the Tooth Relic of the Buddha round Kandy is European-influenced, similar to the style favoured by the British in Madras. The wording of the English description suggests a date before the British conquest of Kandy in 1815, but after the British replaced the Dutch in the maritime provinces in 1796. The scroll is arranged thus:

1. The elephants with the Gajanāyaka Nilamē, or chief of the elephants, walking behind.

2. The people of the Four Kōralēs carrying muskets with the Disāva, or chief of that province.

3. The people and Disāvas of six other provinces of the Kandyan kingdom (Seven Kōralēs, Ūva, Mātālē, Sabaragamuva, Valapanē and Uḍapalāta), with their individual flags.

4. Large images of demons made of bamboo carried by the *oli* caste.

5. Dancers (males dressed as females, no women being allowed in the procession) and musicians.

217. Two jātaka covers

Sri Lanka. Mid-19th century

2 manuscript covers. Gouache on wood. 7 × 41 cm.
OMPB Stowe Or. 28

1. The *Khadiraṅgārajātaka* (number 40, of the acacia-wood embers). The Bodhisattva was the highly charitable Lord High Treasurer of Benares. A Pratyekabuddha (one who has attained Enlightenment but does not preach) came to his house for alms after a fast. Māra, the Evil One, knowing that the Pratyekabuddha would die if not fed, made an acacia-wood fire in the centre of the house. The Treasurer, undaunted, took the food, confronted Māra, and strode through the flames on a golden lotus which rose up to receive his feet. Satisfied, the Pratyekabuddha flew away to the Himalayas to resume his meditations.

216

217 (top pair), 218 (bottom pair)

219(6)

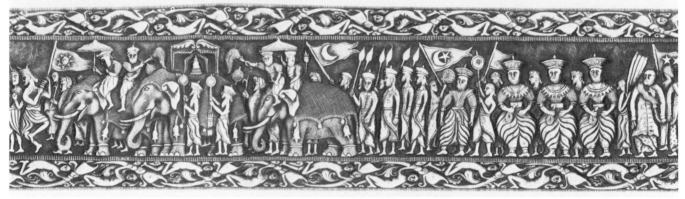

220 (detail)

6. The temple-elephant carrying the *karaṅḍuva*, or relic-casket, followed by the people of the temple with umbrellas, fans, etc. Behind walks the Diyavaḍana Nilamē, the lay guardian of the temple and its relic, who traditionally organises the whole pageant. JPL

220. Bookcover

Sri Lanka, from Galle. 1886
Silver. Length 56cm. OA 1982. 10–8.2

This bookcover showing the Esala Perahera, or Buddha's Tooth Relic procession at Kandy, was made for the Indian and Colonial Exhibition of 1886 by Don Gabrial Dawapura Vimalarathna Jayasingha Arachchi of Galle in southern Sri Lanka. (The courtesy title Don was inherited from the Portuguese who occupied the island's coastline from 1505 to 1658.) In the middle a tusker carries the reliquary casket alone in a howdah; two accompanying elephants bear figures honouring the reliquary with fly-whisks. The procession includes spearmen, musicians, dancers and marchers carrying provincial flags. Contingents from other Kandyan temples joined the tooth procession. Near the front is a dancer from the Kataragama temple wearing a wooden mask; behind the elephants are the lay custodian of the relic, attendants in baggy trousers and officials (*mudaliyārs*) wearing the long buttoned coat of Portuguese origin typical of the southern maritime provinces. WZ

10 Burma

Legends link the foundation of Burma's ancient cities and temples to the time of the Buddha or to the distribution and enshrinement of his relics. However, the earliest evidence of Buddhism in Burma dates from the fifth century AD. Mon settlements in the Lower Burma delta had early contacts with India and Buddhism. The Mon political and cultural centre was, however, in central Thailand where the Mon state of Dvāravatī flourished from the sixth to the eleventh centuries and produced a distinctive style of sculpture. In Burma the main Mon centre was the city of Thaton (Sudhammavatī) whose earliest history is shadowy, while from the ninth century Pegu also became important.

The first major Buddhist capital in Burma was not Mon but that of the Pyu, who entered Burma from the north-east and founded Śrī Kṣetra (near modern Prome). The Maunggun gold plates found at Śrī Kṣetra provide the earliest epigraphical evidence of the spread of the Buddhist Canon to Burma. Excavations there and at other Pyu sites have revealed a rich mixture of Mahāyāna and Hīnayāna Buddhist as well as Hindu remains. The Pyu kingdom is mentioned in Chinese sources from the seventh century onwards, and the Tang dynastic chronicles recorded that the Pyu 'are Buddhists and have 100 monasteries, with bricks of glassware embellished with gold and silver vermilion . . .' In AD 832 the northern Pyu capital of Halin was sacked by the kingdom of Nan-chao, based in western Yunnan. Thereafter little more is known of the Pyu who seem to have been gradually absorbed into the Burmans.

The Burmans (or Mranma) broke away from Nan-chao overlordship and descended into the hot dry plains to establish their first settlements at Kyaukse and Minbu. In 849–50 the city walls of Pagan – which was to become in the eleventh century the capital of Burma's first unified kingdom – were constructed. The early history of Pagan and the Burmans is relatively obscure until the reign of King Anawrahta, or Aniruddha (1044–77), who established control over most of the country. The extent of Aniruddha's campaigns can be traced by the distribution of terracotta votive tablets he left throughout Burma. They usually contain the Buddhist creed in Sanskrit or Pali and either a single central image of the Buddha, or a Bodhisattva, or a number of Buddhas and Buddhist scenes. Aniruddha was a champion of Buddhism, and a driving force in his campaigns was his search for texts of the *Tripiṭaka* and Buddhist relics. In 1057 he conquered Thaton and took the Mon king and his court captive back to Pagan.

The story told in the chronicles that Aniruddha brought from Thaton thirty sets of the *Tripiṭaka* is not supported by any evidence. More important to Pagan's development were the Buddhist monks and skilled Mon artists and craftsmen brought from Thaton. Pagan only obtained copies of the *Tripiṭaka* some twenty years later when King Vijayabāhu I of Sri Lanka, which had been subjected to Hindu Cola rule, invited monks from Pagan to re-establish a valid ordination for the Sinhalese Buddhist Order and in return presented the Burmese monks with copies of the texts. The impact on Pagan's Buddhism and art was great and rapid as new sources for study and illustration were introduced. The brick Pahto-thamya temple (*c.*1080) is filled with wall-paintings that illustrated for the first time many detailed scenes from the life of the Buddha. The *jātakas* were very popular subjects for illustration in Pagan temples – on glazed and unglazed terracotta plaques and on wall-paintings. Study of these *jātakas* and their inscribed titles has revealed two different recensions – one containing 550 stories (introduced from Thaton) and the Sinhalese recension of 547 introduced a little later.

Although Pagan conquered the Mons, the Mons culturally conquered the Burmans and inaugurated the golden age of Pagan art and architecture. The Mon alphabet was adapted to write Burmese, but the inscriptions of Pagan's Burman kings continued to be written in Mon for many years. In beautiful language Pagan's rulers expressed their Buddhist aspirations and concern for the people, as in the following quotation from an inscription of King Alaungsithu: 'May I always be conscious and aware of kindness done me. Union of ill friends be far from me. Beholding the distress, the birth-born distress of man and deathless gods, I would put forth mine energies and save man, spirits, gods, from seas of endless change.'

The gradual shift from Mon to Burmese in the inscriptions was paralleled by a change in temple architecture from a predominantly Mon to a distinctively Burmese style. In 300 years several thousand temples were constructed at Pagan in a sixteen-square-mile area; today some 2,000 temples remain. The motivating force for this amazing proliferation of temples was Buddhism. Theravāda Buddhism co-existed at Pagan for a long time with both Mahāyāna and Tantric Buddhism and

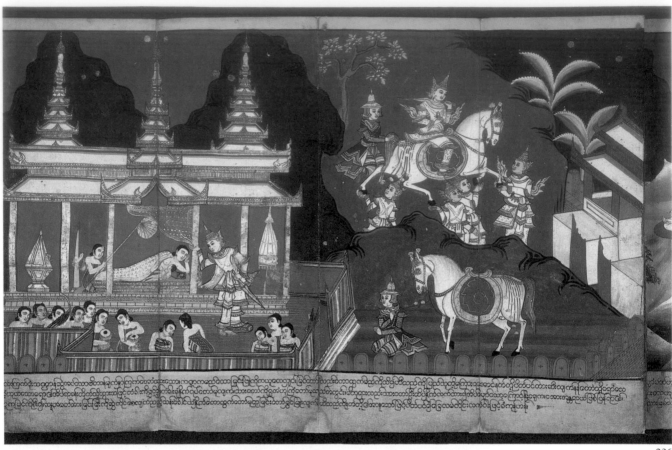

ကျက်ကြာကိုင်းအရပ္ပာနည္သို့ထင်လ္ကာေတာ္ရေွက္ဟင်းကဘောက်ထုေးတိုေသာ ကဂ္ဂကေဆည်္ထထ္တိုမြစ်္ပျက်ိကာယုေလပျာင်္ိပ္ကော္ဘ္ဘ္အ္အာျကင်လိ္က္ြ္တိုတ္ကေ္္ိတိိပ္္တ္တ္ကောင္္ိ္ိနေနာင္ိ္ေ္တ္တိုတ္ားိ္္ိတ္္ိလ္ိ္္လ္ိ္က္္ေတ္ာေ္္ိ္
ိ္ာျမြုင်္ကိုဖ္ျ္ူးဆားမြ္ထ္ဖ္ျ္တ္တ္ေးဗ္ော္ျ္က္္က္္္ည္ိ္ထ္ား္ိိ္္လ္ိ္ဖ္ကိုေတ္ာထ္္ကတ္ေ္ာမ္ည္ဖ္္ိ္ာ္တိ္ဖ္ူ္ျ္လ္ျ္ား္္ုိ္ိ္ိ္တ္တိ္္ိ္ာ္တ္ိ္ားေ္္ာ္ေ္က္ေ္ိ္ိ္ေ္္္ော္ျ္ိ္ိ္္

236

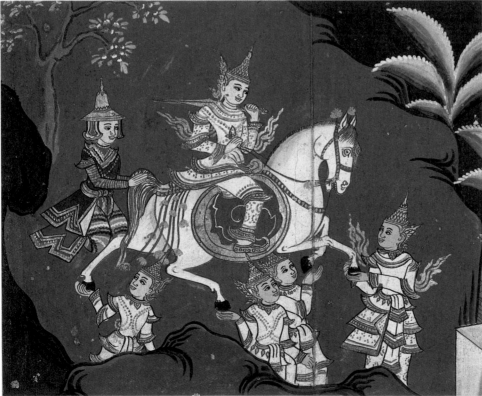

263 (detail)

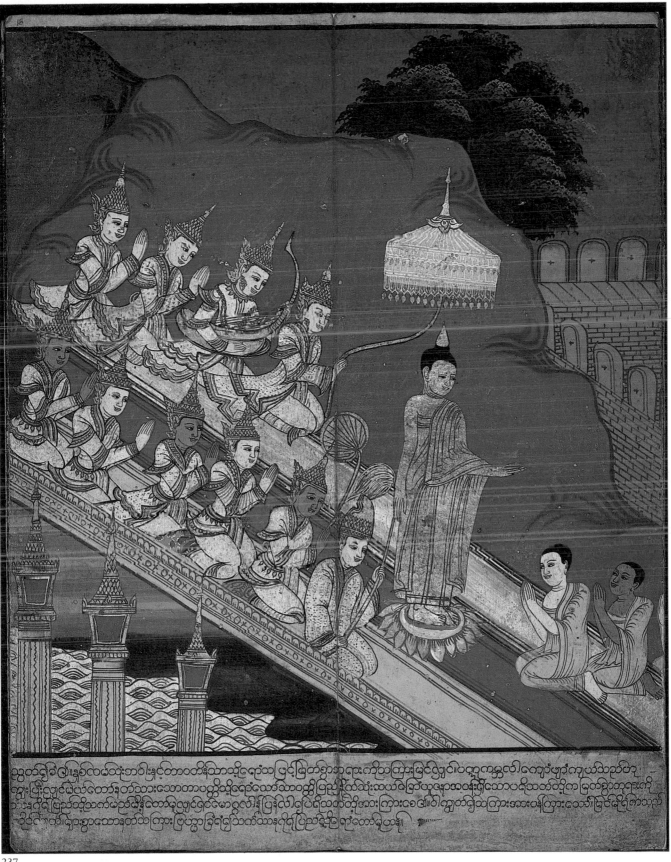

ည္စတ္၍ခဲ့ျ၍ ။နွစ္လ၍သံုးဘင္း.ဒွင္တ္တာဝတိံသာသို့ ရောဘ ျပင္ျမတ္ဲသာာဘုရား ကၢိသိ္ကြား ျမင္ရွ္၍။ပ၍ဠုဂုက္မဒွလါ ိေကၢာ္မၢာ္ကၢယ္သည္ဘဲ့ဘ
ကၢားျပီ့လ္ယှင္ဲ့ယ္ိေတာ္နတ္သာ့ ိသာဘ္တာ ိပၢို့ိေရာ္ိေသာ္သာ ၍ ျပည္ နိုိ္င္သံုးထယ္ မၢ္ခၢာ္ ်ူိေနာအ္ဘ္းဒွ္ိိေသာ ္ ၍ ္ိ္ တ္သ္က္တိုိုက ျမ္္တ္ ္ ္ ဘုရား္က္ို
ိ၍ိဲ္ဒ္ုိ ျ ပ္ည္္ သိ္ုဘ္မ ္ည္ ္ ္နို ္ိေတာ္မၢ္ုလၢ္င္ဲိရှ္ိေမ ာ ္ ္ရ္္ ျပ္ရ္လ္ ္ရ္ပ္ိေရ္လ္ တ္ိုဘ္အား ကြ္ားေ ၍ ။ ္ ္ ္ က္ ္ ္ တ္ ္ ္ တ္သ္ ္ ္ ္ ္ ္ ္

some Hindu forms, but from at least the thirteenth century Theravāda Buddhism became firmly established at all levels of society. One of the greatest temple builders was King Kyanzittha (1084–1113). His Nanda (or Ananda) temple, c.1105, with its four large halls each with the same series of sixteen sculptures (thus enabling four groups of visitors to be instructed simultaneously) and its corridors with 1,600 stone sculptures and 1,400 terracottas, was designed to present systematically Buddhist doctrines and the Buddha's life. Similarly, the countless wall-paintings of Pagan's temples also helped spread and popularise the Buddhist faith.

Pagan's sculpture and wall-paintings still require much study before influence upon Pagan art and the stages of its artistic development can really be understood. An important early influence were Pāla Bengal and Bihar, but external models were soon transformed into a distinctive local style. Pagan became a centre of religious and artistic activity and patronage, and was renowned as a centre of Pali scholarship, excelling in grammatical studies and the *Abhidhamma*. Buddha images in Pagan art by their posture and expression radiate meditative calm and strength.

The rapid pace of temple building and the large-scale donation of land and labour to the Order is considered to have eventually undermined Pagan economically. Pagan's collapse was hastened by the Mongol occupation of 1287–8 and by the rise of rival Shan chieftaincies. The Pagan empire became fragmented, and the Burmans were only gradually able to reassert their hegemony over the Mons based at Pegu and the Shans at Ava. In 1635 the Burmese capital moved from Lower Burma to Ava in the dry zone. Upper Burma was to remain the heartland of the Burman empire until 1885.

Burmese art from the end of Pagan to the eighteenth century cannot be traced clearly. Insufficient dated images exist to establish a firm typology, although differences in the Buddha's features, hands and flaps of his robe are discernible and certain generalisations can be made: for example, the increasingly elaborate head-dress with long side ribbons on crowned Buddha figures, the waisted throne, and – from the late eighteenth century – flowing robes and the addition of a wide band, often with decorated or jewelled insets, above the forehead. Burmese Buddhist art is by no means uniform, and different styles reflect Burma's ethnic diversity. The early Arakan kingdom, which remained independent of Burma until 1784, produced a distinctive style.

Burma's rich manuscript art is represented in the exhibition by examples from the eighteenth and nineteenth centuries. Few earlier manuscripts have survived owing to the ravages of climate and insects. Burmese manuscripts are usually either palm leaf or paper, although ivory, stiffened cloth and thin silver, gold or metal sheets were also used. Palm-leaf manuscripts were made from the leaves of the talipot (*Corypha umbraculifera*). The leaves were separated from the central rib, dried, soaked, redried and rubbed smooth. The text was then incised on both sides of the leaf with a metal stylus, after which the leaf was rubbed with charcoal dust or lamp black and the surplus brushed off leaving the incised text legible. The palm-leaf edges were usually gilded and the leaves stacked between decorated wooden binding boards. The majority of palm-leaf texts are religious, preserved by repeated copying. A more elaborate decoration was used for *Kammavācā* manuscripts, texts for higher ordination and other monastic ceremonies. Paper manuscripts were made from long, wide strips of stout paper folded concertina fashion. Some folding books (*parabaik*) extend to as much as 10 m, but they were never intended to be viewed as a continuous strip, only opening by opening. Common subjects were the life of the Buddha and the *jātakas*, court pastimes and Buddhist cosmology. There is a close similarity between wall-paintings and the earlier illustrated manuscripts, as if the composition has been transferred from a wall and confined to the manuscript page.

In the nineteenth century Burma's rulers faced growing British commercial and diplomatic pressure. The annexation, after three wars, of the proud Burmese kingdoms by an alien, non-Buddhist power threw the country and the Order into crisis. One way that King Mindon (1853–78) tried to solve his nation's problems and unify the Order was by great religious devotion and the convening of the Fifth Buddhist Council in 1871 when an authoritative text of the *Tripiṭaka* was inscribed on 729 marble slabs at the Kuthodaw temple in his new capital city, Mandalay. Burma's loss of independence and her monarchy in 1885 brought to an end centuries of symbolism and royal patronage of the Saṃgha and the arts. However, the identification of the Burmese nation and people with Buddhism has been strong enough to survive colonial rule and make independent Burma a country renowned for its living faith and art. PMH

221

223

221. Bodhisattva

Burma, Perhaps 9th century

Gilt bronze. Height 18.5 cm. Victoria and Albert Museum
(IM 39–1922)

This figure is one of the best examples of a tradition preceding
that of Pagan. A number of enigmatic pieces resembling it and
found at Pagan have been compared with Bodhisattvas flank-
ing the Buddha from Prome (Śrī Kṣetra) and Pagan itself.
Their Buddhist association is therefore certain. On one of the
separate pieces from Pagan a Pyu inscription seems to identify
it as 'Metriya' (i.e. Maitreya). Here the identification may
not be final; both Lowry and Chutiwongs suggest that
Avalokiteśvara may be intended. WZ

222. Buddha

Burma. 12th–13th century

Bronze. Height 34 cm. Brooke Sewell Fund. OA 1971.7–27.1

One of the finest known Burmese bronzes of the Pagan
period, this piece reflects the powerful influence of eastern
India and particularly the adaptation of a stylistic current in
the Bodh Gayā region. The broad forehead, slightly Mongoloid
eyes, tapering face so that the chin appears to be coming to a
point, together with the form of the high *uṣṇīṣa*, which

once held a precious or semi-precious stone, all help to dis-
tinguish this Buddha from the styles of Bihar and Bengal. A
strut at the back of the image suggests a lost backplate; both
may have rested on a sculpted pedestal. The gesture of the
right hand, symbolising the Enlightenment, became by far
the commonest in Burmese Buddha images. WZ

223. Plaque

Burma, from Pagan. 13th century

Height 16.5 cm. Terracotta. Given by Lt. Dobson. OA 1899.10–16.1

The eastern Indian representations of scenes from the Buddha's
life around a main image (cf. no. 148) are also found in Pagan-
period stone carving. On this plaque a central Buddha making
the earth-touching gesture in the Mahābodhi temple is sur-
rounded clockwise by the monkey's gift of honey, possibly
with the elephant Pārileyya crouching below the Buddha,
apparently a Burmese innovation, the First Sermon (with two
monks), the taming of the elephant, the death, the descent
from the heaven of the Thirty-three Gods, the miracle of
Śrāvastī (with two Buddhas) and the birth. A two-line in-
scription in Indian characters at the bottom contains the
Buddhist creed. WZ

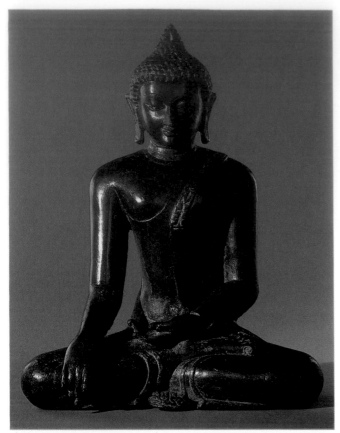

222

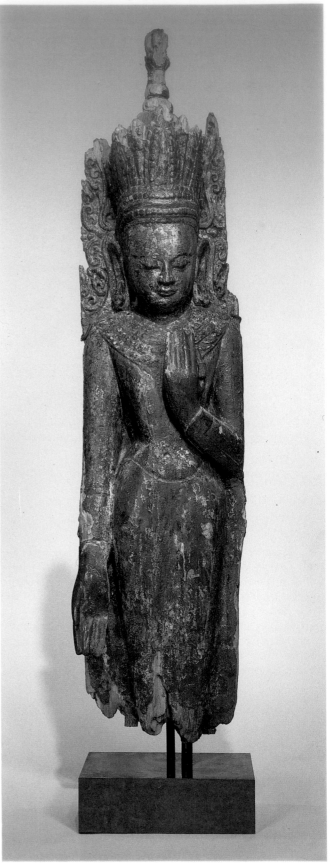

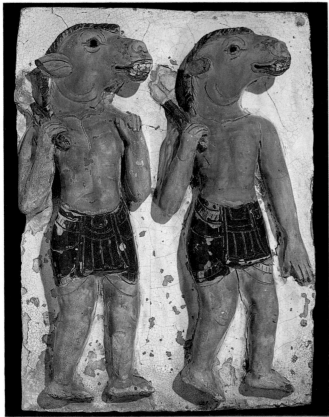

226

225

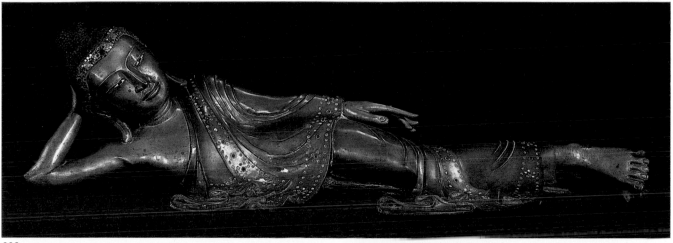

230

231

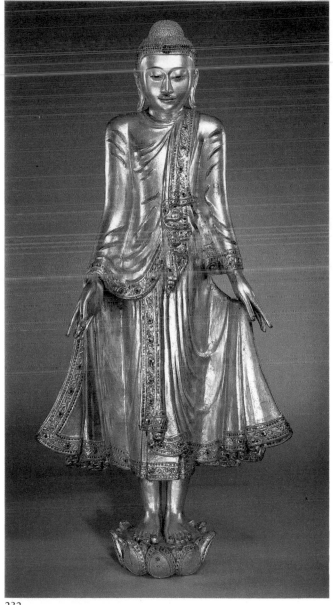

232

224

224. Plaque

Burma. 13th century
Terracotta. Height 19.5 cm. Given by Cdr Rundle. OA 1947.2–8.2

Another example of Burmese votive plaques of Indian type shows the Buddha beneath a triple arch and a parasol, in the earth-touching gesture associated with Bodh Gayā. The tree is shown by branches with the unmistakable Bodhi leaf. The small surrounding Buddhas in pearled niches with indications of a tree above and around them are a series of twenty-eight predecessors of the 'historical' Buddha. Two *stūpas* fill spaces at the top, and a line of Burmese characters runs at the bottom of the impression. WZ

225. Crowned Buddha

Burma. 13th century or later
Wood painted and gilt. Height 1.14 m. Brooke Sewell Fund. OA 1981.6–11.1

The face and certain ornaments are still close to eastern India (cf. no. 148), but in other respects the image has a developed local appearance; the tall finial above the crown and the almost vegetal ornamentation beside it follow a quite different idiom from the high style of Pagan and anticipate the Jambupati images. A number of similar wooden pieces survive and their identity has been in question. On this figure the raised left hand holds an oblong strip still clearly part of the robe, and it is reasonable to see here a stiff but powerful adaptation of the Indian crowned Buddha in an early Burmese form. WZ

Illustrated on page 162

226. Tile

Burma. 15th century or later
Glazed pottery. Height 51 cm. Given by Cyril Newman, Esq. OA 1965.12–17.1

Rows of glazed pottery tiles, a feature of Burmese temples since the Pagan period, when they particularly represented *jātakas*, also used themes from the Buddha's life. This tile, with its ass-headed figures, shows warriors of Māra and is in the style of those placed in niches of buildings commemorating the first seven weeks of the Buddha's Enlightenment near the Shwegugyi pagoda, constructed near Pegu by King Dhamma-ceti (1472–92). Among these tiles those representing pairs of Māra's soldiers show a variety of animal heads on human bodies; another series has female figures, also in pairs, representing the daughters with whom Māra tried to tempt the Buddha. WZ

Illustrated on page 162

227. Buddha with adorants

Burma. 18th century
Brass. Height 32.5 cm. OA 1939.1–20.5

A frequent Burmese representation of the Buddha shows him flanked by two attendant monks, his chief disciples, Sāriputta and Moggallāna. This Buddha sits on a waisted pedestal with openwork vegetal scrolling holding a bowl and the myrobalan. His robe combines the traditional open mode of bare right shoulder with a partial covering by the third garment and is decorated at the edges with incised lines and dots. Beside him on separate stalks inserted at the bottom of the base are the two adorant monks, with long ears like the Buddha, and both holding lotuses or plants in homage. WZ

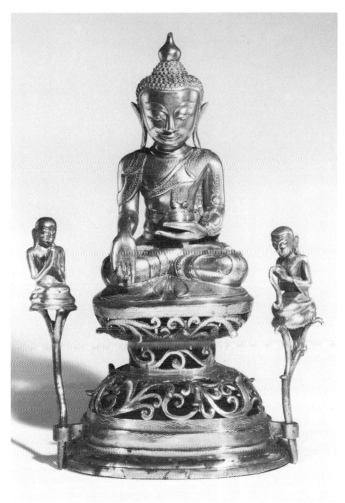

227

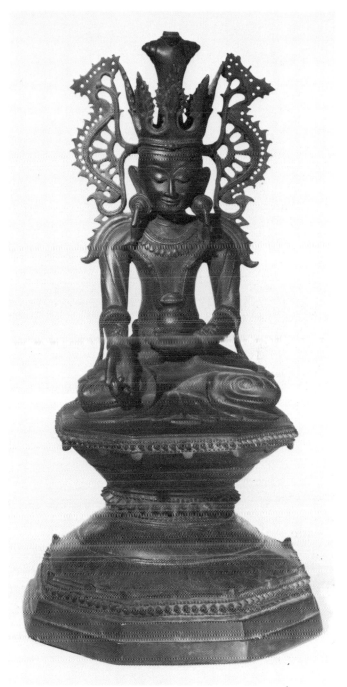

228

228. Buddha

Burma. 18th–19th century (?)

Bronze. Height 53 cm. Brooke Sewell Fund. OA 1969 2–11 1

Burmese Buddha images continued the crowned type derived from eastern India's influence at Pagan. Here great openwork appendages have developed from the ribbon-ends of the crown. Above the head was a bulbous finial, now broken. In addition to the necklaces and armlets of the crowned type this Buddha has a bowl and, in the right hand, the myrobalan which has medicinal properties. The Buddha as healer is an old and widespread concept; the 'historical' Buddha is also recorded as having received a myrobalan from the god Indra after the Enlightenment. This crowned type is called Jambupati Buddha in South-east Asia after a story, unkown from Indian sources, which tells of an ambitious king of that name whom the Buddha humbled and converted by appearing in the unmatchable splendour of a Universal Monarch. WZ

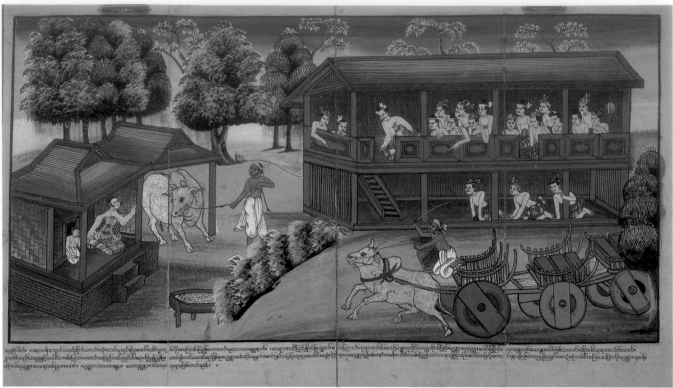

ဧရွင်ပါဝင်း "အသွက်တွေကြောင်းတကြောင်းတိုင်းထံးမှည့်မ်းရှည်ရမယ်လိုထိုးလျင်း ကိုကြိုင်ကြောင်းဖြစ်ထွေးစောင်းမှသောသာယွာယျားပါဝင်း "အာရာဏာကြိုပြင်ရှိုင်ရှည်လွှတ်ပင်း ကြဲငျထာတရာတလိုဝ်မလျှပ်လျာလျက်တိုင်း လျှယ်လိုရွာင်းရွှေးလျှဲပူလျှာယျှယ်ကိုမိုပ်ကိုရာ အသွေးရ္ထာတ်ရေးရာယျေးလယ်ရှိုဝ်သထဝ်ဝိုဝ်ဝယ်ရွာသထမရာ

အဖွင်ထိုရေတွေလျှတ်ကိုလိုတ်ကယ်ကိုရှေတှာဝါသောတပ်ထောင်လျတ်လိုရှိုလျှာဝျာဝျှာဝှာဝျော်လိုဝါ သွင်ထိုဝ်လ်ရွေးတွေလလ်ရွေးလျှည်ရယ်ရတ်ဝါရေဝ်ရွေးတွေဝ်လွပ်ရောဝ်ဝ်လိုတ်ဘူရာလိုင်ထိုင်လ်ရွှေးလမ်ကမ်ရလျော်လမ်ရ

238

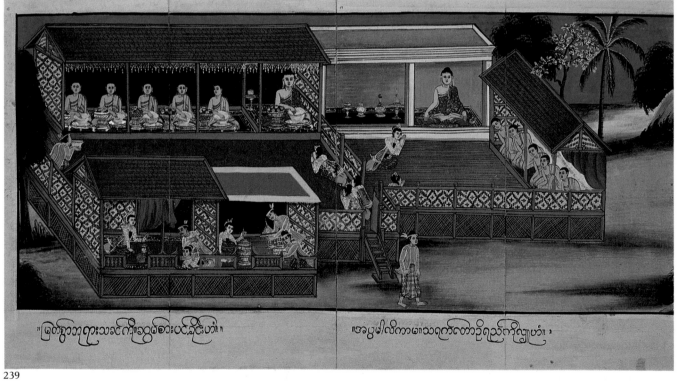

"မြတ်စွာဘုရားသခင်ကို ဆွမ်းခါး ပင်းခိုင်း ပါ။ " "အဖွားလိကာမာ သရက်တောဲ့ ရည်ကိုလျှုပါ။"

239

240

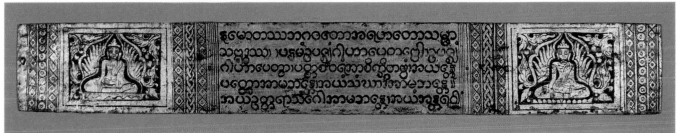

242

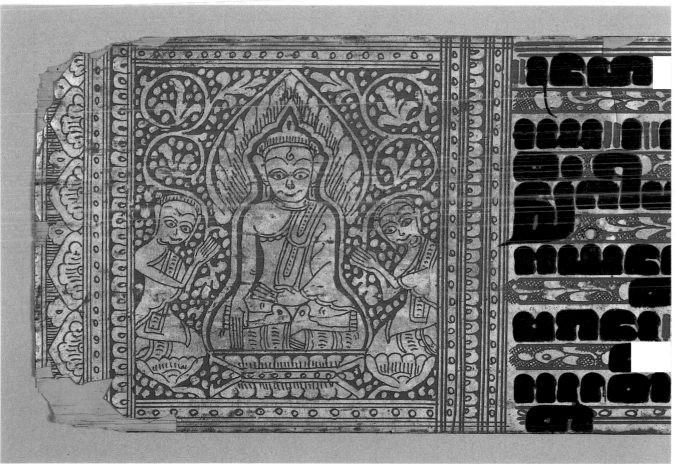

243

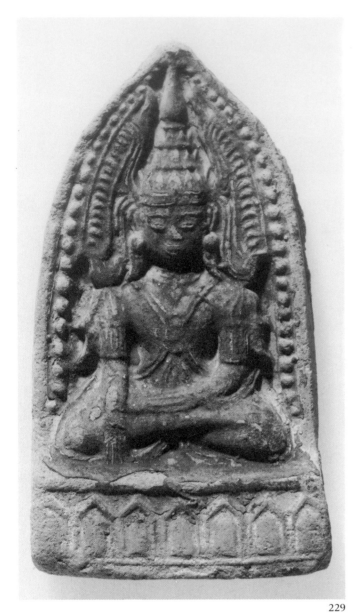

229

229. Plaque

Burma. 19th century (?)
Terracotta with traces of lacquer. Height 15.2 cm. Given by
Dr W.L. Hildburgh. OA 1925.4–2.1

The Indian votive plaque, so closely followed at Pagan, later
often carried only the Buddha image, in this instance the
Burmese crowned type. The development of the side flowers
of the crown produces two thin ribbed strips curving towards
the finial of the crown as it touches the pointed top of the
plaque. The Buddha sits in a pearled frame on a single lotus
base with straight petals. On the lacquer ground specks of
gilding are still visible. WZ

230. Buddha

Burma. 19th century
Copper alloys set with mirror-glass. Length 68 cm. OA 1891.2–25.1

The Buddha reclines before his death in a posture shared by
other South-east Asian traditions which show not a dying
man but one comfortably, even elegantly, recumbent and still
alert. The figure is made of two different-coloured alloys, the
darker indicating the robe, inlaid at the edges with the
common and late coloured mirror-glass. The hair has dark
pigment, and the eyes, of glass, have white eyeballs and black
pupils. The gilt band above the forehead is particularly gaudy
with various colours of mirror-glass making a floral pattern.
WZ

Illustrated on page 163

231. Tile

Burma. Early 19th century
Glazed pottery. 24 × 24 cm. OA 1894.7–19.4

This tile is of the type made for the Mingun pagoda, left
unfinished at the death of King Bodawpaya (1819). Above its
plinth are stepped terraces where the glazed green, brown
and yellow tiles would have been inserted. They show in
very formalised fashion the Buddhist councils held until
then. On this tile, inscribed 'Third Council', four monks sit
stiffly in a building surmounted by a three-tiered roof, each
tier ending in a dragon head. The border, base of the building
and roofs are decorated with lotuses. WZ

Illustrated on page 163

232. Buddha

Burma, said to be from Mandalay. 19th century
Wood, lacquered and gilt and set with coloured mirror-glass.
Height 1 m. Given by Mrs Ballantine. OA 1923.3–5.1

His face marked by the gentle expression of the Mandalay
style, this Buddha stands with both shoulders covered and an
ornate cascade of decorated cloth falling from his left shoulder.
His left hand pulls the lower part of the robe outwards, while
the excess cloth of the tightly wrapped arm above curls
almost into a roll. His right hand holds the myrobalan. A
floret marks the middle of the decorated band between the
forehead and the hair, and the feet stand on a lotus with
opening petals in the Indian tradition of the lotus base. WZ

Illustrated on page 163

233. Monk

Burma. 19th century

Marble. Height 1.04 m. OA 1880–257

Standing with the bowl held against his body, a young monk, or novice, has both shoulders covered by his robe. This, according to ancient rules, is the correct outdoor wear unless saluting a superior when the right shoulder should be in the open mode, or uncovered. The open mode, however, is proper inside the monastery and optional during solitary retreats or on pilgrimage. The material of the robe is tightly wound around the left arm, and the excess cloth forms a roll between the arm and the body. Considerable traces of pigment remain on the marble, a widely used medium for sculpture in Burma.

WZ

234

233

234. Monk

Burma. 19th century

Wood lacquered and gilt. Height 13.5 cm. OA 1919.7–17.15

Monastic rules allowed the monk three garments, an eating bowl, worn in Burma by a cord round the neck during the begging round, a belt, razor, needle and water-strainer so that no living thing was inadvertently killed when drinking. The Burmese monk was also given a small axe for firewood. This model carries a staff and a rosary, from his left shoulder hang a rectangular bag and two bowls or pots, and he holds by a curved handle the usual Burmese monk's fan made from a leaf of the talipot palm.

WZ

241

241

235. Woven manuscript wrapping ribbon

Upper Burma. 19th century

Red cloth with Burmese text interwoven in white. 2.5 cm × 3.4 m.
OMPB Or. 11767/ribbon

The text on this ribbon states that the manuscript and the ribbon were donated by the Chief Queen of King Mindon, founder of Mandalay, owner of the White Elephant, and convener of the Fifth Buddhist Council. It expresses the donor's wish to attain *nirvāṇa* swiftly by her meritorious deed, and to share her act of merit with all sentient beings, both human and *nat*, and asks all to commend this religious act and thereby also obtain merit.

Little is known about the Burmese art of weaving words into cloth, a skill once practised by women but now extinct. The commonest colours are red and white, blue and white, and red and yellow. The text nearly always gives the donor's name and pious wishes, often in verse. PMH

235

236. Life of the Buddha

Burma. Early 19th century

Illustrated paper book in 42 folds with Burmese text. 48 × 19 cm.
OMPB Or. 4762. ff. 3–6, 10

This manuscript is third in a series on the Buddha's life. It begins with Siddhattha's resolve to renounce royal status after the Four Encounters and ends with his austerities as a forest ascetic. The opening shows (from left to right) Siddhattha leaving his sleeping wife and baby son, riding out of the palace on his horse Kanthaka (with his groom Channa holding the horse's tail) while the gods muffle the sound of the hooves

245

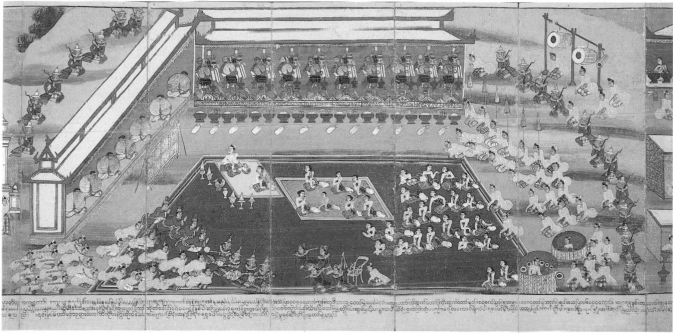

247

with their hands, and meeting Māra who tries to persuade him to abandon his resolve. The last scene (far right) shows him cutting off his long hair with his sword and tossing it into the air to be caught by the god Sakka (Indra) who enshrines it in his heaven.

The accompanying text closely follows the popular Burmese prose life of the Buddha, *Ma-la lin-ga-ra wut-htú*, compiled by Kawí-wun-tha-bí-daza in 1798. The painting style is a fine example of court art. Typical are the blocks of glowing colours highlighting architectural features and figures depicted against them, and the generous gilding. PMH

Illustrated on page 158

237. Life of the Buddha

Burma. Early 19th century

Illustrated paper book in 70 folds with Burmese text. 48 × 19 cm. OMPB Or. 5757, ff. 9–10, 17–18

This manuscript is eleventh in a series and illustrates the Buddha's life after his Enlightenment, his miracles, and places where he spent each rainy season, or Buddhist Lent (*vassa*). The first scene shows Gaṇḍa, gardener of the King of Sāvatthi, offering a ripe mango to the Buddha, accompanied by disciples. The Buddha eats the mango, tells Gaṇḍa to plant the stone, and asks Ānanda to water it from the Buddha's bowl. Instantly, a huge mango tree springs up covered in flowers and fruit. The second scene shows the Buddha preaching to his mother, assembled gods and spirits in the heaven of the Thirty-three Gods, followed by his descent down a flight of ruby stairs, flanked by gods who descend by gold and silver stairs. His disciples kneel in greeting at the foot of the triple stairway.

This manuscript always shows the Buddha entirely gilded, and his feet rest upon a lotus, symbol of purity. PMH

Illustrated on page 159

238. The previous lives of the Buddha

Burma. Mid-19th century

Illustrated paper book in 164 folds with Burmese text of the *Jātaka*. 41 × 18 cm. OMPB Or. 4542/A, ff. 23–5

Jātaka illustrations have long been popular. While many great Buddhist temples of Pagan (11th–13th centuries) are decorated with representations of *jātakas* on tiles and wall-paintings, manuscript illustrations probably began only in the late 18th or early 19th centuries when the first popular Burmese prose translations were produced. The opening displayed depicts the *Sārambha-jātaka* (no. 88), the story of the Buddha's birth as the ox Sārambha. Every *jātaka* conveys a moral precept – here to speak only kind words for harsh words cause sorrow. The ox's owner, a rich Brahmin, wagers that his animal can pull 100 loaded carts; but when he urges it forward, uses rough language. The ox refuses to budge until the Brahmin realises his fault and uses kinder language, whereupon the ox easily wins the wager.

In all Burmese *Jātaka* manuscript illustrations the Bodhisattva is shown gilded – whether as a human, animal or bird. Their charm is the freedom with which the artist has drawn upon everyday surroundings, providing a record of architecture, costume and life. PMH

Illustrated on page 166

239. Life of the Buddha

Burma. Late 19th century

Illustrated paper book in 59 folds with Burmese captions in black ink. 18 × 39 cm. OMPB Or. 13534, ff. 18–19

This manuscript depicts the Buddha's later life. The opening displayed shows the courtesan Ambapālikā offering a meal to the Buddha and his disciples, and donating a mango grove. The painting style here differs greatly from that of earlier manuscripts. Its lateness is indicated by the use of Western perspective, the court clothes of the lay figures and the Buddha's gold-spangled robe. PMH

Illustrated on page 166

240. Ritual texts

Burma. 18th century

Manuscript of *Kammavācā* in Pali. Burmese square script. Cloth, stiffened and lacquered, inlaid mother-of-pearl decoration. 3 folios. 10 × 23.5 cm. OMPB Add. 23939, f.1

The name *Kammavācā* denotes texts extracted from the *Vinayapiṭaka* and used at meetings of the Order for the valid performance of certain ceremonies. The most important and commonest *Kammavācā* text is the *upasampadā*, for higher ordination. Others are concerned with bestowing of robes, electing elders, dedication of monasteries, settling of boundaries for fast-days (*uposatha*), and release from monastic vows. The most usual texts are those on ordination, admonitions to the newly ordained monk (*ovāda-khaṇḍa*) and bestowal of robes (*kaṭhina*). The ordination section is always included and eight or more other sections are known. Although they are common to all Theravāda countries, apparently only Burma has produced to this day highly ornate and decorative *Kammavācā* manuscripts.

The leaf displayed, made from discarded monastic robes, is unusual and particularly fine. A common feature of Burmese *Kammavācā* manuscripts is a script called square or tamarind. PMH

Illustrated on page 167

241. Ritual texts

Lower Burma. 18th century

Manuscript of *Kammavācā* in Pali. Burmese square script. Palm leaf, gilded and lacquered in red, black lacquered text. 16 folios. 8 × 53 cm. OMPB Or. 1608, ff.1, 14

This is an exceptionally finely decorated *Kammavācā* manuscript, with delicate interlinear patterns of leaves and birds, and with cockerels in the margins of the opening and closing leaves. The leaves displayed contain the beginning of the ordination section (*upasampadā*) and part of the admonitions section (*ovāda*). PMH

Illustrated on page 170

242. Ritual texts

Lower Burma. 18th–19th century

Manuscript of *Kammavācā* in Pali. Burmese script. Board, gilded and decorated in black. 5 folios. 7.5 × 53 cm. OMPB Add. 15290, f.1

Opening leaf of the ordination section (*upasampadā*). The margins of the opening and closing leaves are decorated with a figure of the Buddha in the earth-touching gesture. Unlike most *Kammavācā* texts from Burma which use square script, this manuscript is written in ordinary Burmese characters. PMH

Illustrated on page 167

243. Ritual texts

Burma. Early 19th century

Manuscript of *Kammavācā* in Pali. Burmese square script. Palm leaf, gilded and lacquered in red, black lacquered text. 10 folios. 11 × 55 cm. OMPB Or. 12010/C, f.1

Opening leaf of the ordination section (*upasampadā*). The margins of the opening and closing leaves are decorated with a figure of the Buddha in the earth-touching gesture and his chief disciples, Sāriputta and Moggallāna. The gilding has flaked in places, revealing the palm leaf underneath. PMH

Illustrated on page 167

244

244. Ritual texts

Burma. 19th century

Manuscript of *Kammavācā* in Pali. Burmese square script. Ivory, black lacquered text, with geometrical decorations in gold and red. 18 folios. 9 × 54 cm. OMPB Or. 14008, f.1

The leaf displayed opens the ordination section (*upasampadā*). Less rare than the use of stiffened cloth, the use of ivory sheets for *Kammavācā* manuscripts is uncommon. Ivory is difficult to decorate since the gilding and lacquered characters do not easily adhere. PMH

245. Ritual texts

Upper Burma. Late 19th century

Manuscript of *Kammavācā* in Pali. Burmese square script. Board, gilded and lacquered, brown lacquered text, between decorated binding boards. 16 folios. 13 × 54 cm. OMPB Or. 4949, f.1, cover.

Opening leaf of the ordination section (*upasampadā*), decorated in each margin with a figure of a deity. The style of decoration is typical of the Mandalay period (1857–85). PMH

Illustrated on page 171

246. Burmese Buddhist cosmology

Upper Burma. 19th century

Illustrated paper book in 59 folds with Burmese text. 20.5 × 54 cm. OMPB Or. 14004, ff.34–5

This lavish manuscript with accompanying text describes Theravāda cosmology as found in Pali commentaries and Buddhaghosa's *Visuddhimagga* (c. AD 400), but with some Burmese variations. The universe is divided into three layers – the spheres of desire (*kāmadhātu*), form (*rūpadhātu*) and no-form (*arūpadhātu*). The first contains the six heavens and palaces of the gods, above which are the two spheres of form and no-form. Below them is the earth with the cosmic axial mountain, Meru, at its centre, surrounded by seven concentric rings of seas and mountains. Four islands or continents, abodes of mankind, lie at the cardinal points of Meru; in the southern (Jambudvīpa) all Buddhas are born. Below come the human and animal heavens and lower still the Buddhist hells.

The opening displayed shows the fabulous region of Himavant covered in forests with seven great lakes, and inhabited by gods, sages, demons and wild animals. The artist has painted only the wild animals, emphasising the elephants and their lake, Chaddanta. PMH

Illustrated on page 174

247. Royal donations

Burma. Mid-19th century

Paper book in 36 folds with scenes and descriptive Burmese text of royal donations. 54 × 24.5 cm. OMPB Or. 13681, ff. 5–7, 10–11

This manuscript records and illustrates donations by King Mindon (r. 1853–78) to the Order between 1853 and 1857, in keeping with his function as its chief protector and patron. The openings displayed show the donations made in 1854 and 1856. In the foreground courtiers of Amarapura with musicians in attendance prepare the offerings and pay reverence to the monks, who are hidden by their giant fans. King Mindon and his queen are seated on the yellow mat (f. 6 mid-foreground) with his chief ministers, in red robes and hats, to the left. The offerings for the monks lie heaped in rows. Besides the eight requisites of a monk, donations include gilded manuscript chests, palm-leaf manuscripts and cloth wrappers, beds decorated with glass mosaic, gold lace mosquito nets, spices, candles and brooms. The text records them in great detail, giving the exact cost, and states that the king poured the traditional dedication water, calling the earth to witness, and shared his great merit. PMH

Illustrated on page 171

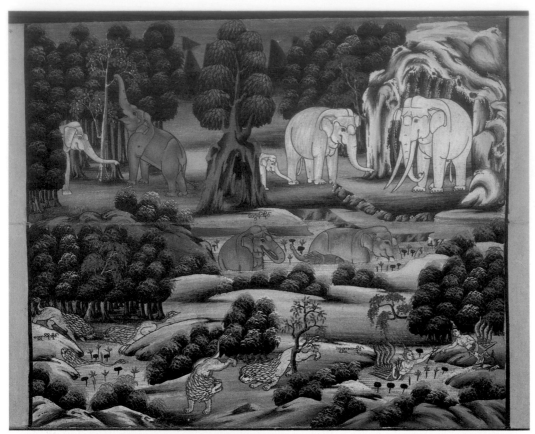

246

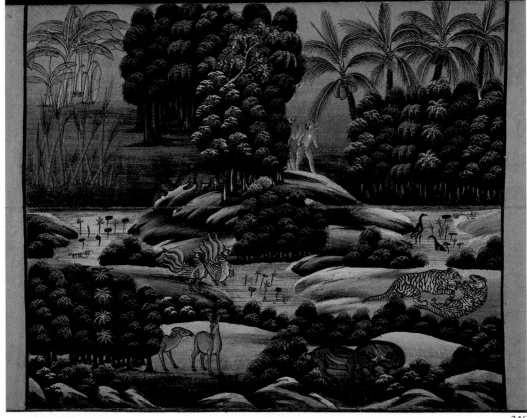

246

11 Thailand and Cambodia

A variety of Buddhist ethnic groups have inhabited Thailand and Cambodia where Buddhism has encompassed quite distinct cultures, each with its own art style. The most notable are the Mons, the Khmers (or Cambodians), and the Thai (or Siamese). The last were relatively late arrivals from China, only significant culturally from the thirteenth century. The rich rice plains of Thailand and Cambodia and the tropical climate, combined with irrigation systems, assured the development of prosperous states. However, underpopulation has been a chronic problem, and a major objective of war and conquest was the acquisition of population to grow food and build up the state's resources.

Buddhism probably reached the area from India by the early centuries of our era, but its first surviving remains date from the fourth or fifth centuries. The earliest sculptures are bronzes from India or Sri Lanka. They no doubt served as models which were copied, but local styles developed rapidly. The first known state in Thailand is that of the Buddhist Mon flourishing from the sixth to the eleventh centuries in central Thailand. It is referred to today as Dvāravatī, from the appearance of this name on excavated coins. A rich heritage of sculpture, both Hīnayānist and Mahāyānist, in terracotta, stone and bronze, as well as remains of *stūpas*, survive from this splendid Buddhist culture.

Our knowledge of the early Khmer kingdoms in Cambodia dates from the sixth century. Here Hinduism and Buddhism often within a single period were honoured and followed by the rulers. Superb stone sculpture has survived from these early kingdoms, some of it Buddhist, together with numerous, mainly Hindu, brick and stone temples based on Indian prototypes but magnificently decorated in the Cambodian idiom. Bronzes are rare from Cambodia before the tenth century, but hoards of buried bronzes recently uncovered at Prakhonchai and Bān Fāi have revealed masterpieces of lost-wax bronze casting closely akin to Cambodian art. They are our only indications of Buddhist states in north-east Thailand of the highest sophistication in the seventh and eighth centuries. Another state in north central Thailand, Sī Thēp, also produced extraordinary stone sculpture in the same period, Buddhist and Hindu, in a style equally linked with metropolitan Cambodian art.

Similarly in south Thailand, in small states in the mountainous Malay peninsula, magnificent early Buddhist stone sculpture was carved in a style suggesting close contacts with Cambodia during this period. However, from the eighth to the eleventh centuries the peninsular region was part of an important Buddhist kingdom now called Śrīvijaya, largely on the basis of Chinese references. The location of the centre of Śrīvijaya is still unknown, and archaeological remains are minimal, but the rich examples of Buddhist sculpture in bronze, stone and silver, found in a broad area along the peninsula as well as on Sumatra and Borneo, suggest that

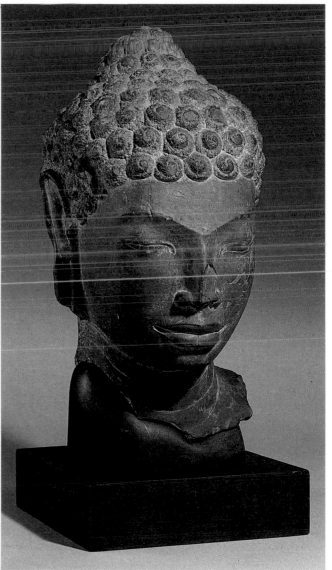

248

many small states were united by sea from a central point. Characteristic of this period of peninsular sculpture are its extremely close links with the Buddhist art in Java of the same period. Indeed, many bronze sculptures found on the peninsula may well be Javanese imports. Other pieces are distinct enough to be pinpointed as specifically peninsular or 'Śrivijayan'.

In Cambodia the twelfth and thirteenth centuries saw an extraordinary growth of an empire, with a profusion of building and carving quite unique in world history. This period saw the creation of Angkor Wat, one of the greatest stone temples in the world, and included in the last decades of the empire the creation of a complex Buddhist temple, Bayon, with large towers bearing huge faces generally interpreted as images of the deified king in the form of a Bodhisattva. In all the lands under Khmer domination, including much of Thailand, vast quantities of sculpture were produced.

The mammoth Cambodian empire collapsed in the thirteenth century, and the country languished into modern times on a relatively small scale. There was continual conflict with new neighbours, the Thai, whose first state appeared in the thirteenth century at Sukhothai in north central Thailand. This kingdom was, according to its stone inscriptions, relatively egalitarian under a just and tolerant king, in strong contrast with Cambodia's highly stratified society and deified kings. Its religion was Hīnayāna Buddhism following close links with the Buddhist clergy in Sri Lanka. Since then Thai Buddhism has been almost entirely Hīnayānist. The ruins of Sukhothai, now restored, reveal much about its architecture, influenced by Cambodia, Burma, Sri Lanka and the Mons.

A new sculptural style of great individuality arose, in some respects without any obvious antecedents, characterised by long smooth curves and rounded full volumes. The walking Buddha is its most striking contribution to Buddhist imagery. North of Sukhothai a distinct Thai culture flourished from the fourteenth century, known as Lān Nā, with Chiangmai as its capital. Where the classic Sukhothai Buddha image has a flame finial, the northern type ends in a lotus bud; where the Sukhothai image's legs are laid one upon the other, the northern type has legs crossed with soles upward; and where the folded robe end falls to the waist in Sukhothai, it stops above the breast on classic northern images. Later examples tend to combine and vary these characteristics. Beginning in the fifteenth century many of the northern images were made with dated inscriptions, so their development can be traced in detail. The northern kingdom later fell under Burmese control for two centuries until the later eighteenth century.

In 1350 another Thai kingdom was established in lower Thailand at Ayutthaya, heavily influenced by both the Mon and Khmer institutions prevalent in this region for so many centuries. Indeed, for all periods of central Thai history large segments of the population were Mon, Khmer and, in later times, Chinese, and these non-Thai cultural influences have always been prominent. The restored ruins of Ayutthaya, destroyed by the Burmese in 1767, show an architecture which combines a variety of traditions. The first surviving examples of Thai drawing and painting are of the fifteenth century and give a vague idea in their ruinous state of a fine linear art tradition that continues to more recent times in a form relatively debased, yet still often full of delicacy, charm and rich colouring. Banner, mural and manuscript painting were its main applications.

The Thai capital moved south to the Bangkok region following the sack of Ayutthaya, and the Buddhist arts of the most recent Thai dynasty survive in great profusion. Elaborate decoration of Buddha images in the form of gilding, crowns, adornments, jewellery, set upon carved bases of wood or stucco also gilded and set with coloured glass or gems, can be richly impressive and beautifully worked, but the quality of sculptural modelling is usually mediocre.

The Buddhist art of neighbouring Laos is an offshoot of northern Thailand. Linguistically and culturally Laos is closely related to this part of Thailand. To the east Vietnam has also had a long Buddhist history, both under Chinese and, as in the kingdom of Campā, under Indian traditions. HG

248. Buddha

Thailand. 7th century AD

Limestone. Height 33 cm. Given by the heirs of Dr Louise Elsa Samson. OA 1963.10–16.1

The graceful style of this head goes back to an eastern Indian Gupta prototype, most probably that of Sārnāth; its resemblance to the bronze from Danesar Khera (no.130) has also been noted. The features of heads in the Dvāravatī tradition are thought to reflect ethnic traits of the Mon people, seen here in the high cheekbones, full lips and broad nose. The *ūrṇā*, as in Sārnāth and usually in Thailand, is missing; the joined eyebrows curve typically, and with its open eyes the face contrasts with those that are closer to the meditative Gupta type. WZ

Illustrated on page 175

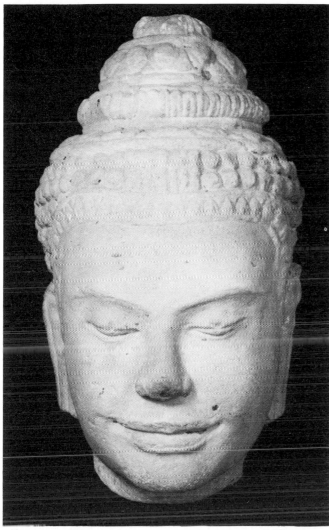

249

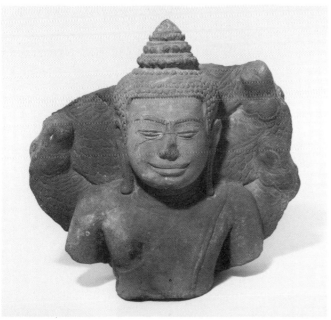

250

249. Buddha

Thailand. 13th century

Sandstone. Height 40 cm. Given by Col. M. Earle, CB, CMG, DSO.
OA 1951.11–12.1

This ornamented Buddha head in the Khmer Lopburi style
has a long, smoothly modelled face. Above the elegantly
undulating browband are rows of curls and a ring of lotus
petals around the base of the damaged, tapering *uṣṇīṣa*
with its two types of lotus-petal ornament. It is impossible to
say whether the head came from a standing or seated image.

WZ

250. Buddha

Thailand. 13th–14th century

Sandstone. Height 32 cm. Given by H.G. Beasley, Esq.
OA 1948.7–16.39

This fragment in the Lopburi style of Khmer inspiration has
now only three serpent heads left from the usual seven of the
Buddha's many-headed protector Mucalinda; the scales con-
tinue on the back. The face retains characteristic Khmer
features: full lips hinting at a smile and eyebrows forming a
continuous raised and curved band. A provincial flavour is
very marked, but the crudely cut eyes have a sense of
intensity. The head is surmounted by a tiered *uṣṇīṣa* in
three rows of lotus petals, and below the roughly incised
three necklines (*trivali*) the robe is worn with the right
shoulder bare.

WZ

251. Buddha

Thailand. 14th century

Bronze. Height 28 cm. OA 1947.5–14.1

Images in the history of Buddhist art have expressed the
accessibility of the Buddha to the devotee by appearing to
move towards him, and narrative scenes have also shown a
Buddha in movement, but the three-dimensional walking
Buddha is the invention of the Sukhothai metal sculptors. Its
direct precursor lies in such narrative representations as the
descent from the heaven of the Thirty-three Gods, found in
stucco reliefs at Sukhothai; the partly three-quarter view was
adapted for frontal representation in the round. The Buddha's
right hand is here raised in reassurance, and his left foot has
almost left the ground. The style of this image is close to the
Khmer tradition as represented in the formative stages of the
Ayutthaya style.

WZ

Illustrated on page 180

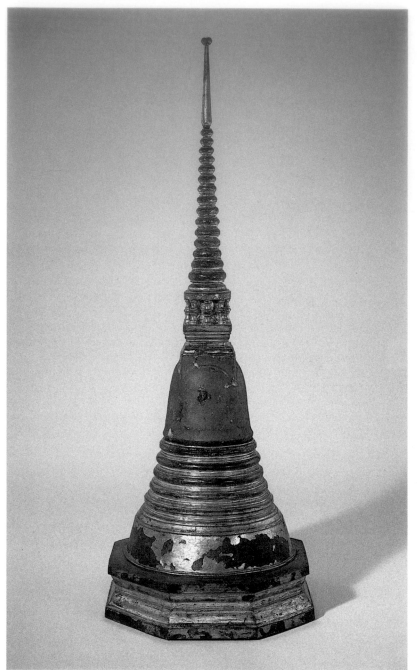

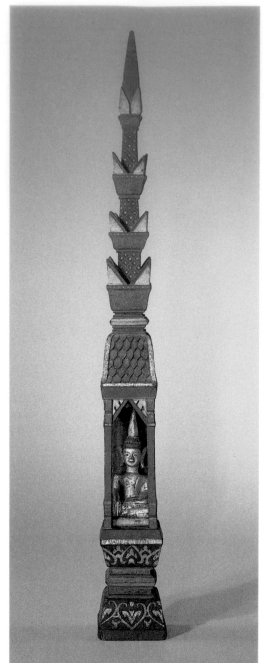

254

256

261

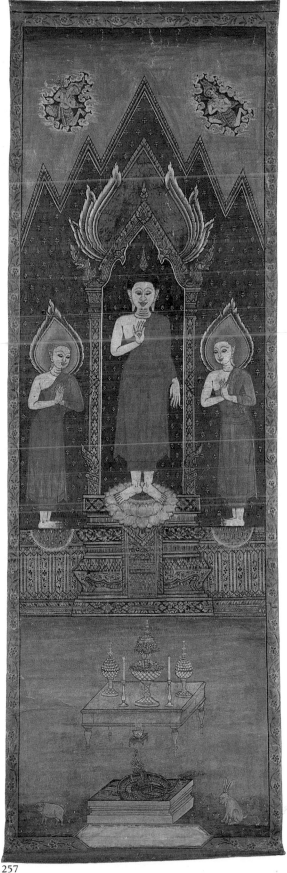

257

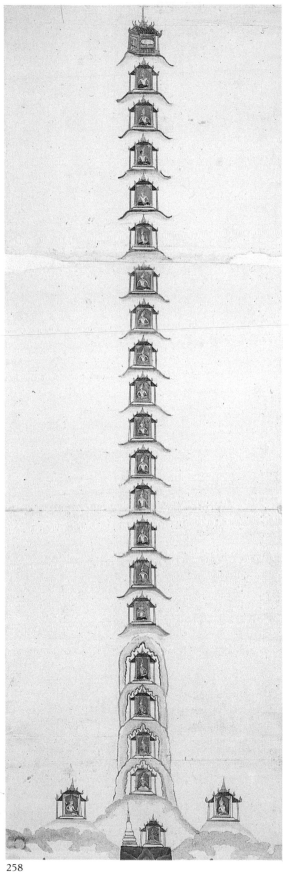

258

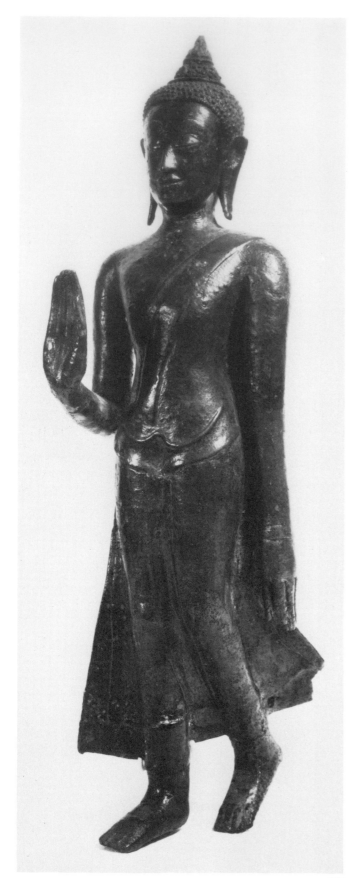

251

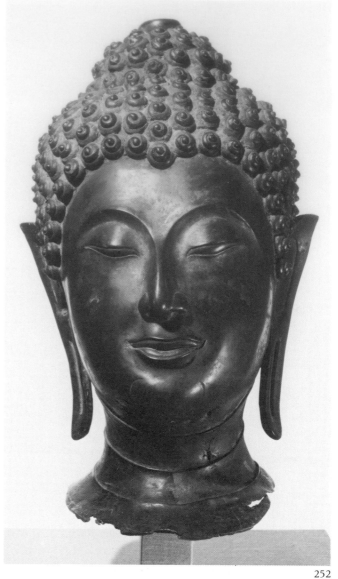

252

252. Buddha

Thailand. 14th century AD

Bronze. Height 48 cm. Given by P.T. Brooke Sewell, Esq.
OA 1957.7–26.3

Part of a figure, either standing or seated and over life-size, this head is broken off at the neck below its standard auspicious three lines (*trivalī*) and has lost the flame finial above the *uṣṇīṣa* which emerges harmoniously from a mass of curls twisted in the Indian manner; the hairline at the middle of the forehead comes to a gentle point as in Indian Buddhas; the ears are pointed at the top, a Sukhothai innovation in Thailand thought to be inspired from Sri Lanka. The oval shape of the head is a classical achievement of Sukhothai, and the features fit well with it: the eyes, partly veiled behind the lids, sweep upwards under the arched and slightly ridged eyebrows, and the lips are formed with stylised simplicity. wz

253. Buddha

Northern Thailand. Dated 1540/1

Bronze. Height 55 cm. Given by Sir A.W. Franks (Bock Collection). FB. Ind. 5

This crowned and ornamented Buddha, making the earth-touching gesture on a large oval lotus base above a moulded hexagonal pedestal with three inscribed faces, may be considered of a mixed type combining the graceful Sukhothai tradition with the more masculine lion type of northern Thailand. The latter, also called Late Chiangsen, after an earlier northern state, derives from eastern India and particularly Bodh Gayā, a site recreated at Chiangmai under King Tiloka (1441–87) of the northern kingdom of Lān Nā by copying the Mahābodhi temple. The ornaments consist of armlets, bracelets, pearled bands and four-petalled flowers, one of which marks the chest instead of a necklace, and a crown made of a graceful series of tiered triangles surmounted

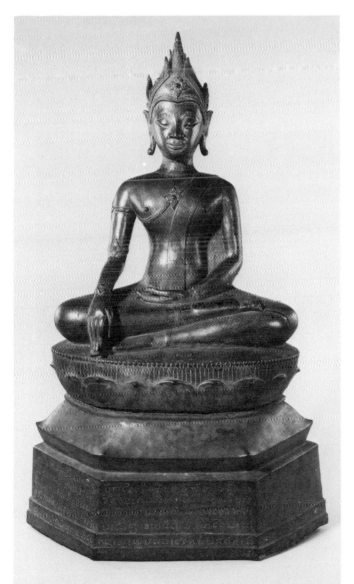

253

by a finial of *stūpa* form. The inscription records the dedication by three persons of an image of the earlier Buddha Sikhi for a monastery and expresses the wish that they may be born, grow old and gain merit together in all their future lives until they have attained *nirvāṇa*. The date corresponds to 1540 or 1541. WZ

254. Stūpa

Thailand. 16th century or later

Brass lacquered and gilt. Height 78.7 cm. Given by R. le May, Esq. OA 1957.10–14.1

A round bell-shaped *stūpa* in the style of Sri Lanka, incorporating columns between the *harmikā* and the bulbous rings of the spire, a feature which became prominent in the Ayutthaya period. This *stūpa* is in two parts, the octagonal base and the dome and spire. The dome is hollow. WZ

Illustrated on page 178

255. Buddha

Thailand. 18th century

Terracotta gilt on a painted ground and set in a wooden mount. Height 31.5 cm. OA 1894.9–26.18

Mounted in a somewhat decayed wooden panel, this terracotta plaque in the Ayutthaya style represents a late stage in the Buddhist tradition of making votive plaques. In Thailand it had a lively existence through the phases of its arts. This example shows the crowned and ornamented Buddha associated in South-east Asia with the Jambupati legend and the Buddha's universal sovereignty. WZ

Illustrated on page 184

256. Model temple

Laos(?). 19th century (?)

Painted wood. Height 63.5 cm. OA 1880–3452

The origin of this little model is not recorded, but its architectural type and the square, linear quality of carving of the seated Buddha, recalling northern Thai styles, suggest a source in north east Thailand or Laos. The same attenuation can be seen, for instance, in slender, tower-like structures around the That Luong, near Vientiane, founded in 1586. The roof of the sanctum has lotus petals carved in relief, and the plinth has painted decoration also recalling the lotus petal. WZ

Illustrated on page 178

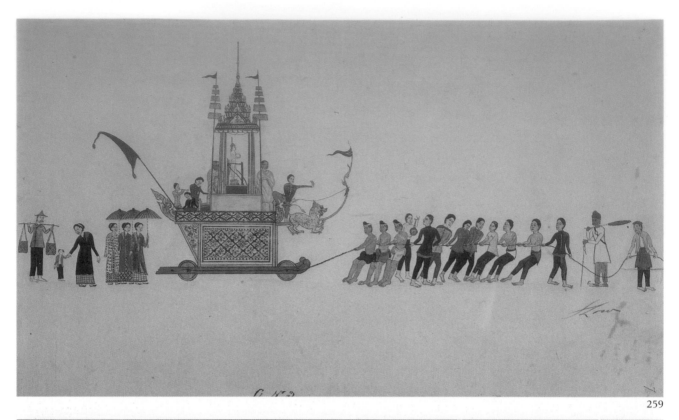

259

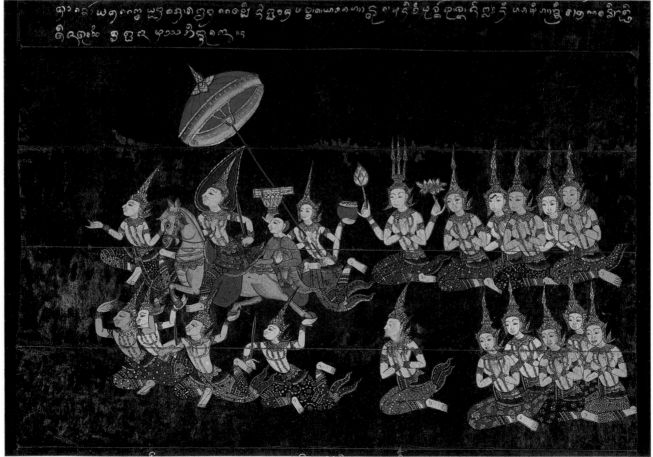

262

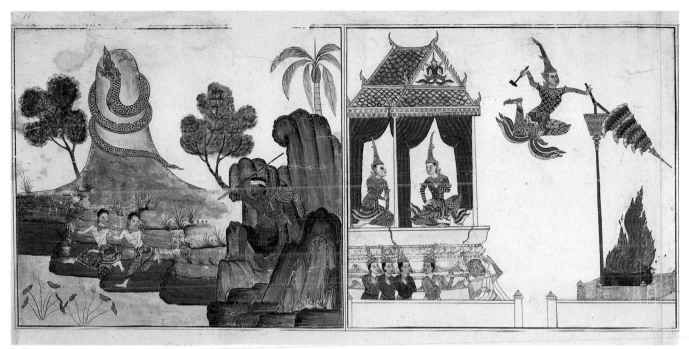

260

263 (f.1)

264

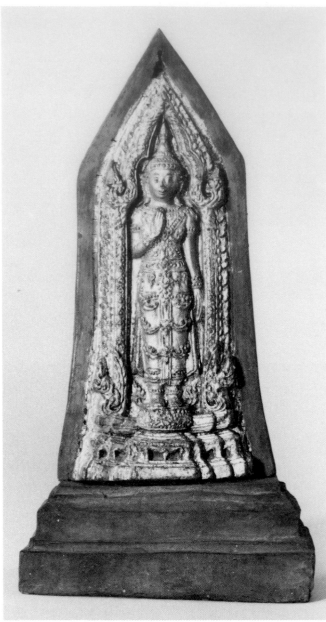

255

257. Buddha

Thailand. 19th century

Painting on cloth. Height 2.84m × 89cm. Brooke Sewell Fund. OA 1959. 10–10. 09

The Buddha stands on a lotus in the centre of a symmetrical composition consisting of a late Thai niche on a moulded pedestal decorated with floral and leaf motifs. Flanking the Buddha's blue niche, against a brown background, stand haloed monks in adoration, presumably Sāriputta and Moggallāna. In the sky are deities holding flowers and ringed by clouds. Below are an offering table and a dragon in water (?) flanked by a sow and a rabbit which may have a calendrical application. The Buddha's tapering head-dress has a pearled ring, and the *uṣṇīṣa* is surmounted by a late form of the Thai flame-finial. The Buddha's halo, too large to fit into his niche, rises above the arch. WZ

Illustrated on page 179

258. Diagram of the world, heaven and hell from Capt. Low's Thai album

Thailand. *c.*1820

Painting on European paper. 155 × 27 cm. OMPB Add.27370. f.5

This long diagrammatic drawing indicates the complete universe of old Thai Buddhist cosmology, derived from Indian sources. At the top is a stack of little pavilions containing divinities, representing the many levels of heaven. These ascend above the seven-tiered central mountain, flanked by sun and moon chariots, the stars, and two figures from mythology. Lower down at the base of the mountain are the creatures that inhabit the magical forests there. Next, five continents are represented in map section in an ocean encircled by a great double serpent. Further down are some of the levels of hell, each reserved for specific types of punishment. HG

Illustrated on page 179

259. Festive procession of a Buddha image from Capt. Low's Thai album

Thailand. *c.*1820

Painting on European paper. 33 × 54.5 cm. OMPB Add. 27370. f.7

The custom of pulling in festive procession a revered Buddha image mounted on a decorated wheeled cart occurs in Thailand only in the southern regions, where it must be an adaptation from Indian Hindu custom. The Thai artist has recorded the scene for his European patron with lively detail and humour. Young men haul the cart by rope through the town. Observers include a Chinese pedlar on the far left, and ladies, a child and a man all in typical Malay rather than Thai dress, which must have been that of the far south. On the cart two monks attend the standing Buddha image, and three musicians play a drum, oboe and gongs. HG

Illustrated on page 182

260. The last ten birth tales from Capt. Low's Thai album

Thailand. c.1820

Painting on European paper. 55 cm × 1.31 m. OMPB Add. 27370. f.11

Adapted from traditional Thai manuscript illustration of the last ten birth tales, this version was painted by a Thai artist for his European patron on Western paper. The stories are laid out in order in two neat rows, with one scene from each story. The second and third scenes in the lower row can be compared with the traditional renditions. The artist here has included in rich detail the decorative arts of his period, such as architectural features and textiles, which were made in India to Thai order for use as clothing and curtains. HG

Illustrated on page 183

261. An explanation of meanings

Thailand. c.1830–50

Manuscript of *Padatthayojanā* in Pali. Cambodian script. Fine gilt and lacquer painted cover leaves to each of 19 bundles of leaves, mother-of-pearl inlaid wooden cover boards. 449 palm leaves. 5 × 58 cm. OMPB Or. 5107

A commentary by Ñāṇakitti expanding the *Samantapāsādikā*, which is Buddhaghosa's commentary on the *Vinaya Piṭaka*. The fine quality of decoration of this text suggests that it was commissioned by a high-ranking prince. Thirty-eight cover leaves are lavishly decorated in gold and lacquer painting with rows of *devas* (heavenly beings) seated between ceremonial fans and surrounded by rich foliate decoration. The central cartouche contains the title of the work. The wooden cover boards are delicately inlaid with mother-of-pearl in a foliate pattern. HG

Illustrated on page 178

262. Ritual text

Northern Thailand. Late 19th century

Folding stiffened cloth manuscript of *Kammavācā* in Pali. Northern Thai script in gold with 2 illustrations. Wooden cover boards with lacquer and gold floral decoration. 19 folds. 10 × 60 cm. OMPB Or. 14025

The text is the ordination service (*upasampadā*). Decorated ordination texts are not common in Thailand, and this example, because of the script, probably comes from the northern capital Chiangmai or near by. The painting style, however, is typical of central Thailand and Bangkok, and may be by a Bangkok artist. It depicts the great departure of Siddhattha, borne silently away in the night on his horse by the gods. The manuscript is made of stiffened cloth, blackened with soot paste in the same way that paper folding books were often treated in Thailand. HG

Illustrated on page 182

263. Legend of Phra Malai

Thailand. 1868

Paper manuscript in Pali and Thai. Cambodian script. 7 pairs of illustrations. 92 folds. 14 × 66 cm. OMPB Or. 6630. ff.1,43

The story of the monk Phra Malai has been extremely popular in Thailand in recent centuries as a preaching text. Phra Malai gained extraordinary powers through his meditations and was able to travel to heaven and hell. Later he returned to earth to relate what awaits us in these places. The text was commonly recited at funerals in Thailand, as a vivid reminder of the afterlife and of the rewards or punishments for our behaviour on earth. The scenes shown are set in heaven with a variety of divinities and angels. Phra Malai appears on the lower left in discussion with the god Indra (in green). HG

Illustrated on page 183

264. Ritual texts

Laos. 1805

Manuscript of *Kammavācā* in Pali. Incised Lao Tham script. Palm leaf, with gilded edges between wooden binding boards, raised gilt and coloured glass decoration. 27 folios. 6 × 59.5 cm. OMPB Or. 11797, f.1, covers

Opening leaf of ordination section (*upasampadā*). In Laos a special script called Lao Tham (*dham*) was used for writing religious texts in Pali. Unlike Burmese *Kammavācā* manuscripts, those from Laos are generally dated and this manuscript is inscribed (f.27b) Cullasakkarāj 1167 (1805). Although the covers are decorated, the manuscript is much less ornate than Burmese *Kammavācās*. PMH

Illustrated on page 183

12 Indonesia

Indian culture reached Indonesia by the fifth century AD, and the earliest Buddhist images found, of about this period or a little later, are imported bronzes or local imitations of the Indian or Sri Lankan Amarāvatī styles. According to the Chinese pilgrim Faxian (AD 414), Buddhism hardly existed in Java; but conversions soon followed and at the end of the seventh century various schools of the Hīnayāna had adherents 'in the islands of the Southern Sea'. Subsequently the Mahāyāna and Vajrayāna became dominant in Indonesian Buddhism and particularly in Java.

Around AD 750 the Matarām dynasty in south-central Java became, for a century, vassals of the Śailendra kings; then this dynasty regained power while the Śailendras ruled Śrīvijaya in Sumatra and the Malay peninsula. In c. AD 930 the Matarām dynasty moved its capital to the east. The great Buddhist monuments of the eighth to ninth centuries, creative adaptations of Indian models, belong to what is called the central Javanese period.

Its most celebrated monument, Borobudur (c. AD 800), consists of a hill covered with masonry in the form of a terraced structure of five rectangular and four circular levels, originally 37 m high and stretching 123 m along its axes. The building is a *maṇḍala*: the visitor ascends from the earthly plane of desire through the world of form without desire to the formless world where the summit represents the Absolute. A level now almost completely covered has carved panels illustrating a text on *karma*; panels in the galleries of the rectangular levels above illustrate the life of the historical Buddha according to the *Lalitavistara*, *jātakas*, the spiritual odyssey of Sudhana, and scenes with the Bodhisattvas Maitreya and Samantabhadra. On the parapet walls of the rectangular levels were 432 Buddha images. Seated in niches crowned by small *stūpas*, they are, on four levels, the Buddhas of the cardinal points, making their appropriate gestures; those on the top wall, however, making the gesture of argumentation, may be Samantabhadra as a Buddha, or Vairocana, Buddha of the centre. On three circular levels above Buddhas in seventy-two latticed *stūpas*, making the gesture of preaching, may also be Vairocana. An unfinished Akṣobhya, in the earth-touching gesture, in the central crowning *stūpa*, has been thought intrusive. While these are obviously dispositions of a cosmic and spiritual hierarchy, its exact iconography is not now clear.

Other temples in central Java are distinctive. Candi Mendut contains three superb stone figures, a Buddha and two Bodhisattvas, Lokeśvara and Vajrapāṇi, so large that the temple had to be built round them; they represent another hierarchy. Candi Sewu and Candi Kalasan each have a central building of cruciform plan, perhaps of eastern Indian inspiration. At Candi Sewu some 240 small temples are arranged around the sanctum, and at Candi Plaosan the disposition of small temples and *stūpas* similarly suggests a *maṇḍala*. Except at Mendut no principal cult images survive but there is evidence of large-scale metal casting.

The sculptural styles drew on peninsular and north-eastern India. The abundant small metal sculpture often closely resembles that of Nālandā, where monks from the Śailendra dominions had a monastery. There was also influence from Bengal, where a related style existed, through maritime traffic from ports such as Chittagong. A number of images in precious metals survive and provincial distinctions have been noted.

The unexplained move, around 930, of the Javanese capital eastwards inaugurated the east Javanese period, lasting until c. 1520 when Islam became dominant. The early eastern style bronzes of Nganjuk are evidence for continued Buddhist Tantrism. The distinction between it and Hindu Tantrism became blurred, but recognisable Buddhist sculpture under the Singasāri dynasty (1222–93), influenced by north-eastern India, also used an Indian script to label images. The last Singasāri king, Kṛtanagara (1268–92), apparently followed a Tantric cult and saw himself as Śiva-Buddha incarnate. The Buddhist temple of Candi Jago was built in his reign, and there were also buildings and sculpture in Sumatra where east Bengal influence is evident.

Under the kings of Majapahit (1293–1528) Buddhist dedications diminished, and from the thirteenth century mercantile traffic brought Islam and conversions. Tantric Buddhism, no longer renewable from the land of its birth, was too far removed from the Hīnayāna of South-east Asia, and both Hinduism and Buddhism had always been religions of the higher court culture, connected with administration and political theory. No mass conversions took place when Majapahit disintegrated in the face of Muslim settlements. The small island of Bali alone has remained Hindu. wz

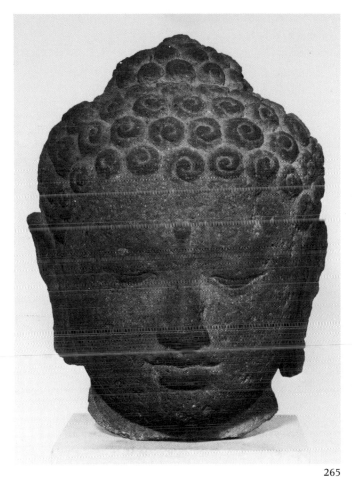

265

265. Buddha

Java, from Borobudur. 9th century AD

Volcanic stone. Height 23 cm. Given by Canon Flint.
OA 1859.12–28.176

This head must have come from one of just over 500 Buddhas occupying niches and trellised *stūpas* on the Borobudur monument. Its style, already Indonesian, is at the same time still post-Gupta and eastern Indian with reminiscences of Bihar and Orissa in its globular head and full rounded features. wz

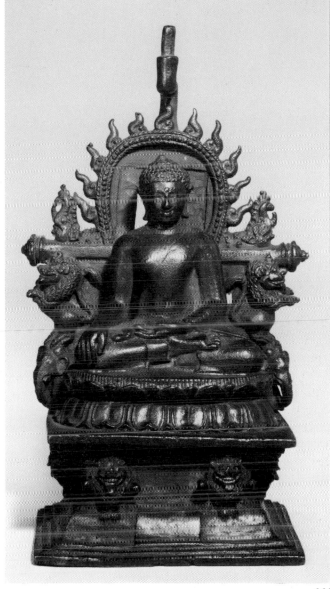

266

266. Buddha

Java. 9th century AD

Bronze. Height 19 cm. Given by Canon Flint. OA 1859.12–28.41

This Buddha is close to the stone figures of Borobudur and an excellent example of metal images in the eastern Indian tradition followed in Java. The Buddha sits on the royal lion-throne with a double lotus base, against a throne-back with a bold cross-bar separating it from the halo and the bent shaft for the missing parasol. On the sides of the throne-back are superbly modelled leogryphs mounted on elephants, a regular Indian combination. Above the cross-bar, flanking the halo, are *makara* heads, and radiating from the pearled border of the halo is the distinctively Javanese flame surround, longer and more spaced than the Indian prototypes. The rectangle cut into the halo may have contained a lost replacement patch since the backplate in general shows casting faults. wz

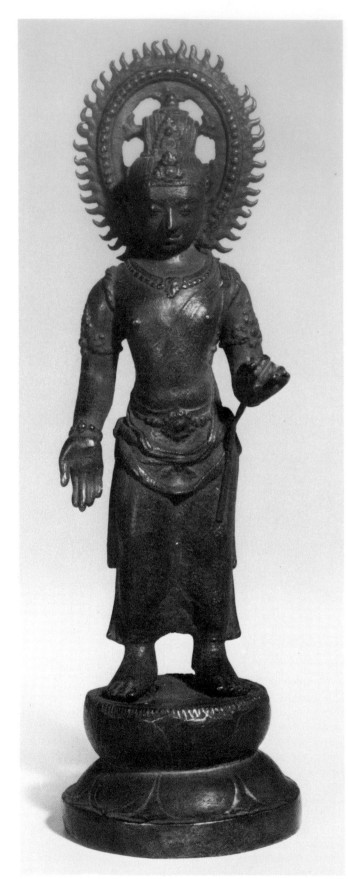

267

267. Avalokiteśvara

Java. 9th century AD

Bronze. Height 23 cm. Given by Canon Flint. OA 1859.12–28.50

On this well-modelled Padmapāṇi, or lotus-holder form of Avalokiteśvara, the stalk of the lotus is broken above the left hand; the other is in the gesture of liberality. The head in profile is particularly close to eastern Indian 9th-century metal sculpture, and the girdle of the lower garment has a pearled circular clasp resembling those on Bihar statuary of the early Pāla period. This figure, may, with a Vajrapāṇi, have flanked a Buddha, as in the Mendut triad, thus constituting a group held in Java to be an intermediate manifestation of ultimate reality.　　　　　　　　　　　　　WZ

268. Vajrapāṇi

Java. 9th century AD

Bronze. Height 23.5 cm. Given by Canon Flint. OA 1859.12–28.49

This slender Bodhisattva holds his attribute, the *vajra*, here an elongated and pointed wand without curved prongs, in his right hand and may have flanked a central Buddha like the Vajrapāṇi in Candi Mendut, but his left hand makes a different, expository, gesture. His lower garment is shorter than that of Padmapāṇi and ends in elaborate pleats, and his pearled sacred cord falls almost as far. His ornamented head-dress has no indication of hair, as has Padmapāṇi, but recalls the Nepalese Vajrācārya's crown (no. 166); like the Padmapāṇi, however, he has a strand of hair falling over each shoulder to the armpit.　　　　　　　　　　　　　WZ

269. Vairocana

Java. 10th century

Bronze. Height 29 cm. Given by Canon Flint. OA 1859.12–28.77

The central position often held by Vairocana in *maṇḍalas* makes him one of the more important deities in Tantric Buddhism. The disposition of Candi Sewu is thought to reflect his *maṇḍala*. Here he is crowned and ornamented; the monastic Vairocana occurs in Java at Borobudur, and there are also some published bronzes of monastic type. This example shows exceptionally crisp and distinct detail of the figure, the scrolling of the throne-back and the double lotus base.　　WZ

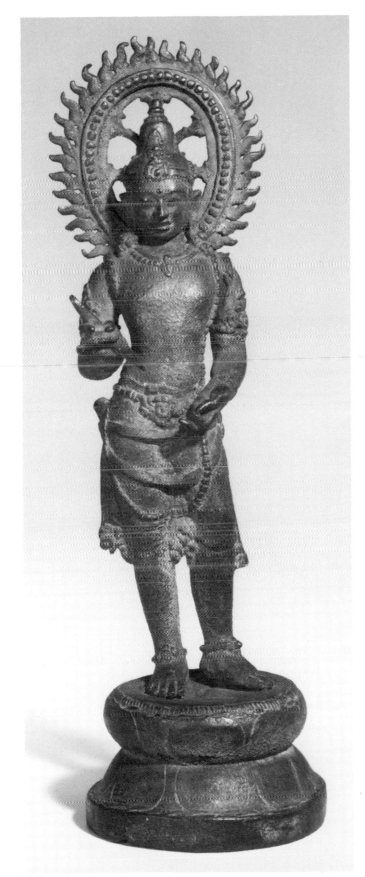

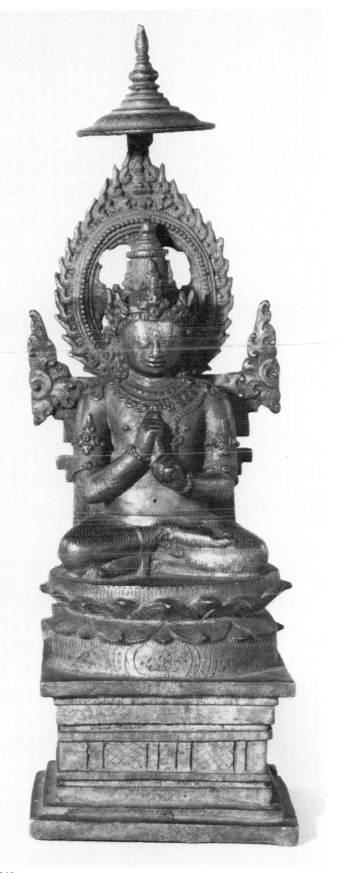

268

269

189

270. Ghaṇṭā

Java. 10th century

Bronze. Height 20 cm. Given by Canon Flint. OA 1859.12–28.116

As elsewhere the Indonesian *ghaṇṭā* played an important part in ritual and symbolism. This example consists of an ornamented bell surmounted by four heads above a double lotus and a ring on which another double lotus supports a damaged five-pronged *vajra*-finial. The surviving curved prongs were not joined to the middle prong, a distinction said to be diagnostic between central Javanese (as here) and eastern Javanese *vajras*. This distinction is supported stylistically by the four heads which have been supposed to manifest the Absolute and the universality of Buddhist Doctrine. WZ

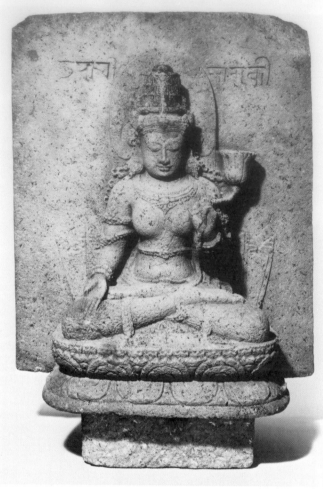

271

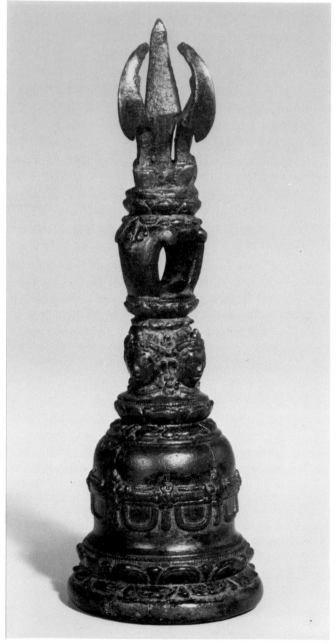

270

271. Māmakī

Java, from near Singasāri. 13th century

Volcanic stone. Height 48 cm. Given by Canon Flint.
OA 1859.12–28.171

The five Dhyāni Buddhas also had female partners, and one of them, Māmakī, appears here, with lotus and right hand in the gesture of giving, as in recent Nepalese drawing. The identifying inscription in Indian characters reads 'Lady Māmaki'; the style both of the characters and the carving associates the sculpture with revived Indian influence during the Singasāri period (1222–92). WZ

13 Central Asia

The many previous references to Central Asia, or the Tarim basin of Xinjiang and Dunhuang in Gansu, where the oldest Buddhist manuscripts and Indian objects have been found, are due to the Silk Road. From late Hellenistic times until Marco Polo it carried silk and other merchandise between China and the West across Syria, Iraq, Iran, Afghanistan or Soviet Central Asia, the Tarim basin and the Gansu corridor. Roads from India led through Afghanistan, the Swat valley of Pakistan and Kashmir, and the prosperity of Buddhist Gandhara was already due to this traffic. Buddhism rapidly followed and, in the early centuries AD, became firmly established in the Tarim basin and from there entered China.

In this arid region the Silk Road split into a northern branch at the foot of the Tianshan and a southern passing below the Kunlun mountains. Rivers from these ranges fed oases which formed small kingdoms. Along the southern line of the route lay the centres of Khotan with substantial Buddhist monuments; the northern route ran near cliff faces with cave temples and monasteries in the Indian and Afghan tradition also adopted in western China, in the fourth and fifth centuries.

The inhabitants were varied and their important languages preserve translated Buddhist texts in Khotanese, Soghdian, Tocharian and Chinese. Sanskrit manuscripts were copied and translated and Buddhism was studied. The Chinese ruled Xinjiang from the end of the second century BC until the early fourth century AD and again under the early Tang (618–c.750); they were expelled by Tibetans between c.750 and 850 and by Turks, amongst whom the Uyghurs favoured Buddhism. The eastward movement of other, Muslim, Turks from the tenth century eventually determined the character of this region for, although China regained it, Islam here, as in India, destroyed Buddhism, and a form of Turkish became the language of what is today the Xinjiang Uyghur Autonomous Region of the People's Republic of China, also called Xinjiang province.

When, at the end of the last century, it was realised that Xinjiang was of the highest archaeological interest, expeditions were mounted by many countries. The southern routes, parts of the northern, and Dunhuang were investigated by the great scholar-explorer, Sir Aurel Stein, who found the manuscripts and antiquities shown in this exhibition. He uncovered clay and plaster sculpture, stūpas, monasteries, even wall-paintings of Classical inspiration and documents preserved in the dry sands covering settlements abandoned as the water-supply diminished. He was the first to understand the importance of the huge cache of paintings and manuscripts accidentally discovered in a sealed cave at Dunhuang, the main source of Central Asian and other Buddhist manuscripts and of paintings whose particular importance is due to the destruction of Buddhist art in the ninth-century persecution elsewhere in China. The Dunhuang cache was probably walled up in the eleventh century but its contents go back many centuries earlier.

The artistic traditions of Central Asia are varied and preserve, chiefly in the service of Buddhism, styles, sometimes mixed, from India, Gandhara, Kashmir, Iran, Afghanistan, the Classical West and China. Their distribution varies geographically as do sectarian affiliations. Indian and Iranian influences predominate in the south and west, but sculpture and painting related to Afghan styles also cover walls of northern shrines; the Dunhuang caves are full of sculpture and painting in which Chinese styles predominate, though the early caves show influences from India and Central Asian sites such as Kucha. Notable is the huge quantity of perishable material recovered from the desiccated sites – wooden sculpture, painted wooden panels, wooden architectural members with ornamental carving and textiles. The vital role played by the Silk Road in the eastward transmission of Buddhism is its principal contribution to history. W7

272. Tablet (takhtī) with drafts of letters

Found at Niya, Xinjiang province, China. 2nd–3rd century AD
Ink on wood in Prakrit. 5 lines of *Kharoṣṭhī* script. 6 × 43 cm.
OMPB Or. 8211/1355 (N. xvi 2)

This interesting document contains a letter from two Buddhist monks, Baṃgusena and Pacgoyae, addressed to the *cojhbos* Namtasena and Cataroyae, saying that they have heard with great sorrow of the death of Anasena, but 'that is something beyond even the powers of a Buddha, or a Pratyekabuddha, or an Arhant or a Universal Monarch. All come to the same end. Care must be exercised how we go, virtuous acts performed and purity maintained'. JPL

Illustrated on page 193

273. Stūpa finial

From Loulan, Xinjiang province, China. Han dynasty or later, 3rd-4th century AD

Wood. Height 51.5 cm. OA MAS 706

This wooden *stūpa* finial, unmistakably Buddhist, is among many architectural pieces found in ruined structures at the ancient site of Loulan near the dried-up salt lake of Lopnor. Documents on wood in Chinese and *Kharoṣṭhī* script dated between AD 264 and 270 were found in the refuse of a Chinese administrative station near by (Loulan VI). Early in the 4th century the site and route across the desert through Loulan were abandoned. Relics like this *stūpa* finial, and a beam carved with seated Buddhas, found by Sven Hedin, are therefore among the earliest surviving evidence for the spread of Buddhism into China. RW

274

273

274. Buddha

From Rawak, near Khotan, Xinjiang province, China. 4th-5th century AD

Clay. Height 23.5 cm. OA 1907.11–11.174

The great *stūpa* at Rawak, north of Khotan, was surrounded by a large *vihāra* court, 49.1 m by 43 m. Considerable parts of the enclosing wall, adorned with images on both its faces, were preserved beneath the sand. These figures, many of them colossal, were of unfired clay supported on a timber framework, which had rotted away, so that some of the smaller heads alone could be removed. The present head is from one of the smaller Buddhas standing between colossal Buddhas on the inner south-east wall. The body of a similar figure visible in Stein's photographs is narrow-waisted, with thin drapery in narrow raised lines, as in Gupta sculptures.

RW

272

275. Buddha

From Rawak, near Khotan, Xinjiang province, China.
4th-5th century AD

Clay. Height 12 cm. OA 1907.11–11.180

As with the slightly larger head (no. 274), the Indian affinities
of this Buddha are evident in the prominent eyes and nose.
The head would probably have been framed, when *in situ*, by
a nimbus with scrolling cloud or flame edges, enclosing
applied moulded motifs of miniature seated Buddhas and
vajras, giving a rich effect. RW

Illustrated on page 195

276. Moulded figure of standing Buddha

From Karasai, near Khotan, Xinjiang province, China. 5th century AD

Stucco. Height 20 cm. OA MAS 340

Standing as well as seated figures of the Buddha appear in the
mandorlas of larger sculptural images at shrines in the vicinity
of Khotan, and were produced by the same method in one-
piece moulds. This and similar figures found in two Buddhist
shrines in the Khotan district were gently baked to harden
them, and coated with a very thin layer of pure white gypsum
to give a porcelain-like finish and colour, over which other
pigments were originally applied. The figures were attached
to the background of the large mandorla by a pad of clay or
stucco. RW

277. Leaf from a portable shrine

From Mingoi, near Karashahr, Xinjiang province, China.
5th-6th century AD

Wood with traces of pigment. Height 28.2 cm. OA MAS 1000

This is the left-hand leaf of a small triptych shrine which,
when closed, would have presented the appearance of a
smooth cylinder tapering to a point. The middle register
shows one of the legends of Śākyamuni's previous lives,
when as a young Brahmin student, he knelt before Buddha
Dīpaṃkara spreading his hair beneath his feet and vowed to
become a Buddha himself. More circumstantial depictions of
the occasion, on which he also obtained flowers from a young
woman, the future Yaśodharā, in exchange for a promise of
marriage in subsequent lives, are found in stone carvings
from Gandhara (cf. no. 15). RW

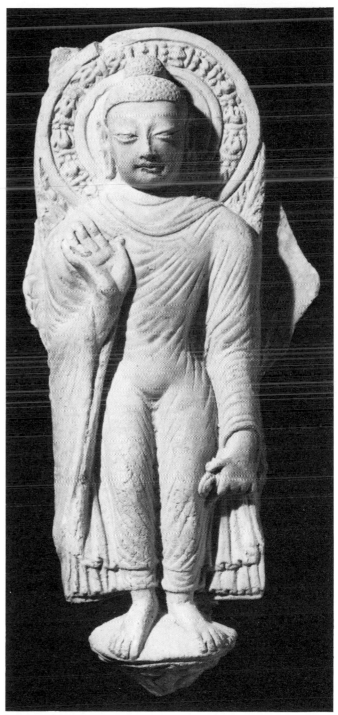

276

193

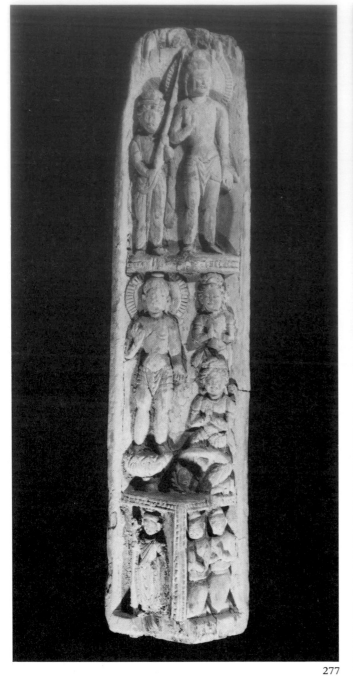

277

278

278. Mould for a plaque with seated Buddha

From Khadalik, Xinjiang province, China. 5th-6th century AD
Stucco. Diameter 7.6 cm. OA MAS 426

Small clay images of the Buddha were made in single moulds.
Some of the possible variations are seen when this mould is
compared to the seated Buddha from Siyelik (no. 279). Here
the legs are in the lotus position, and there is no separate
nimbus for the head. The lotus petals surrounding the figure
are double rather than single with a midrib. Such differences
are mainly in quality, and both pieces are similarly inspired
by Gandharan art and are probably of similar date. RW

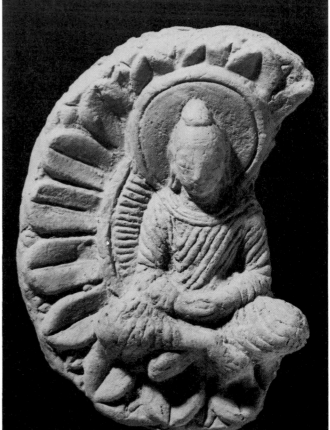

279

280

279. Moulded plaque with seated Buddha

From Siyelik, near Khotan, Xinjiang province, China.
5th-6th century AD
Clay. Height 9.2 cm. OA MAS 330

Miniature Buddha images were affixed to the haloes surrounding larger figures, while their small size also made them ideal for the devotions of individual worshippers. They were made of clay in one-piece moulds (see no. 278). The lotus petals form a surround to the Buddha, seated with legs crossed at the ankles, and hands laid in the lap. In the earliest Chinese images from the cave temples at Dunhuang larger figures with crossed ankles represent Maitreya, the Buddha of the Future.

RW

280. Mould, and curls of hair produced from a similar mould

From Khadalik, Xinjiang province, China. c. 6th-7th century AD
Stucco. Length 12.7 and 7 cm. OA MAS 410 & 421

The use of moulds to produce parts of larger figures was widespread in Central Asia. At Dunhuang and elsewhere small elements such as groups of curls or locks of hair, to be applied to the head of a large figure, or for decorative borders, are common. On the northern route at Mingoi some of the shrines contained hundreds of moulded figures forming narrative tableaux. Basic types could be given individual character after moulding by modelling or applying further moulded details. At Dunhuang and elsewhere in China, the practice was paralleled in wall-painting by the use of stencils to produce images in regular series, to be distinguished by painting in different colours.

RW

275

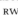

281

281. Part of a vesica

From Mingoi, near Karashahr, Xinjiang province, China.
6th-7th century AD
Carved and gilt wood. Height 51.3cm. OA MAS 1090

Small seated figures of the Buddha in meditation are commonly found in the mandorlas or edging the haloes of larger images, in the Gandharan tradition. The shrines at Mingoi were free-standing, many with a rich decoration of small stucco figures. In this case the main image may also have been of clay or stucco, with a wooden surround, tenoned and mortised to fit. Similar carved and gilt wooden surrounds with seated Buddhas have been found at other sites in the Tarim basin, notably near Kucha. RW

282. Fragment of a wall-painting

From Balawaste, near Khotan, Xinjiang province, China.
5th-6th century AD
Height 29.5 cm; width 25.5 cm. Given by Sir Clarmont Skrine.
OA 1925.6–19.26

Though a small fragment, this piece demonstrates the high quality of Khotanese wall-painting. It has been shown by Gropp to be the proper left hand of a seated Bodhisattva. Another fragment in the British Museum (OA 1925. 6–19. 30), shows part of the Bodhisattva's upper forearm on his decorated mandorla. According to Gropp, the Bodhisattva may have formed part of a large composition with life-size Bodhisattvas and Lokapālas on the side walls of a rectangular *cella* in the temple at Balawaste. RW

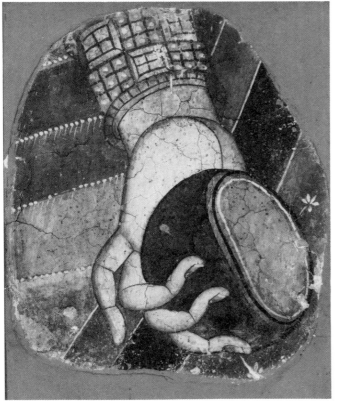

282

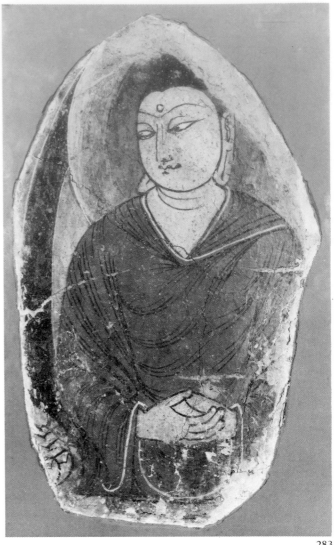

283

283. Seated Buddha

From Khotan, Xinjiang province, China. 6th-7th century AD(?)
Painting on plaster. Height 47 cm; width 32 cm. Given by
Sir Clarmont Skrine. OA 1925.6–19.20

The art of Khotan, once a flourishing Buddhist centre, is known from only a few fragments. There must have been numerous shrines with painted walls. This Buddha seated in a niche has the characteristic stance and proportions of similar small figures, all looking in the same direction and varying only in the colour of the robes, which covered whole walls as 'Thousand Buddha' images. The robes show schematised drapery patterns, originally much freer, derived from the art of Gandhara: note the grouping of fold lines in threes, and the sharp angle made by the upper edge of the garment of the neck. RW

14 China

The development of Buddhist art in China parallels the translation of the Canon. Just as new iconography and styles in painting and sculpture were introduced and assimilated in stages, so pilgrims continued travelling to India for new texts, which when translated inspired new schools of thought.

Small votive pieces carved all over China, mixing Central Asian and Indian influences with Chinese sculptural styles, are dwarfed by the greatest of Buddhist monuments, the massive rock carvings and painted cave complexes at Yungang, Longmen and Dunhuang. Although the earliest cave was said to have been carved out at Dunhuang in AD 366, the scale of the early remains there does not compare with the great complex at Yungang, where the first caves were cut in AD 460 under the patronage of the Toba Wei, a group of possibly Mongolian extraction, who ruled north China during the fifth and early sixth centuries.

The Yungang caves were carved out of a soft cliff in imitation of the cave temples of western Central Asia. Over more than thirty years twenty vast caves were hollowed out, some around enormous Buddhas, and all are intricately carved with small niches, decorated ceilings and fine doorways. The early great seated Buddha, over 14 m high, that fills cave 20 is evidence of strong Central Asian influence, particularly in the treatment of the mantle with its flattened folds.

The form of the caves themselves, with their central pillar based on the apsidal *stūpa*, also follows the Central Asian model with its origin in India. Some of the lesser figures in smaller caves begin to reveal a different effect, with slimmer faces and bodies, marvellously pleated robes and often a slightly leaning posture. These figures combine with a renewed sense of movement and line in the second great group of Toba Wei cave temples at Longmen, near Luoyang, the Wei capital from 495 after their conquest of this southern area. Here in the grey limestone cliffs along the river Yi, the Wei once again demonstrated their faith by commissioning the carving of a series of 1,352 caves. Beginning in 495, the work continued for centuries.

At Longmen some early sixth-century caves show an interesting contrast between religious and secular figures. Seated Buddhas with attendants, more elongated and decorated with greater complexity than at Yungang, are serene and stiff when compared with the life-size reliefs of imperial donors and attendants or the *apsarases* with their flying,

swirling robes. This treatment is a direct inheritance of earlier Chinese decorative styles. Central Asian and Indian influences, however, continued to reach China. At Xiangtan Shan caves of the late sixth century show Persian influence in the decoration of the doorways and provide further examples of the provincial Classical foliage designs seen at Yungang.

Much early Buddhist sculpture has been lost through looting, vandalism and the destruction of smaller, free-standing icons in more plastic materials, leaving scanty evidence of less monumental art forms. The great site of Dunhuang in the Gobi desert, however, contains numerous well-preserved wall-paintings of the late fifth century onwards which reveal achievements in Chinese Buddhist painting and the development of the depiction of landscape. The early sixth-century *jātaka* illustrations allow the greatest freedom, for the stories are set either in landscape with the beginnings of characteristically tooth-shaped mountains or, more domestically, in architectural settings. The stories are divided by mountains, trees, rocks or buildings, so that a whole wall is covered with a landscaped series of vignettes. These scenes, where the Buddha's life is set amongst Chinese buildings, trees and mountains, contrast with the contemporary paradise paintings where the surface is rigidly organised into a more highly patterned effect: rich canopies float over the Buddhas, attendants bear lotuses and chased silver incense burners, all in rich red and glowing orange. These paintings, records of meditation visions, were composed as meditation aids and are the most dramatic products of Chinese esotericism.

During the Tang dynasty (618–907) Buddhist painting at Dunhuang and sculpture, both at Dunhuang and at Longmen, show new Chinese mastery of an Indian style. Whether painted on a flat wall or sculpted in the round (a technique first perfected in Tang China), the Buddhist figures are rounded and tactile, their garments soft and clinging with ropes of beads emphasising curves. Apart from Buddhas still rendered hieratically, Bodhisattvas, attendant figures and even fierce guardians stand or sit in a relaxed, curved stance, the weight on one hip and the shift of weight emphasised in the placing of the arms and the tilted head. Although the style comes from Central Asia and India, it was perfectly absorbed in the luxurious plasticity of Tang China.

Throughout its early history in China, Buddhism had a rather unstable relationship with rulers. The Toba Wei

adopted it in the late fourth century, but towards the middle of the fifth the third Wei emperor changed this entirely and issued a decree requiring that all *stūpas*, paintings and foreign *sūtras* be burnt and all monks executed. It is not known how thoroughly the decree was enforced, but the similar great suppression of 845 marks the beginning of the slow decline and transformation of Buddhism in China. Monastic wealth was confiscated, bronze images and bells were melted down, iron figures were turned into agricultural implements (a gesture which recalls a major Chinese complaint about Buddhist monks – that they did not work), and jade, gold and silver objects were to be seized by the Bureau of Public Revenue. This suppression had a decisive effect on Buddhism which survived but more modestly. No more great cave-temple complexes were begun; only in the north, under the alien Liao, some magnificent temples were built in the eleventh to thirteenth centuries, filled with elongated, forward-leaning stucco figures.

Fine pagodas built under the Northern Song (960–1127) have produced important archaeological finds, but all Buddhist art after the tenth century existed on a reduced scale. As the wealth of the monasteries had been curbed, wooden and stucco figures were commoner than work in precious metals or laborious stone carvings. Many wooden figures are larger-than-life representations of the increasingly popular Bodhisattva Guanyin (Sanskrit Avalokiteśvara) sitting with one leg drawn up, the other dangling (very effective for a raised altar) – an extremely attractive development from Tang sculpture. Many wall-paintings and carved wooden figures seem to have been by itinerant temple craftsmen. That the skills were often hereditary is demonstrated at one temple, the Guang sheng si near Lin Fen, where records show that members of one family produced and maintained its wall-paintings over about 150 years.

An important new influence on Chinese Buddhist art under Mongol rule (1279–1368) and later, again, under the Qing (1644–1911), called Sino-Tibetan, was that of Tibet and Mongolia, dramatically illustrated in the frontispiece to the Qi sha edition of the *Tripiṭaka*. Again in the Qing (another non-Chinese dynasty) Tibetan designs in building and decoration were fashionable and Tibetan Buddhism was fostered by some emperors.

As Buddhism declined philosophically in China from a living and developing system of thought to one of popular devotion directed at salvation, so the scale of its arts diminished. Certain areas more devoutly Buddhist than others specialised to some extent in the production of altar furniture – incense-burners, candle-holders and flower-vases. The coastal province of Fujian was said to be a Buddhist strong-

hold, and from the seventeenth century its ceramic kilns produced fine white figurines, usually of the ever-popular Guanyin, as well as simple incense-burners and pots in the same glossy white-glazed ware.

Devout Buddhists who are still allowed, if not greatly encouraged, to worship in surviving temples, keep up the altar furnishings as best they can. Embroidered hangings and kneeling cushions are still made for temples, sometimes sub-

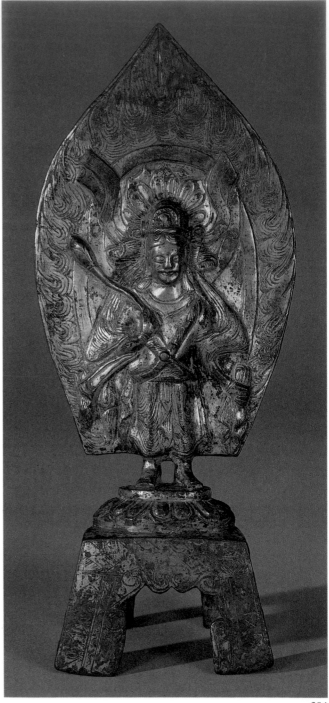

284

stituting rather Taoist-looking cotton patchwork for fine silk embroidery. On the southern holy mountain of Jiuhua shan, dedicated to the worship of Kṣitigarbha, where all the temples were completely destroyed by the mid-nineteenth century Taiping rebellion, the late-nineteenth-century temple halls are often furnished with blue and white porcelain marked with dates of the Republican period in the 1920s, and one very crude grey earthenware incense-burner is dated 1981.

Chinese Buddhism did, however, contribute to one of the great cultural achievements of the Far East – the invention of printing. Texts and illustrations were printed from carved wooden boards; eleventh-century experiments with movable type were taken up more readily in Japan and Korea. The earliest surviving block-prints which can be fairly accurately dated are the small *dhāraṇis* from the Pulguk temple in Korea (probably printed before AD 750) and similar *dhāraṇī* texts printed in Japan between 764 and 770. Printing almost certainly originated in China where the world's earliest surviving printed 'book', a copy of the *Diamond Sūtra*, printed in AD 868, was found. All these texts are Buddhist, and it is likely that the technique was greatly promoted by the Buddhist stress on earning merit by repeating prayers and charms. The small stamped Buddhas from Dunhuang and printed prayer sheets, the epitome of repetition, may well antedate some of the *dhāraṇī* texts. Printing itself implies repetition, and such examples as the *Diamond Sūtra* were printed in large editions, for wide distribution as an act of merit. As printing grew, a great variety of Buddhist texts was produced in China, from the massive and beautifully illustrated *Tripiṭaka* editions to small illustrated booklets for the semi-literate. FW

284. Padmapāṇi

China. Northern Wei dynasty, 5th year of Huangxing, AD 471
Gilt bronze. Height 25.5cm. Given by P.T. Brooke Sewell, Esq.
OA 1958.4–28.1

Padmapāṇi, lotus-bearing manifestation of Avalokiteśvara (Chinese Guanyin, or Guanshiyin), was a popular deity in early Chinese Buddhism, and many images survive, from the 5th century to the late Tang and Five Dynasties. This bronze can be compared with stone figures in caves 7 and 8 at Yungang (c.AD 467), and a series of similarly cast bronze Padmapāṇi images (c.450–550), including the example, dated 478, from a hoard of over 100 Northern Wei bronzes recently excavated at Boxing, Shandong province. Incised on the reverse of the pointed mandorla are Śākyamuni and Prabhūta-ratna seated within a hall surmounted by a phoenix, the Red Bird of the South. DG

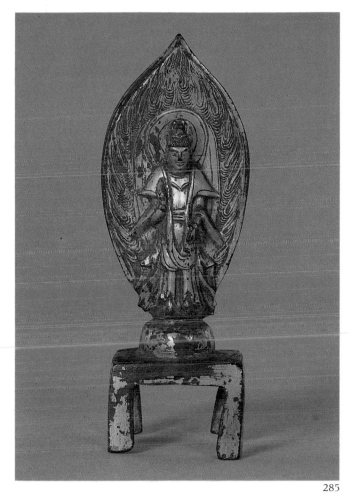

285

285. Padmapāṇi

China. Northern Wei dynasty, 3rd year of Yongan, AD 530
Gilt bronze. Height 12.4cm. Oppenheim Bequest.
OA 1947.7.–12.390

The flame-like robes so characteristic of late Northern Wei sculpture are associated with the carving of the first series of Buddhist cave temples at Longmen. A new manner of depicting drapery was evolved there, in which the flared edges of robes and scarves were pulled out into tapering points, conveying the linear rhythms of Chinese calligraphy and painting. The rounded modelling and semi-naturalistic bunching of the garments on this Padmapāṇi's feet anticipate sculpture of the succeeding Eastern Wei dynasty (533–50). An important collection of similar Bodhisattvas made on a larger scale in white marble, of the late Northern Wei and Eastern Wei dynasties, has been found at the Xiude temple, Quyang, Hebei province. DG

286. Votive stele

China. Northern Qi or Sui dynasty, c.AD 560–90
Stone. Height 1.63m. Victoria and Albert Museum (A 61–1937)

The principal face of this intricately carved stele has three
niches, containing from the top: Maitreya accompanied by
Ānanda, Kāśyapa and two Bodhisattvas; Śākyamuni and
Prabhūtaratna, their hands in *abhaya* and *varada mudrā*;
Śākyamuni with Ānanda and Kāśyapa. On the two narrower
faces are a standing and a seated Buddha, and at the back a
niche with a seated Bodhisattva in profile – probably again
Maitreya. The crown of the stele is ornamented with lotus
plants and palmette scrolls, and below the Maitreya group
hangs an elaborate beaded canopy fringe. On the sides and
back are incised donors' names from two clans, the Zhang and
Chen. A similar arrangement of shaped niches in three tiers is
found on a substantial roofed stele (dated 582) probably now
in Kaifeng, Henan province. DG

287. Amitābha

China. Sui dynasty, 5th year of Kaihuang, AD 585
Micaceous white marble. Height 5.78m. Presented by C. T. Loo to the
Chinese Government and by them to the British Museum in memory
of the Chinese exhibition in London, 1935–6. OA 1938.7–15.1

Dedicated at the Chongguang temple, Hancui village, Hebei
province, this monumental figure of Amitābha was originally
flanked by a smaller standing Bodhisattva (3.07 m), now in the
Tokyo National Museum. Hancui, which no longer exists,
was located between Dingzhou and Baoding, a region renowned
for its white marble. The hands of the figure, now missing,
were fixed into the arm sockets with wooden dowels, still
visible. The right hand would have been raised, palm out-
wards, in reassurance (*abhaya mudrā*), and the left lowered in
liberality (*varada mudrā*); these *mudrās* can be seen in no. 290.
The carving is crisply executed, with sharp pleats in the robe.
Sculptural styles which employ clinging drapery and ana-
tomically credible bodies first appeared in China in the early
6th century, at Wanfo si, Sichuan province, and reflect Gupta
or Central Asian influence. DG

288. Śākyamuni as Lord of the Double Trees

China. Northern Qi or Sui dynasty, late 6th century AD
Earthenware with black patination. Height 18cm. OA 1982.1–27.1

As with sandalwood objects, few brittle earthenware shrines
of the Tang and pre-Tang period survive. It is therefore
notable that several are taken either from the same or similar
moulds. These depict the Buddha seated below the double
trees associated with his death. In China the *Mahāpari-
nirvāṇasūtra* was regarded by Zhiyi (AD 531–97), founder
of the Tiantai sect, as belonging to the last, supreme stage of
the Buddha's teaching, and as Tiantai gained in popularity
during the 6th century so did scenes and motifs related to the
sūtra. In this case Śākyamuni is shown meditating below the
trees, not lying. DG

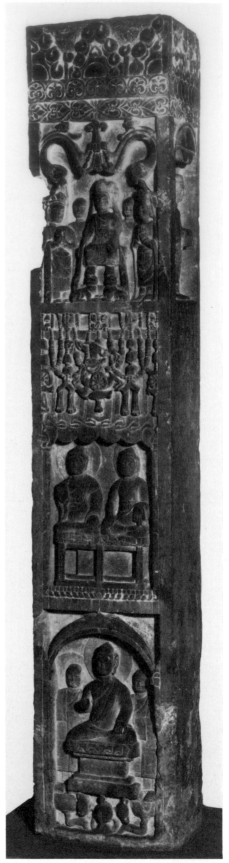

286

289. Door lintel

China. Sui–early Tang dynasty, 6th–7th century AD
Black stone. Width 1.41m. OA 1937.7–16.1

Of lunette form, the lintel is carved with a paradise scene, probably Amitābha in the Western Paradise. Seated under a large canopy and flanked by Bodhisattvas and *lohan*, at his feet are two newly born souls on lotus flowers. On the lower register are dancers and musicians, who play vertical and transverse flutes, a lute, a harp, *sheng* pipes and cymbals. Underneath, and facing down into the doorway, is a lotus scroll. Lintels of this shape were placed at the entrances of vaulted corridors into pagodas – the best known are at the Dayan ta, Big Goose Pagoda, erected in Xi'an in 647. The figures here are more schematic and better related to Sui-dynasty murals at Dunhuang (e.g. in caves 420, 423). DG

290. Amitābha

China. Tang dynasty, 7th century AD
Gilt bronze. Height 10cm. OA 1938.5–24.709

This miniature image, made for personal devotion, is iconographically similar to the colossal white marble Buddha (north staircase). The hands are in *abhaya* and *varada mudrā*, as they would have been on the Sui figure. The monastic robe is simply depicted with incised curvilinear folds, which hint at the body underneath; sculpturally it falls between the tubular modelling of the later 6th century and the more naturalistic, sometimes sensuous, images of the late 7th and early 8th centuries. DG

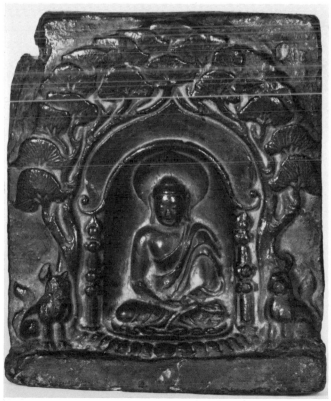

287

288

289

291. Padmapāṇi

China. Tang dynasty, 8th century AD

Gilt bronze. Height 18.5cm. Bought from the Brooke Sewell Bequest.
OA 1970.11–4.2

Central Asian and Indian Gupta styles continued to influence
Chinese Buddhist art into the Tang, and against the secure
and prosperous climate of the 7th and early 8th centuries
regional and metropolitan Buddhist styles began to converge.
The swirling scarves and sensitively modelled torso of this
bronze can be matched with Bodhisattva images seen in the
paintings (murals and banners) and sculpture of Dunhuang
and Bingling si, both in Gansu province. Metropolitan versions
in stone survive at several major sites; amongst those which
best reflect 'high Tang' styles are stone images at Tianlong
shan, Shanxi province, and in the environs of Xi'an (the Tang
capital Chang'an), Shaanxi province. DG

292. Śākyamuni group

China. Tang dynasty. 8th–9th century AD

Gilt bronze. Height 20.3cm. Bought from the Brooke Sewell Bequest.
OA 1963.2–12.1

Śākyamuni sits on a draped throne supported on a high pillar,
his right hand held in *abhaya mudrā*. Two Lokapālas stand at
the front corners of the pierced platform, flanking an incense
burner and two lions. A similar Śākyamuni group is found in
the central panel of a portable triptych sandalwood shrine,
carried to Japan and installed, in AD 806, in the Kongōbuji
temple at Kōyasan by Kōbō Daishi (Kūkai), founder of the
Shingon sect. The exceptional quality of that, and of other
surviving sandalwood images, reminds us that during the
Tang very fine detail in sculpture was achieved not only in
metalwork. DG

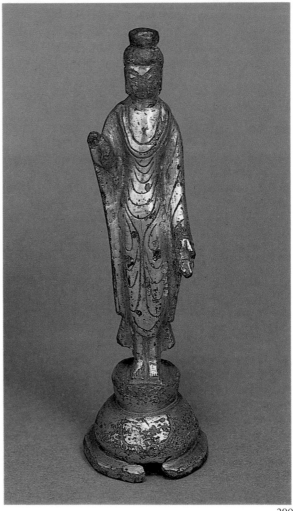

290

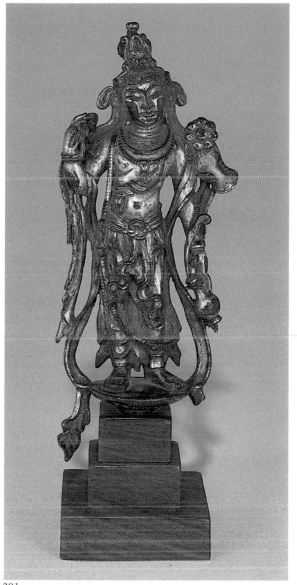

291

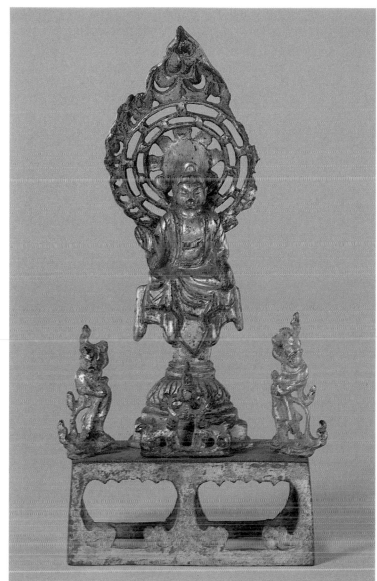

292

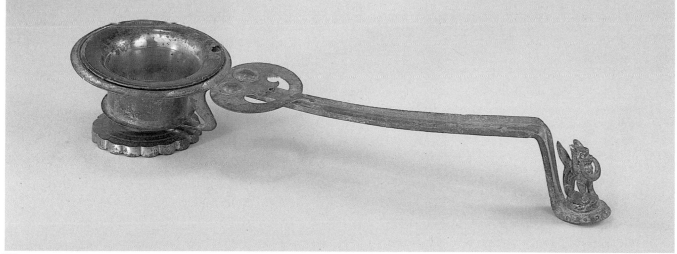

293

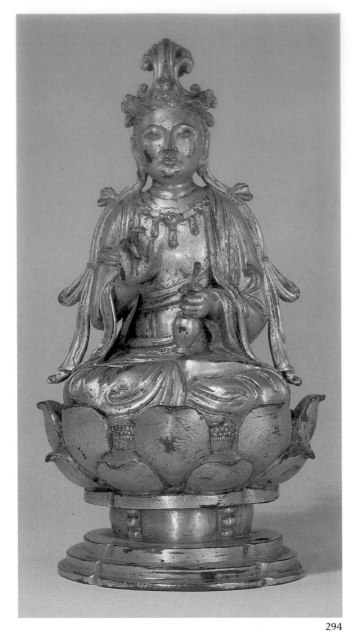

294

294. Maitreya

China. Liao dynasty, 11th century

Gilt bronze. Height 20.2 cm. OA 1959.7–13.1

The image is identified as Maitreya by the small *stūpa* in the crown. In style it is comparable with the seated clay Bodhisattvas within the *Bojiajiao (Bhagavat)* library hall, constructed in 1038 at the Lower Huayan temple, Datong, Shanxi province, when that city was western capital of the Khitan Liao dynasty. The *mudrā* of the right hand, an eccentric variation on *vitarka*, argumentation of the Doctrine, is common to several Huayan figures. DG

295. Lohan

China, found at Yixian, Hebei province. Liao dynasty, AD 907–1125

Glazed stoneware. Height 1.03m. Given by the National Art-Collections Fund. OA 1913.11–12.1

An austere youthful *lohan (arhat)*, this ceramic sculpture belongs to the celebrated set of sixteen or eighteen once placed in caves to the west of Yixian, Hebei province. The surviving *lohan* from the set are so individually modelled that they have been considered portraits of eminent monks; however, a tradition of representing *lohan* with very human faces certainly existed in China since the middle Tang, as evidenced by those surrounding Śākyamuni in no. 312. The Yixian figures are striking for their sombre dignity and power, and have nothing of the elevated caricature associated with Chan *lohan* painting of the Five Dynasties and Song periods. The clay images in a *maṇḍala* of the Three Worlds and Ten Directions within the 11th-century library at the Huayan si, Datong, include similarly imposing *lohan*. DG

296. Avalokiteśvara

China. Song or Jin dynasty, 11th–12th century

Polychromed wood. Height 1.7m. Given by the National Art-Collections Fund. OA 1920.6–15.1

Wooden sculptures, often life-size or over, were common in north China from about the 10th to the 14th centuries. Their construction is particularly associated with Shanxi province, where the two pre-eminent centres of Buddhist activity were Taiyuan and Wutai shan. The style can generally be traced back to late 7th- and 8th-century Tang sculpture, as at the Tianlong shan caves, Taiyuan. Compared with the delicate-limbed deities there, these wooden figures are more fleshily modelled, with naturalistic faces and sometimes, as here, glassy, reflecting eyes; their voluminous yet relaxed bodies offer a compelling vision of the Bodhisattva ideal.

A number of the sculptures represent the *nanhai* Guanyin (Avalokiteśvara of the Southern Seas), originally placed upon carved wooden plinths. This refers to Guanyin residing at Mt Potalaka on the southern coast of India, an idea introduced into China with the translation of the *Avataṃsaka* (Huayan) *Sūtra* in the early 5th century. Few retain their original colour scheme – this image has been repainted, and the limbs are partly restored. DG

293. Censer

China. Tang dynasty, AD 618–906

Silver and gilt bronze. Length 45cm. OA 1936.11–18.183

Long-handled censers were common in China during the Tang period, as in contemporary Japan. Banner paintings from Dunhuang show them carried by priests and Bodhisattvas. This handsome example was constructed with several pieces: a long strap handle angling down at the end to accommodate a small lion with a ring through its jaws; at the other end, adjoining the bowl proper, a flat pomegranate-shaped appliqué ornamented with two bosses; a detachable liner (there was probably once a pierced cover); and below, bolted on, a lobed base decorated with turned concentric bands. DG

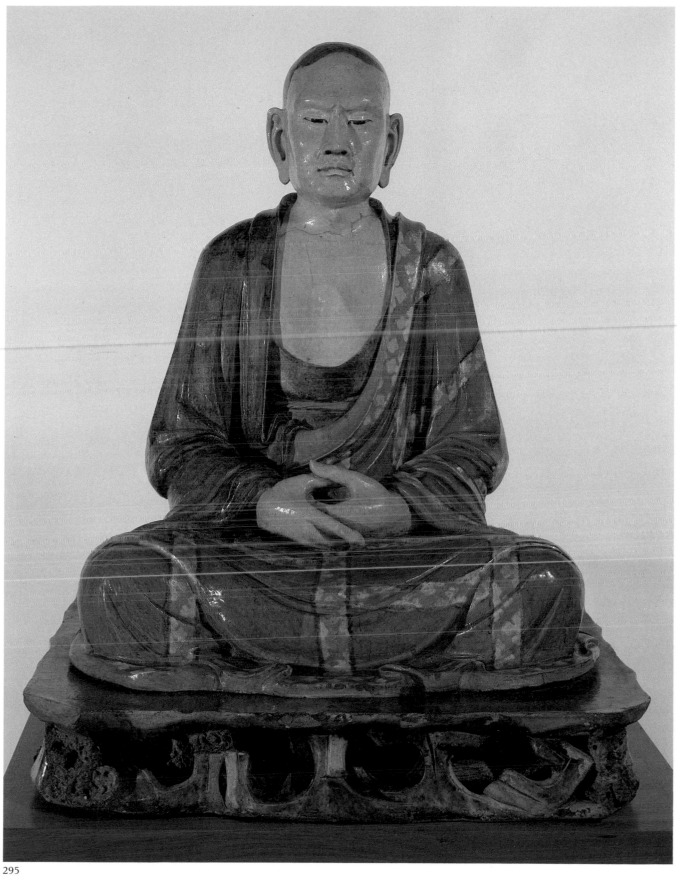

295

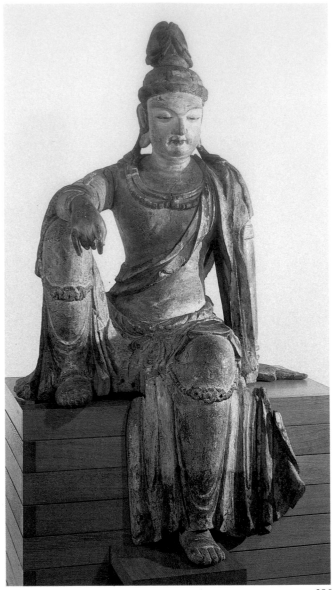

296

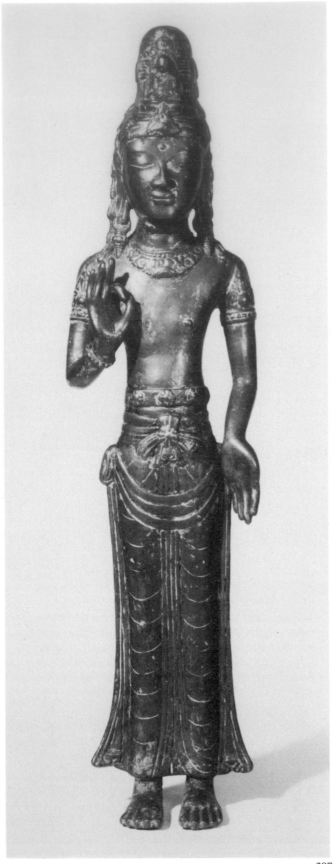

297. Avalokiteśvara

Dali kingdom. 11th–12th century
Gilt bronze. Height 44.7cm. Given by J.F. Mowbray, Esq.
OA 1950.2–15.1

This type of Avalokiteśvara image was made for the Dali court, in what is now Yunnan province, south-west China. Based upon Pallava and Śrivijaya styles, such images appear to have been cast as talismans for the royal family. A painted version is included in a handscroll executed for the Hou (Later) Li court in the 1170s; there the image entitled *zhenshen* Guanshiyin (True body Guanshiyin) is surrounded by a moon-like halo, and floats on a lotus over waves. The painting and bronzes are unlike any Buddhist figures of the contemporary Song and Jin dynasties, although the halo, and the waves below, recall more familiar depictions of the *shuiyue* (Water Moon) Guanyin. DG

297

206

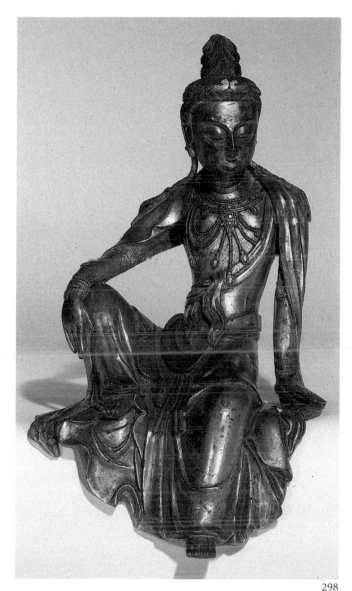

298

298. Avalokiteśvara

China. 13th–14th century

Gilt bronze. Height 28.7cm. Oppenheim Bequest. OA 1947.7–12.392

The position in which this Avalokiteśvara is seated, a variant form of *rājalīlāsana* (royal ease), was a popular sculptural formula between the 10th and 14th centuries. The earliest datable Chinese Bodhisattva thus seated is a finely cast gilt bronze made under the 10th-century Wu-Yue kingdom in east China, excavated from the Wanfo pagoda, Jinhua, Zhejiang province; its distinctive halo, a plain band with three flaming cusps, quite alien to contemporary Chinese styles, supports the supposition that this iconography was a post-Tang import. DG

299. Maitreya

China. Yuan–early Ming dynasty, 14th–15th century

Lacquered wood. Height 63cm. OA 1937.4–16.198

The Bodhisattva sits with his hands in *dharmacakra mudrā*; two large disc-shaped earrings touch his shoulders, and there is more jewellery at his wrists and on the crown. The original colours are much degraded, both on the gessoed area (face and chest) and on the lacquered robe, but there remain traces of red, blue, green and gilt pigments. The Lamaistic style is similar to that of the images carved into the Cloud Terrace of the Juyong guan gate, erected to the north of Peking (1342–5), and to some large porcelain Buddha figures made at Jingdezhen in the early 14th century. DG

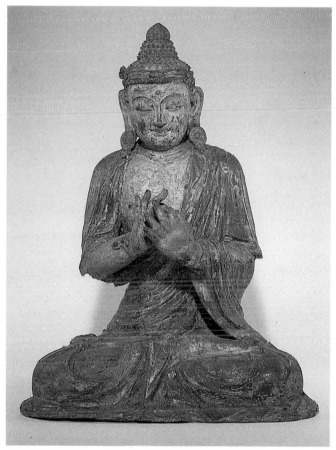

299

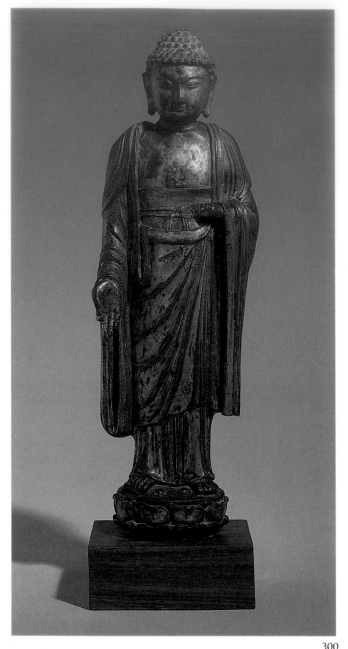

300

300. Amitābha

China. Ming dynasty, dated Hongwu *bingzi* year, 1396
Gilt bronze. Height 23cm. Seligman Bequest. OA 1973.7–26.81

According to the inscription, this was one of forty-eight bronzes commissioned by Zhou Fu to repay the four kindnesses (of mother, father, Tathāgata and the teaching of the Doctrine). The right hand is in *vitarka mudrā*, and, as can be seen from another bronze, in the Nitta Collection, Tokyo, so was the left; together these *mudrās* are associated with the *jieyin Fo*, Amitābha coming to receive souls into the Western Paradise. This manifestation (Japanese *raigō*) is frequently shown in Kamakura-period paintings and sculpture, which the bronze resembles stylistically. DG

301. Water vessel

China. Ming dynasty, early 15th century
Cloisonné enamel. Height 20.3cm. Given by Sir Harry and Lady Garner to mark the retirement of D.E. Barrett, Esq., Keeper of Oriental Antiquities. OA 1977.7–18.1

This type of vessel, related to the larger *kuṇḍikā* flasks, and known in Tibet as a *spyi-blugs*, was used by monks to wash their mouths after meals. The lotus scroll around the body is a common ornament on 15th- and 16th-century Chinese cloisonné vessels, and especially appropriate for those connected with Buddhist ritual. The gilt underside of this opulent example is incised with a *viśvavajra*. DG

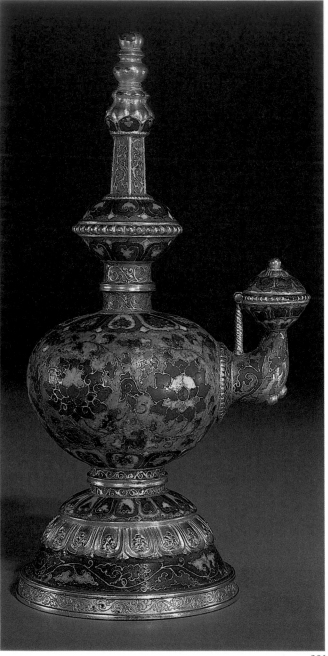

301

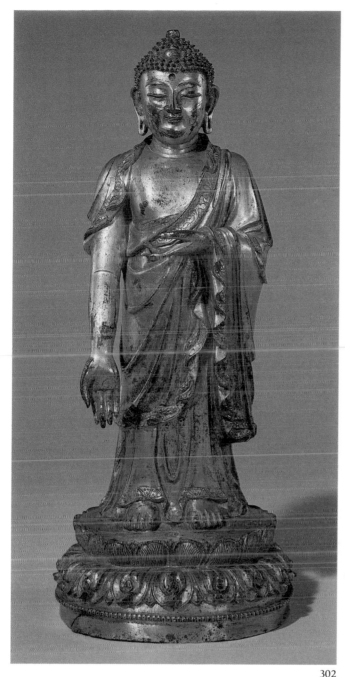

302

303. White-robed Avalokiteśvara

China, Dehua, Fujian province. Ming dynasty, 17th century
Porcelain. Height 46.3cm. Donnelly Bequest. OA 1980.7–28.290

In Ming and Qing dynasty Buddhist art Avalokiteśvara is often represented as female. The reasons for this are imperfectly understood, but it was at least partly due to the introduction during the 8th century of the Indian goddess Pāṇḍaravāsinī, associated with Avalokiteśvara. In Chinese her name was *baiyi* Guanyin (White-robed Guanyin), where *baiyi* corresponds exactly to the Sanskrit. Early images of a cowled female Bodhisattva, dating from the Song dynasty, are found at Maiji shan (cave 165), Gansu province, and at Dazu (cave 136), Sichuan. From the 17th century onwards the porcelain kilns at Dehua were celebrated for their production of Buddhist models, amongst which Guanyin figures were prominent.

DG

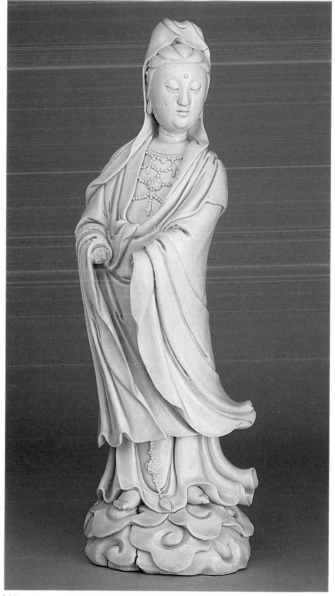

302. Amitābha

China. Ming dynasty, dated 3rd year of Chenghua, 1467
Gilt bronze. Height 32cm. OA 1942.4–17.1

The very long right arm reaches out to souls destined for the Western Paradise. Pure Land Buddhism continued to be popular in the Ming and Qing dynasties, as did Chan Buddhism, with both schools sharing more ideas – a trend that had begun in the 10th century. The drapery on later Chinese Buddhist bronze sculpture is rarely naturalistic, the preference being for a flatter, more linear approach, enlivened here by the vigorous undulation of the robe borders.

DG

303

304. Lokapāla

China. 12th–14th century

Gilt bronze. Height 45.5 cm. OA 1972.3–1.1

This Chinese Lamaistic image is an especially good example of post-Tang bronze casting. The detail is everywhere sharp and vigorous, giving great force to the fierce and macabre aspects of the deity. It has not been possible to identify the image with certainty, but it most probably represents a Tantric version of the Lokapāla Vaiśravaṇa. The figure appears in a 12th-century Yunnanese handscroll, alongside a more conventional Vaiśravaṇa (see no. 297). The nine-headed, eighteen-armed Defender of the North holds up a conch, skull, toad, tortoise, pearl, head, *vajras*, and, across his shoulders, an outstretched body. Seven of the heads are crowned with a skull, the central three flanked by snakes. Around the waist he wears the skin of a flayed head, hands and feet; these can also be seen along the tops of later Tibetan *thangkas* and temple hangings. DG

307

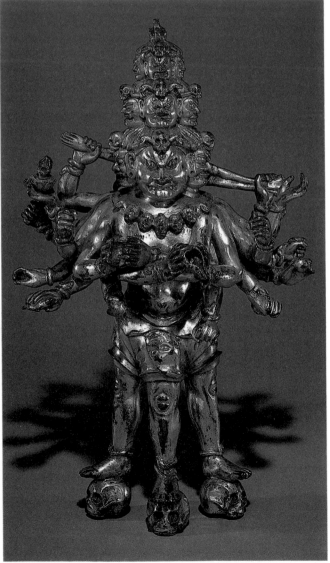
304

305. Śākyamuni

China. Ming dynasty, Yong'le (1403–24) mark and period

Gilt bronze. Height 59 cm. OA 1908.4–10.4

This richly worked bronze is cast in three pieces: the Buddha, his hand in *bhūmisparśa mudrā*, and double lotus throne; the rectangular stepped base, densely ornamented with lotus, leaf and classic scrolls; and the arched mandorla pierced with fire and flower scrolls. It is one of the largest and most lavish Yong'le-period Sino–Tibetan bronzes, and can be closely related to images of the Buddha in 14th- and early 15th-century illustrated *sūtras*, such as a Sino–Tibetan illustrated woodblock edition of the *Suvarṇaprabhāsasūtra* (dated to 1419), and the *Qi sha Tripiṭaka*. DG

Illustrated on page 2

306. Qi sha Tripiṭaka

China. 1301

One of 6,362 *juan*, woodblock-printed with 4-page frontispiece and 80 text pages. 30 × 12 cm. OMPB Or. 80. d. 25

The first Chinese *Tripiṭaka* was printed between 972 and

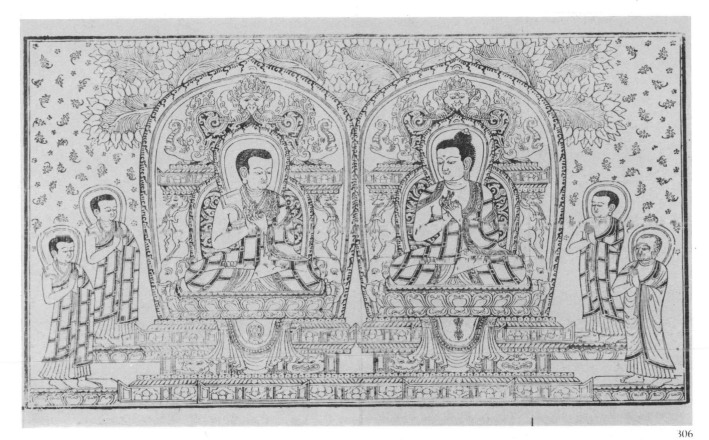

306

983 in Sichuan province and comprised 1,076 titles in 5,048 *juan* (sections). Four further editions appeared during the Song dynasty (960 1279). In the middle of the Song north China suffered successive invasions, culminating in the establishment of the Mongol Yuan dynasty (1279) and the introduction of Tibetan Buddhism. This edition, begun in Jiangsu province, southern China, in 1231, was not completed until about 1322, and the fine woodblock frontispiece demonstrates the new strongly Sino-Tibetan character of contemporary illustration. FW

307. Khaṭvāṅga

China. Ming dynasty, Yong'le (1403–24) mark and period
Iron with gold and silver inlay. Length 44 cm. OA 1981.2–7.1

The various elements on the upper part of this sceptre are pierced by a shaft of square section which slides into the long tapering body. A *khaṭvāṅga*, which can symbolise the Thought of Enlightenment, should have the image of a freshly severed head, a decomposing head, a skull and the vase of life – here finely inlaid with lotus, chrysanthemum and peony flowers and overhung by four slender leaves. The prongs of the half-*vajras* at the ends and of the crossed *vajras* at the centre issue from animal masks. This imperially commissioned artefact (the reign mark is around the lowest knop) might have been used for a rite of identification with a particular god. DG

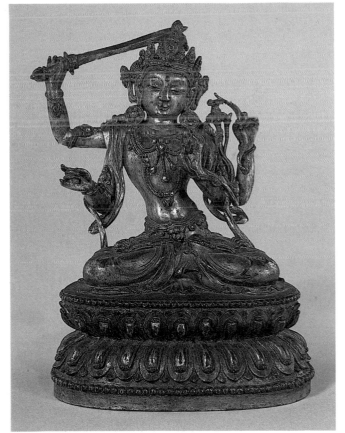

308

211

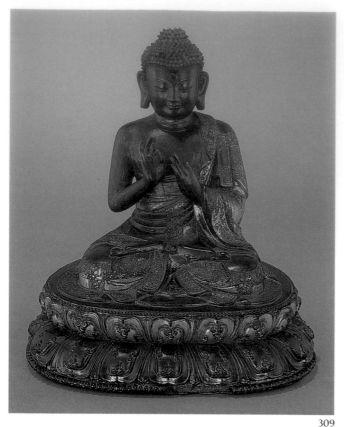

309

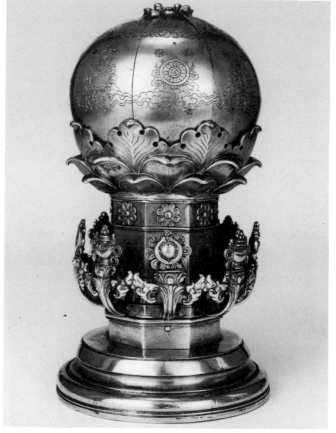

310

308. Mañjuśrī

China. Ming dynasty, Yong'le (1403–24) mark and period
Gilt bronze. Height 19 cm. Given by Dr W. L. Hildburgh.
OA 1953.7–13.4

The Bodhisattva's two left hands hold a lotus, which supports the *Prajñāpāramitāsūtra*, and a bow; his upper right hand clasps the sword that cleaves ignorance, and the lower, empty, would have held an arrow. The style is completely dependent upon a Tibetan or Nepalese original: the torso has a sinuous elastic line rarely seen in Chinese Buddhist art. This image, like the Yong'le Buddha and *khaṭvāṅga*, was made at a time when China was keen to revive its flagging relationships with Tibet for political, commercial and religious reasons. DG

309. Buddha

China. Qing dynasty, Kangxi period, 1692
Lacquered wood with some surface gilding. Height 32cm. Given by F.V. Appleby, Esq. OA 1983.10–10.1

The Buddha sits with his hands in *dharmacakra mudrā*. The gilding on this sturdy Qing dynasty image must have once given the surface the appearance of a gilt bronze, especially with the thread-like relief in gesso at the robe borders. Within the body was a wealth of consecration matter in Tibetan, including many *mantras* and the name of the monk-donor (Blo-bzang dPal-'byor) with the date of dedication.

DG

310

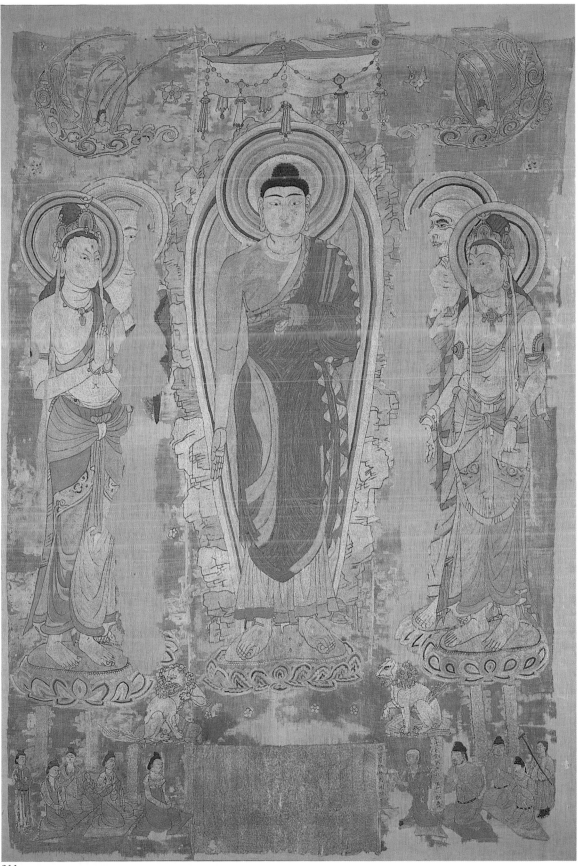

311

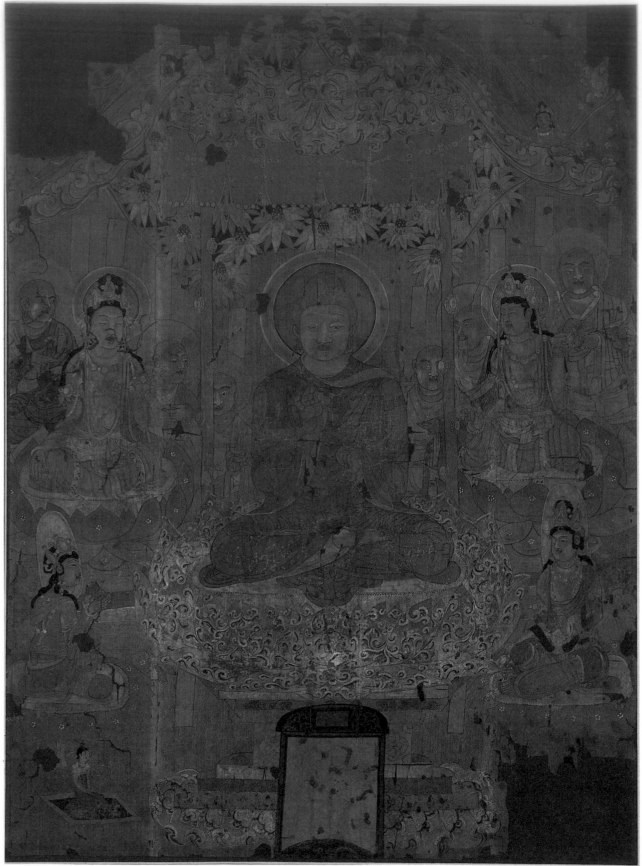

310. Maṇḍala

China. Qing dynasty, 17th–18th century

Gilt bronze. Height 24 cm. Given by Miss Humphreys in memory of Edward Humphreys, Esq. OA 1939.1–18.1

Resembling the eastern Indian bronze lotus *maṇḍala*, this Chinese Lamaist version is cast as an articulated pomegranate. At the centre is a tutelary deity, Yi-dam, of Buddha rank locked in embrace with his *prajñā*, or wisdom partner. Twenty lesser divinities surround them, two or three on each petal, before circular drums or altars. The petals are incised outside with deities and emblems, including a horse, elephant, wheel, censer, ewer, staff, parasols, ribbon, canopies and jewels. DG

Illustrated on page 212

311. Buddha

China, from Dunhuang, Gansu Province. Tang dynasty, 8th century AD

Embroidery on hemp cloth faced with silk. 2.41 × 1.59m. OA Ch.00260

This splendid embroidery, as large as any Dunhuang paintings found by Stein, shows the Buddha in the rocky surround of the Vulture Peak (Gḷrdhrakūṭa) at Rajagṛha preaching the *Lotus Sūtra*. It had been carefully folded to protect the Buddha, but beneath the fold the two disciples representing the Hīnayāna are damaged. Celestial figures scatter flowers from above, and the donor family is ranged on either side below. The style and quality make this one of the finest Tang dynasty works. RW

Illustrated on page 213

312. Buddha preaching

China, from Dunhuang, Gansu province. Tang dynasty, early 8th century AD

Ink and colours on silk. 1.39 × 1.02m. OA 1919. 1–1. 06

This, one of the earliest and best preserved paintings from Cave 17, is related to Sui (AD 581–617) and early Tang preaching scenes on the walls of the caves. Celestials scatter flowers on the assembly below where, among Bodhisattvas of the Mahāyāna, the six monks representing the Hīnayāna indicate that the central figure is probably the historical Buddha. The space left and ruled for a dedication takes the form of a monumental stele. The kneeling lady donor is in early 8th-century costume; her husband on the right is now lost except for the smoke from his incense-burner. RW

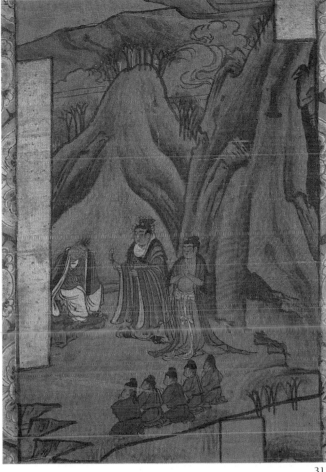

313

313. Scenes from the life of the Buddha

China, from Dunhuang, Gansu province. Tang dynasty, 8th century AD

Ink and colours on silk. 58.5 × 18.5 cm. OA 1919.1–1.097

This banner shows, from the top downwards, the Prince's farewell to his horse and groom, and the shaving of his head as he takes up the religious life. The landscape, of exceptional completeness and great beauty, is built up from the bottom, where Siddhārtha is shown in meditation on a rock. His body is emaciated and birds have built a nest on his head during his period of austerity. Further scenes from the Buddha's life were depicted on separate banners: each hung from a triangular headpiece and was completed by tail streamers and a weighting-board, here lost. RW

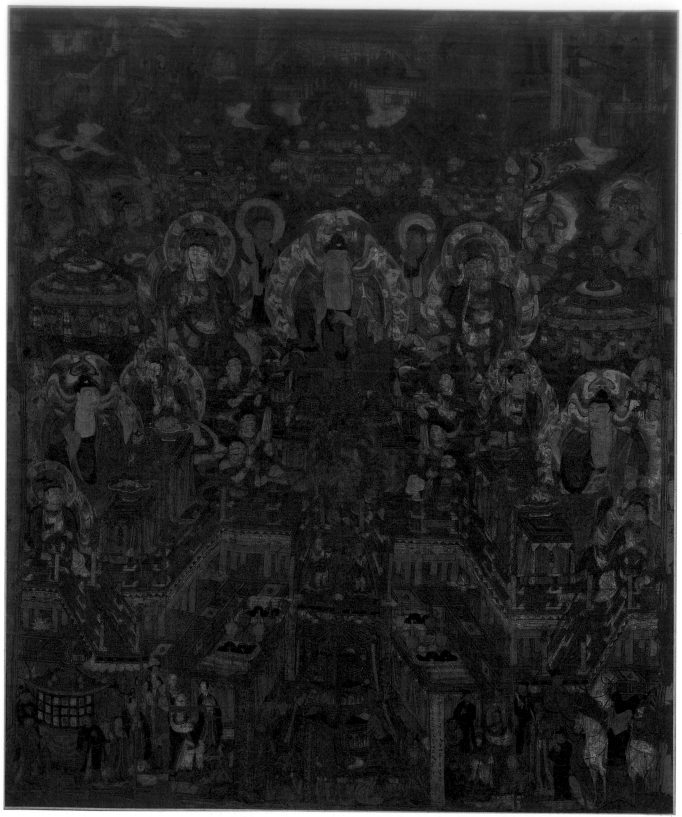

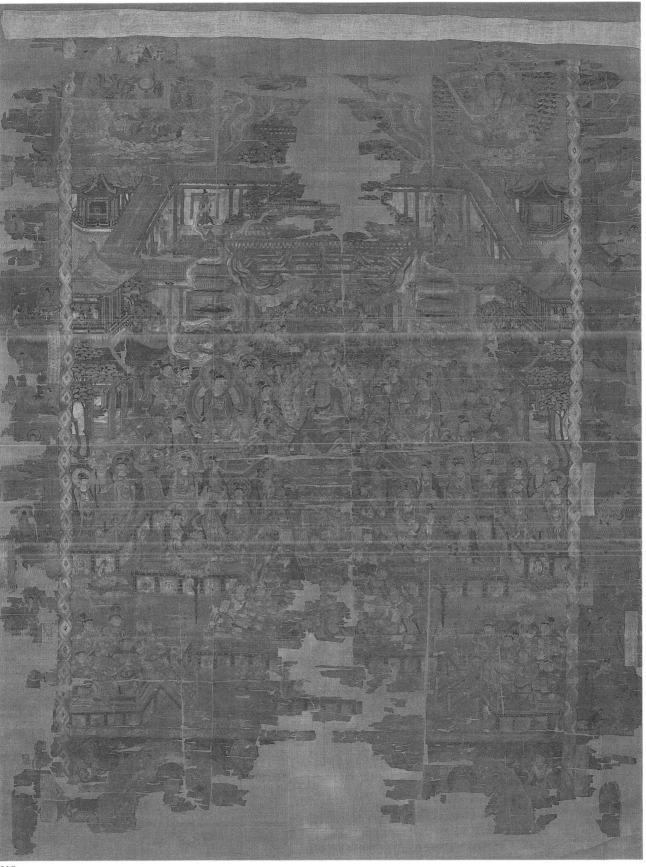

315

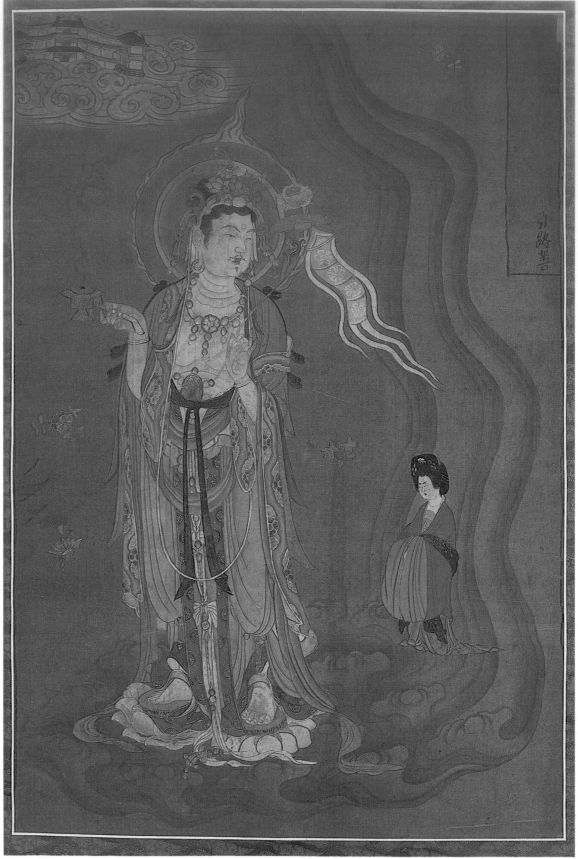

314. Maitreya's paradise

China, from Dunhuang, Gansu province. Late Tang or early Five Dynasties, 9th–10th century AD

Ink and colours on silk. 1.39 × 1.16m. OA 1919.1–1.011

On this painting inscriptions from the *Maitreya Sūtra* describe the joys when Maitreya descends to earth. At the centre are Maitreya and attendants, the guardian kings Vaiśravaṇa, holding a banner with black and white streamers, and Virū-pākṣa, holding a sword, each with a Dharmapāla. Smaller groups of Buddhas with seated and standing Bodhisattvas appear on either side. Distinctive of these paintings are ordination scenes as here, showing gifts – scrolls or silk bundles, water sprinklers, a silver dish, and baskets with cakes or mounds of sacred grain. A king and queen with attendants are seated as their heads are shaved. Some *Maitreya Sūtra* scenes showing wedding feasts, ploughing and reaping, were taken from pre-Buddhist depictions in their original associations of peace and plenty. RW

315. Bhaiṣajyaguru's paradise

China, from Dunhuang, Gansu province. Tang dynasty, 9th century AD

Ink and colours on silk. 2.06 × 1.67m. OA 1919.1–1.036

The Buddha of Healing, a latecomer to the Buddhist pantheon, with his Eastern Paradise, enjoyed great popularity at Dun-huang. This large painting is the equivalent of some of the most complex and even larger paradise scenes on Dunhuang cave walls and is laid out like a depiction of Sukhāvatī, the Western Pure Land. Around the Buddha six figures make offerings. The Bodhisattvas Sunlight and Moonlight are sur-rounded by figures including the four Lokapālas and two demons. Above, on layers of red and blue clouds, appear Avalokiteśvara with 1,000 hands and Mañjuśrī with 1,000 bowls. The Eastern Paradise is completed by side scenes – the Nine Forms of Violent Death (right) and the Twelve Vows of Bhaiṣajyaguru (left). These side scenes and the twelve *yakṣa* warriors in two groups on side terraces in the foreground distinguish the paradise of the Buddha of Healing from the Western Paradise of Amitābha on which it is closely modelled.
 RW

316. Guide of Souls

China, from Dunhuang, Gansu province. Tang dynasty, late 9th century AD

Ink and colours on silk. 80.5 × 53.8cm. OA 1919.1–1.047

The inscribed title, *yinlu pu* (Bodhisattva Guide of Souls), does not identify the Bodhisattva, but Avalokiteśvara might be a general model. There is, however, an association with Kṣiti-garbha since another painting, dated 953 in the Musée Guimet, shows the Bodhisattva alone, with a cartouche 'praise to the Bodhisattva who leads the way' in a separate panel balancing the donor. This Bodhisattva holds a censer and a lotus; gold leaf has been used on the censer, the Bodhisattva's jewellery and, in small diamond shapes, it adorns the hair of the soul being led to paradise. From her attire the lady seems a noble-woman or princess. RW

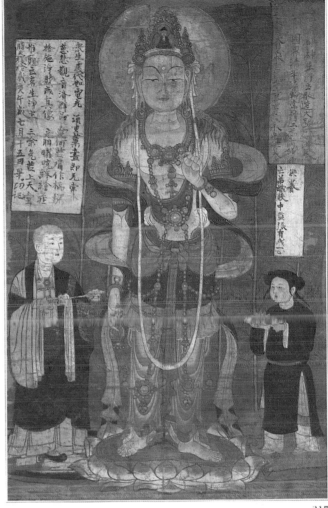

317

317. Avalokiteśvara

China, from Dunhuang, Gansu province. Five Dynasties, but dated 10th year of Tianfu (the penultimate reign of Tang AD 910)

Ink and colours on silk. 77 × 48.9cm. OA 1919.1–1.014

The principal inscription in the upper right hand corner reads: 'Praise to the great merciful, great compassionate saviour from hardship Avalokiteśvara Bodhisattva, in perpetual offering. Offered in the hope that the Empire may be peaceful and that the Wheel of the Law may continually turn therein. Secondly, on behalf of my elder sister and teacher, and on behalf of the souls of my deceased parents, that they may be born again in the Pure Land, I reverently made this Great Holy One and with whole heart dedicated it.'

The other inscriptions identify the 'elder sister and teacher' as the deceased Very Reverend nun Yanhui, admitter to the Dharma and Vinaya in the monastery of Universal Light, who is seen on the left, while the young man on the right is named as the probationary Chamberlain Zhang Youcheng, younger brother of the donor. RW

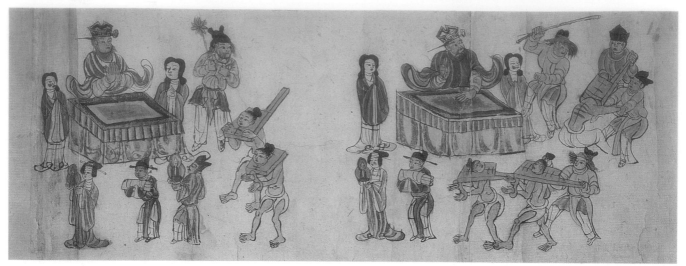

318

318. Ten Kings Sūtra illustrations

China, from Dunhuang, Gansu province. Five Dynasties, 10th century

Ink and colours on paper. 27.8 cm × 2.4 m. OA 1919. 1–1. 080

The Dunhuang handscrolls showing the Ten Kings of the Underworld appear late in the iconography of the Bodhisattva Kṣitigarbha. In this fragment five kings are each seated behind a table, attended by the recorders of a person's good and evil deeds and by lictors and gaolers driving the souls before the court. Some souls wear wooden cangues and hand fetters; all have only a loincloth. The virtuous are in 10th-century costume; the men hold bundles of scrolls, the women small Buddha images in token of their meritorious deeds. Kṣitigarbha, dressed as a monk, appears at the end of the scroll, rescuing souls from hell. RW

319. Vaiśravaṇa

China, from Dunhuang, Gansu province. Tang dynasty, 9th century AD

Ink and colours on silk. 37.6 × 26.6 cm. OA 1919.1–1.045

Vaiśravaṇa, Guardian King of the North, in splendid armour, patrols his domain with heavenly troops on a purple cloud advancing across a sea of waves. His attributes, a golden halberd and a purple cloud supporting a *stūpa* with a seated Buddha inside, immediately suggest his role as chief protector of the Buddhist Doctrine. In front is Śri Devī, his sister, holding a golden dish of flowers. On the other side the *ṛṣi* Vasu is portrayed as a white-haired old man. One of Vaiśravaṇa's attendants takes aim at a fleeing demon in the sky. RW

Illustrated on page 6

320. Avalokiteśvara

China, from Dunhuang, Gansu province. Tang dynasty, early 9th century AD

Ink and colours on silk. 2.26 × 1.67 m. OA 1919.1–1.035

The increasing popularity of Vajrayāna during the Tibetan domination of Dunhuang is shown by this painting and the large Paradise of Bhaiṣajyaguru where 1,000-armed forms of Avalokiteśvara and Mañjuśri are found. Within the circle of hands, each with a single eye, are forty larger forearms and hands, grasping an attribute or making a *mudrā*. Below the Bodhisattva are a *preta* (hungry ghost) and a beggar, who stretch out their hands to receive sweet dew and the Seven Treasures. Below, left and right, with two of the Four Guardian Kings are the Peacock King and the Golden-winged Bird King, riding a phoenix. RW

321. Ucchuṣma

China, from Dunhuang, Gansu province. Tang dynasty, late 9th century AD

Ink and colours on paper. 80.7 × 30.8 cm. OA 1919.1–1.040

Ucchuṣma, 'Fiery-headed *Vajra*', a Bodhisattva known in China as 'The Unclean' because he subdues all unclean influences, appears in several Dunhuang paintings as part of a larger assembly centering on the Thousand-armed, Thousand-eyed Avalokiteśvara. RW

Illustrated on page 224

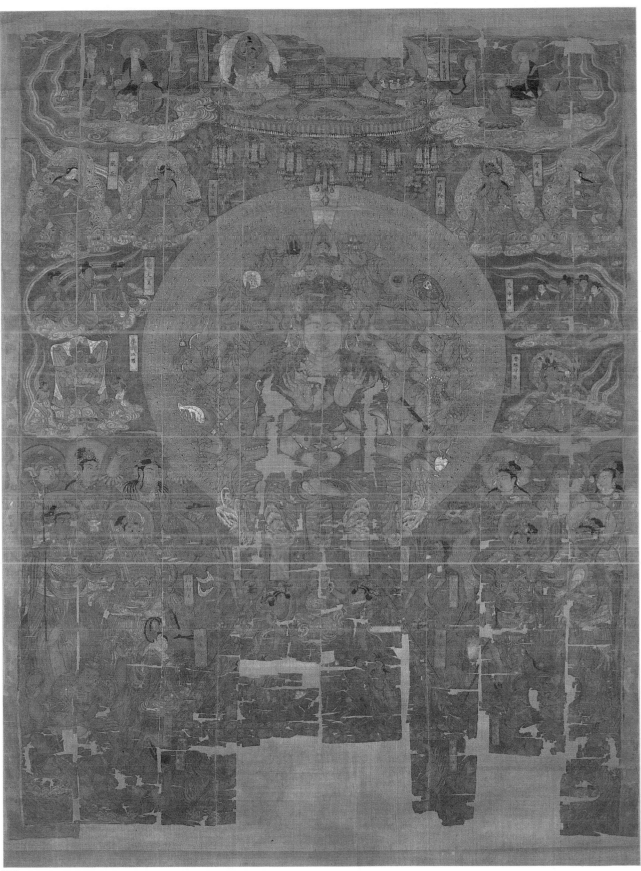

322. The Five Dhyāni Buddhas

China, from Dunhuang, Gansu province. Tang dynasty, late 9th century AD

Ink on paper. 44.8 × 43.2cm. OA 1919.1–1.0173

The Dhyāni Buddhas Amitābha (top), Ratnasambhava (left), Amoghasiddhi (right) and Akṣobhya (bottom) alternate with four Bodhisattvas with lamps and flowers; Vairocana occupies the centre. At the compass points, each with an animal, are four *vajra* guardians wreathed in flames. Notable is the early depiction of the *ba ji xiang* (Eight Emblems of Good Augury), two at each corner, on pedestals. During the Qing dynasty (1644–1911), when China was open to considerable Lamaistic influence, these emblems were manufactured in metalwork and porcelain for use on altars. DG

323. Magic diagram

China, from Dunhuang, Gansu province. Tang dynasty, late 9th century AD

Ink on paper. 58.5 × 57.5cm. OA 1919.1–1.0172

This large diagram has a lotus flower, or wheel, at the centre of a square marked with the compass points. North is shown here at the bottom. The surrounding space is filled with fine crossed lines and cryptically marked *jin sheng jie dao* (Golden Cord Releasing Way). Around it are deities and Buddhist emblems, including the conch, wheel and *vajra*; at the perimeter are water and flowering and fruiting trees. This drawing appears to preserve an early stage of Chinese esoteric Buddhist practice, preceding the developed Vairocana worship from which the Japanese Shingon sect took its ideas in the 9th century. DG

324. Diagram of an altar prepared for recitation of the Uṣṇīṣavijayā dhāraṇī

China, from Dunhuang, Gansu province. Tang or Five Dynasties, 9th–10th century AD

Ink on paper. 44 × 30.5cm. OA 1919.1–1.0174

Reciting this spell was believed to destroy the effects of evil *karma*; in the *Uṣṇīṣavijayā dhāraṇī sūtra*, translated into Chinese c.AD 676, the Buddha teaches it to the King of the heaven of the Thirty-three Gods to prevent his descent into hell. The circular bowls on the altar are for incense and water, and there are also lamps and vases. An image of the Buddha is placed at the centre. Inclusion of the names Bhaiṣajyarāja, Bhaiṣajyasamudgata, Bodhisattvas of Healing, together with Avalokiteśvara and Mahāsthāmaprāpta, suggests that the diagram was more likely intended for the recitation of a *dhāraṇī* connected with meditation on the first two Bodhisattvas. The officiating Tantrist is seated at the south side of the altar (the bottom of the diagram) with another incense burner (or burners) behind him. DG

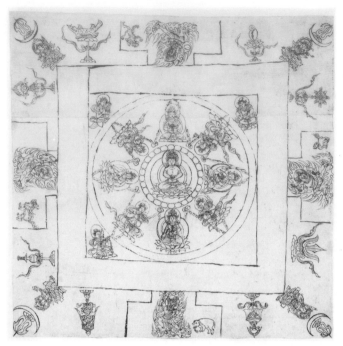

322

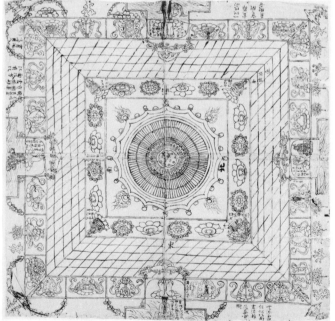

323

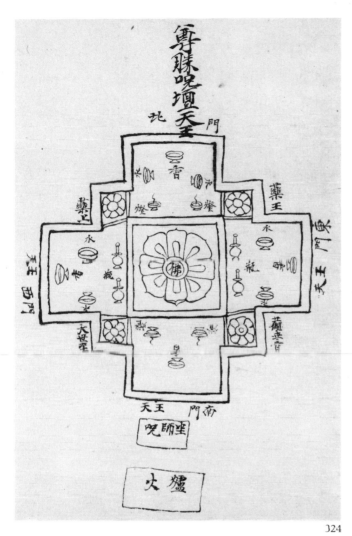

<div align="right">324</div>

325. Raising the Alms Bowl

China. Song or Jin dynasty, 12th century
Ink and colours on silk. 1.09m × 27.3cm.
OA 1925.2–18.01

This short handscroll depicts the encounter between Śākya-muni and Hārītī (Chinese Guizi mu), Mother of Demons, when the Buddha imprisoned her favourite son under his alms bowl in order to make her experience the anguish she caused humans by devouring their children. Similar to six others, the painting shows Śākyamuni at the opening of the scroll, on the right, seated amidst Buddhist and Daoist deities viewing numerous demons trying to raise the bowl with a hoist and tackle. Other spirits and gods, including the Mother of Lightning and the Duke of Thunder, lend their support to Hārītī, who stands at the centre. In the *Samyuktaratna-piṭaka* the Mother of Demons 'exhausted her powers' attempting to free the child, capitulated to the Buddha, and agreed to obey his precepts. These Chinese pictorial versions of the story are notable for equating Hārītī's powers with a legion of demons, depicted graphically and rather wittily. DG

Illustrated on page 225

326. Four lohan and attendants

China, Zhejiang province. Ming dynasty, 15th century
Ink and colours on silk. 1.69m × 87cm.
OA 1983.7–5.02

Of the sixteen or eighteen *lohan (arhats)* usually shown to-gether in Chinese paintings this scroll has only four, with two attendants (in buff robes), suggesting that it may have been one of a set of four such paintings. At the lower left are two tribute bearers, apparently Indians, wearing rich brocaded robes and holding a *hu* ceremonial sceptre and a model of a mountain; they are dwarfed by the *lohan*, in Chinese monastic clothes. The setting, a bamboo grove on a mountain slope, is painted with the clear outlines and hard-edged strokes of the Zhejiang *Zhe* school of landscape painting. Zhejiang had been a centre of Buddhist painting since the Song dynasty, and much of its output emanated from Ningbo from where it was taken to Japan. DG

Illustrated on page 228

327. Three Bodhisattvas

China, from Xingdang xian, Hebei province. Ming dynasty
15th century
Painting on plaster. 4.3 × 4m. OA 1927.5–18.8

The middle figure faces outwards, while those flanking him are in curved postures. Two of the Bodhisattvas, one holding a sceptre and both with a 'parent' Amitābha in the head-dress, are the classical Avalokiteśvara; the remaining figure has three gems in his crown and holds a fly-whisk. All are prominently haloed and with narrow repetitive falling drapery folds. Although the ruined temple from which they are said to come, called Chingliang (Pure Coolness), was founded in 1183, an inscription of 1485, still standing there in recent times, states that the wall-paintings 'with three great figures of Guanyin and others' were executed in 1424 by monks from a temple at Wutai shan and that subsequent work, including painting, was done in 1437 and 1468. These dates accord readily with both style and colouring, clearly in the tradition of large wall-paintings in Shanxi and Hebei attributable to extensive restorations by the Yongle emperor (1403–24). RW

Illustrated on page 229

<div align="right">223</div>

328

328. Scroll of Bodhisattvas

China, from Dunhuang, Gansu province. Tang dynasty,
9th century AD
Woodblock print. Ink on paper. 27.5 × 42cm. OA 1919. 1–1. 0258

Among the variety of Buddhist woodblock prints at Dunhuang,
those which most eloquently witness personal devotion are
fragments of long scrolls, joined sheets of paper carrying
hundreds of individually impressed Buddhas or Bodhisattvas.
One scroll bears dates showing that twenty-one images were
printed on certain days each month. The practice spread to
Japan where blocks were commonly engraved with ten or 100
small images. There the printed sheets were paid for by
devotees but retained by the monastery and enclosed in
bundles within carved wooden images. RW

329. Sūtra of Buddha's names

China, from Dunhuang, Gansu province. Five dynasties,
early 10th century
Woodblock print. Ink and colours on paper. 28cm × 2.74m.
OA 1919. 1–1. 074

Like other scrolls at Dunhuang this contains a simple enumer-
ation of the Thousand Buddhas of the present age (*kalpa*). The
robe colours of successive Buddhas alternate regularly as do
those of the Thousand Buddhas painted on the walls of the
Dunhuang cave temples. RW

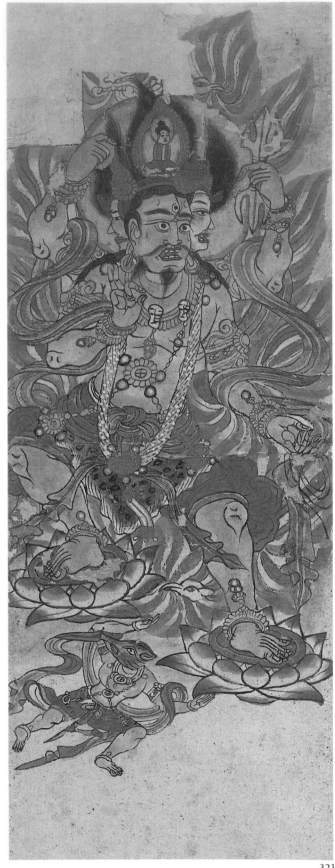

321

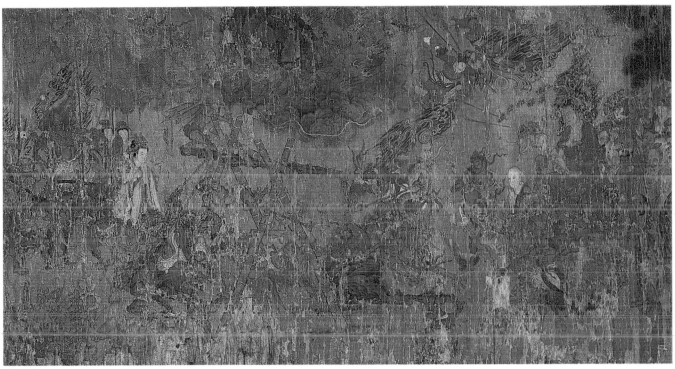

325

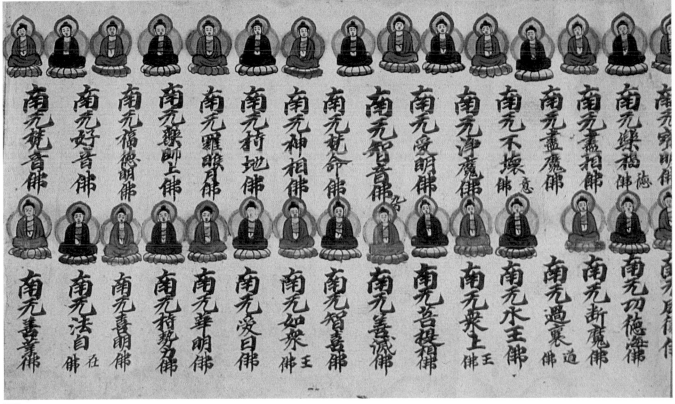

329

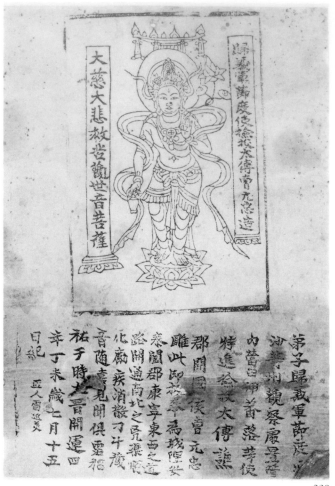

330

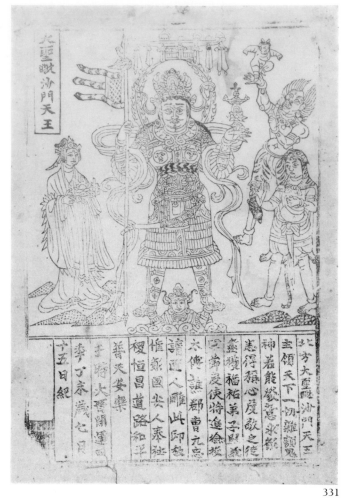

331

330. Avalokiteśvara

China, from Dunhuang, Gansu province. Five dynasties, dated the year *dingwei* (AD 947) of the Kaiyun reign, Jin dynasty
Woodblock print. Ink on paper. 31.7 × 20cm. OA 1919. 1–1. 0242

The left-hand lotus cartouche calls Avalokiteśvara the Great Compassionate, Great Merciful Saviour from Hardship, Bodhisattva who hears the Cries of the World; the right-hand column says that the print was made for Cao Yuanzhong, the Commissioner of the Guiyi army at Dunhuang, who inherited the title in AD 946 and ruled until 975. The text below, engraved on a separate block, carries the date. Avalokiteśvara, in *tribhaṅga* pose, holds a medicine bottle and lotus flower, his 'parent' Buddha just visible in his headdress. Other surviving impressions from the same block confirm its popularity.

RW

331. Vaiśravaṇa

China, from Dunhuang, Gansu province. Five dynasties, dated in the year *dingwei* (AD 947) of the Kaiyun reign, Jin dynasty
Woodblock print. Ink on paper. 40 × 26.5cm. OA 1919. 1–1. 0245

This dated print, like that of Avalokiteśvara, was made to mark Cao Yuanzhong's accession to power in the Dunhuang area. The size of the print probably reflects the importance of Vaiśravaṇa, Guardian of the North, in China and Central Asia. China was most at risk from northern invaders, and Vaiśravaṇa was especially associated with Khotan, for its king had once prayed for and received a son – the naked child held up by a demon – from that deity. Over a dozen copies of this print were found at Dunhuang.

RW

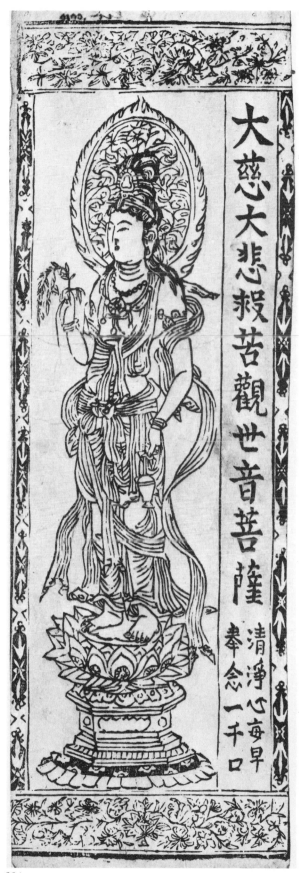

334

332. Amitābha

China, from Dunhuang, Gansu province. Five dynasties, 10th century
Woodblock print. Ink on paper. 26.7 × 17.1cm. OA 1919. 1–1. 0232

This print, of similar quality to no. 333, of Avalokiteśvara, may have formed a triad with that and another Bodhisattva. With the image above and text below it represents the most developed form of print from Dunhuang. The same arrangement is found in Japanese narrative scrolls following Chinese models, e.g. *Kako Genzai Ingakyō* (*Sūtra* of Cause and Effect) of the 8th century and still used for printed Buddhist and secular stories in the 16th and 17th centuries. RW

333. Avalokiteśvara

China, from Dunhuang, Gansu province. Five dynasties, 10th century
Woodblock print. Ink on paper. 27.3 × 17.2cm. OA 1919. 1–1. 0233

This print may have been intended to accompany that of Amitābha but when found was pasted over a larger painting with another impression of Avalokiteśvara. The second impression was both hand-coloured and had decorative borders of blue-printed paper at top and bottom. Such prints and numerous votive paintings testify to Avalokiteśvara's great popularity at Dunhuang and elsewhere in Chinese Buddhist art. RW

334. Avalokiteśvara

China, from Dunhuang, Gansu province. Five dynasties,
10th century AD
Ink on paper. 30 × 9.6cm. OA 1919. 1–1. 0240

The caption calls Avalokiteśvara Great Compassionate, Great Merciful Saviour from Hardship, the Bodhisattva who Hears the Cries of the World and promises that the devotee will, with pure heart, recite this every morning 1,000 times. The Bodhisattva holds the flask and willow branch, symbols of healing. The printed floral borders reproduce the way in which votive prints were sometimes mounted. RW

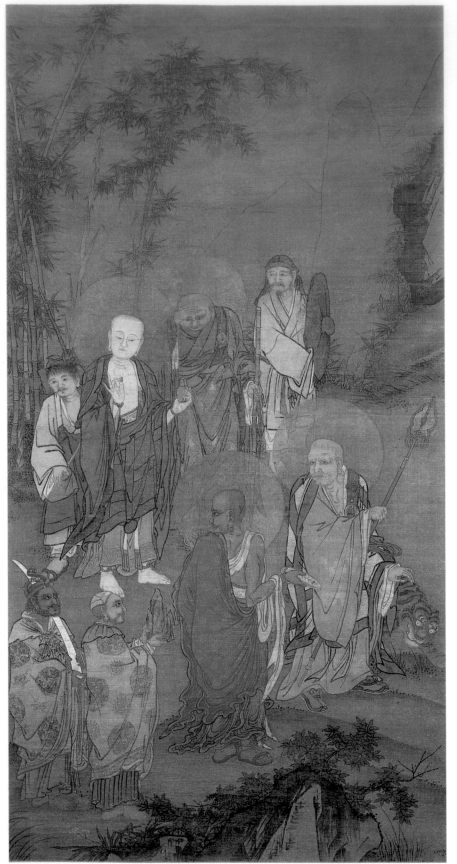

332

333

327

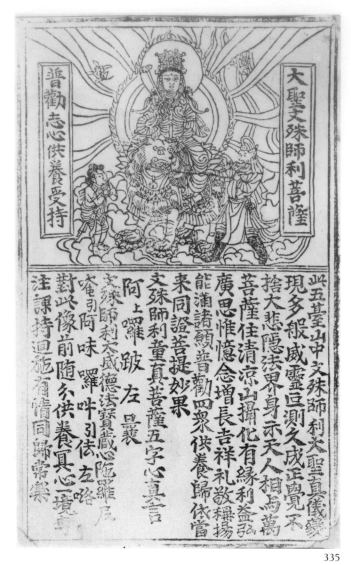

335

336. Sūtra of the great dhāraṇī of the Buddha mind

China. Ming dynasty, 1368–1644
Small printed edition of *Fo ding xin da tuo tuo luo ni jing* with half-page woodblock illustrations above text. 22 × 9 cm. OMPB Or.80.d.21

The 'comic-book' format of this uncanonical text was a common form of popular printing, both secular and religious, during the Ming. Its predecessors are manuscript examples such as no. 72. The illustration on the right depicts one of Buddhism's greatest crimes, the killing of living beings which will be punished in hell. On the left a devout couple read the *sūtras*, and the text praises those who rise early to burn incense and pray. FW

Illustrated on page 233

337. Rules for confession in the place of the merciful and compassionate one

China. Ming dynasty, 1368–1644
Ci bei dao chang chan fa with 4-page frontispiece, woodblock print. 37 × 12 cm. OMPB Or.80.d.23

A late canonical work compiled either by a prince of the Qi (AD 479–502) or King Wu of the Liang (AD 502–57). Though the authorship is doubtful, the frontispiece confidently depicts a royal figure sitting with a bearded monk with whom he has presumably been discussing doctrinal points. The colophon records that it was printed at the Zhaoqing temple in Hangzhou, a city still famous for its temples set beside the West Lake. FW

338. Guide to Putuo shan

China. 18th century.
Nan hai sheng jing Pu tuo shan zhi, illustrated woodblock print. 24 × 24 cm. OMPB 15269.d.6

Putuo shan is China's eastern Buddhist mountain, dedicated to the Bodhisattva Guanyin who, according to the *Lotus Sūtra*, helps those in trouble and the childless. A popular place for pilgrimage, the mountain, which lies off the east coast, is also exceptionally beautiful and has always attracted tourists. This crudely printed guide is intended for both tourists and pilgrims as the maps show the route up the mountain past all the important temples. FW

335. Mañjuśrī

China, from Dunhuang, Gansu province. Five dynasties, 10th century
Woodblock print. Ink on paper. 27.9 × 16.8 cm. OA 1919. 1–1. 0237

Two slightly different versions of this print attest its popularity at Dunhuang. Both show Mañjuśrī on his lion mount, attended by a lion tamer of marked Western appearance and worshipped by a small boy. The inscription calls him Mañjuśrī from Wutai shan, the mountain in Shanxi province where, as the future Buddha, he would make his earthly abode. The oldest wooden temple buildings in China, built in AD 782 and 897, still stand there. RW

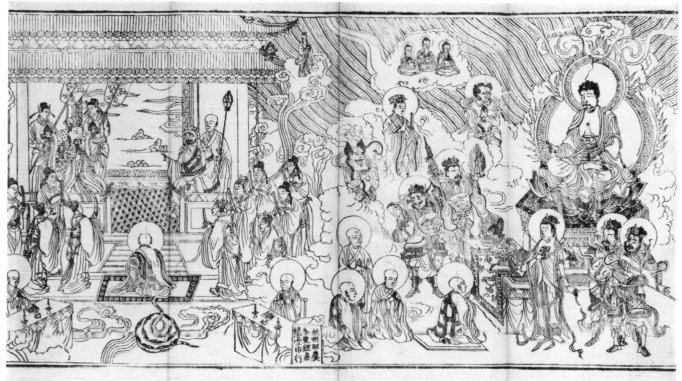

337

338

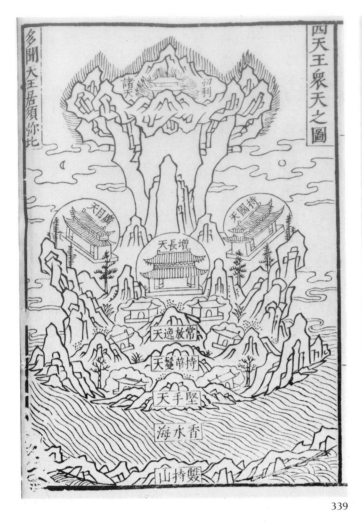

<div align="right">339</div>

<div align="right">341</div>

339. Illustrated world of the Dharma

China, Guangzhou. *c.*1800

Fa jie an li tu in 4 *juan*, illustrated woodblock print. 29 × 36 cm.
OMPB 15101.c.10

Buddhist *sūtras* constantly refer to numbers as part of a
vast classification scheme. This illustration depicts the abode
of the 'heavenly guardians' of the four quarters who live
above the seven concentric mountains and the fragrant sea.
The number four alone can include the Four Noble Truths,
the four passions, the four *dharmas*, the four benefactions, the
four all-embracing Bodhisattva virtues, the four universal
vows and the four minutest atoms. FW

340. Jade record of bounty

China. 1810

Ci en yu li, illustrated woodblock print. 26 × 16 cm. OMPB 15101.a.7

This late, uncanonical work stresses the bounty of the popular
and compassionate Bodhisattva Guanyin. The illustrations
shown follow a sequence depicting tortures in different
Buddhist hells. The soul passes through these hells to be reborn,
and the picture on the right depicts one half of the circle

illustrating two of the four forms of existence, the water-born
(worms and fishes), the oviparous, and one of the six modes of
human existence – poverty. On the left is the figure of
Guanyin. The attendant holds a banner which explains that
Guanyin rescues from suffering and trouble. FW

Illustrated on page 234

341. Collection of Sino-Tibetan texts

China. 1825

Yao shi qi fo gong yang yi gui and 16 other texts in 4 *ce*, illustrated
woodblock print. 29 × 15 cm. OMPB 15101.g.8(1)

One section of this collection illustrates the 'method of
arranging the altar' according to the Tibetan rite. From the
top five-coloured banners; altar candles; the seven precious
jewels of the Universal Monarch – general, elephant, queen,
minister, wheels, horse, wishing jewel; the eight auspicious
emblems: parasol, golden fish, jar of treasures, lotus, white
conch, knot of eternity, standard of victory, golden wheel;
the eight glorious offerings – mirror, medicines, curds, grass,
conch, vermilion, white mustard and vases of flowers. FW

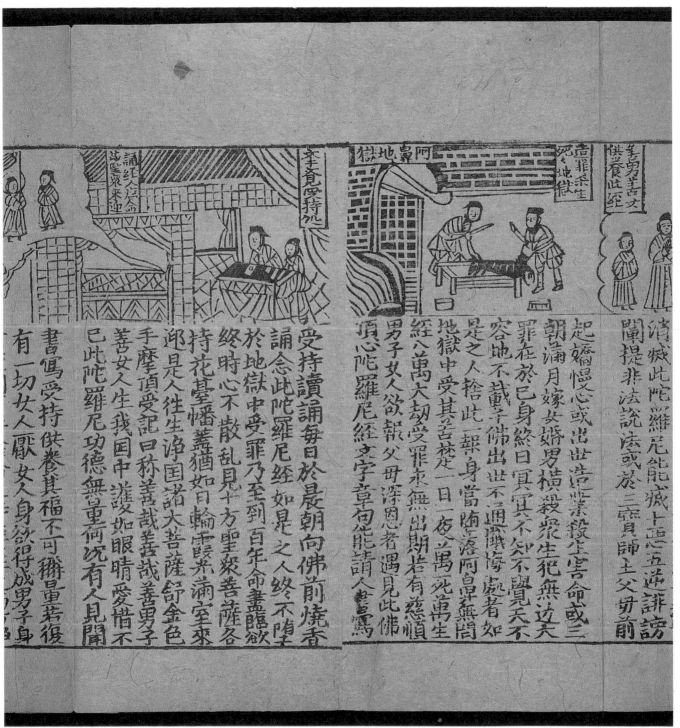

清淨此陀羅尼能滅上惡五逆誹謗
闡提非法說法或於三寶師主父母前

起嬌慢心或出出造業殺生害命或三
朝滿月嫁女娶男橫殺眾生犯無邊天
罪在於已身終日冥冥不知不覺天不
容地不載于佛出世不遇懺悔處者如
是之人捨此一報身當隨墮阿鼻無間
地獄中受其苦楚足一日一夜萬死萬生
經八萬大劫受罪永無出期若有慈順
男子女人欲報父母深恩者遇見此佛
頂心陀羅尼經文字章句能請人書寫

受持讀誦每日於晨朝向佛前燒香
誦念此陀羅尼經如是之人終不墮
於地獄中受罪乃至到百年命盡臨欲
終時心不散乱見十方聖眾善薩各
持花臺幡葢猶如日輪霞米滿室來
迎是人往生淨国諸大菩薩舒金色
手摩頂受記曰稱善哉善哉善男子
善女人生我国中遊護如眼睛愛惜不
已此陀羅尼功德無量何況有人見聞
書寫受持供養其福不可稱量若復
有一切女人厭女人身欲得成男子身

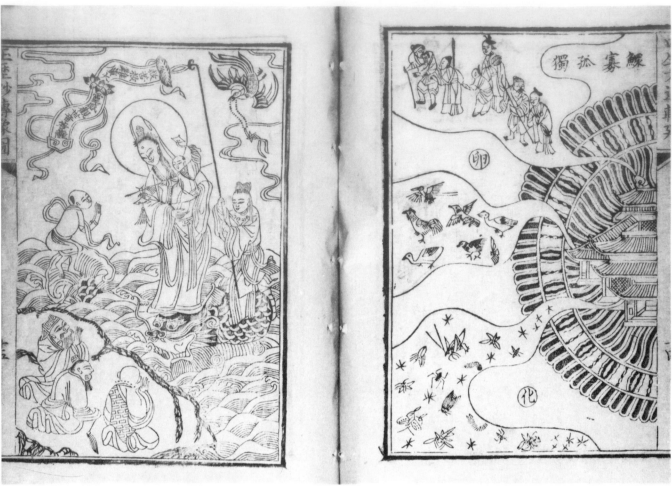

340

15 Korea

The traditional date for the introduction of Buddhism to Korea, AD 372, was anticipated in the early fourth century. During the Three Kingdoms period (?37 BC– AD 668) Koguryŏ adopted Buddhism as the state religion in 372, Paekche in 384 and Silla in 582. Then, as later, the ruling élite sought in Buddhism a protective force against constant invasion. A powerful state creed, as well as a widely followed popular faith throughout the Unified Silla and Koryŏ periods (AD 668–935; 918–1392), it lost its hold on the court with the accession of Yi Sŏng-gye, when Confucianism became the official religion of the Chosŏn dynasty (1392–1910).

Despite the destruction of almost all the early temples and major religious buildings, literary evidence and excavations indicate that early Korean rulers spent lavishly to promote Buddhism, turning to it in times of trial to invoke the Buddha's supernatural powers in the country's defence. The Silla capital, Kyŏngju, imitated the Sui and Tang city of Chang'an and its many temples also followed Chinese models, reflecting direct experience of them by Korean monks. The oldest surviving Buddhist temple, the Pulguk (Buddha land) near Kyŏngju (sixth century and rebuilt 751–74), still retains its eighth-century entrance gate, stone steps and pagodas, but most of its buildings are Chosŏn reconstructions. This and other temples built by the devout Silla rulers so taxed the kingdom's resources that the population suffered great hardship from their rulers' piety.

The impact of Buddhism on Korean art appears best in sculpture in stone and metal, which unlike painting has survived in abundance from the sixth century. Small figures of bronze or clay were used in domestic ceremonies, while larger images of the Buddha in stone, or cast in bronze or iron, stood in temple halls. Large wall sculptures were carved on rock faces, mountainsides and in caves in imitation of the monumental work in China and Central Asia. Korean sculptors were important in the transmission of Chinese artistic influences to Japan; some early images in Japanese temples are thought to have been made by craftsmen from the south-western kingdom of Paekche.

Korean sculpture soon freed itself from the powerful initial Chinese influence. At first Koguryŏ in the north produced linear, stylised figures of Northern Wei type, while Paechke images show more human, smiling features derived from the southern Chinese state of Liang (502–57). Later Korean sculp-ture tended towards two-dimensional representation and an abstract rendering of garment folds. Although there are many Buddhist stone sculptures in Korea, the outstanding achievement of Buddhist art in stone is the cave temple at Sŏkkuram, near the Pulguk temple, and built 751–74. It houses a monumental seated Śākyamuni on a pedestal, surrounded by fine reliefs of Bodhisattvas, *arhats*, heavenly kings and guardians. The grace and dignity of the Sŏkkuram Buddha express to the full the faith of the Silla kingdom.

Buddhism was so important a force in the Silla and Koryŏ periods that scarcely any of the arts escaped its influence. Bronze casting was stimulated by the need for temple bells and religious implements such as water sprinklers, incense holders and caskets for holy relics. No survey of Buddhist achievements in Korea should ignore the development of printing, which began modestly in the eighth century under Chinese influence. Texts and images were carved on to wood-blocks for large-scale reproduction, and by the eleventh century the entire *Tripiṭaka* had been carved. Although the first Korean edition was destroyed during the Khitan invasion, a thirteenth-century set of woodblocks of the Korean Canon survives, housed in a special hall at Haein temple. EMCK

342. Buddha

Korea. 8th century AD

Gilt bronze. Height 23.7 cm. Given by P.T. Brooke Sewell, Esq. OA 1957.7 18.1

While adapted from Chinese Tang sculpture, this is a characteristic Silla-period bronze. The right hand is raised in the gesture of reassurance, while the position of the left can be explained as symbolising one of the Nine Classes of Life in the Pure Land, according to the specific merits of the devotee in relation to his rebirth in Paradise. VH

343. Buddha

Korea. 8th century AD

Gilt bronze. Height 20.5 cm. Bought from the Eumorfopoulos Collection with the aid of public subscription. OA 1938.5–24.711

This almost flat figure with a stylised suggestion of corpulence is a hollow half-casting with two small pegs behind the shoulders, perhaps for a lost nimbus or aureole, and stands on a hexagonal base. The drapery is executed largely with incised

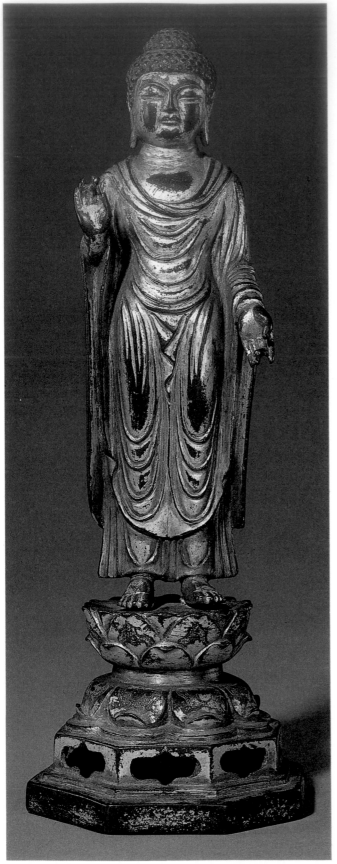

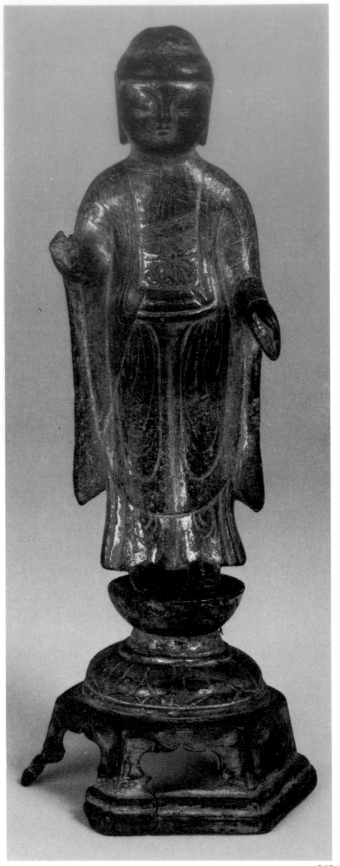

342

343

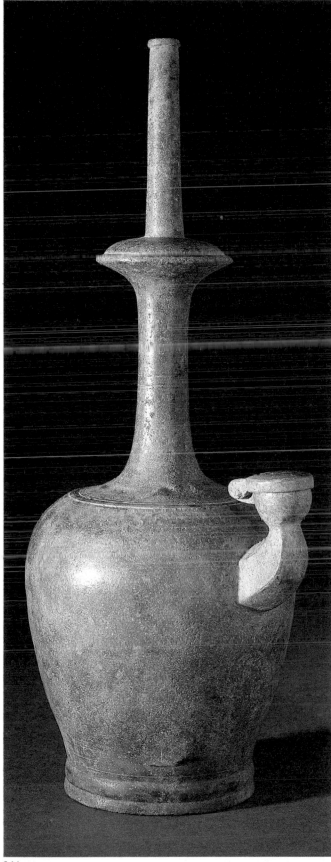

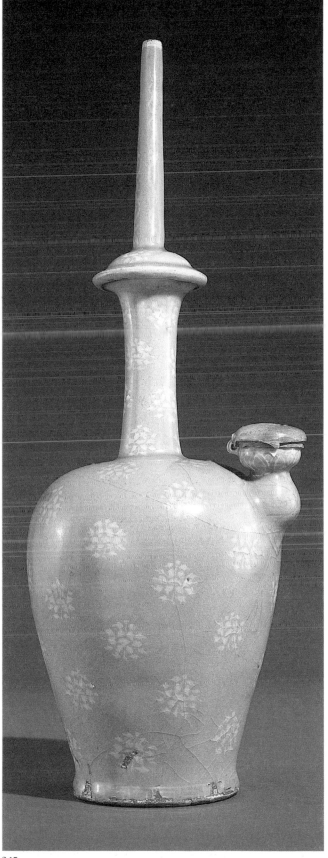

344

345

lines. The raised right hand makes the gesture of reassurance, while the left may be explained as indicating the devotee's merits in respect of his rebirth in the Pure Land. VH

344. Kuṇḍikā

Korea. 12th–13th century
Bronze. Height 29.5 cm. OA 1974.10–31.1

This slender spouted ritual water vessel derives from similar Chinese vessels and ultimately from India. It is filled through the spout at the side which is closed by a hinged lid. Its characteristically Korean features have been described by Pak as the faceting of the spout and the rings emphasising the vessel's form at the mouth, neck, shoulders and base, the surface being otherwise plain. VH

345. Kuṇḍikā

Korea. 13th century
Glazed stoneware. Height 44.5 cm. OA 1936.10–12.198

Ceramic *kuṇḍikās* follow the shape of those in metal. This celadon vessel is decorated under the glaze with the regularly repeated floral motifs often found in Korean Buddhist art of the 13th century, as, for example, on the exhibited lacquer *sūtra* box. The decoration is executed by the *sanggam*, or inlay, technique with white slip. VH

346. Sūtra box

Korea. 13th century
Lacquer inlaid with mother of pearl and silver wire. Height 25.5 cm. Bought from the Brooke Sewell Bequest. OA 1966.12–21.1

This *sūtra* box is decorated with a stylised chrysanthemum design similar to that found on contemporary Korean celadons. It was probably made by the government office established by King Wŏnjong to hold the Buddhist scriptures reprinted after the Mongol invasions. Such boxes are very rare, and this example is remarkable in that the clasp, hinges and original leather interior are in perfect condition. VH

Illustrated on page 241

347

347. Censer

Korea. 14th century
Bronze inlaid with silver. Height 26.2 cm. Bought from the Eumorfopoulos Collection with the aid of public subscription. OA 1936.11–18.196

For ritual use on an altar as part of a larger set, this censer is typical of the accomplished Koryŏ-period metalwork. The decorative pattern and Indian *Siddham* characters, used to write invocations, are inlaid in silver. The characters can be read anticlockwise to make a mystic formula whose sounds, *Oṃ raṃ svāhā*, give the seed-syllable *raṃ*. VH

348. Amitābha Sūtra

Korea. 1341
Manuscript in 16 folds. Gold and silver paint on blue paper. 22 × 8.5 cm. OA 1983.10–8.01

This typically Koryŏ-period manuscript has one illustration, spread over two leaves, showing Śākyamuni flanked by Bodhisattvas and monks preaching to deities and other Buddhas, while two Bodhisattvas welcome souls to paradise. The text, Kumārajīva's Chinese translation, in silver lettering, was written by a monk called Ch'onggo for his mother's spiritual benefit. The manuscript has been more fully discussed recently by Pak. VH

Illustrated on page 240

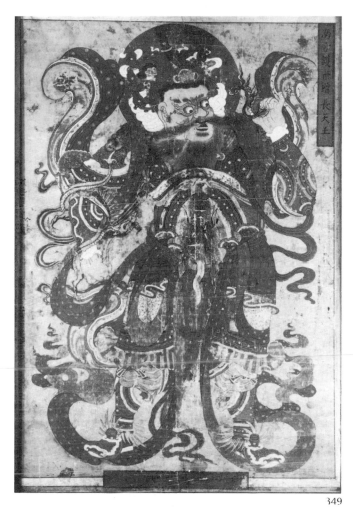

349

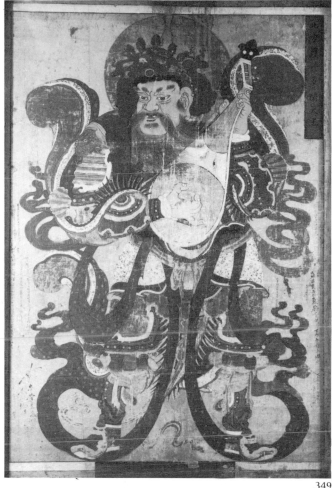

349

349. Two Guardian Kings

Korea, probably from Taegu, Kyŏngsang province Yi dynasty,
18th–19th century
Colours on hemp cloth. Each 3 × 2 m OA 1920.3 17. 2 & 3

Although labelled top right as guardians of the North and
South, these figures represent respectively those of the East
(Dhṛtarāṣṭra) and West (Virūpākṣa), the former with his
lute, and the latter holding a serpent in his right hand and
what may be a flaming jewel in the left. The four guardians of
the cardinal points and defenders of Buddhism are found both
as paintings and sculpture at the entrance to Korean temples.
The huge size of the two canvases, the dynamic and decorative
lines and the combination of green and earthy colours are
typical of Korean Buddhist paintings. Both bear signatures of
later devotees in addition to the original dedicatory cartouches
in red at the lower centre. Although the name of the temple
and the exact date have been erased, enough remains to show
that the latter was in the Chinese reign period of Jiaqing
(1796–1820). RW

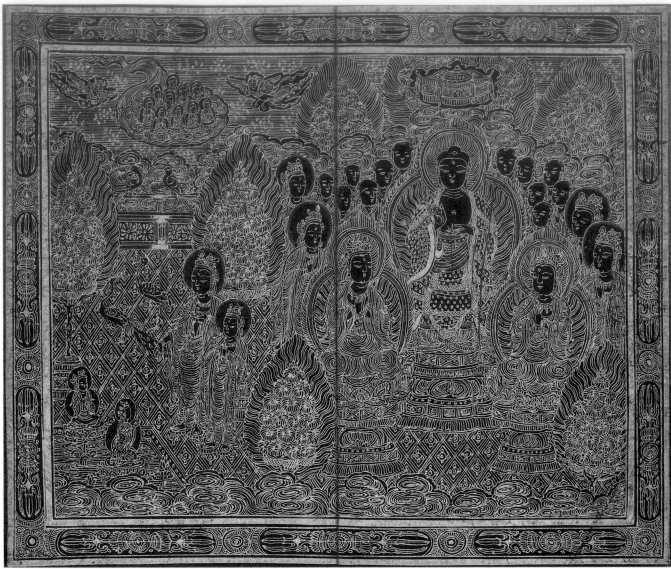

348

350. Catalogue of the Tripiṭaka

Korea. 1248

Woodblock edition of *Taejang Mongnok*. 37 × 22 cm. OMPB 15103.e.9

Around 1010, during repeated invasions by the Liao, King Hyŏnjong ordered the carving of the first Korean *Tripiṭaka*; previously, the Koreans had relied mainly on China for Buddhist texts. This *Tripiṭaka* and its printing blocks were destroyed during the Mongol invasions. Immediately afterwards, King Kojong pledged to reprint it, and the 81,137 blocks carved between 1236 and 1251 are still preserved. This catalogue is amongst the blocks, though the copy displayed may be a later printing. It is organised in the order of the 'Thousand character classic', a primer learned by every Korean and Chinese schoolboy. EMCK

351. Illustrated life of the Buddha

Korea. 17th century

Sŏksi wŏnnyu, woodblock print. 4 vols. 37 × 22 cm. OMPB 15510.a.3

Śākyamuni is shown riding outside the palace meeting an old and a sick man, two of the encounters arranged by the gods to show him the transitoriness and decay of human life. The text is an excerpt from the *Buddhacarita*, a Sanskrit verse biography of Śākyamuni by Aśvaghoṣa, translated into Chinese by Dharmarakṣa between AD 414 and 421 and again by Jñānagupta in 587. Similarities between such Buddhist volumes and the popular illustrated fiction of Ming China lie in the block-carver's page layout which breaks up each page and makes the stories accessible to uneducated readers. EMCK

Illustrated on page 242

薩雲分陁利經一卷　竺譯人名今附西晉錄

妙法蓮華經七卷　姚秦三藏鳩摩羅什　譯

鳳函入十卷　入紙十四牒八張

正法華經十卷　西晉月氏國三藏竺法護　譯

在函入十卷　入紙十六牒二張

添品法華經七卷　隋天竺三藏闍那崛多共笈多　譯

維摩詰所說經三卷　姚秦三藏鳩摩羅什　譯

樹函入十卷　入紙十三牒三張

維摩詰經二卷　吳月氏優婆塞支謙　譯

說無垢稱經六卷　大唐三藏法師玄奘　譯

大方等頂王經一卷　西晉月氏三藏竺法護　譯

大乘頂王經一卷　梁優禪尼國王子月婆首那　譯

白函入十卷　入紙十三牒四張

善思童子經二卷　隋天竺三藏闍那崛多　譯

大乘悲分陁利經八卷　失譯二藏名今附秦錄

駒函入十卷　入紙十四牒六張

悲華經十卷　北涼天竺三藏曇無讖　譯

食函入十卷　入紙十牒十二張

350

346

道見病臥 二十三

本行經云。爾時作瓶天子。復見思惟菩薩
在彼宮內。取於五欲。放逸情蕩。已經多時
世間無常。盛年易失。應當早捨宮內出家
使其覺悟。令速厭離。菩薩宿福因緣忽然
發心。欲出遊戲。太子即召駈車者意莊嚴好
車。出城遊玩。太子乘車。從城南門出瀕向
園林作祇。忽復面色痿黃喘氣微弱命在須
臾。太子見此是病人。復問何名病人。答曰此
是病人。身體羸瘦。病人已問駈者言此是何人。
駈者報言。恐威德已盡困篤無力。死時將至。
人不善安隱。此人不久自應命終。欲得求
活無有是處。復問為獨此人為當一切眾
人者皆當一切天人皆未免此。
言非我此人。不敢是病難得度者我今不
言若我獨此身。不懼是病。
假園林遊戲。即勒迴車。而還宮中靜坐思
惟。一心繫念淨飯王聞已憶阿私陀仙恩
記之一語決定真實。太子莫復捨我出家

16 Japan

Japan can claim the greatest surviving concentration of the material arts of Buddhism in its 80,000 temples and their contents. The temples themselves are the most remarkable phenomenon, many retaining intact or in part features from the Nara (710–94), Heian (794–1185), Kamakura (1185–1333) or Muromachi (1392–1573) periods, rather in the manner of the cathedrals of Europe. Three factors have contributed to this exceptional survival. One is the highly institutional nature of Japanese Buddhism, leading to both local and national continuity and pride. Another is the ancient, pre-Buddhist tradition of building mainly in wood with constant renewal and restoration. The third is the respect for tradition inherent in all Japanese life; the past is preserved wherever possible.

Before the Nara period Buddhist architecture in Japan relied heavily on Korean models, as did sculpture, such as the sinuously sensuous seventh-century Kudara Kannon figure from the Hōryūji temple. In the Nara period Chinese influence was dominant, and the bases of Japanese Buddhist painting were laid on Tang models. When the capital moved to Kyoto in 794, a more native style emerged. Temples began to utilise features of the new native palace architecture, including the use of the straw-coloured *tatami* matting units for floors in subsidiary rooms, while the walls consisted of paper-covered sliding units. Though sometimes painted with Buddhist scenes, they increasingly depicted Japanese landscape, a persisting secular style of decoration. Today celebrated artists such as Higashiyama Kaii continue to paint sets for such decoration (*fusumae*) for temples. Architecture also favoured gardens seen from raised verandas, and their design became one of the great Japanese Buddhist arts from the thirteenth century onwards, when the Zen sects began to use them as an aid to contemplation.

In the main halls of worship, however, traditional altars honoured carved images, and places were reserved for hanging scrolls or painted panels depicting Buddhas, Bodhisattvas, *arhats* and an increasing body of heavenly and diabolic beings. Japanese sculpture and figural painting of divinities gradually took on a softly human yet detached aspect, as in the numerous images of the merciful Amitābha (Japanese Amida) descending to receive the faithful, or his forms as the Bodhisattvas Avalokiteśvara (Japanese Kannon) or Kṣitigarbha (Japanese Jizō). A more energetic and warlike side of Japanese personality, expressed normally by the *samurai* (warrior) class, inspired an impressive body of muscular and violent sculpture in the twelfth and thirteenth centuries. This period also saw the beginning of a fine tradition of expressive portraiture of patriarchs such as Shōtoku Taishi or Jion Daishi, or of recently dead abbots. Japanese reverence for the founder of a line and the desire to maintain its traditions motivated this art form but tended ultimately to produce a dead repetitiveness.

In the seventeenth century with the massive increase of institutionalisation and control of temples by the Tokugawa regime (1600–1868), which most favoured Confucianism, Japanese Buddhism seemed set for rapid decline. Its strong integration with the life of ordinary people proved its salvation. While large-scale sculpture declined, smaller forms flourished for private devotion. These more portable images were made not only in wood and lacquer, traditional materials since the eighth century, but also increasingly in bronze. As humanism gained ground, favoured subjects became the most recognisably human ones – Śākyamuni himself, his disciples, Shōtoku Taishi, or former priests and abbots. The divinities were increasingly burlesqued in popular paintings and prints, or in the miniature carved toggles called *netsuke*.

Popularism also kept alive painting of scenes of heaven and hell imagined in the Pure Land sects and of the complex and often ferocious deities of the Tantric Shingon sect. Shingon had popular appeal, since its introduction by the patriarch Kōbō Daishi in the ninth century, because of its supposed magical power. Kōbō Daishi remains the most revered of all Japan's Buddhist founders. Popular interest also caused in the seventeenth century a revival of the painted narrative handscroll, a most characteristic Japanese art form. From the eighth to the sixteenth centuries scrolls depicting Buddhist lives and legends or temple histories had been produced in official studios for the *sūtra* stores of religious establishments. In the more secular seventeenth century pictorial scrolls were produced in larger numbers and by a greater range of artists for private worship. Their vigour and artistic qualities are becoming increasingly appreciated.

The Japanese bias to the arts, as one of the most noticeable features of the attitude to Buddhism, was above all true of the Zen sect, which came to dominate the arts of the ruling military class in the fourteenth and fifteenth centuries. Zen's

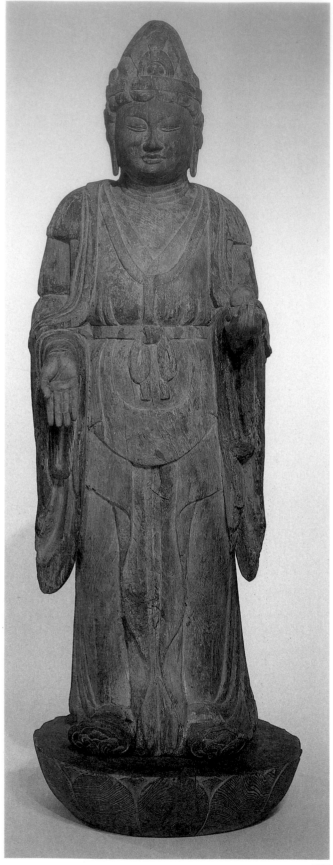

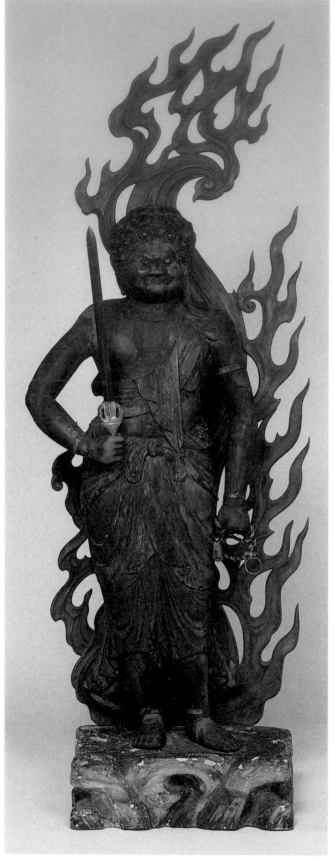

356

357

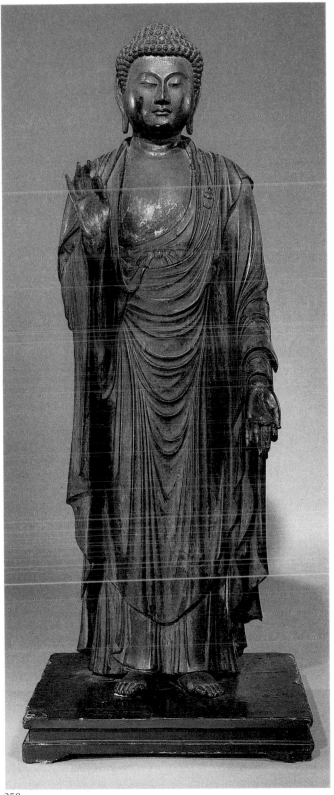

358

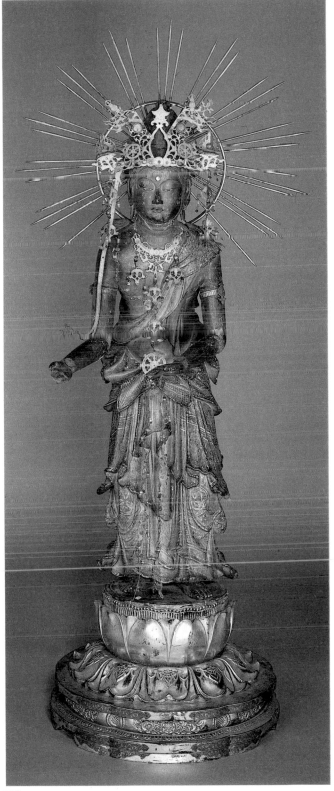

360

almost worldly preoccupation with painting, calligraphy, the arts of the Tea Ceremony (especially pottery), architecture, gardens, interior design, music and the martial arts led to an unusual degree of integration between Japanese aesthetics and the austere and restrained attitudes of Zen. As a result the standards of restraint, appreciation of art and objects, and love of the natural world, taken for granted in the Tea Ceremony since the sixteenth century, have been diffused among all cultivated Japanese, who have become in consequence heavily influenced by Zen Buddhism. LRHS

Calligraphy and printing

The Japanese contribution to Buddhism lay, as we have seen, not in the development of a grand doctrinal system but in art, not least that of book production. Some of the finest examples of Japanese calligraphy and printing are Buddhist. Indeed, Buddhist domination in traditional woodblock printing was almost total right up to the advent of movable type in the 1590s. No book was printed outside a temple, and only the Zen sect, propagating a view more worldly than other sects, countenanced topics not related to the faith.

The earliest surviving manuscript of native origin is the seventh-century *Hoke gisho*, a commentary on the *Lotus Sūtra*. It is written in masterly Chinese by Prince Shōtoku (573–621), the enlightened statesman now revered as the true founder of Japanese Buddhism. Whether or not this manuscript is in his own hand is still debated. At all events, its existence betokens the extraordinary facility with which Buddhism (along with the Chinese script) was adopted from China. It also symbolises the special relationship between Buddhism and the state, which was to become a salient Japanese characteristic.

Much the same can be said of Japan's earliest surviving example of printed matter – the *Hyakumantō darani* (One Million Pagoda *dhāraṇī*). On a scale matching that of modern best sellers, these charms were printed between 764 and 770 by order of Empress Shōtoku (718–70) in thanksgiving for the defeat of a rebellion against her Buddhist-orientated court. Yet they stand in strange isolation in the history of Japanese printing. There is no further record of printing until the tenth century and the next specimens come from the 1080s. Throughout the intervening years manuscript was preferred for its calligraphic elegance and on account of the special merit that hand-copying would bring the copyist and his patrons.

In the eighth century copying of the entire Buddhist Canon (*Tripiṭaka*, or in Japanese *issaikyō*) was strongly promoted by Emperor Shōmu (701–56) who made Buddhism the state religion. *Sūtra*-copying became a major industry, institutionalised in the scriptoria (*shakyōsho*) set up within the imperial court and in many temples. The three complete sets of the *issaikyō* commissioned by the Emperor's consort, Kōmyō (701–60), represent the peak of disciplined elegance in Nara calligraphy.

For the nobility of the Heian period (794–1185) Buddhism was more than an official ideology; it was a source of zestful aestheticism. More and more care was taken to obtain the very best paper and ink. Important texts, such as the *Lotus Sūtra*, were executed in gold and silver ink on paper or silk, dyed in indigo or decorated with designs. Some scrolls were provided with an illuminated frontispiece. The commissioning of ornate copies reached its apogee in the twelfth century but was to be emulated, though with less finesse, right up to the seventeenth.

Around the year 1000, printing resumed in Japan, stimulated largely by examples brought back by student monks of the first printing of the *Tripiṭaka* from Song China. However, Heian-period printing is not noted for either volume or quality. It is the ensuing Kamakura period (1185–1333) that marks the golden age of Japanese Buddhist printing. Three developments in the faith itself contributed to this: the emergence of a popular Pure Land (*Jōdo*) sect with its many offshoots among the lower classes; a revitalisation of the ninth-century Tendai and Shingon sects and of the original 'Six Sects' of Nara; and a flourishing of Zen within the ruling military aristocracy.

It has been customary to distinguish various editions by the name of the temple or area in which they respectively originated in line with their sectarian affiliations. Famous among them are the *Kasuga-ban* (Kasuga imprints) of the Hossō sect, the *Kōya-ban* (Mt Kōya imprints) of the Shingon sect, and the *Gozan-ban* (Five Monasteries imprints) of the Zen sect. However, the prolific output of the evangelical Jōdo sect was not tied to any one location and was known simply as the *Jōdokyō-ban*, the Jōdo sect imprints. With the exception of the *Gozan-ban* which followed closely the uniform style of Song and Yuan printing in China, printing by other sects exhibits distinctively Japanese features – individual variation of the script form, thick quality paper, glossy jet-black ink, and superb artistry in block-cutting and binding.

Buddhist dominance started to wane in the 1590s when native literary classics began to be printed by laymen applying the movable-type technique introduced from Korea. The establishment of a neo-Confucian government in the Edo period (1600–1868) accelerated its decline. As literacy spread among the emergent townspeople after 1650, commercial printing houses catering for popular taste became pre-eminent.

Buddhist works continued to be printed throughout the Edo, but were given secular treatment and absorbed into the main-

stream of popular literature. Doctrinal texts of the Amidist sects, for example, were printed with the phonetic *kana* syllabary to assist the newly literate reading public. Fictional accounts of the lives of the Japanese 'saints' were published with profuse illustrations. Maps and pictorial guide-books for pilgrimages were issued in their thousands to organised groups of travellers, seeking worldly pleasure more than rebirth in Paradise in their religious progress. Henceforward, Japanese Buddhism was to be truly secularised, yet all the more pervasive. YYB

352. Avalokiteśvara

Japan. *c.*1920 (original 7th century AD)
Wood with pigments on a gesso ground. Height 3.1 m. Bought with contributions from Sir Percival David, Bt, the National Art-Collections Fund and Mrs Alexander White. OA + 8

The celebrated Kudara Kannon (Avalokiteśvara) in the Hōryūji temple, Nara, is called after the Korean kingdom of Paekche (Japanese Kudara) and has the 'archaic' smile and the treatment of drapery of early work made under Korean influence. Carved, like the original, by the *ichiboku zukuri* method, almost wholly out of a single block of camphor wood and hollowed at the back to prevent splitting, this is one of two copies made by Niiro Chūnosuke. VH

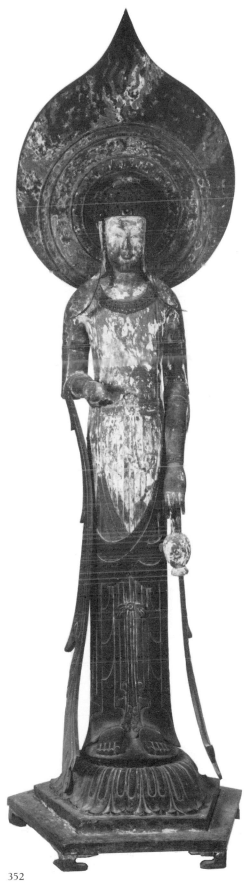

352

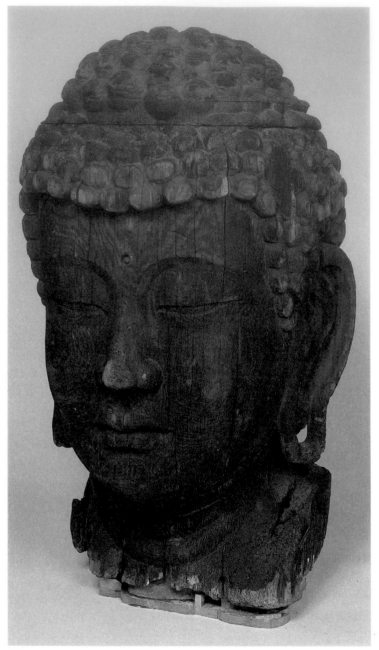

361

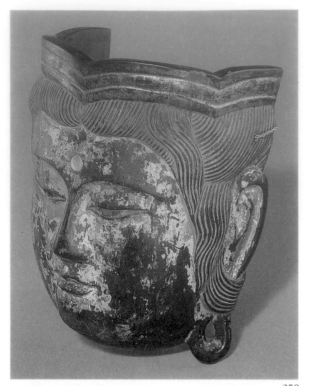

359

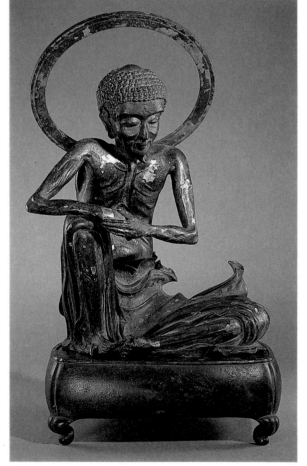

362

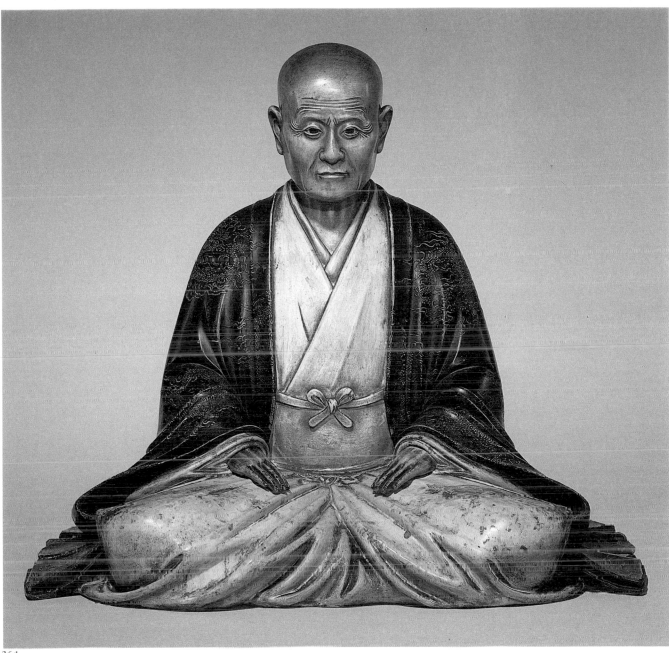

364

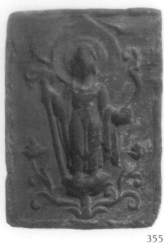
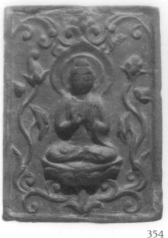

354 355

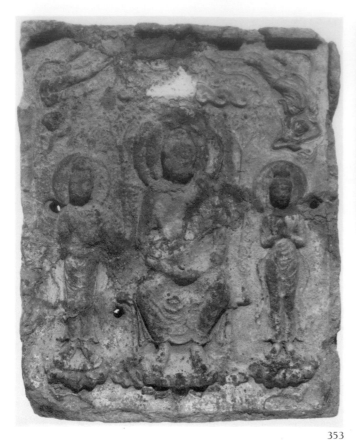

353

353. Plaque

Japan. 8th century AD

Eathenware. 23.8 × 18.9 cm. OA 1922.12–18.1

The practice of covering temple walls with figural plaques derives from China, and plaques like this example, excavated from early Nara temple sites, follow Chinese models very closely. Flanked by attendants, the Buddha sits on a canopied lotus throne before the Tree of Enlightenment while *apsarases* rain down flowers. VH

354. Plaque

Japan. 8th century AD

Earthenware. 6 × 4.3 cm. OA 1922.12–18.15

On this plaque from a temple wall the Buddha, seated on a lotus and flanked by lotus stalks, makes the preaching gesture.

VH

355. Plaque

Japan. 8th century AD

Earthenware. 6 × 4 cm. OA 1922.12–18.16

This temple wall plaque shows the Bodhisattva Kṣitigarbha (Jizō) standing on a lotus, holding the monk's staff and the wishing jewel that grants desires. The six rings on the staff can symbolise the six worlds of rebirth in which Kṣitigarbha is active as saviour. VH

356. Śrī

Japan. 11th century

Wood. Height 1.19 m. Bought from the Brooke Sewell Bequest. OA 1965.4–15.1

Śrī (Kichijōten), goddess of good fortune, sometimes shown with Vaiśravaṇa (Bishamon) either as consort or sister, was particularly associated with good harvests. As here, she usually wears the elegant robes of a lady of Tang China, crowned, with in one hand the wishing jewel and with the other making the gesture of liberality. The figure is partly restored.

VH

Illustrated on page 244

357. Acala

Japan. 12th century

Wood with traces of paint on a gesso ground. Height 1.08 m. OA 1961.2–20.1

Chief among the Vidyārājas (Myō-Ō), or personified spells and protectors of the Shingon sect, is Acala (Fudō or the Immoveable), whose attributes are a sword and rope. He symbolises spiritual steadfastness, and his fierceness his power to protect. The image is carved from one piece of wood with attached arms in the *ichiboku zukuri* technique prevalent until the 13th century. VH

Illustrated on page 244

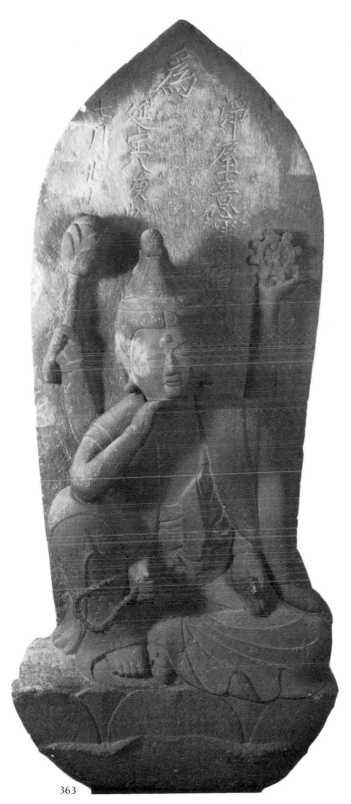

363

358. Amitābha

Japan. 13th century

Lacquered wood. Height 96 cm. Given by the National Art-Collections Fund. OA 1945.4–19.1

The *vitarka* gesture identifies this Amitābha (Amida), the principal deity in temples of the True Pure Land or Jōdo Shinshū sect, as welcoming the souls of the dead (Japanese *raigō*) into Sukhāvatī, or the Pure Land. The hollow image with its realistic drapery was made by assembling separately carved pieces of wood (the *yosegi zukuri* technique), and the crystal eyes were inserted from behind before the head was complete. VH

Illustrated on page 245

359. Bodhisattva mask

Japan. 13th century

Lacquered, gilt and painted wood. Height 23 cm. Bequeathed by Oscar Raphael, Esq. OA 1945.10–17.401

In the Gyōdō ceremony derived from Tang China priests wearing Bodhisattva masks parade images outside temples and are preceded by others wearing masks of mythical beings such as the lion-dog (*shishi*). Bodhisattva masks are particularly associated with *raigō* forms of these ceremonies, enacting the welcome of the dead into paradise. VH

Illustrated on page 248

360. Avalokiteśvara

Japan. 14th century

Lacquered and gilt wood enhanced with gilt bronze, crystal and stones. Height 87 cm. OA 1886.3–22.7

This Avalokiteśvara, in traditional posture as member of a triad welcoming the souls of the dead, is hollow, constructed by the *yosegi zukuri* technique. The decorative leaves, waves, linked swastikas and hatching of the robes are of gold foil widely used in Kamakura painting and sculpture. VH

Illustrated on page 245

361. Buddha

Japan. 15th–16th century

Wood with traces of gesso. Height 1 m. Bought with a contribution from the National Art-Collections Fund. OA 1950.10–25.1

From a considerably over life-size figure, probably seated, this head has an unusually long face and marked emotional individuality of expression. VH

Illustrated on page 248

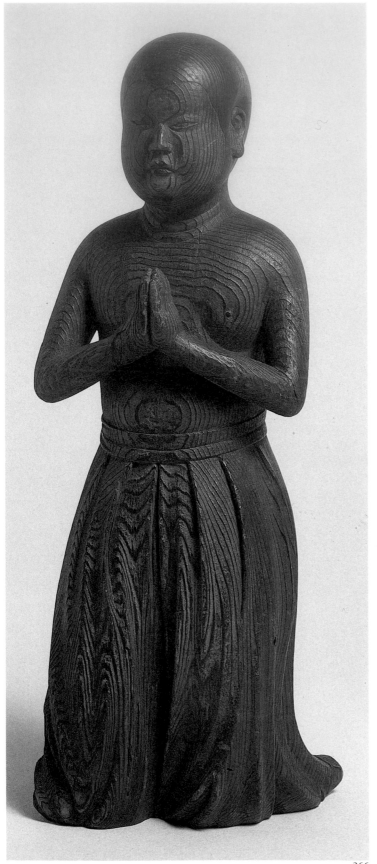

366

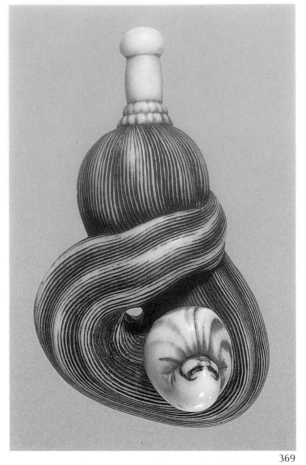

369

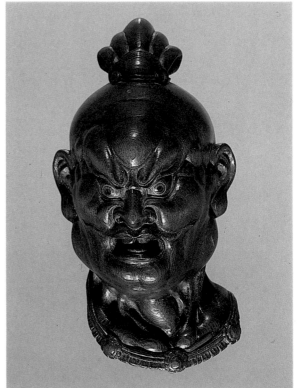

370

372

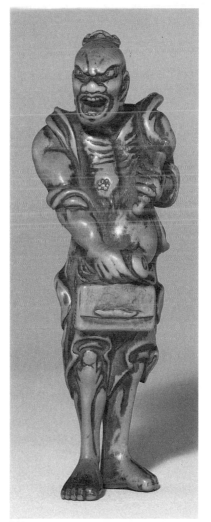

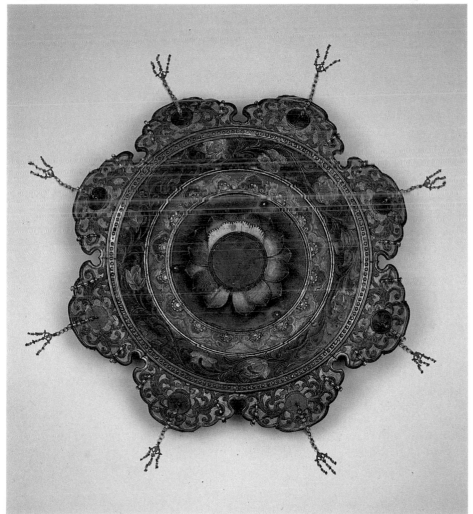

368

373

362. Emaciated Śākyamuni

Japan. 1630

Signed Minamoto Masakatsu. Bronze, gilt and lacquered.
Height 37.8 cm. Given by Sir A.W. Franks. OA 1891.9–5.20

With the economic decline of the Buddhist temples in the Edo
period the production of large metal sculpture diminished,
but small images were still made. According to the inscribed
base, this image, commissioned by Jōkaku, third abbot of the
Mankōji temple, was consecrated on 15 February 1630, when
the Buddha's death is commemorated. The dull lacquer over
the gilding represents the tradition that when an ascetic his
golden skin turned dark. VH

Illustrated on page 248

363. Cintāmaṇicakra

Japan. 1674

Stone. Height 1.43 m. Victoria and Albert Museum (A 125–1920)

This form of Avalokiteśvara (Japanese Nyoirin Kannon) is
called after the wishing jewel (*cintāmaṇi*), and the Wheel of
the Doctrine (*cakra*), his two principal attributes. The inscrip-
tion is dated the equivalent of 2 July 1674 and gives the
kaimyo or Buddhist name of the deceased as Jōyai Seishin [no]
Jo, a lady. Characters used in writing the name could indicate
that she belonged to the Pure Land sect. The stele would have
been erected in a temple precinct. VH

Illustrated on page 251

364. Portrait

Japan. *c.*1700

Lacquered and painted wood. Height 41.5 cm. Given by
Sir A.W. Franks. OA 1885.12–27.98

This realistic portrait is probably of a respectable townsman
and merchant who became a Buddhist lay follower while
continuing his secular activities. Priestly portraits of such
people helped to preserve the integrity of their family and its
Buddhist traditions. VH

Illustrated on page 249

365. Sesshū Tōyō

Japan. 1788

Signed Miwa. Painted wood. Height 23.5 cm. OA 1981.6–12.1

Sesshū (1420–1506) was perhaps Japan's greatest painter. His
ordination as a Zen monk occurred when Zen Buddhism was
the main force behind traditional schools of painting, poetry,
fencing, the Nō theatre, flower arrangement and the Tea
Ceremony. He painted largely landscapes in the Song style,
and gained recognition in China while perfecting his art in
Tiantong monastery. VH

365

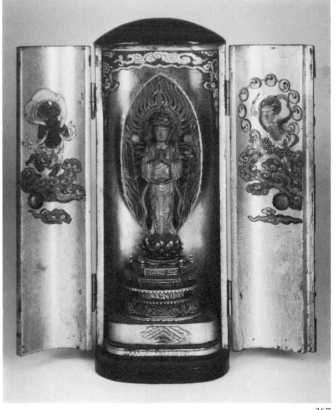

367

366. Shōtoku Taishi

Japan. 18th century

Wood. Height 28.8cm. Given by H. Turner, Esq. OA 1944.10–19.1

The Prince Regent Shōtoku (AD 574–622), promulgator of Buddhism and skilled in secular affairs, has attracted many legends; he could speak at birth, recite *mantras* in childhood, perform acts of wisdom and piety, and was worshipped as an emanation of Avalokiteśvara. He is variously represented – as a child, as a young adult praying for his father's recovery, and as the adult regent. The *Namu Butsu* (Hail to the Buddha) representation, as a child reciting *mantras*, has been popular since the Kamakura period and this image copies 13th-century Kamakura work. VH

Illustrated on page 252

367. Shrine

Japan. 18th century

Lacquered wood with metal fittings. Height 16.3cm. Given by Rev. C.J. Roffe Silvester. OA 1921.3–7.13

Image shrines, or *zushi*, vary in shape and size and can even contain texts. The deity here is the Thousand-armed Eleven-headed Avalokiteśvara (Senju Jūichimen Kannon) whose attributes emphasise his compassion and power to save. The figures painted on the shrine doors are (left) the Wind God (Fūden) and (right) the Thunder God (Raiden). VII

368. Netsuke

Japan. 19th century

Signed Shūzan. Wood. Height 12.3cm. Bequeathed by Oscar Raphael, Esq. OA 1945.10–17.648

Netsuke, the decorative toggles used to suspend pouches and other objects from the belt, were an important manifestation of Edo-period craftsmanship. This example shows a Niō, or guardian, traditionally one of a fierce pair flanking temple gates. The humorous treatment with pipe and tobacco pouch represents a secularisation particularly marked with minor deities. VH

Illustrated on page 253

369. Netsuke

Japan. 19th century

Ivory. Length 15.2cm. OA 874

Bodhidharma (Japanese Daruma) is the Indian reputed to have brought Zen to China. During a nine-year-long meditation his legs rotted away and he cut off his eyelids to avoid falling asleep. This accounts for the staring eyes and the heavy legless base of this figure represented as a toy, for here too secularisation has taken over and the Daruma doll is a universal mascot. He sits on a priest's flyswitch. VH

Illustrated on page 252

370. Netsuke

Japan. 1910

Signed Kōseki. Height 9.3cm. Bequeathed by Oscar Raphael, Esq. OA 1945.10–17.530

This mask of a Niō, or temple gate guardian, is by an artist who specialised in Buddhist subjects like the following shrine. It was made for the testator. VH

Illustrated on page 252

371. Shrine

Japan. *c.*1920

Inscribed as carved by Kōseki and lacquered by Komatsu. Lacquered wooden shrine and carved sandalwood figures. Height 11.5cm. Bequeathed by Oscar Raphael, Esq. OA 1945.10–17.488

Amitābha is flanked in this miniature shrine by the Bodhisattvas Avalokiteśvara and Mahāsthāmaprāpta (Seishi). Avalokiteśvara offers a lotus with three wishing jewels, while Mahāsthāmaprāpta is in adoration. Such shrines have Tang antecedents; several Chinese examples survive in Japanese collections and must have served as models. VH

Illustrated on page 258

372. Ritual box

Japan. 15th century

Wooden box covered in gilt copper, lacquer and textile. 33.9 × 29.5cm. Bought from the Brooke Sewell Bequest. OA 1968.2–12.1

Ritual boxes, or *suebako*, occurred in pairs, containing documents and implements used during ceremonies, and before the Muromachi period were of different sizes. This is the lower of a two-tier set; the copper sheeting over the wooden box has pinned to it decorative lotuses; other boxes have designs including phoenixes, the Wheel of the Doctrine and crossed *vajras*. Inside the box is lacquered and covered in textile. VH

Illustrated on page 253

373. Canopy

Japan. 15th-16th century

Painted wood edged in gilt copper with crystal pendants. Diameter 61cm. Bought from the Brooke Sewell Bequest. OA 1967.2–20.1

The Japanese canopy, or *tengai*, derives from the Indian royal parasol placed above the Buddha and other figures in sculpture and painting; Central Asian fragments in textile have been found at Dunhuang. In Japan it hangs from temple ceilings over Buddha and Bodhisattva images. Usually of painted wood in a metal frame, it can be carved with elaborate openwork. Forms of the canopy are used in the esoteric Kanjō initiation ritual derived from Indian consecrations (*abhiṣeka*) involving lustration from the cardinal points. VH

Illustrated on page 253

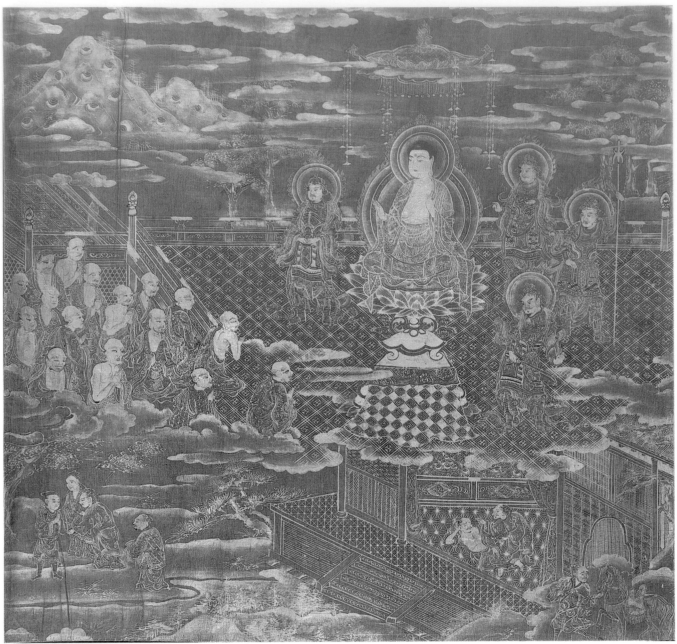

378

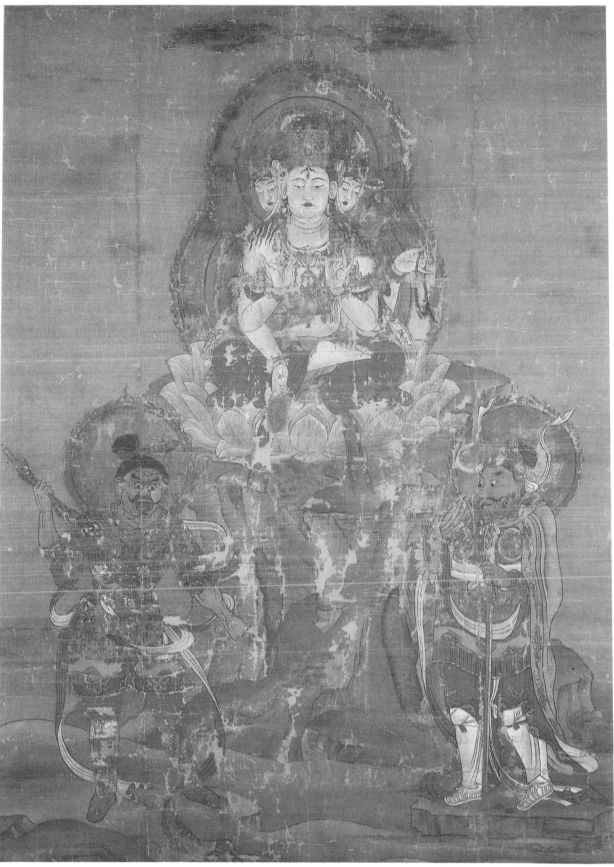

379

371

374

374. Sword blade

Japan. *c.*1600

Signed Nantō jū Kanabō Hayato Rai Masazane. Steel.
Max. length 82 cm. Bequeathed by R.W. Lloyd, Esq.
OA 1958.7–30.84

Up to the Edo period *samurai* religious beliefs were illustrated
on sword blades by carved Chinese and Sanskrit invocations,
Buddhist implements and deities. This blade shows Acala; the
impassivity behind his ferocious aspect was the spiritual
attitude to which swordsmen aspired. On the reverse is the
invocation *Namu Amida Butsu* (Homage to Amitābha).
Buddhist, especially Zen, concepts are still realised by means
of ritual sword exercises. VH

375. Vajras and ghaṇṭā

Japan. 19th century or earlier

Gilt bronze. Max. length of *vajras*: 15.3, 14.3, 13.9 cm; height of
ghaṇṭā 19.3 cm. OA 1885.12–17.57, 58; 1906.2–9.1; 1893.7–8.1

In Japanese Tantrism three varieties of *vajra*, or *kongōsho*, and
a *ghaṇṭā*, or *kenchi*, form a ritual assemblage. The single-
pronged *vajra* represents non-duality, the three-pronged the
triple concept of Buddha, lotus and *vajra*, and the five-
pronged variety Five Wisdoms and Dhyāni Buddhas. The
ghaṇṭā symbolises the connection between the phenom-
enal (*garbhadhātu*) and ultimately real (*vajradhātu*), its sound
standing for the illusory nature of the former. This group is
used ritually when *mudrās* are performed, accompanying
sūtra readings, and the five-pronged *vajra* consubstantiates
the practitioner in Buddhahood. VH

258

375

376

376. Alms bowl

Japan. Date uncertain

Lacquered iron. Diameter at rim 18.3 cm; height 13 cm.
OA 1892.4–18.1

The alms bowl is, in Japan, still one of the traditional possessions of the monk. Bronze bowls are reserved for altar use and iron or ceramic bowls to gather alms for the monastery.

VH

377

377. Heart Sūtra

Japan. *c*.1200

Manuscript of the *Prajñāpāramitāhṛdayasūtra* in Chinese with one illustration. Gold ink on dark blue paper. 1 roll. 26 cm × 2.55 m. OA 1966.12–12.01

The illustration shows the Buddha in paradise with Bodhisattvas, attendants and musicians. The two devotees arriving by boat possibly represent the donors who would have commissioned this copy for donation to a temple. VH

378. The Lotus Sūtra, chapter 8

Japan, probably Kyoto. Mid-17th century

Manuscript of Myōhō rengekyō: gohyaku deshi jukihon. Gold ink on indigo paper with illuminated frontispiece. Random gold leaf decoration on borders; gold stencil designs on reverse. Brocade endpiece, gilt metalwork on both ends of roller bearing Shogun Tokugawa's family crest. 1 roll. 28 cm × 3.77 m. Or. 13926

This lavishly ornamental scroll carried on the tradition of decorative *sūtra*-copying from the Heian period (see no. 377). Although without colophon, this is believed to be part of a set of thirty-three scrolls of the *Lotus Sūtra* commissioned by the retired Emperor Go-mizunoo (1596–1680) in memory of his grandfather-in-law, the first Shogun Tokugawa Ieyasu. Known as *Nikkō kuyō-kyō*, this set was originally dedicated to Ieyasu's mausoleum, the Nikkō Shrine where most of the scrolls are still kept. The meticulous style of painting suggests that this was a work of the Imperial Painting Bureau of the Tosa school. The frontispiece represents two themes: Śākyamuni granting promises of Buddhahood to his disciples (top); and a parable narrating how a poor man lived in poverty without

377

378

knowing that he possessed a precious jewel (an allusion to the *Lotus Sūtra*) which a compassionate friend had secretly sewn into his garment the night before he set out on his journey (bottom section). YYB

Illustrated on pages 22, 256, 261

379. Amoghapāśa

Japan. 13th century
Hanging scroll. Painted on silk. 1.23 m × 87.4 cm. OA 1967.2–13.02.

The Bodhisattva Fukukenjaku, a form of Avalokiteśvara worshipped since the 6th century in Japan, corresponds to the Indian Amoghapāśa. Described in a text of AD 709, he occurs in various forms, the commonest with four arms. With his characteristic attribute, the noose, he implements his vow to save all beings; both in Japanese and Sanskrit his name means that the noose is always effective. The two attendants, Vaiśravaṇa (right) and Vajrapāṇi (Shitsu Kongōjin) on the left, are stylistically close to the clay attendants on the dry lacquer standing Amoghapāśa in the Hokedō of the Tōdaiji temple where this painting probably originated. The simple vivid colouring is characteristic of Nara painting. VH

Illustrated on page 257

380. Death of the Buddha

Japan. 13th century
Hanging scroll mounted flat. Ink, colours and gold leaf on silk. 2.26 × 1.55 m. OA 1881.12–10.7

On the fifteenth day of the second month paintings of the Buddha's death are hung in temples at commemorative ceremonies. The Buddha is traditionally depicted among trees surrounded by mourners. Peculiarly Japanese is the arrival of his mother Māyā with attendants at the top. This considerably restored painting displays 13th-century compositional characteristics and stylistic affinities with Song China. The gold leaf on the Buddha's robes and the gold dust on the Bodhisattvas' faces supported by the white pigment behind the silk are also 13th-century features. VH

Illustrated on page 262

261

382

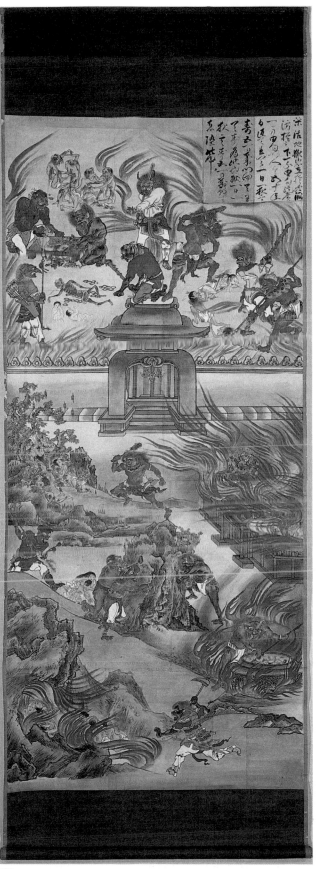

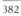

381

381. Hell

Japan. Late 18th century (original 13th century)
Hanging scroll. Ink and colours on paper. 1.52 m × 70 cm.
OA 1881.12–10.69

Belief in the horrors and sufferings of rebirth in the six worlds characterised Pure Land teachings of the Kamakura period. This scene in hell is copied from one of fifteen vivid paintings in the Seishū Raigōji temple, which include scenes of infernal torments and a judgement before Yama (Emma-Ō), god of the dead, in the presence of the Pure Land saviour Kṣitigarbha.

VH

Illustrated on page 263

382. Rāga

Japan. 13th-14th century
Hanging scroll. Ink, colours and gold leaf on silk. 85.8 × 46.9 cm.
OA 1913.5–1.02

One of the Vidyārājas, also called Kings of Light in the Shingon sect, Rāga (Aizen), whose image was first brought from China by Kōbō Daishi in the 8th century, is red with glaring eyes and carries a *vajra*, lotus bud, bow and arrow, bell and Wheel of the Doctrine. He has a leonine beast (*shishi*) in his crown and sits on a treasure vase (*hōbyō*). He represents passion (*rāga*) utilised as a means of salvation. The faded inscription at the top is the Nichiren sect invocation *Namu Myōhō Rengekyō* (Hail to the *Lotus Sūtra*), added later. VH

Illustrated on page 263

383. Kasuga maṇḍala

Japan. 14th century
Hanging scroll. Ink and colours on silk. 1.3 m × 34.9 cm.
OA 1961.4–8.02

Interaction between Buddhism and the native Shintō resulted in the *honji suijaku* concept by which Shintō and Buddhist deities were identified with each other. The Fujiwara clan's ancestral Kasuga shrine, established in AD 709 adjacent to the Buddhist Kōfukuji temple at Nara, has five Shintō deities which were equated with the five Kōfukuji deities, and the cult survived the decline of the Fujiwara. This *maṇḍala* shows the shrine buildings against mountains with bands of mist symbolising its holy aura. The Buddhist deities at the top, counterparts of those in the four main Kasuga buildings and the later Wakamiya shrine, are repeated below with other deities and guardians. VH

Illustrated on page 266

384. Amitābha trinity

Japan. 14th century
Hanging scroll. Ink, colours and gold on silk. 1.32 m × 58.5 cm.
OA 1913.15–1.02

Amitābha is flanked by Avalokiteśvara and Mahāsthāmaprāpta welcoming the dead into the Pure Land. Avalokiteśvara offers the lotus on which the believer was to be reborn, while Mahāsthāmaprāpta stands in adoration. The attraction of such paintings lay in the simple devotional Pure Land beliefs, as contrasted with the complexities of other sectarian positions, and they were commonly hung beside the dying. This painting has been attributed to the Chinese expatriate artist Zhang Sixun whose name is written on the back. VH

Illustrated on page 266

385. Kṣitigarbha

Japan. 14th century
Hanging scroll. Ink, colours and gold leaf on silk. 1.35 m × 40.5 cm.
OA 1967.6–19.05

Kṣitigarbha (Jizō) stands holding his monk's staff and the wishing jewel. The five Buddhist counterparts of the Shintō gods of the Kasuga shrine, shown above, make this a painting of the mixed Pure Land-Shintō cult associated with that shrine. Specifically Kṣitigarbha corresponded to the deity of the Kasuga Sanden building but later represented the whole complex. Kṣitigarbha's Pure Land associations make this a *raigō* painting in which he welcomes the dead into paradise. VH

Illustrated on page 267

386. Jion Daishi

Japan. 14th century
Hanging scroll. Ink and colours on silk. 1.31 m × 59 cm.
OA 1964.7–11.01

The Chinese monk Kuiji, known in Japan as Jion Daishi (AD 632–82), translated texts into Chinese and wrote 120 commentaries. Founder of the Faxiang (Japanese Hossō) sect and particularly venerated from the 11th century onwards, he is commemorated annually at the Jion-e ceremony when his portrait is displayed. Of striking appearance identifiable from earlier portraits based on Chinese originals, he wears a voluminous stole draped in a relaxed manner suggesting saintly magnanimity. The text at the top is biographical. VH

Illustrated on page 267

387. Shōtoku Taishi

Japan. 14th century
Hanging scroll. Ink and colours on silk. 1.05 m × 52 cm.
OA 1961.4–8.01

In this painting the sixteen-year-old prince, carrying a long-handled censer, prays for the recovery of his sick father, the Emperor Yomei. The subordinate representation of his attend-

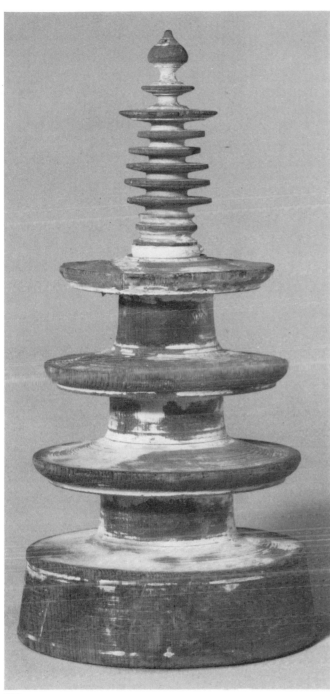

390

ants, though in the court costume of Shintō portraits, suggests Buddhist attendants, and the gentle treatment of the prince his status as an emanation of Avalokiteśvara. VH

Illustrated on page 274

388. Life of Shōtoku Taishi

Japan. 16th century
Part of a handscroll. Ink and colours on paper. 32.5 × 53.5 cm.
OA 1931.11–16.01

Two scenes from a handscroll life of Shōtoku Taishi depict (left) the thirty-five-year-old prince lecturing amidst a shower of lotus petals on the *Shomangyō (Queen Śrīmālā's Sūtra)*, a text of One-Vehicle teaching, and (right) a scene from the prince's childhood captioned 'six-year-old prince'. This may refer to the gift of *sūtras* from Paekche in Korea, with whose help the seven-year-old Shōtoku tried to persuade the Emperor Bidatsu to institute days in each month on which it was forbidden to kill animals. This scroll is unusual in showing scenes out of chronological sequence. VH

Illustrated on page 270

389. Legend of the long-nosed goblins

Western Japan. Early 17th century
Illustrated manuscript (*Nara ehon*) of *Tengu no dairi* in colour, decorated with gold leaf, probably executed by monks. 2 rolls.
OMPB Or.13839

The Tengu are mythical forest dwellers, with red faces and noses of inordinate length. According to folklore, they wilfully broke the Buddha's precepts and therefore belong neither to heaven nor hell, and so could fly unhindered between the two realms. The manuscript recounts a fantastical flight in the company of King Tengu by Minamoto-no-Yoshitsune (1159–98), one of the most popular warriors of medieval Japan. This torture scene in the Hell of the Blood Pond is based on an apocryphal *sūtra* in which women are warned of being forced by demons into the ghastly pond because of their sins on earth. YYB

Illustrated on page 271

390. Stūpa

Western Japan. 8th century
Wood with traces of gesso. Height 21.2 cm. Given by the Hon. Mrs Walter Levy. OA 1930.4–24.1

This is one of a million miniature *stūpas* or pagodas for *dhāraṇīs* commissioned by the Empress Shōtoku in thanksgiving for the suppression of the Emi rebellion of AD 764. 100,000 were made for each of the ten greater monasteries. VH

383

384

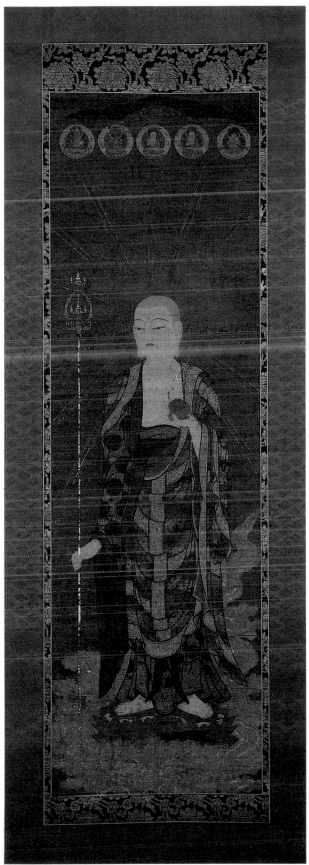

385

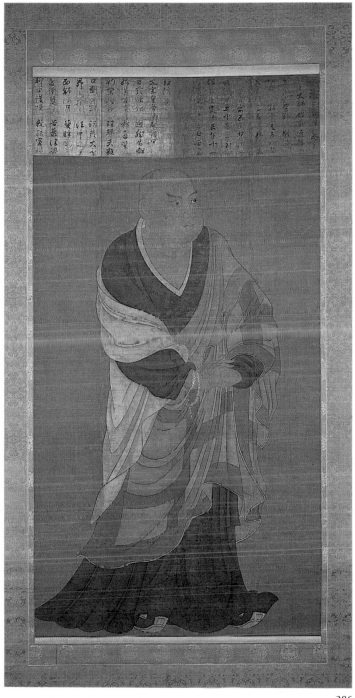

386

391. The million charms of Empress Shōtoku

Western Japan, Nara. AD 764–70

4 *dhāranī*, block-printed, probably from metal plates on small strips of paper. 47.3 × 5.5cm; 36.2 × 5.5cm; 40.4 × 5.6cm; 24 × 4.9cm. OMPB Or. 78. a.11

Between 764 and 770 Empress Shōtoku ordered a million copies of four *dhāraṇīs* to be printed. They were placed inside miniature wooden pagodas (no. 390) and distributed to ten leading monasteries in western Japan. The texts, from the *Vimalanirbhāsasūtra* (Japanese *Mukujōkō-kyō*), are in Sanskrit, transcribed into Chinese script, the only script known in 8th-century Japan. Among the few complete surviving copies are a 'standard' and a 'variant' form. The four variant forms are shown here; the standard forms are on display in the British Library's standing exhibition in the King's Library.

These are the oldest printed documents produced in Japan. With the possible exception of a single block-printed *dhāraṇī* discovered in 1966 at the Pulguk temple in Korea, perhaps printed before AD 751, they can claim to be the earliest printed documents of confirmed date so far discovered. KBG

Illustrated on page 270

392. Buddhas

Japan. 12th century

Woodblock print. 42.8 × 29.6 cm. OA 1958.10–11.025

This sheet of Amitābha figures printed in blocks of twelve is identical with sheets printed from the same block and found sealed, as was customary, inside an Amitābha at the Jōryūji temple of 12th-century date. VH

393. The Lotus of the Good Law

Japan, Nara or Kyoto. Late 12th–early 13th century

Saddharmapuṇḍarīkasūtra (Myōhō rengekyō), woodblock print on paper. Vol. 8, sections 25, 27, 28. 27.5 cm × 7.7 m. OMPB Or.64.b.34

This fine copy of the *Lotus Sūtra* is printed in an elegant style of script notable for the graceful roundness and lightness of touch in the shape of the engraved Chinese characters, and contrasts sharply with the dense, square and monumental style of much Buddhist printing of the Kamakura period (no. 73).

The roll is not dated but it may be attributed to the beginning of the Kamakura period. The text is printed on strong, white *gampi* paper of high quality, treated with a light sprinkling of mica dust, and ornamented with gold borders. The lines of text are separated by gold rules. The protective paper at the beginning of the roll, contemporary with the printed text, is decorated with patterns of gold and silver foil on both sides. KBG

392

妙法蓮華經觀世音菩薩普門品第二十五　八
尒時無盡意菩薩即從座起偏袒右肩合掌
向佛而作是言世尊觀世音菩薩以何因緣
名觀世音佛告無盡意菩薩善男子若有無
量百千萬億衆生受諸苦惱聞是觀世音菩
薩一心稱名觀世音菩薩即時觀其音聲皆
得解脫
若有持是觀世音菩薩名者設入大火火不
能燒由是菩薩威神力故若為大水所漂稱
其名号即得淺處若有百千萬億衆生為
求金銀瑠璃車磲馬瑙珊瑚琥珀真珠等寶
入於大海假使黑風吹其舩舫飄墮羅刹鬼
國其中若有乃至一人稱觀世音菩薩名者
是諸人等皆得解脫羅刹之難以是因緣名
觀世音

393

大般若波羅蜜多經卷第三十四
畢竟不可得性非有故況有預流果我无我
增語及一來不還阿羅漢果我无我增語此
增語既非有如何可言即須流果若我无
我增語是菩薩摩訶薩即一來不還阿羅漢
果若我无我增語是菩薩摩訶薩

為先師成遍出離辯脫門弟合力敎奉殿當卷樓章
于時嘉祿三年丁亥三月九日釋永全記之

394. The Perfection of Wisdom in 600 maki

Japan, Kōfukuji temple, Nara. 1227

Dai hannya haramitta-kyō (Mahāprajñāpāramitāsūtra), woodblock print on a mixture of *gampi* and mulberry paper dyed yellow. 1 roll, 34th *maki* (of 600). 24 cm. × 9.2 m OMPB Or.64.b.6

Despite its length, this *sūtra* was frequently printed, often with a frontispiece (see no. 99), probably because as a non-sectarian basic work, it was universally popular. Its length also made it most suitable for printing passages chosen by devotees. The present edition of the Karoku era (1225–7) constitutes the single greatest printing venture ever undertaken by the Kōfukuji, a wealthy temple affiliated to the ruling Fujiwara family. Early editions printed there are known as *Kasuga-ban* after the Fujiwara shrine of the same name. This superb edition reproduces the bold brush strokes of the Chinese script in glossy jet-black ink. Shown here is the colophon of the thirty-fourth *maki*, one of the very few to bear a printed date, i.e. Karoku 3 (1227).　　YYB

394

388

391

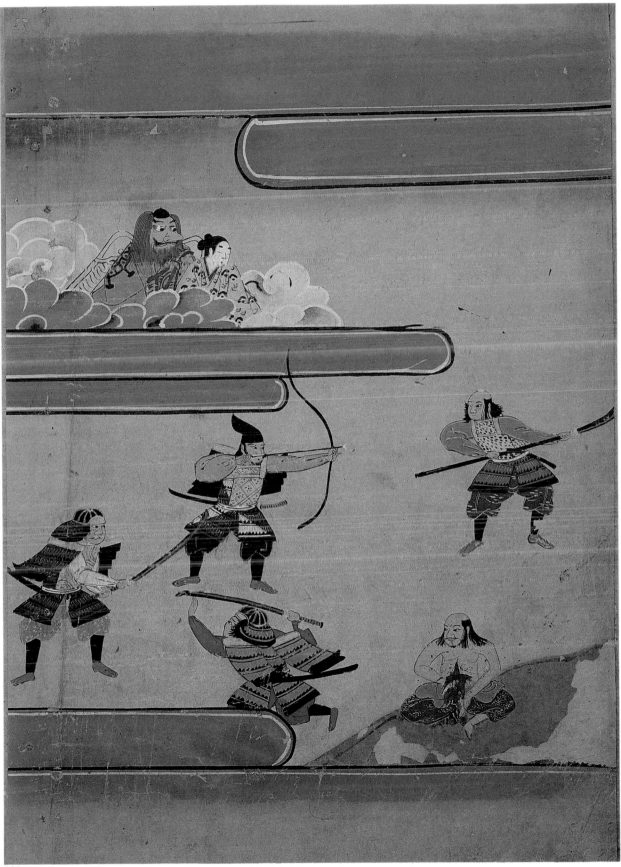

389

395. The secret of the thunderbolt realm

Western Japan, Mt Kōya. 1279

Kongōchō issai nyorai shinjitsushō daijō genshō daikyōōkyō (Sarva-tathāgatatattvasamgrahanāmamahāyānasūtra), woodblock print on greyish re-cycled paper composed of mixed *gampi* and mulberry fibres; 3 vols bound in *detchō* style. 26 × 16 cm. OMPB Or.81.c.10

Though geographically remote, Mt Kōya became a thriving centre of Shingon printing from the 1250s for over six centuries, thanks to the continuing patronage of the ruling military aristocracy. The text, one of the three basic esoteric scriptures introduced by Kūkai from China in the 8th century, was printed at the Kongōbuji, his chief monastic foundation. The colophon states that this edition was commissioned by the Buddhist layman Adachi Yasunari, formerly a noted warrior of the Kamakura Shogunate and renowned as a leading patron of Buddhist printing. The quality of the block-cutting, inking and press-work make this an outstanding example of Mt Kōya printing. YYB

396. Commentary on a basic Tendai scripture

Japan, monastery on Mt Hiei, near Kyoto. 1281–6

Hokke gengi shakusen, woodblock print on mixed *gampi* and mulberry paper bound in *detchō* ('butterfly') style with original dark brown covers. 25.6 × 16 cm. OMPB Or.81.c.9

A rare example of an *Eizan* (or *Hieizan*) edition, part of the first and largest printing exercise ever undertaken by monks of Mt Hiei, printed at the huge Tendai monastic complex there. 150 volumes of Buddhist scriptures were printed between 1278 and 1296. This commentary by the monk Zhanran on a Chinese doctrinal work, *Fa hua xuan yi* by Zhiyi, founder of the Tiantai sect in China, explains the teachings of the *Lotus Sūtra*. This edition was commissioned by a high Buddhist dignitary named Shōsen. The calligraphers responsible for the manuscripts from which the blocks were engraved are also named. To aid Japanese readers with the Chinese text handwritten reading marks have been added. KBG

Illustrated on page 275

395

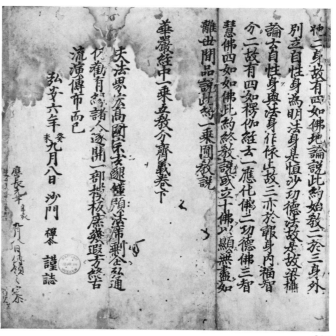

397

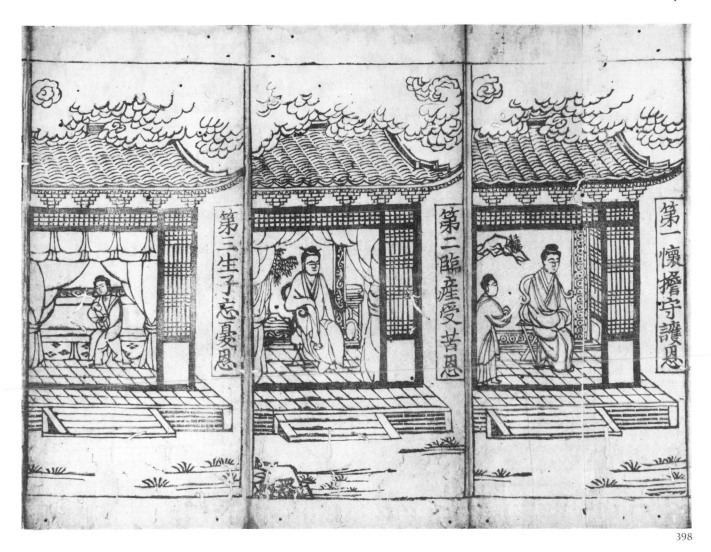

398

397. Treatise on the One-Vehicle Doctrine

Japan, Tōdaiji temple, Nara. 1203

Kegon gokyō-shō, woodblock print on a mixture of *gampi* and mulberry paper. 1 folding vol. 28 × 10 cm. OMPB Or.74.cc.10

Tōdaiji printing was greatly stimulated by Kōfukuji, the earliest of the six temples in Nara to have printed on a large scale. While Kōfukuji monks concentrated on Hossō works, Tōdaiji, the leading state temple, was the centre of Kegon printing. This introduction to the *Avataṃsakasūtra* of the Kegon school was printed in Kōan 6 (1283) on the authority of Zenji, a disciple of the abbot Gyōnen who established the sect at Tōdaiji. Among the few surviving copies, this is of special interest being the one used by Zenji's disciple, Kanji, when lecturing, and contains his handwritten endnote and reading marks. YYB

398. Non-canonical sūtra on filial piety

Japan, probably Kyoto. Mid-14th century

Bussetsu daihō bumo onjūgyō, woodblock print. 1 folding vol. 24.5 × 11 cm. OMPB Or. 64. b. 17

The earliest Japanese sects reproduced texts to gain merit or for monastic use. The rise of later, more popular sects, however, eager for a wider appeal, inspired a functional role for the illustrated book. One of the most copiously illustrated early Buddhist works, it was printed by a Zen temple and contains twenty illustrations – ten of children's debts towards their parents and ten of punishment for breaches of filial duty. For a Korean example see no.104. YYB

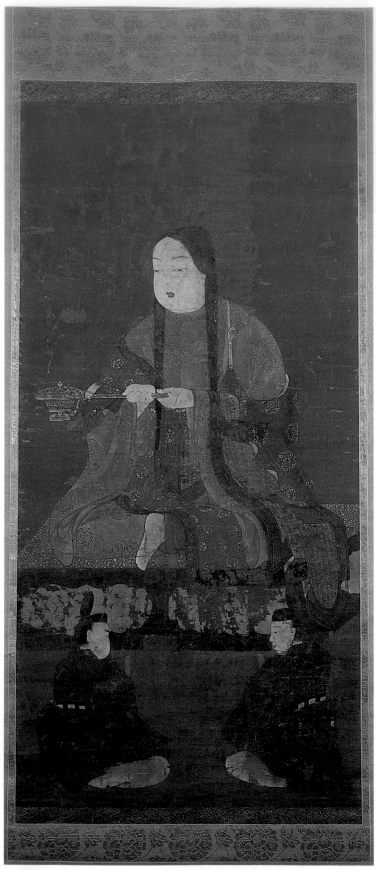

387

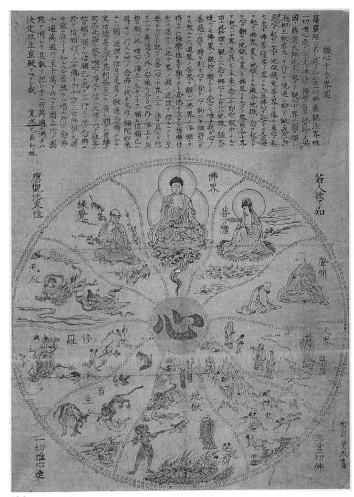

406

396

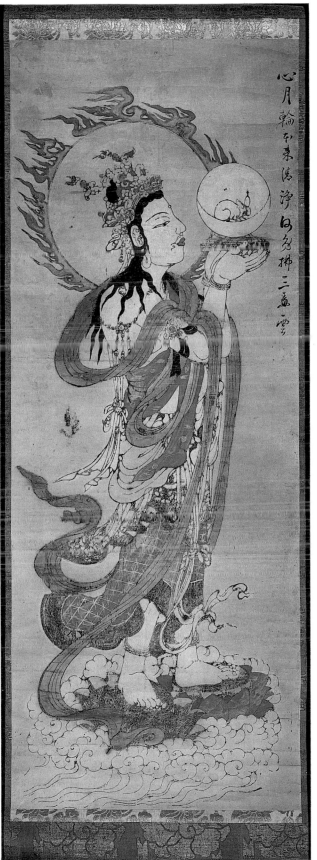

400

275

399

399. Zen view of the nature of life

Japan, probably Rinsenji temple, Kyoto. 1358

Zengen shosen-shū tojo, woodblock print on mulberry paper. 1 vol. bound in *fukurotoji* style. 25 × 18 cm. OMPB 15103.b.5

Books printed by two separate groups of Zen temples in Kamakura and Kyoto from the late 13th century to *c*.1590 are called *Gozan-ban* (Five Monasteries imprints). Most followed Chinese exemplars in the Song and Yuan tradition with a uniform printing style; and the wholesale application of the 'thread-bound' technique fixed the format of Japanese books for the next 500 years. Moreover, the *Gozan-ban* were the first to include topics not related to Buddhism.

This edition of the introductory text to the synthesis of Zen with Kegon doctrines is a typical yet outstanding example of *Gozan-ban*. One of two extant copies, it bears the personal seal of the eminent monk Tenkai (1536–1643). YYB

400. The Moon Goddess

Japan, Yota temple, Kagawa prefecture. 1407

[*Gatten zuzō*], woodblock print on paper. Outline and black areas block-printed, colours applied by hand. Mounted as a hanging scroll. 1.09 m × 41 cm. OMPB Or.80.c.2

One of the great landmarks in Japanese block-printed Buddhist iconography, this is one of a set of twelve large prints representing the Guardian Deities, of both Chinese and Japanese iconography, commissioned by Zōun, abbot of the Kokūzōin or Yota temple in the island of Shikoku, and dedicated to the temple. This print is not dated but that representing Brahmā (Japanese Bonten) bears a printed colophon naming the printer and block-cutter, Shōyū, and dating the whole set clearly to the twenty-first day of the third month, 1407.

The goddess holds an orb representing the moon, containing the crouching hare, traditionally associated in Eastern mythology with the moon. KBG

Illustrated on page 275

401. Japanese doctrine of the Pure Land sect

Western Japan. 1419

Kimyō hanganshō, woodblock print in mixed Chinese characters and Japanese *hiragana*. Vol. 2, 26 leaves bound in *fukurotoji* style. 26 × 20.4cm. OMPB Or. 64. b. 19

This work aimed to interpret simply the Pure Land (Jōdo) doctrine of salvation through invocations to Amida Buddha. The author, Shōken (1263–1345), is said to have written it after a dream about a discussion between Amida and Gautama Buddha. This is the second oldest known work to be printed in the script commonly used for Japanese today – a mixture of Chinese characters and the native *kana* syllabic script. A manuscript note attributes the publication to the twenty-sixth year of the Ōei period (1419), and external evidence supports this. No other copies of this edition have yet been found. Until its discovery the earliest known edition was that of 1649. KBG

402. Introduction to the doctrine of the Nichiren sect

Japan, Honkokuji temple, Kyoto. 1595

Hokke gengi-jo, printed from movable type on mulberry paper sprinkled with mica. 1 folding vol. 29 × 9cm. OMPB Or. 75. b.1

Introduced to Japan from Korea during Toyotomi Hideyoshi's invasions (1592–8), movable-type printing was adopted by the Emperor and rapidly spread into official, religious and secular use. It provided Buddhist printing with a fresh impetus before its suppression by secular publishers. This edition was printed by a priest at the Honkokuji temple of the Nichiren sect. Together with another work from that temple of 1575, it survives as the earliest Buddhist movable-type printing in Japan and was probably the first scripture printed by that sect. YYB

403. Guide to places of interest in Kyoto

Japan, Kyoto. 1658

Kyōwarabe, woodblock print with *sumizuri* illustrations. 6 vols. 29 × 17cm. OMPB 16107.g.36

From the mid-17th century gazetteers known as *meisho-ki* (records of famous places) were produced commercially for pilgrims and travellers. This work by the physician Nakagawa Kiun (1638–1705) is the first of its kind. Although the artist is unknown, the realistic portrayal of contemporary life shows traces of the early influence of *ukiyo-e* (pictures of the floating world), a school of Japanese art famous in the West. This picture shows two easy-going pilgrims touted by tea-house girls outside the temple gate, with the guardian deities looking suitably scandalised. YYB

Illustrated on page 280

401

402

415

416

高祖御一代略圖 〔印〕佐州流刑南田假名書目

417

高祖御一代略圖 〔印〕佐州塚原室中

418

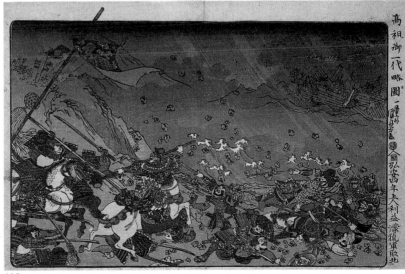

高祖御一代略圖 一勇齊國芳畫〔印〕弘安四年夫利益濛瑣軍敗北

419

さるゑうりやかだし

404

404. Pilgrimage to the six temples of Amitābha

Japan, Edo. Mid 17th century

Roku amida denki, hand-coloured woodblock print with *sumizuri* illustrations. 6 vols. 27 × 18 cm. OMPB 16006.e.39

Improvements in economic conditions during the Edo period, together with development of communications, enabled farmers and merchants to participate in pilgrimages hitherto the preserve of the upper class. This collection of anecdotes on the spiritual efficacy of a pilgrimage to the Amida temples was one of the earliest published in the expanding new capital of Edo. The double-page opening depicts, from right to left, *samurai* bidding farewell to guardian gods at the temple gate; an elderly couple arriving; and a group of pilgrims invoking the name of Amida, while a monk serves tea. YYB

405. Illustrated biography of Kūkai

Western Japan. Mid 17th century

Kōya Daishi gyōjō zuga, woodblock print with *sumizuri* illustrations. 10 vols. 28 × 20 cm. OMPB 16006.e.35

Kūkai (774–835), the founder of the Shingon sect, known honorifically as Kōbō Daishi or Koya Daishi, is a national cult figure adored as saint, scholar, poet, painter and calligrapher. This is one of several codex editions reproduced in the Edo period from a 16th-century printed scroll illustrated by artist(s) of the Tosa school. Depicted here is a group of 'baptised' monks and their 'witnesses', after the *Kanjō* ceremony first performed by Kūkai. It is a form of privileged initiation into the higher mysteries. YYB

Illustrated on page 282

405

406. Ten Worlds Diagram

Japan. 1669
Hand-coloured woodblock print. 41.3 × 29 cm. OA 1931.5–13.029

This print explains the *Avataṃsaka* (Kegon) *Sūtra* to the layman and depicts the six worlds of rebirth and the four offering escape; those of the Pratyekabuddha, Buddha, Bodhisattva and *arhat*. The central character ('heart') implies that the way to the Pure Land lies in it. According to the text, each world contains the others, and – as Tendai teaches – one instantaneous thought contains 3,000 worlds. Further, if each time the believer recites the *sūtra* 10,000 or, better, 100,000 times and inks in one of the small circles, he will reach the Pure Land when all are completed. VH

Illustrated on page 275

407. Five hundred arhats

Japan, probably Mampukuji temple, Uji, near Kyoto. 1693
Single-sheet woodblock print mounted in an album. 80 × 30 cm.
OMPB 16007.d.1(3)

This Chinese-based presentation of the *arhats* (Japanese *rakan*) receiving teachings from Śākyamuni was issued with a calligraphic eulogy by Kōsen (1633–95), the fifth patriarch of Mampukuji, head temple of the Ōbaku sect. The varied and humorous expressions of the individual *arhats* are captured in starkly simple line drawings. The Ōbaku sect was founded by the Chinese master Yinyuan (Japanese Ingen) (1592–1673) who sought refuge in Japan from the Manchu conquest, bringing with him the new Zen Buddhism which had evolved in Ming China incorporating the Amidist faith. It was to be the only new sect introduced into Japan during the 250 years of isolation under the Shogunate. It added fresh inspiration and flavour to Japanese Zen. YYB

408

407

408. Legend of the sect of the 'Interfusion of Invocation'

Japan, Kyoto. 1700

Yūzū dai-nembutsu engi, woodblock print with *sumizuri* illustrations.
2 vols. 28 × 18cm OMPB 16218.d.23

Ryonin (1072–1132), founder of the Yūzū Nembutsu sect, proclaimed that by practising the *nembutsu* (chanting of the Buddha Amida's name) one unites or interfuses (*yūzū*) with other practitioners, and that leads to rebirth in the Pure Land. The patriarch is shown here standing on a rock and converting the multitude in a distinctly Edo-period setting. Note the tiny figures of Amida appearing in the sky in response to his invocation. YYB

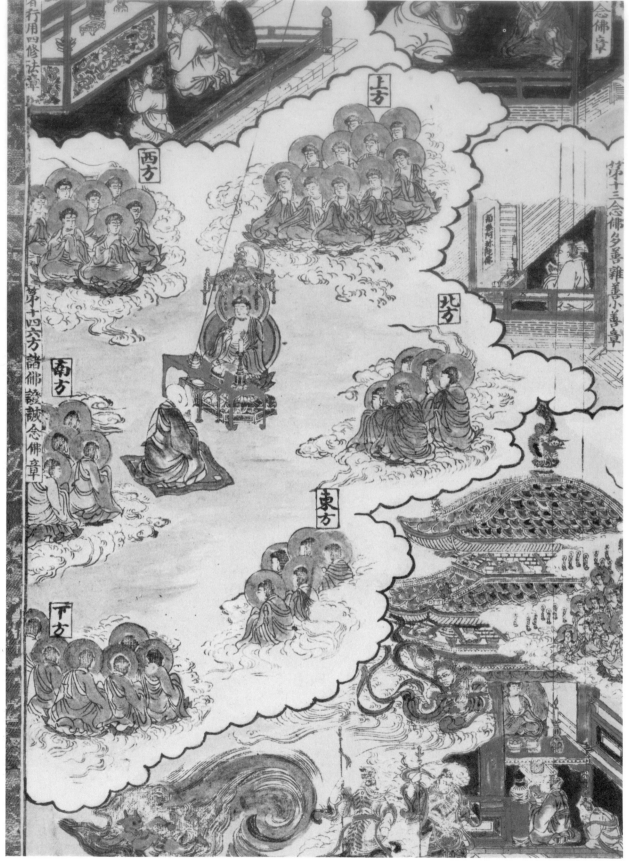

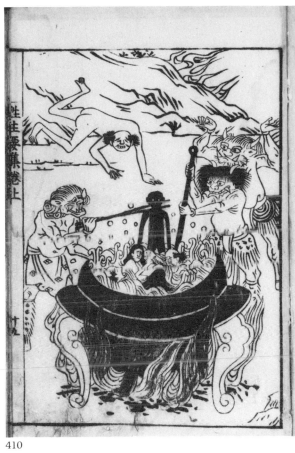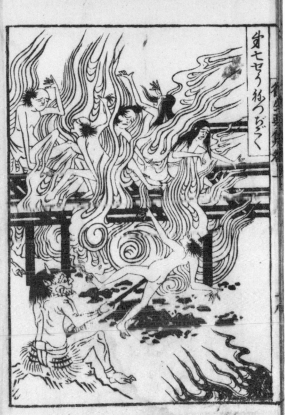

410

411

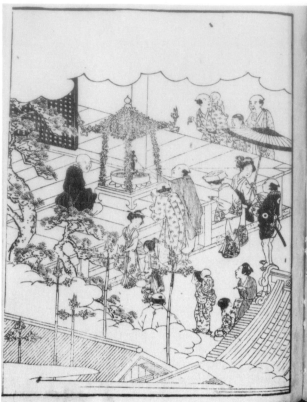
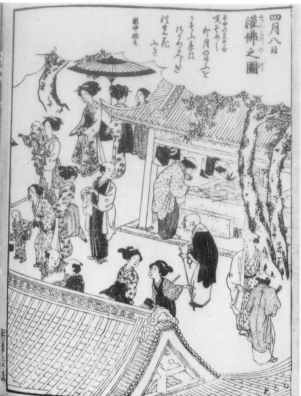

412

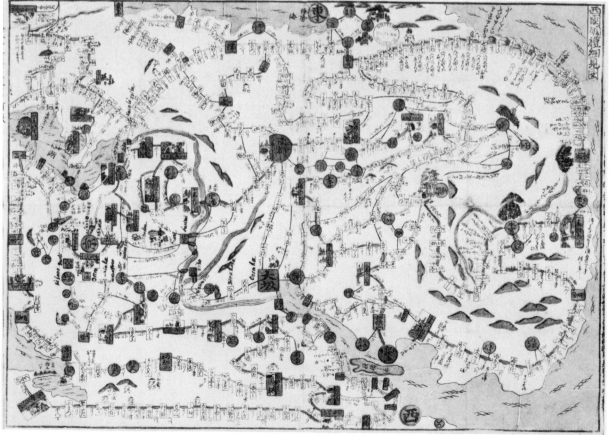

413

409. Graphic presentation of the Pure Land doctrine

Japan, Shiga prefecture. 1714

Senchaku-shū jūrokushō no zu, single-sheet hand-coloured, woodblock print. Mounted as a hanging scroll. 1.11 m × 49.7 cm. OMPB Or.80.c.3

In this collection of texts on the original vow and invocation of Amida in sixteen chapters Hōnen (1133–1212) laid the doctrinal foundation of an independent Japanese sect of the Pure Land (*Jōdo-shū*). His emphasis on salvation through exclusive invocation obviated the need for temples, priests and rituals; so the hanging of picture scrolls encapsulating his teachings, such as this example by an artist of the Kanō school, Takada Keiho, served as a direct and powerful affirmation of this popular faith. YYB

Illustrated on page 284

410. The Foundations of Rebirth

Japan, Kyoto. 1790

Ōjō yōshū, woodblock print with *sumizuri* illustrations (printed black-and-white line drawings). 3 vols. 20 × 15 cm. OMPB 16218.d.21

This 10th-century exposition by Genshin of belief in Amida (Amitābha) encouraged the formation of several Pure Land sects in Japan in the 12th and 13th centuries. His colourful descriptions of the Western Paradise and of the Buddhist hells stimulated successive generations of artists to adopt new motifs and forms. However, it was not until the Edo period that the text was rendered in Japanese with phonetic *hiragana* syllabary, together with many woodcuts for easier comprehension. (For an early edition entirely in Chinese see no. 107.) YYB

Illustrated on page 285

411. A novelist's dream of becoming Kannon

Japan, Edo. 1791

Kareki ni hana sakusha no seigan, woodblock print with *sumizuri* illustrations. 3 vols. 17 × 12 cm. OMPB 16108.a.58

The secularisation of Buddhism in Edo Japan is well illustrated by the free, often irreverent, adaptation of Buddhist themes to humorous ends in a style of popular fiction called the *kibyōshi* (yellow-cover books). This novelette written by Shitchin Mampō (alias Morishima Chūryō) and illustrated by the *ukiyo-e* master Toyokuni, tells how an impoverished novelist was overwhelmed with supplications from worshippers when he took the place of Kannon for just one day. The picture shows the writer, Yokurō, envious of the wealth that Kannon had obviously amassed from worshippers' offerings, asking if he could do his job (right). Having granted the writer's wish, Kannon himself strolled off to the pleasure quarters, disguised in a worldly outfit (left). YYB

Illustrated on page 285

412. The annual festivals

Japan, Osaka. 1806

Nenjū gyōji taisei, woodblock print with *sumizuri* illustrations. 6 vols. 26 × 16 cm. OMPB 16075.d.8

With the popularisation of Buddhism in the Edo period many religious rites came to be conducted for the benefit of the laity. Japanese festivals and customs are thus pervaded by Buddhist spirituality and practices. This ambitious account of annual festivals throughout Japan was written and illustrated by the prolific artist, Hayami Shungyōsai (d. 1823). The opening page depicts townspeople attending the *Kambutsue* (rite of bathing the Buddha) on the Buddha's birthday (8 April). Popularly known as *Hana matsuri* (Flower festival), its main practice consists in sprinkling a figure of the infant Buddha with sweet tea. YYB

413. Pilgrimage map

Japan, Kyoto. 1820

Saikoku junrei saiken-zu, coloured woodblock print. 34.5 × 47 cm. Map Library 62987(1)

The thirty-three places in western Japan sacred to Kannon have been a traditional focus for pilgrims. This map guides them to each temple in prescribed order, zigzagging from Seigantoji in Kumano (extreme right) to Kegonji in Gifu prefecture (top left hand corner). The locations of temples, shrines, towns, villages, inns and river-crossings are clearly marked. Each temple enshrines one of the thirty-three compassionate manifestations of Kannon. Religious pilgrimages were virtually the only travel allowed to commoners by the autocratic Edo Shogunate. For many country folk this was their only opportunity to see Kyoto and other historical sites, and enjoy themselves. YYB

414. Nichiren converting a fisherman

Japan, 19th century

Single-sheet woodblock print mounted in an album. 38 × 25 cm OMPB 16007.d.1(5)

Nichiren (1222–82), the last great reformer and sectarian founder of the Kamakura period, preached that all can attain Buddhahood through faith in the *Lotus Sūtra*. He wandered throughout Japan beating a drum to awaken people to this truth and his fervour attracted numerous disciples. Many post-war religious groups, such as the Sōka Gakkai, have drawn on his teachings and adopted the chanting of the title (*daimoku*) of the *Lotus Sūtra*, i.e. *Namu Myōhō Rengekyō* (Homage to the *Lotus Sūtra*). Followers of these Nichiren offshoots are particularly zealous.

This print depicts a famous incident in Nichiren's life where a fisherman was persuaded to give up fishing and follow the Buddha. Note the large characters at top centre which spell out the *daimoku*. Many such single-sheet tracts were made in the Edo period for free distribution. YYB

Illustrated on page 288

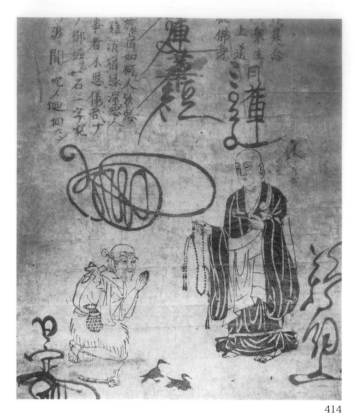

414

415. Nichiren confuses his enemies

Japan. *c*.1830

Woodblock colour print. 37.3 × 24.5 cm. OA 1913.4–15.016

The inscription dates this print to 1264 and gives as the caption 'Tōjō Komatsubara'. The event illustrated is probably the attempted assassination in that year of Nichiren at Awa by his old enemy Tōjō Kagenobu, a follower of the Pure Land sect. Nichiren had returned to Awa, where he had previously denounced (1253) the Pure Land and Zen sects, after ten years' absence during which he had further developed his religious views. VH

Illustrated on page 278

416. Nichiren making rain

Japan. 19th century

By Utagawa Kuniyoshi (1797–1861). Woodblock colour print. 37 × 25.2 cm. OA 1948.4–10.0115

This print shows Nichiren at Ryō gan ga saki (1271) successfully praying for rain, thus proving the superiority of his teachings. VH

Illustrated on page 278

417. Nichiren calms the sea

Japan. *c*.1830

By Utagawa Kuniyoshi (1797–1861). Woodblock colour print. 37.3 × 24 cm. OA 1913.4–15.010

Following the insurgency of his *samurai* followers in support of his opposition to the government and other sects, Nichiren was arrested and condemned to death in 1271. Exiled to Sado Island instead when the execution was miraculously averted, he is here shown calming the waves among which can be discerned a horizontal row of characters forming the words *Namu Myōhō Rengekyō*, his invocation to the *Lotus Sūtra*. VH

Illustrated on page 279

418. Nichiren in exile

Japan. *c*.1830

By Utagawa Kuniyoshi (1797–1861). Woodblock colour print. 37.4 × 25.8 cm. OA 1908.6–16.175

Nichiren is depicted alone in the snows of Sado Island, where he was exiled between 1271 and 1274 after his near execution. Most of his followers deserted him, and in his isolation Nichiren underwent a spiritual crisis which led to his views becoming more extreme and the composition of one of his most notable works. VH

Illustrated on page 279

419. Nichiren's destruction of the Mongol fleet

Japan. *c*.19th century

By Utagawa Kuniyoshi (1797–1861). Woodblock colour print. 37.2 × 24.6 cm. OA 1913.4–15.0111

The divine aid of the weather foiled the second attempted invasion of Japan by Kublai Khan (1281). Nichiren is popularly thought responsible for summoning the divine wind called *shimpū*, despite constantly preaching that Japan would be overthrown for ignoring his teaching. VH

Illustrated on page 279

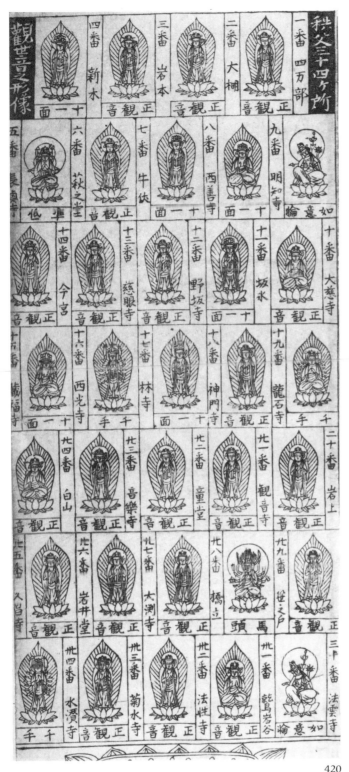

420

421

420. Amulet of thirty-four images of Kannon

Eastern Japan. 19th century

Chichibu sanjūshi-ka-sho Kanzeon no zōkei, single-sheet woodblock print mounted in an album. 61 × 30 cm. OMPB 16007.d.1(2)

Pilgrimages to the thirty-four Kannon temples in the Chichibu region flourished against the background of the prosperous commercialism of the near-by capital, Edo. The number 34 was an attempt to reach the magical figure of 100 in association with the other two centres of Kannon worship, namely the thirty-three temples respectively in western Japan (see no. 413) and in the Bandō region. Printed amulets or talismans were issued in large numbers by temples and Shintō shrines to pilgrims who delighted in simple souvenirs. Pasted on the same mount are some examples with devotional images. YYB

421. Amulet

Japan. 19th century

Paper with textile fragments. 16.3 × 8.5 cm. OA 1894.5–10.11

This amulet shows Kōbō Daishi (Kūkai) who founded the Shingon sect's headquarters on Mount Koya. He is always depicted with his 108-bead rosary doubled over and a five-pronged *vajra* in his left hand. The text states that the amulet is available from temples on Mount Kōya and will protect travellers. The accompanying textile fragments are said to be from the garments of Kūkai himself, but their efficacy for the faithful does not depend on their being authentic. Considerable income is derived from the sale of amulets and trinkets by both Buddhist temples and Shintō shrines. VH

422 (detail)

422. Asakusa Kannon Temple

Japan. 19th century

Woodblock colour print. 56 × 95.5 cm. OA + 045

The temple dedicated to Avalokiteśvara at Asakusa is said to
have been built where an image of the deity, discovered in the
Sumida river, was enshrined. This image promotes prosperity
and is honoured by shopkeepers. The temple's annual festival
and merrymaking attract thousands of visitors. VH

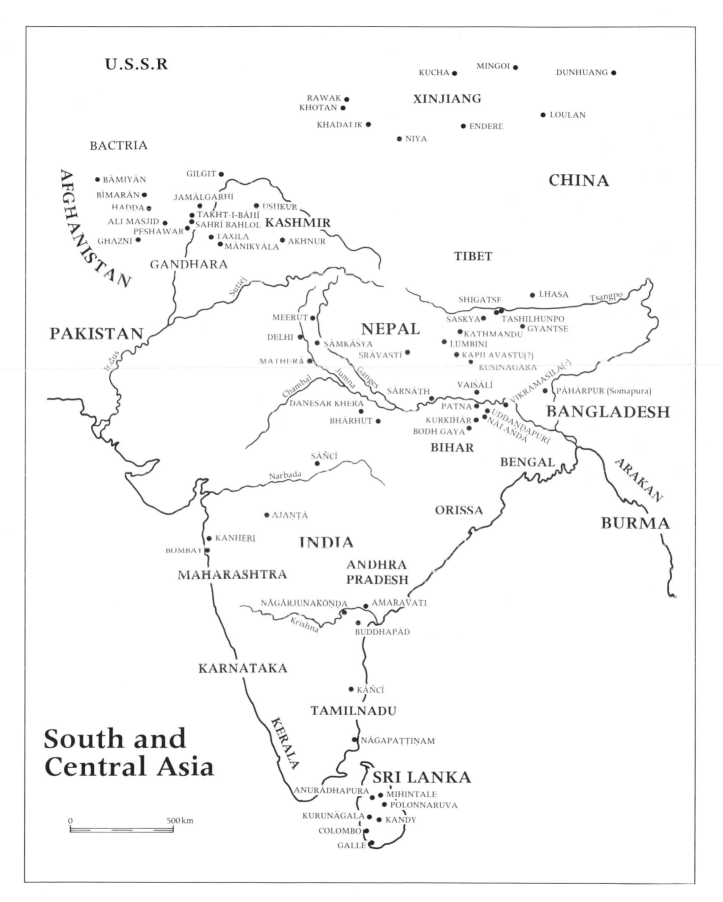

U.S.S.R

KUCHA ● MINGOI ● DUNHUANG ●

RAWAK ●
KHOTAN ● XINJIANG
 LOULAN ●
KHADALIK ● ENDERE ●
 NIYA ●

BACTRIA

CHINA

AFGHANISTAN

● BĀMIYĀN GILGIT ●
BĪMARĀN ● JAMĀLGARHĪ ●
HADDA ●● USHKUR ●
 TAKHT-I-BĀHĪ ●
ALI MASJID ● SAHRĪ BAHLOL ● KASHMIR
PESHAWAR ●
GHAZNI ● ● TAXILA
 ● MĀNIKYĀLA ● AKHNUR

TIBET

GANDHARA

Sutlej

PAKISTAN

Indus

SHIGATSE ● LHASA Tsangpo
MEERUT ● NEPAL SASKYA ● ● TASHILHUNPO
DELHI ● ● KATHMANDU GYANTSE
 SĀMKĀSYA ● LUMBINI ●
 ŚRĀVASTĪ ● KAPILAVASTU(?) ●
MATHURĀ ● KUSINAGARA ●
 Jumna Ganges SĀRNĀTH VIKRAMAŚĪLA(?)
Chambal VAIŚĀLĪ ● ● PĀHĀRPUR (Somapura)
DANESAR KHERA ● PATNA ● UDDANDAPURĪ
 BHĀRHUT ● KURKIHĀR ● NĀLANDĀ BANGLADESH
 BODH GAYĀ ●
 BIHAR
SĀÑCĪ ●
Narbada BENGAL ARAKAN

ORISSA

BURMA

AJANTĀ ●

INDIA

KANHERI ●
BOMBAY ●
 MAHARASHTRA ANDHRA
 PRADESH

NĀGĀRJUNAKŌNDA ● ● AMARAVATI
 Krishna ● BUDDHAPĀD

KARNATAKA

● KĀÑCĪ

TAMILNADU

KERALA

● NĀGAPAṬṬINAM

SRI LANKA

ANURĀDHAPURA ●
 ● MIHINTALE
 ● POLONNARUVA
KURUNĀGALA ● ● KANDY
COLOMBO ●
GALLE ●

South and Central Asia

0 500 km

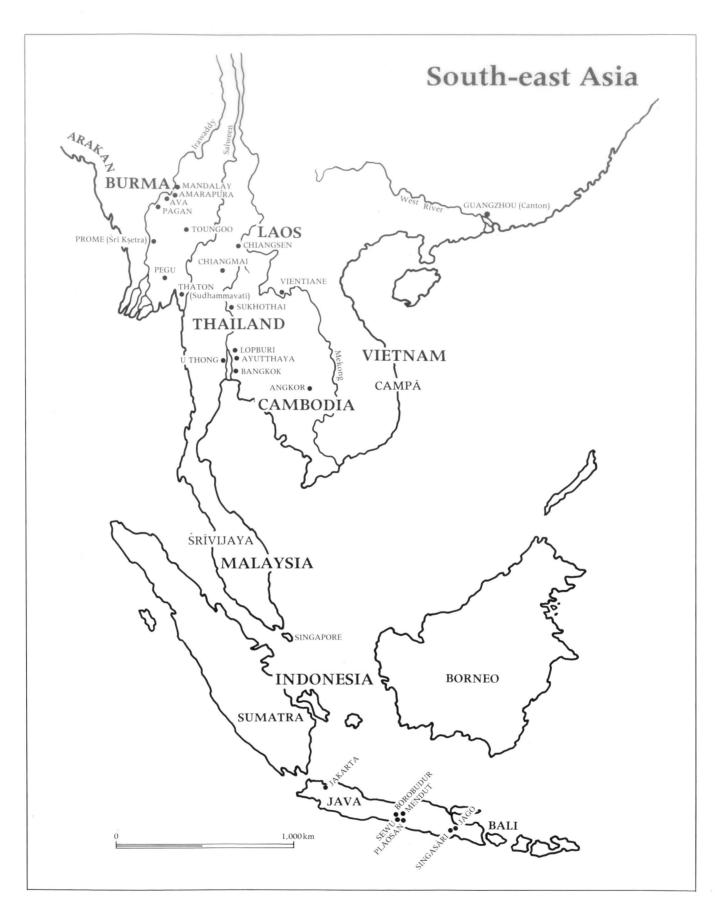

South-east Asia

ARAKAN

BURMA

Irawaddy

Salween

MANDALAY
AMARAPURA
AVA
PAGAN

TOUNGOO

LAOS

West River

GUANGZHOU (Canton)

PROME (Śrī Kṣetra)

CHIANGSEN

CHIANGMAI

PEGU

THATON
(Sudhammavati)

VIENTIANE

SUKHOTHAI

THAILAND

LOPBURI
U THONG • AYUTTHAYA
BANGKOK

ANGKOR

CAMBODIA

Mekong

VIETNAM

CAMPĀ

MALAYSIA

ŚRĪVIJAYA

SINGAPORE

INDONESIA

BORNEO

SUMATRA

0 1,000 km

JAKARTA

JAVA

BOROBUDUR
SEWU MENDUT
PLAOSAN

JAGO

SINGASĀRI

BALI

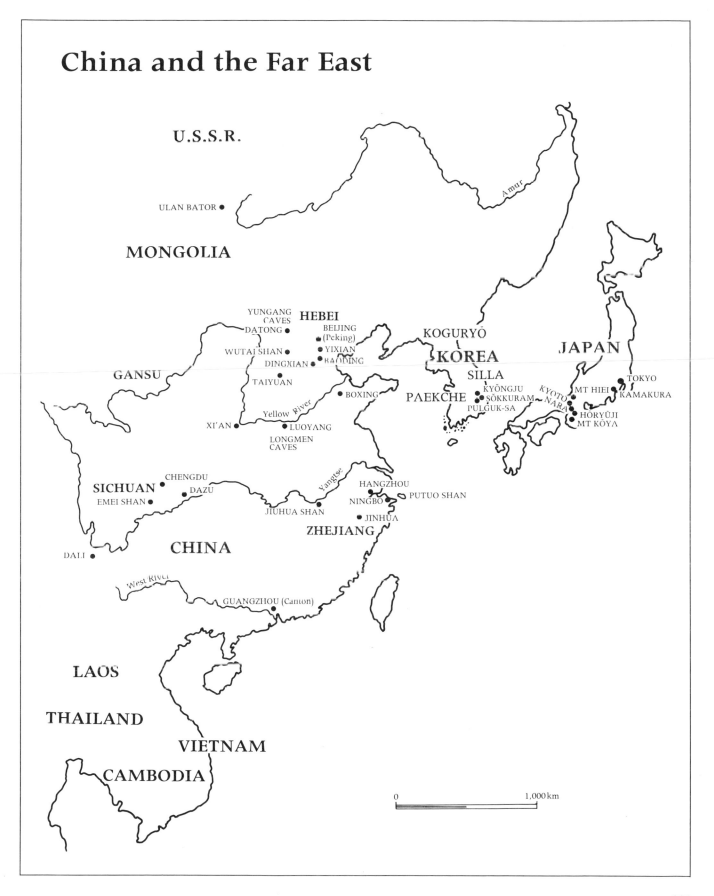

China and the Far East

U.S.S.R.

Amur

ULAN BATOR ●

MONGOLIA

YUNGANG CAVES **HEBEI**
DATONG ● BEIJING ● (Peking)
WUTAI SHAN ● YIXIAN
GANSU DINGXIAN ● BAODING
 ● TAIYUAN
 Yellow River ● BOXING
XI'AN ● ● LUOYANG
 LONGMEN CAVES

KOGURYŎ
KOREA **JAPAN**
SILLA
PAEKCHE KYŎNGJU KYOTO ● MT HIEI ● TOKYO
 ● SŎKKURAM ● NARA ● KAMAKURA
 PULGUK-SA HŌRYŪJI ●
 ● MT KŌYA

SICHUAN CHENGDU ● *Yangtse* HANGZHOU ●
 ● DAZU ● PUTUO SHAN
EMEI SHAN ● NINGBO ●
 JIUHUA SHAN ● ● JINHUA

ZHEJIANG

CHINA

DALI ●

West River

GUANGZHOU (Canton)

LAOS

THAILAND

VIETNAM

CAMBODIA

0 ———————————— 1,000 km

293

Bibliography

Titles in the general section may also be relevant for subsequent sections.

Numbered titles refer to individual catalogue entries, and those with an asterisk contain a useful bibliography.

General

* Bechert, H., and Gombrich, R., *The world of Buddhism*, London, 1984

* Conze, E., *A short history of Buddhism*, London, 1982

Conze, E., *Buddhism, its essence and development*, 3rd edn, Oxford, 1960

Dasgupta, S. B., *An introduction to Tantric Buddhism*, Calcutta, 1950

Dutt, N., *Buddhist sects in India*, 2nd edn, New Delhi, 1968

Getty, A., *The gods of northern Buddhism*, Oxford, 1928 (reprinted Rutland, Vt., and Tokyo, 1977)

Hanayama, S., *Bibliography of Buddhism*, Tokyo, 1961

Humphreys, C., *A popular dictionary of Buddhism*, 2nd edn, London, 1976

India, Ministry of Information and Broadcasting, *The way of the Buddha*, Delhi, n.d.

Lamotte, E., *Histoire du bouddhisme indien*, Louvain, 1958 (reprinted 1976)

* Lee, S. E., *A history of Far Eastern art*, 4th edn, New Jersey and New York, 1984

Lefebvre d'Argencé, R-Y., *Chinese, Korean and Japanese sculpture in the Avery Brundage collection*, San Francisco, 1974

* Mallmann, M-T. de, *Introduction à l'iconographie du Tântrisme bouddhique*, Paris, 1975

* Mitra, D., *Buddhist monuments*, Calcutta, 1971

* Pal, P., *Light of Asia, Buddha Sakyamuni in Asian art*, Los Angeles, 1984

* Rowland, B., *The art and architecture of India*, 3rd rev. edn, Harmondsworth, 1977

* Rowland, B., *The evolution of the Buddha image*, New York, 1968

* Seckel, D., *The art of Buddhism*, London, 1964

* Snellgrove, D. L., *The image of the Buddha*, Paris and London, 1978

Stcherbatsky, T., *The central conception of Buddhism and the meaning of the word 'Dharma'*, London, 1923 (reprinted Delhi, 1970)

Swearer, D. K., *Buddhism and society in Southeast Asia*, Chambersburgh, Pa., 1981

* Thomas, E. J., *The history of Buddhist thought*, London, 1951

Tucci, G., *The theory and practice of the maṇḍala*, trans. by Alan Houghton Brodrick, London, 1969

Warder, A. K., *Indian Buddhism*, 2nd edn, Delhi, 1980

Watters, T., *On Yuang Chwang's* [Xuan Zang] *travels in India*, 2 vols, London, 1904–5

Zürcher, E., *Buddhism, its origin and spread in words, maps and pictures*, London, 1962

1. Early cult monuments

Barrett, D., *Sculptures from Amaravati in the British Museum*, London, 1954

Cunningham, A., *Mahâbodhi or the great Buddhist temple . . . at Bodh Gaya*, London, 1892

* Dehejia, V., *Early Buddhist rock temples*, London, 1972

Starza, O. M., *The Bodh Gaya pillar*, Victoria and Albert Museum, London, 1974

6. Cunningham, A., *Archaeological survey of India, report of 1863–64*, Simla, 1871, pp. 166 f., pl. LXV

10-11. Prinsep, J., 'On the coins and relics discovered . . . in the Tope of Manikyala', *Journal of the Asiatic Society of Bengal*, III (1834), pp. 315 f.

 Court, A., 'Further information on the Topes of Manikyala', *Journal of the Asiatic Society of Bengal*, III (1834), p. 559 (fn.)

2. The Buddha legend

Cowell, E. B., *The Jātaka, or stories of the Buddha's births*, Cambridge, 1895–1913

* Thomas, E. J., *The life of the Buddha as legend and history*, 3rd rev. edn, London, 1949

25. Kṣemendra, *Avadānaśataka*, no. 58

 Lyons, I., and Ingholt, H., *Gandhāran art in Pakistan*, New York, 1957, p. 101, fig. 164

3. The scriptures and their transmission

Bode, M. H., *The Pali literature of Burma*, London, 1909 (reprinted 1966)

* Brough, J., *The Gāndhārī Dharmapada*, London, 1962

Burnouf, E., *Le lotus de la bonne loi*, Paris, 1852

Chaudhary, R., *The university of Vikramaśīla*, Patna, 1975

Conze, E., *Buddhist texts through the ages*, Oxford, 1954

Conze, E., *The Aṣṭasāhasrikā Prajñāpāramitā translated into English*, Calcutta, 1958

Conze, E., *The Prajñāpāramitā literature*, 2nd rev. and enlarged edn, Tokyo, 1978

Emmerick, R., *A guide to the literature of Khotan*, Tokyo, 1979

Hoernle, A. F. R., *Manuscript remains of Buddhist literature found in eastern Turkestan*, Oxford, 1916

Hinüber, O. von, 'Die Kolophone der Gilgit-Handschriften' in *Studien zur Indologie und Iranistik*, Hft. 5/6, Reinbek, 1980, pp. 49–82

Lamotte, E., *Vimalakīrtinirdeśa, the teaching of Vimalakīrti*, London, 1976

Malalasekara, G. P., *The Pali literature of Ceylon*, London, 1928

Mitra, R., *The Sanskrit Buddhist literature of Nepal*, Calcutta, 1882 (reprinted 1971)

Nanjio, B., *A catalogue of the Chinese translation of the Buddhist Tripitaka*, Oxford, 1883

* Norman, K. R., *Pāli literature: including the canonical literature in Prakrit and Sanskrit of all the Hīnayāna schools of Buddhism*, Wiesbaden, 1983

* Seyfort Ruegg, D., *The literature of the Madhyamaka school of philosophy in India*, Wiesbaden, 1981

Suzuki, D. T., *The Lankavatara Sutra*, London, 1932

* Stein, M. A., *Ancient Khotan*, 2 vols, Oxford, 1907

* Stein, M. A., *Serindia*, 5 vols, Oxford, 1921

* Stein, M. A., *Innermost Asia*, 4 vols, Oxford, 1928

Tripitaka. Virtually the entire Theravāda Canon has been published in transliteration and translation by the Pali Text Society, London, 1889–

Utz, D. A., *A survey of Buddhist Sogdian studies*, Tokyo, 1978

4. The Buddha image

* Lohuizen-de Leeuw, J.E. van, *The Scythian Period*, Leiden, 1948

4. * Lohuizen-de Leeuw, J.E. van, 'New evidence with regard to the origin of the Buddha image' in H. Härtel, *South Asia Archaeology 1979*, Berlin, 1981, pp.377–400

121-2. Cribb, Joe, 'The origin of the Buddha image' in *South Asian Archaeology 1981*, Cambridge, 1984, pp.231–44

128-9. Barrett, D., 'Gandhara bronzes', *Burlington Magazine*, CII (1960), pp.361–5, figs 30–4

130. Smith, V.A., and Hoey, W., 'Ancient Buddhist sculptures . . . from Bandā District', *Journal of the Asiatic Society of Bengal*, 64 (1895), pp.152–62, pls VIII–XI

Sircar, D.C., 'Copper coin of Harigupta', *Epigraphia Indica*, 30 (1959 60), pp.95 8

5. Afghanistan, Pakistan and Kashmir

* Allchin, F.R., and Hammond, N., *The archaeology of Afghanistan*, London, 1978

* Frumkin, G., *Archaeology in Soviet Central Asia*, Leiden and Cologne, 1950

Pal, P., *Bronzes of Kashmir*, Graz, 1975

6. Eastern India

* Bhattacharyya, B., *The Indian Buddhist iconography*, 2nd edn, Calcutta, 1958

* Huntington, S.L., *The 'Pāla-Sena' schools of sculpture*, Leiden, 1984

Lawson, S.D., 'A catalogue of Indian Buddhist clay sealings in British museums', unpublished thesis, Oxford University, 1982

Losty, J.P., *The art of the book in India*, London, 1982

Saraswati, S.K., 'East Indian manuscript painting' in *Chhavi*, ed. Anand Krishna, Benares, 1971, pp.243–62

Saraswati, S.K., *Tantrayana art: an album*, Calcutta, 1977

139. Harris, E.B., *Description of Buddhist remains discovered at Sooltangunge . . .* , London, 1864, pl.1

7. Nepal and Tibet

* Pal, P., *Art of Nepal, a catalogue of the Los Angeles County Museum of Art collection*, Berkeley, 1985

* Pal, P., *Art of Tibet, a catalogue of the Los Angeles County Museum of Art collection*, Berkeley, 1983

* Pal, P., *The arts of Nepal*, 2 vols, Leiden, 1974, 1978

Snellgrove, D.L., *Buddhist Himalaya*, Oxford, 1957

* Tucci, G., *The religions of Tibet*, London and Henley, 1980

154. Karmay, H., *Early Sino-Tibetan art*, Warminster, 1975, p.92

162. Bhattacharyya, B., *The Indian Buddhist iconography*, 2nd edn, Calcutta, 1958, p.61, fig.25

165. Pal, P., 'Two Buddhist paintings from Nepal', *Bulletin of the Muzeum van Aziatische Kunst* (Amsterdam), 5 (1967), no.43

166. Béguin, G., 'A propos d'une tiare d'officiant bouddhique', *La Revue du Louvre et des Musées de France*, 1984, no. 3, pp.176–83

167. Foucher, A., *Etude sur l'iconographie bouddhique de l'Inde*, Paris, 1900

168. Béguin, G., 'A propos de deux couvertures de livre du XIIe siècle', *La Revue du Louvre et des Musées de France*, 1983, no. 1

172. Wujastyk, D., 'The spikes in the ears of the ascetic: an illustrated tale in Buddhism and Jainism', *Oriental Art* (N.S.), 30 (1984), pp.189–94

189. Olschak, B.C., and Wangyal, G.T., *Mystic art of ancient Tibet*, London, 1973, p.125, fig.53

198. Hatt, R.T., 'A thirteenth-century Tibetan reliquary', *Artibus Asiae*, 42 (1980), pp.175–220

8. The Deccan and south India

Barrett, D., 'The late school of Amarāvatī and its influences', *Art and Letters*, 28 (1954), pp.41–53

Ramachandran, T.N., *The Nagapattinam and other Buddhist bronzes on the Madras Museum*, Madras, 1965

204. Krairiksh, P., *Art styles in Thailand*, Bangkok, 1977, pp.58–9

9. Sri Lanka

Boisselier, J., *Ceylon (Sri Lanka)*, Geneva, 1979

Coomaraswamy, A.K., *Mediaeval Sinhalese art*, 2nd rev. edn, New York, 1956

208. Parker, H., *Ancient Ceylon*, London, 1909, p.327ff., figs 93–110, 156

210. Paranavitana, S., 'Mahayanism in Ceylon', *Ceylon Journal of Science*, II (1928), pp.35–71

211. Mudiyanse, N., 'Some antiquities from Ceylon at the Edinburgh Museum', *Spolia Zeylanica*, 32 (1972), pp.65–6

219-220. Aluwihare, R., *The Kandy Esala Perahera*, 2nd edn, Colombo, 1964

10. Burma

* Luce, G.H., *Old Burma, early Pagan*, 3 vols, New York, 1969–70

Mendelson, E.M., *Sangha and state in Burma*, Ithaca, N.Y., 1975

Ono, T., *Pagan no bukkyo hekiga: Pagan mural paintings of the Buddhist temples of Burma*, Tokyo, 1978

Ray, N.R., *An introduction to the study of Theravada Buddhism in Burma*, Calcutta, 1946 (reprinted 1977)

Ray, N.R., *Sanskrit Buddhism in Burma*, Calcutta, 1936

Thaw, Aung, *Historical sites in Burma*, n.p., 1972

221. * Chutiwongs, N., 'Avalokitesvara in mainland South-east Asia', unpublished thesis, Leiden University, 1984, p.497

Lowry, J., *Burmese art*, London, 1974, no.18

11. Thailand and Cambodia

Boisselier, J., *Thai painting*, Tokyo, 1976

* Boisselier, J., *The heritage of Thai sculpture*, New York and Tokyo, 1975

Bowie, T., *The sculpture of Thailand*, New York, 1982

* Giteau, M., *Khmer sculpture and the Angkor civilisation*, London, 1965

Parmentier, H., *L'art du Laos*, 2 vols, Paris and Hanoi, 1954

Reynolds, F.E., *Three worlds according to King Ruang: a Thai Buddhist cosmology*, Berkeley, 1982

* Stratton, C., and McNair Scott, M., *The art of Sukhothai, Thailand's golden age*, Kuala Lumpur, 1981

* Wray, E., *Ten lives of the Buddha, Siamese temple paintings and Jataka tales*, New York and Tokyo, 1979

253. Griswold, A.B., *Dated Buddha images of northern Siam*, Ascona, 1957, pp.41, 91

Penth, H., 'Kunst im Lān Nā Thai (7)', *Artibus Asiae*, 38 (1976), pp.139–53, figs 1–8

12. Indonesia

* Bernet Kempers, A.J., *Ageless Borobudur*, London, 1976

* Bernet Kempers, A.J., *Ancient Indonesian art*, Cambridge, Mass., 1959

265. * Le Bonheur, A., *La sculpture indonésienne au Musée Guimet*, Paris, 1971, p.260

Rowland, B., *The art and architecture of India*, 3rd rev. edn, Harmondsworth, 1977, p.458

267-8. Le Bonheur (1971), pp. 51–2 (fn.1)

270. Le Bonheur (1971), p.232.

271. Bhattacharyya, B., *The Indian Buddhist iconography*, 2nd edn, Calcutta, 1958, p.61, fig.24

13. Central Asia

* Stein, M.A., *Ancient Khotan*, 2 vols, Oxford, 1907

* Stein, M.A., *Serindia*, 5 vols, Oxford, 1921

* Stein, M.A., *Innermost Asia*, 4 vols, Oxford, 1928

Whitfield, R., *The art of Central Asia: the Stein collection in the British Museum*, 3 vols, Tokyo, 1982–5

282. Gropp, G., *Archäologische Funde aus Khotan, Chinesisch-Ostturkestan*, Bremen, 1974, pp.106, 147

14. China

Akiyama, T., *Arts of China, neolithic cultures to the Tang dynasty: recent discoveries*, Tokyo and Palo Alto, 1968

Boerschmann, E., *Die Baukunst und religiöse Kultur der Chinesen*, 3 vols, Berlin, 1911–31

Ch'en, Kenneth K.S., *Buddhism in China, a historical survey*, Princeton, 1964 (reprinted 1973)

Fung, Yu-lan, *History of Chinese philosophy*, London, 1952

Giles, L., *Six centuries at Tunhuang; a short account of the Stein collection of Chinese manuscripts*, London, 1944

Prip-Møller, J., *Chinese Buddhist monasteries*, Copenhagen, 1937

Reichelt, K.L., *Truth and tradition in Chinese Buddhism*, Shanghai, 1927

Reischauer, E.O., *Ennin's diary, the record of a pilgrimage to China in search of the law*, New York, 1955

Reischauer, E.O., *Ennin's travels in T'ang China*, New York, 1955

* Sickman, L., and Soper, A., *The art and architecture of China*, 3rd integrated and reprinted edn, Harmondsworth, 1978

Waley, A., *The real Tripitaka*, London, 1952

* Welch, H., *The Buddhist revival in China*, Cambridge, Mass., 1968

* Welch, H., *The practice of Chinese Buddhism 1900–1950*, Cambridge, Mass., 1967

Wright, A.F., *Buddhism in Chinese history*, Stanford and London, 1959 (reprinted 1965)

* Yang, C.K., *Religion in Chinese society*, Berkeley, 1961

Zürcher, E., *The Buddhist conquest of China*, 2 vols, Leiden, 1959

284. Soper, A.C., *Chinese, Korean and Japanese bronzes*, Rome, 1966, pp.14–15, fig.7

Wenwu, 1984, 5, p.23, fig.3

285. *Gugong bowuyuan yuankan*, 1960, 2, pp.53–5

286. *Chugoku no Bukkyo Bijitsu*, Tokyo, 1968, pp.169–86, figs67–73

288. Yen, Chüan-ying, 'The double tree motif in Chinese Buddhist iconography', pt2, *National Palace Museum Bulletin*, XIV, 6 (1980), p.10, fig.18

297. Chapin, Helen B., 'A long roll of Buddhist images', pt1, *Artibus Asiae*, XXXII (1970), p.8, fig.1

cf. Lefebvre d'Argencé, R-Y., *Chinese, Korean and Japanese sculpture in the Avery Brundage collection*, San Francisco, 1974, no.140

304. Chapin, Helen B., 'A long roll of Buddhist images', pt4, *Artibus Asiae*, XXXIII (1971), pp.122–3, pl.45

305. Karmay, H., *Sino-Tibetan bronzes*, Warminster, 1975, fig.49

323. Waley, A., *A catalogue of paintings recovered from Tun-huang by Sir Aurel Stein*, London, 1931, pp.166–7

324. Waley (1931), pp.xii–xiii, 169

325. Murray, Julia K., 'Representations of Hārītī, the mother of demons and the theme of "raising the alms-bowl" in Chinese painting', *Artibus Asiae*, XLIII (1981–2), pp.253–68

15. Korea

Buddhist culture in Korea, Seoul, 1974

Chinul, *The Korean approach to Zen*, trans. by Robert E. Buswell, jun., Honolulu, 1983

* Goepper, R., and Whitfield, R., *Treasures from Korea*, London, 1984

Kim, Chewon, and Lee, Lena Kim, *Arts of Korea*, Tokyo, 1974

Lancaster, L.R., *The Korean Buddhist Canon: a descriptive catalogue*, Berkeley, 1979

342–3. Pak, Youngsook, *Korean Art, 5th–19th century, catalogue*, Ingleheim, 1984, p.50

344. Pak (1984), p.52

348. Pak (1984), p.61

16. Japan

* Andrews, A.A., *The teachings essential for rebirth: a study of Genshin's Ōjōyōshū*, Tokyo, 1973

* Anesaki, Masaharu, *History of Japanese religion*, London, 1930 (reprinted 1963)

* Anesaki, Masaharu, *Religious life of the Japanese people*, Tokyo, 1961

Bandō, Shojun, *A bibliography of Japanese Buddhism*, Tokyo, 1958

* Chibbett, D., *The history of Japanese printing and book illustration*, Tokyo, 1977

Eliot, Charles, *Japanese Buddhism*, London, 1935 (reprinted 1964)

* Hakeda, Yoshito, *Kūkai: major works, translated with an account of his life and a study of his thought*, New York, 1972

Inagaki, Hisao, *A dictionary of Japanese Buddhist terms*, Kyoto, 1984

* *Japanese–English Buddhist dictionary*, Daitō Shuppansha, Tokyo, 1965

* Kitagawa, Joseph, *Religion in Japanese history*, New York, 1966

Nanjiô, B., *A short history of the 12 Japanese sects*, Tokyo, 1886

* Nishikawa, Kyōtaro, and Sano, Emily J., *The great age of Japanese Buddhist sculpture AD 600–1300*, Fort Worth, 1982

* Paine, R.T., and Soper, A., *The art and architecture of Japan*, 2nd rev. edn by D.B. Waterhouse and Bunji Kobayashi, Harmondsworth, 1974

* Pratt, J.B., *The pilgrimage of Buddhism and a Buddhist pilgrimage*, New York, 1928

Rosenfield, J.M., *The courtly tradition in Japanese art and literature: selections from the Hofer and Hyde collections*, Boston, 1973

* Rosenfield, J.M., and ten Grotenhuis, E., *Journey of the three jewels*, New York, 1979

Sawa, Takaaki, *Art in Japanese esoteric Buddhism*, New York and Tokyo, 1972

Suzuki, D.T., *Zen Buddhism and its influence on Japanese culture*, Kyoto, 1938

* Tani, Shin'ichi, 'Japanese art' in *Encyclopedia of World Art*, McGraw-Hill, New York, 1971, vol.VIII, 845–97

* Watanabe, Shōkō, *Japanese Buddhism, a critical appraisal*, Tokyo, 1968

Yamamoto, Kōshō, *An introduction to Shin Buddhism*, Uke, 1963

Index

This index is in part a glossary: expressions most fully treated are those occurring frequently and unexplained in the catalogue.
Names bracketed after titles of works are those of translators.
Terms, words and titles are in Sanskrit unless followed by (B) Burmese; (C) Chinese; (H) Hindi; (J) Japanese; (K) Korean; (P) Pali; (Si) Sinhalese; (T) Tibetan, or other explanation.
Numbers in bold type refer to catalogue entries; other references are to pages.

abhaya (mudrā) reassurance, protection 92; **128,** **286–7, 290, 292**
Abhayagiri, monastery, Sri Lanka 148; **90**
Abhidhamma (P) *see* Abhidharma
Abhidhammapiṭaka (P) Sthaviravāda canonical books 40, 41
extracts **91**
commentary *Tīkāpaṭṭhāna* (P) **41**
Abhidharma, Abhidhamma (P) systematisation of Doctrine 13, 16, 17, 40, 41, 160; **41, 42, 89**
Abhidharmakośakārikā by Vasubandhu Uyghur supercommentary on Sthiramati's commentary **42**
Tibetan commentary **43**
Abhiniṣkramaṇasūtra in Chinese (Jñānagupta) **44**
Acala (Caṇḍamahāroṣaṇa), Fudō (J) protector deity 176, 357, 374
Ādi Buddha, Supreme or Primordial Buddha 18; 184; *see also* Vajradhara, Vajrasattva
Afghanistan, Buddhism 13, 100, 101
Aizen (J) *see* Rāga
Akṣayamati, Bodhisattva 157
Akṣobhya, Dhyāni Buddha, usually of the east 18, 186; **152, 153, 162, 181, 183, 184, 209, 322**
Amarāvatī, *stūpa* site, Āndhra Pradesh, India 145, 148; **13**
Amitābha, Dhyāni Buddha, lord of the Western Paradise, Amida (J) 16, 18, 22, 243; **57, 107, 112, 157, 158, 181, 287, 289, 290, 300, 302, 315, 322, 327, 332, 358, 371, 374, 384, 392**
Amitābhasutra **348**
Amitaprabha, Bodhisattva **168**
Amitāyuḥsūtra see Sukhavatīvyūha
Amitāyus, Amitābha as Buddha of Long Life 57, 192
Amoghadarśin, Bodhisattva 157
Amoghapāśa, Fukūkenjaku (J) **379**
Amoghasiddhi, Dhyāni Buddha of the north 18; **177, 180–1, 322**
Ānanda, disciple of Buddha **286**
Aniruddha, Anawrahta (B) 157
Anurādhapura, capital in Sri Lanka and associated style-period (3rd century BC–10th century AD) 148; **208, 210, 214**
Aparājitā Sitātapatrā, goddess **197**
Aparimitāyuḥsūtradhāraṇī in Khotanese 57, 66
arhat
enlightened person 11, 13, 14, 40
as protector, *lohan* (C) 235, 243; **191, 272, 295, 326, 407**
Āryajāṅgulī, goddess 157
Asaṅga, philosopher 17; **80, 109**
Aśoka (273–232 BC), Maurya emperor of India, Buddhist patron 26, 41, 120, 148; **1, 44, 68**
Aśokakāntā, goddess 157
Atīśa, scholar 42

Avalokiteśvara, also Lokanātha, Lokeśvara, Guanshiyin (C), Guanyin (C), Kannon (J), Bodhisattva 16, 148, 198, 243; **62, 70, 72, 101, 112, 114, 124–5, 138, 143, 157–9, 167, 173, 176, 204, 209, 221, 267, 296–8, 303, 315–17, 320–1, 324, 327, 330, 333–4, 338, 340, 352, 360, 363, 367, 371, 384, 411, 413, 420, 422;** *see also* Cintāmaṇicakra, Padmapāṇi, Siṃhanāda
Avataṃsaka, Huayan (C), Hwaŏm (K), Kegon (J), school of One-Vehicle Buddhism 20, 21; **78, 397, 406**
Avataṃsakasūtra (Buddhāva) in Chinese (Buddhabhadra) **78, 296**
Ayutthaya, capital in Thailand and associated style-period (1350–1767) 176; **251, 254, 255**

Beg-tse (T), protector and war god **194**
Bhairava, Hindu god 163
Bhaiṣajyaguru, Buddha of Healing 117, 315, 320
Bhaiṣajyarāja, Bhaiṣajyasamudgata, Bodhisattvas **324**
Bhikkhupāṭimokkha (P) *see Prātimokṣa*
bhikṣu, monk, member of Nepalese Buddhist caste (śākyabhikṣu) 120; **178**
Bhikṣuprātimokṣa see Prātimokṣa
bhūmisparśa (mudrā), earth-touching gesture 91; **222, 305**
Bodh Gayā, Bihar, India, site of Enlightenment and commemorative temple (Mahābodhi) 9, 27, 104; **4, 14, 22, 222, 224**
Bodhidharma, Daruma (J) 145; **369**
Bodhisattva
historical Buddha on the way to Buddhahood (in *jātakas* and his last life) 32, 91; **9, 15–17, 21**
in Mahāyāna, being vowed to Buddhahood acting as saviour, e.g. Avalokiteśvara 14, 16, 17, 20, 92, 176; **61, 67, 70, 74, 124, 312, 315–16, 322, 328, 339, 340, 359, 377, 406**
bodhyagrī (mudrā), gesture **174**
Bonmōkyō koshakki (J) **106**
Borobudur, Java 186, 263–6, 269
Brahmā, Hindu god 33; 8, 9, 18, 24, 142
Brahmajālasūtra, Chinese commentary by Tae-hyŏng **106**
Brahmajalasutta (P) **30**
Buddha (Siddhārtha Gautama, historical Buddha) life 24, 32–3
life events represented (asterisked entries are among the Eight Great Events)
conception **15;** *birth **17, 18, 147, 223;** return to Kapilavastu 18; schooling **51;** marriage 19; Four Encounters 50, 51, 351; Great Renunciation 20, 236; Great Departure **236, 313;** cutting off the hair 50, 171–2, **236, 313;** cowherds' attack 50, **313;** Sujātā offers food 21, 172; *Māra's assault and temptation 98, 132–4, 171–2, 223, 236; sheltering by Mucalinda 13, 49, 50; *First Sermon 22, **133–4, 148, 169, 223;** conversion of Kāśyapas 23; *miracle at Srāvastī 148, 223, 237; *descent at Sāṃkāśya 24, 48, 142, 223, 237; *taming of Nālāgiri 147–8, 155, 159, 171, 223; *monkey's gift of honey 148, 223; story of humped bull 25; *death 26–7, 48, 147–8, 223, 230, **288, 380;** distribution of relics 28
biographical texts
Abhiniṣkramaṇasūtra in Chinese (Jñānagupta) **44;** *Buddhacarita* by Aśvaghoṣa in Chinese 351; *Lalitavistara*

45; *Mahābuddhaguṇa* (P) **94;** *Ma-la lin ga-ra wut-htú* (B) by Kawi-wun-tha-bi-daza **236;** *see also jātaka*
Buddhaghosa 41, 149; **89, 90, 246, 261**
Buddhamātrkā Mahāmāyūrī vidyārājñī sūtra in Chinese (Amoghavajra) **110**
Buddhist creed 33 (translated), 145, 157; **91, 139, 142, 144–6, 148, 183, 223**
Burma, Buddhism 23–5, 157, 160
transmission of texts 41
Bussetsu daihō bumo onjūgyō (J) **398**

caitya, stūpa or shrine 82, 157
Cambodia, Buddhism 175–6
transmission of texts 41
Candraprabha 'Moonlight', Bodhisattva 156, 167, 315
Chan (C), Sŏn (K), Zen (J), school 20, 21, 23, 243, 245–6; **79, 295, 302, 374, 399, 408**
Chiangmai, Thailand 176; **253, 262**
Chiangsen, Thailand 253
Chichibu sanjūshi ka-sho Kanzeon no zokei (J) **420**
China, Buddhism 19, 20, 101 ff.
printing 199
transmission of texts 40–2
Chinul (K), master 21
Chogye-jong (K), school 21
Chūron geju (J) *see Madhyamakakārikā*
Ci bei dao chang chan fa (C) **337**
Ci en yu li (C) **340**
Cintāmaṇicakra, Nyoirin (J), form of Avalokiteśvara **363**
cosmology 160; **246, 258**
Councils 13, 25–6, 40, 100, 160; **231**
Cundā, goddess 167

Dai hannya haramitta-kyō (J) *see Prajñāpāramitā-Mahāprajñāpāramitāsūtra*
Daruma (J) *see* Bodhidharma
Devadatta, historical Buddha's cousin 33
Dhammacakkappavattanasutta (P) **29**
Dhammaceti, Burmese king 41; **226**
dhāraṇī, in Vajrayāna, spell, formula 17, 199, 246; **57, 82, 84–6, 105, 110, 116, 197, 324, 390–1**
dharma, dhamma (P)
Buddhism 26; **1, 65, 218, 317, 339**
element, phenomenon 13, 16–17; **60**
dharmacakra, Wheel of Doctrine 22, 29, 46, 61, 66, 71, 76, 133, 201, 317, 363, 372, 401
dharmacakra (mudrā) preaching gesture 92; **62, 130, 131, 309**
Dharmagupta(kas), Hīnayāna school 13; **44**
Dharmapāla, protector deity **314**
Dharmarakṣa, translator 41; **71**
Dharmatrāta, author 35
Dhṛtarāṣṭra, guardian king (lokapāla) of the east **349**
Dhyāni Buddha, transcendental Buddha (also Jina, Tathāgata and 'parent' Buddha) 18, 92; *see also* Akṣobhya, Amitābha, Amoghasiddhi, Ratnasambhava, Vairocana
Dīpaṃkara, previous Buddha 15, 167, 192, 277
Droṇa 33; **28**
Dunhuang, Gansu, China, site of cave temples and source of MSS. 191, 197; **42, 61, 64, 100, 279–80, 289, 291, 293, 311, 315, 320–1, 330–1, 335, 373**
Dvāravatī, Mon state in Thailand and associated style-period (7th–12th centuries AD) 157, 175; **248**

Eight Great Events *see* Buddha (Siddhārtha Gautama, historical Buddha)
Emptiness doctrine *see śūnyatā*
Esala Perahera, tooth relic procession 219, 220

Fa Hu, translator 55
Fa jie an li tu (C) 339
Faxiang (zong) (C), Hossō (shū) (J), idealist school 109, 111, 386, 397
First Sermon 9, 32, 91; *see also* Buddha (Siddhārtha Gautama, historical Buddha)
Fo ding xin da tuo tuo luo ni jing (C) 336
Fo shuo shi wang jing (C) 103, 318
Fo Tu Deng, evangelist in China 97
Four Noble Truths 9–12; 29, 31, 34
Fudō (J) *see* Acala
Fukukenjaku (J) *see* Amoghapāśa

Gandahasti, Bodhisattva 167–8
Gandhara, region in Pakistan, Afghanistan, name of Buddhist sculptural tradition under Graeco-Roman influence (1st–6th centuries AD) 26, 33, 91, 92, 100, 191; 119, 120–1
gati, any of six worlds of rebirth 10; 103
Gautama, Gotama (P), the Buddha Siddhārtha's clan-name, also used of him 9; 15, 22
Gayadhara, Indian teacher in Tibet 195
Genshin (J), sectarian master 107, 410
ghaṇṭā, kenchi (J), ritual bell 163, 186, 202, 270, 375
Ghṛdrakūṭa, Vulture Peak, Rājgir 311
Go-mizunoo (J), emperor 378
Guanshiyin (C), Guanyin (C) *see* Avalokiteśvara
Guhyasamājatantra in Tibetan 87
Guṇabhadra, translator 79
Gupta, Indian dynasty and associated style-period (AD 320–550) 92, 104, 120, 145; 160–1, 291
Gyōdō (J), ceremony 359

Hāritī, Guizi mu (C) 325
harmikā, base of parasol shaft on a *stūpa* 208, 214, 254
Heart Sūtra *see Prajñāpāramitāhṛdayasūtra*
Heruka, fierce Buddha manifestation 152
Hīnayāna, 'Little Vehicle' sectarian tradition 13, 14, 40–1, 175–6; 45, 54, 106, 311–12
Hokke gengi-jo (J) 402
Hokke gengi shakusen (J) 396
Hōnen (J), sectarian master 409
Hossō (J) *see* Faxiang
Huayan (C) *see* Avataṃsaka
Huviṣka, 2nd century Kuṣāṇa ruler 10–11, 14

Indonesia, Buddhism 186
Indra (also Sakka (P)), Hindu god 33; 8, 9, 18, 24, 142, 156, 218, 263

Jāliniprabha, Bodhisattva 156, 167
Jambhala, god of riches 159, 164–5, 168
Jambupati, name of crowned Buddha image in South-east Asia 228, 255
Japan, Buddhism 21–3, 243, 246
 printing 246–7
 Eizan or Hieizan-ban 396
 Gozan-ban 246; 399
 Jōdokyō-ban 246
 Kasuga-ban 246; 111
 Kokūzōin (Yota) 400
 Kōya-ban 246; 395
 transmission of texts 41
jātaka 'birth-tale' story of previous existence of historical Buddha 14, 32, 40, 157, 160, 186, 197; 260
 Pali canonical book 53
 Paññāsaj° (Pali extracanonical book) 93, 218
 single texts and subjects:
 Candakumāra (P) 94; Dīpaṃkara 15, 277; Dhammasoṇda (P) 218; Haṃsa (P) 4; Khadiraṅgāra (P) 217; Nārada (P) 94;

Nigrodhamiga (P) 216; Samugga (P) 217; Sārambha (P) 238; Sudhana (P) 93; Vidhurapaṇḍita (P) 215; Vaṇṇāroha (P) 53; Viśvantara, Vessantara (P) 16, 52
jieyin Fo (C), *raigō* (J), Amitābha's welcoming of souls into his paradise 22; 300, 302, 358–9, 360, 384
Jina, title of historical and transcendental (Dhyāni) Buddhas 9, 18; 177, 180–1
Jion Daishi (J) *see* Kuiji
Jizō (J) *see* Kṣitigarbha
Jñānagupta, translator 44, 351
Jōdo (J) *see* Sukhāvatī
Jōdo-shū (J), Pure Land school 22, 246; 107, 363, 401, 409
Jōdo-shinshū (J) 358
Jōyuishiki-ron jukki (J) 109

Kālacakratantra 88
Kambutsue (J), ceremony 412
Kammavācā (P) 160; 240, *see also upasampadā*
Kanakavatsa, *arhat* 191
Kandy, capital in Sri Lanka 148; 213, 219–20
Kang Senhui *see* Saṃghavarman
Kaniṣka I (c.AD 100) Kuṣāṇa emperor, patron of Buddhism 26, 91; 8, 9, 121–3, 135
Kannon (J) *see* Avalokiteśvara
Kāraṇḍavyūha 81
Kareki ni hana sakusha no seigan (J) by Shitchin Mampō 411
karma 9, 10, 14, 186
Kashmir, Buddhism 13, 100; 38, 46
Kāsyapa, name of three hermit brothers, early converts 23
Kāśyapa (Mahāk°), disciple 39, 286
Kegon (J) *see* Avataṃsaka
Kegon gokyō-shō (J) 397
khatvāṅga, attribute and ritual sceptre 112, 188, 307
Kichijōten (J) *see* Śrī
Kimyō honganshō (J) 401
Kōbō Daishi (J) *see* Kūkai
Kōken (J) *see* Shōtoku, empress
Kongōchō issai nyorai shinjitsusho daijō genshō daikyōōkyō (J) 395
Korea, Buddhism 20–1, 235
 printing 235; 346, 350
 Pulguk temple 199; 391
 transmission of texts 41
Koryǒ, Korean dynasty and stylistic period (918–1392) 21, 235; 347–8
Kōya Daishi gyōjō zuga (J) 405
Kṣitigarbha, Jizō (J), Bodhisattva 199, 243; 111, 316, 318, 355, 381, 385
Kṣitigarbhapraṇidhānasūtra in Chinese (Śikṣānanda) 111
Kublai Khan, Mongol emperor of China (1280–94), convert to Tibetan Buddhism 120; 115, 191, 419
Kūkai, called Kōbō Daishi and Kōya Daishi (774–835), Japanese Shingon sectarian master 243; 292, 382, 395, 405, 421
Kuiji (C), Jion Daishi (J) 243; 109, 386
Kumārajīva, translator 41; 63, 67, 75, 83, 98, 348
kuṇḍikā, ritual vessel 344–5
Kuṣāṇa(s), Central Asian dynasty ruling in Pakistan, Afghanistan, India (1st–3rd centuries AD) 26, 41, 91, 92; 121–2
 Kujūla Kadphises, ruler 6; *see also* Kaniṣka I, Huviṣka
Kuśinagara, site of Buddha's death 9
Kyanzittha (B), ruler 160; 156
Kyōwarabe (J) by Nakagawa Kion 403

Lalitavistara 186; 45
Laṅkāvatārasūtra in Chinese (Guṇabhadra) 79
Lokapāla, guardian deity of a cardinal point 67, 292, 304, 315, 320, 349; *see also* Dhṛtarāṣṭra, Vaiśravaṇa, Virūpākṣa

Lopburi, Khmer capital in Thailand and associated style-period (c.1000–1250) 204, 249, 250
Lotus of the Good Law, Lotus Sūtra see Saddharmapuṇḍarīkasūtra
Lui-pa (Ña-lto-pa) (T), Indian *siddha* 193
Lumbinī, Buddha's birthplace 32; 18

Madhyamāgamasūtra, Majjhimanikāya (P) *see Sūtrapiṭaka*
Madhyamaka, Middle Way as Emptiness doctrine 16–17, 18; 63, 80
Madhyamakakārikā by Nāgārjuna, *Chūron geju* (J), in Chinese 59
Madhyamakaśāstra in Chinese 58
Mahābodhi, temple of the Enlightenment, Bodh Gayā 32; 4, 14, 22, 145, 154, 156, 223, 253
Mahābuddhaguṇa (P) 94
Mahakāla, protector deity 149, 193–4
Mahāsaṃgha, Mahāsāṃghika, Hīnayāna school 13–14, 40; 90
Mahāsthāmaprāpta, Seishi (J), Bodhisattva 324, 371, 384
Mahāvihāra, monastery, Sri Lanka 148; 89, 90
Mahāyāna, 'Great Vehicle' movement or Bodhisattva path 13, 14–18, 21, 40, 41, 92, 105, 148, 157, 186; 45, 54–81, 90, 125, 312, 339, 340
Mahinda, evangelist in Sri Lanka 41, 148, 149
Maitreya, Bodhisattva, next Buddha after Śākyamuni 9, 92, 186; 62, 83, 122, 125, 139, 156, 161, 167, 192, 221, 286, 294, 299, 314
Maitreyasūtra 314
maki (J), roll or chapter 80, 394
Ma-la lin-ga-ra wut-htú by Kawi-wun-tha-bí-daza 236
Mallas, tribe at Kuśinagara 33; 26
Māmakī, goddess 271
maṇḍala, Vajrayāna ritual or meditational diagram, arrangement of deities 17, 18, 104, 133, 186; 153, 165, 310
Ma-ṇi bka'-'bum (T) 114
Mañjuśrī, Bodhisattva of wisdom 16; 74, 151, 156–8, 165, 180, 189, 308, 315, 320, 335
mantra, in Vajrayāna spell or invocation 17; 76–7, 82, 114, 309
Mantrayāna *see* Vajrayāna
Mantrānusāriṇī *see* Pañcarakṣā
Māra, Buddhist Satan, tempter of the Buddha 32; 217, 226; *see also* Buddha (Siddhārtha Gautama, historical Buddha)
Mārīcī, dawn goddess 156, 167
Mathurā, central India, school of sculpture 91–2, 120; 119, 120–1
Matṛceta, poet 54
Maudgalyāyana, Moggallāna (P), disciple of the Buddha 33; 227, 243, 257
Māyā, mother of the Buddha 32; 17, 380
Māyūrī *see* Pañcarakṣā
Middle Way 17; 21; *see also Madhyamaka*
Mindon, king of Burma 160; 32, 235, 247
Mo he zhi guan (C) by Zhiyi and Guanding 108
Mongolia, transmission of texts 42
mudrā, symbolic hand gesture, *see abhaya, bodhyagrī, bhūmisparśa, dharmacakra, varada, vitarka*
 ritual hand gesture 17; 116, 320, 375
Mūlasarvāstivādins, Hīnayāna school 39, 46–7
Myōhō rengekyō (J) *see Saddharmapuṇḍarīkasūtra*
Myō-Ō (J) *see* Vidyārāja
myrobolan, medicinal fruit 227–8, 232

Nāgapaṭṭinam, monastery site, south India 145; 206–7, 211
Nāgārjuna, philosopher 16–17; 58, 193
Nālāgiri, elephant *see* Buddha (Siddhārtha Gautama, historical Buddha)
Nālandā, Bihar, India, monastery complex and university 104–5, 186; 34, 139, 146, 156, 209
Nāmasaṃgīti, Bodhisattva 174

Nan hai sheng jing Pu tuo shan zhi (C) 338
Nenjū gyōji taisei (J) 412
Nepal, Buddhism 105, 120
 transmission of texts 41
Nīlakaṇṭhadhāraṇī 101
Nichiren (J), sectarian master (1222–82)
 life scenes 414–19
 Nichiren sect 22–3; 382, 402
Niō (J), temple guardian 368, 370
nirvāṇa 10–11, 12, 16, 17, 26, 32; 235, 253
Nyoirin (J) *see* Cintāmaṇicakra

Ōbaku (J), sect 407
Ōjō yōshū (J) by Genshin 107, 410

Padatthayojanā (P) by Ñāṇakitti 261
Padma-'byung-nas kyi rnam-thar (T) 112
Padmapāṇi, form of Avalokiteśvara 124, 147,
 149, 150, 267, 284–5, 291
Padmasambhava, Tantric master 42; 112, 188
Paekche (K), Kudara (J) 235; 352, 388
Pagan, Burmese capital and associated style-
 period (1044–1287) 104, 157–8; 53, 221–3,
 225–6, 228–9, 228
Pakistan, Buddhism 100; *see also* Gandhara
Pāla, eastern Indian dynasty and associated style-
 period (c.AD 750–1200) 104, 105, 160; 48, 62,
 88, 155–7, 176
Pali, Sthaviravāda canonical language 13, 40, 149
Pañcarakṣā, five protective spells and
 corresponding goddesses Mantranusāriṇī,
 Māyūrī, Pratisarā, Sāhasrapramardinī, Sitavatī
 83; 170, 173, 177 80, 182
Pan-chen Lama, abbot of Tashilhunpo, Tibet
 First Pan-chen Lama 193
 Second Pan-chen Lama 194
Pāṇḍaravāsinī, goddess 303
Parākramabāhu I, of Sri Lanka 148–9
Paramārthanāmasaṃgīti 174
Pāramitā, 'Perfection' 14, 17; 60
 deified 171; *see also* Prajñāpāramitā
Paritta (P), *pirit* (Si), spell 148; 92
Parṇaśabarī, goddess 157
Perfection *see* Pāramitā
Perfection of Wisdom *see* Prajñāpāramitā
Phra Malai, legendary Thai monk 263
Phyog-las rnam-rgyal of Bodong (T) 185
Polonnaruva, capital in Sri Lanka and associated
 style-period (1070 1236) 148; 208, 211
Potalaka, Avalokiteśvara's mountain 138, 158,
 167, 209, 296
pothi (H), book form 30, 95
Prabhūtaratna, a Buddha 284, 286
prajñā
 wisdom, insight 18; 58
 'wisdom-partner', consort of a deity 18; 310
Prajñāpāramitā, Perfection of Wisdom 14, 17,
 18, 105
 as deity 65, 156, 167–8, 171, 190
 texts
 fragments 61
 Aṣṭasāhasrikā Prajñāpāramitā 48, 60,
 62, 155–9, 167
 Mahāprajñāpāramitāśāstra in Chinese
 (Kumārajīva) 63
 Mahāprajñāpāramitāsūtra in Chinese 99,
 394
 Prajñāpāramitāhṛdayasūtra 102; in
 Chinese (Xuan Zang) 68, 377; in Tibetan 69
 Prajñāpāramitāsūtra in Tibetan 118
 Śatasāhasrikā Prajñāpāramitā 64–5
 Vajracchedikā Prajñāpāramitā in Khotanese
 66; in Chinese (Kumārajīva) 67
Prajñāruci, translator 47
Prātimokṣa, pātimokkha (P) monastic code 13, 40
 Bhikkhupātimokkha (P) 37
 Prātimokṣasūtra
 in Chinese 38; in Tocharian 36
Pratītyasamutpāda, Dependent Origination,
 causal statement 10
 sūtra 34; *see also* Śālistambasūtra

Pratisarā *see* Pañcarakṣā
Pratyekabuddha, a Buddha who does not preach
 217, 272, 406
Puṇyatrāta, translator 38
Pure Land *see* Sukhāvatī
Pure Land school 20, 22; *see also* Jōdo-shū (J) and
 Jōdo-shinshū (J)
Putuo shan (C), pilgrimage centre 338

Qi sha Tripiṭaka, Chinese edition (1231–1322)
 198; 305–6

Rāga, Aizen (J), protector deity 382
raigō (J) *see jieyin Fo* (C)
Rājagṛha (Rājgir), site of first Buddhist Council
 13
rakṣā, protective spell or deity *see Pañcarakṣā*
Ratnakūṭaparipṛcchasūtra, Gem-heap *sūtra*, in
 Chinese (Fa Hu) 55
Ratnapāṇi, Bodhisattva 157
Ratnasambhava, Dhyāni Buddha of the south 18;
 165, 181, 322
reliquaries 26; 2, 3, 5–11, 208
Roku Amida dengi (J) 404
Rol-pa'i rDo-rje (T), ecclesiastic 189
ṛṣi, seer 319
Ryōnin (J), sectarian master 408

Saddharmapuṇḍarīkasūtra, called *Lotus Sūtra*
 and *Lotus of the Good Law*, *Myōhō rengekyō* (J)
 20, 23; 67, 70–1, 76, 108, 311, 338, 414, 417
 in Chinese 72–3, 378, 393
 Chinese exposition by Zhanran 396
Saddharmasmṛtyupasthānasūtra in Chinese
 (Prajñāruci) 47
Sāgaramati, Bodhisattva 167–8
Sāhasrapramardinī *see Pañcarakṣā*
Saikoku junrei saiken-zu (J) 413
Sakka (P) *see* Indra
Śākya, historical Buddha's tribe 9, 32
Śākyamuni, title of historical Buddha 9, 16, 23,
 235, 243; 82; *see also* Buddha (Siddhārtha
 Gautama)
Śālistambasūtra in Tibetan 113
Samantabhadra 186; 157–8, 167
Saṃgha, Order of monks 11, 12–13, 25, 149,
 160; 65
Saṃghadeva, translator 31
Saṃghavarman (Kang Senhui), translator 56
Sāṃkāśya, where Buddha descended from heaven
 of the Thirty-three gods 33; 24, 142, 223, 237
Saṃyuktāgama, Saṃyuttanikāya (P) *see*
 Sūtrapiṭaka
Saṃvara, fierce Buddha manifestation 152, 163,
 192
Sāñcī, Madhya Pradesh, India, stupa site 26; 2, 3
Sanron (J), Three Treatises school 59; *see also* 63
Saraha, *siddha* 193
Śāriputra, Sāriputta (P), disciple of the Buddha
 33; 227, 243, 257
Sāriputta, Pali author 90
Sārnāth, near Benares, India
 site of First Sermon 9, 32; 22
 centre of sculptural style 92, 104, 120; 139,
 141–2, 248
Sarvanivaraṇaviṣkambhin, Bodhisattva 81,
 158
Sarvāstivāda, Hīnayāna school 13; 8
 texts 33–6, 38
Sa-skya-pa, Tibetan sect 42; 115, 195
*Sa-skya-pa sku-phreng gong-ma lnga'i gsung-'bum
 dkar-cchag* (T) 115
Satapañcāśatikāstotra by Mātṛceṭa 51
Sautrāntikas, Hīnayāna school 13; 43
Seishi (J) *see* Mahāsthāmaprāpta
Senchaku-shū jūrokushō no zu (J) 409
Sesshū Tōyō (J), painter 365
Shi jia ru lai ying hua shi ji (C) 51
Shingon (J), 'True word' Tantric sect 243, 246;
 110, 323
Shōken (J), Pure Land author 401

Shōmu (J), emperor 246
Shōtoku (J), empress, alias Kōken 390–1
Shōtoku Taishi, a founder of Buddhism in
 Japan 22, 243; 73, 366, 387–8
siddha, Vajrayāna master and magical practitioner
 193
Siddhārtha Gautama, Siddhattha Gotama (P),
 historical Buddha 9, 24, 32; 16, 51, 236, 262;
 see also Buddha (Siddhārtha Gautama)
Śikṣānanda, translator 111
Silla (K), kingdom (668–935) and associated style-
 period 20, 235; 342
Siṃhanāda, form of Avalokiteśvara 62
Singasāri, Javanese kingdom 186
Sitavatī *see Pañcarakṣā*
Song (C), dynasty (960 1279) 399
South India, Buddhism 145
Śrāvastī, Sāvatthī (P), Uttar Pradesh, India, site of
 multiplication miracle 33; 148, 223, 237
Śrī
 goddess of good fortune, Kichijōten (J) 319,
 356
 Tibetan protectress (Lha-mo) 193–4
Śrī Kṣetra (Promo), Pyu site, Burma 157, 91, 221
Sri Lanka, Buddhism 13, 40, 41, 104, 145, 148–9,
 157, 175, 176
Śrīvijaya, South-east Asian empire 175, 176, 186;
 204, 297
Stein, Marc Aurel, KCIE, archaeologist and explorer
 in Central Asia 191; 67, 72, 311
sthavira, thera (P), elder, senior monk,
 Sthaviravāda, Theravāda (P), doctrine of the
 elders, a Hīnayāna school 13, 18, 40, 41, 148,
 149
stūpa, also called dāgāba (Si) and pagoda, funeral
 or memorial mound, often with relics, Buddhist
 symbol and votive structure or object 26, 32,
 33, 40, 91, 92, 145, 148, 191, 197; 6, 10, 12, 13,
 44, 144, 147, 175, 186, 198–9, 214, 254, 273,
 390
Sucandra, 'hero' of Buddhist story 165
Śuddhodana, historical Buddha's father 32, 33;
 17
suijaku (J), *honji suijaku* (J) 22; 383
Sukhāvatī, Amitābha's Western Paradise,
 Jōdo (J) 20, 289, 302, 315, 342–3, 358, 384,
 406
Sukhāvatīvyūha (Amitāyuḥsūtra) in Chinese
 (Kang Senhui or Samghavarman) 56
Sukhothai, Thai capital and associated style-period
 (1250–1350) 176; 211, 251–3
śūnyatā, Emptiness, principle underlying
 Prajñāpāramitā and *Madhyamaka* 16, 60, 74, 76
sūtra, sutta (P), discourse, text 13
Sūtrapiṭaka, Suttapiṭaka (P), canonical *sūtra*
 books 13, 40; 32, 42
 Dīghanikāya (P) 30
 Kuddakanikāya (P) 35
 Madhyamāgamasūtra in Chinese
 (Samghadeva) 31
 Majjhimanikāya (P) 32
 Saṃyuktāgama 33
 Saṃyuttanikāya (P) 34
Suvarṇaprabhāsasūtra
 in Chinese
 in Khotanese 77, 305

Taebo pumo ŭnjung-gyŏng (K) 104
Taejong Mongnok (K) 350
Tang (C), dynasty and associated style-period
 (AD 618–907) 20, 157, 197; 356, 371
tantra, Vajrayāna text 17, 18, 41, 42
Tantrism *see* Vajrayāna
Tārā, goddess 83, 114, 147, 167, 187, 210
 Green (Syāma) Tārā 117, 143, 158, 168, 171,
 192, 196, 200
 Mahāśrī Tārā 157
 Vajra Tārā 158
 White (Sita) Tārā 192, 194
Tathāgata, title of historical and transcendental
 (Dhyāni) Buddhas 9; 82

Ten Abstentions 12, 24
Tendai (J) *see* Tiantai (C)
Tengu no dairi (J) 389
Tenkai (J), monk 399
Thailand, Buddhism 175–6
 transmission of texts 41
thangka (T), painting on cloth 304
Theravāda (P) *see* Sthaviravāda
Thirty-three gods (Trāyastrimśa), class of deity
 with its own heaven 24, 33; 251, 324; *see also*
 Buddha (Siddhārtha Gautama, historical Buddha)
Three bodies doctrine *see* trikāya
Tiantai (C), school founded by Zhiyi (531–97),
 Ch'ŏnt'ae (K), Tendai (J) 20, 21, 246; 108, 288,
 396, 406
Tibet, Buddhism 104, 133–4, 198; 341
 transmission of texts 41, 42
tribhaṅga, triple bend (body posture) 330
trikāya or three bodies doctrine *(Dharmakāya,
 sambhogakāya, nirmāṇakāya)* 16
Tripiṭaka, Tipiṭaka (P), threefold division of
 canon *(Vinayapiṭaka, Sūtrapiṭaka,
 Abhidharmapiṭaka),* issaikyō (J) 13, 40, 41,
 157, 160, 235, 246; 99
 catalogue in Korea 350; *see also* Qi sha
 Tripiṭaka
Tsong-kha-pa (T), sectarian master 39, 194

Ucchuṣma, Bodhisattva 321
Ucchuṣma Jambhala, fierce god of wealth 157
Udānavarga, by Dharmatrāta 35
Ŭich'ŏn (K), sectarian master 21
Ŭisang (K), sectarian master 21
upasaṃpadā, ordination 12, 24; 240–5, 262,
 264
upoṣadha, uposatha (P), Buddhist Sabbath 12,
 24; 240
ūrṇā, mark between the Buddha's eyebrows 91;
 207, 248
uṣṇīṣa, Buddha's cranial bump 91; 120
 kaparda type 119
 flame type 206–7, 211–12, 222, 257
Uṣṇīṣavijayadhāraṇī, ritual for recitation
 324

Vairocana, Dhyāni Buddha, usually of the centre
 16, 18; 166, 174–5, 186, 196–7, 269, 322–3
Vaiśālī, Bihar, India, site of Second Council 13,
 40
Vaiśravaṇa, guardian king (lokapāla) of the
 north, lord of riches, Bishamon (J) 194, 304,
 314, 319, 331, 356, 379
vajra, thunderbolt, diamond, in Vajrayāna symbol
 for Absolute and 'male' skill in means,
 kongōsho (J) 18; 149, 153, 163, 186, 202, 375
Vajrabhairava, deity 200
Vajrācārya, Buddhist priest in Nepal 120; 165–6,
 179, 268
Vajradhara, Supreme or Primordial (Ādi) Buddha
 18; 87, 173, 186
Vajrapāṇi
 Buddha's protector in Gandharan sculpture 21,
 25–6
 Bodhisattva 16, 186; 83, 156–7, 162, 268, 379
Vajrasattva, Supreme or Primordial (Ādi) Buddha
 18; 156–7, 162, 166, 196
Vajrayāna, esoteric Buddhism, also called
 Mantrayāna, Tantrism, Shingon (J) 17–18, 20,
 23, 41, 42, 100, 104, 105, 148, 157, 186; 76,
 82–8, 152, 202, 320, 323
varada (mudrā), gesture of liberality 92; 286–7,
 290
Vasubandhu, philosopher 42–3, 109
Vasudhārā, goddess of wealth 157–8, 164–5,
 167–8, 173
Vasudhārādhāraṇī 173
Vessantara (P) *see* Viśvantara
Vidyāmātrāsiddhiśāstra by Dharmapāla, Chinese
 commentary by Kuiji 109
Vidyārāja, protector deity, Myō-Ō (J) 357, 382
Vighna, translator 96

Vijñāna (vāda), Consciousness (doctrine), also
 called Yogācāra 16, 17; 80; *see also* Faxiang
 (zong)
Vikramaśīla, Bihar, India, monastic university
 104, 105; 62
Vimalakīrtinirdeśasūtra 20
 in Soghdian 74
 Chinese commentaries by Kumarajīva, Seng
 Zhao, Dao Sheng 75
Vimalanirbhāsasūtra, Mukujōkō-kyō (J) 391
vinaya, monastic discipline 11, 12, 13, 40; 106,
 233–4
 texts
 in Gāndhārī 40; in Tocharian 36
 Vinayapiṭaka (P), Sthaviravāda canonical
 books 13, 40; *Samantapāsādikā,*
 commentary by Buddhaghosa,
 supercommentary *Sāratthadīpanī* by
 Sāriputta 90; supercommentary
 Padatthayojanā by Ñāṇakitti 261
 Vinayavastu 46; *Vinayavibhaṅga* in
 Tibetan 39
Virūpākṣa, guardian king (lokapāla) of the
 west 314, 349
Visuddhimagga (P) by Buddhaghosa 89, 246
Viśvantara, Vessantara (P) *see* jātaka
viśvavajra, two crossed *vajras* 301, 307, 372
vitarka (mudrā), gesture of argumentation
 212–13, 294, 300, 358

Western Paradise *see* Sukhāvatī

Xiu she yu jie ji yao shi shi tan yi (C) 116
Xinjiang (Central Asia), Buddhism 41, 191
Xuan Zang (602–664), Chinese pilgrim to India,
 translator 41, 104, 145, 148; 68, 80, 98–9, 100,
 109

Yama, god of death, Emma-Ō (J) 103, 174, 194
Yamāntaka, protector deity 174
Yao shi qi fo gong yang yi gui (C) 117, 314
Yi-dam (T), deity who guarantees Buddhahood
 310
Yinyuan (C), Ingen (J), sectarian master 407
Yogācāra, idealist school 20; 80; *see also* Vijñāna
 and Faxiang
Yogācārabhūmiśāstra by Asaṅga, in Chinese
 (Xuan Zang) 80
Yuan, Mongol dynasty in China (1280–1368) 42,
 198
Yūzū dai-nembutsu engi (J) 408
Yūzū Nembutsu sect (J) 408

Zen (J) *see* Chan
Zengen shosen-shū tojo (J) 399
Zhanran (C), Tiantai author 396
Zhi Qian (C), translator 96
Zhiyi (C), sectarian founder 20; 108, 288, 396
Zhong a han jing (C) 31
Zōun (J), abbot of Kokūzōin temple 400